D1327352

Theatre and empire

MANCHESTER
UNIVERSITY PRESS

Politics, culture and society in early modern Britain

General editors
PROFESSOR ANN HUGHES
DR ANTHONY MILTON
PROFESSOR PETER LAKE

This important series publishes monographs that take a fresh and challenging look at the interactions between politics, culture and society in Britain between 1500 and the mid-eighteenth century. It counteracts the fragmentation of current historiography through encouraging a variety of approaches which attempt to redefine the political, social and cultural worlds, and to explore their interconnection in a flexible and creative fashion.

All the volumes in the series question and transcend traditional interdisciplinary boundaries, such as those between political history and literary studies, social history and divinity, urban history and anthropology. They thus contribute to a broader understanding of crucial developments in early modern Britain.

Already published in the series

Forthcoming

Theatre and empire

Great Britain on the London stages under James VI and I

TRISTAN MARSHALL

Manchester
University Press
Manchester and New York

distributed exclusively in the USA by St. Martin's Press

Copyright ©Tristan Marshall 2000

The right of Tristan Marshall to be identified as the author of this work has been asserted by him in accordance with the Copyright, Designs and Patents Act 1988.

Published by Manchester University Press
Oxford Road, Manchester M13 9NR, UK
and Room 400, 175 Fifth Avenue, New York, NY 10010, USA
http://www.man.ac.uk/mup

Distributed exclusively in the USA by
St. Martin's Press, Inc., 175 Fifth Avenue, New York, NY 10010, USA

Distributed exclusively in Canada by
UBC Press, University of British Columbia, 2029 West Mall, Vancouver, BC, Canada V6T 1Z2

British Library Cataloguing-in-Publication Data
A catalogue record for this book is available from the British Library

Library of Congress Cataloging-in-Publication Data applied for

ISBN 0 7190 5748 5 *hardback*

First published 2000

07 06 05 04 03 02 01 00 10 9 8 7 6 5 4 3 2 1

Typeset in Scala with Pastonchi display
by Koinonia Ltd, Manchester

Printed in Great Britain
by Bookcraft (Bath) Ltd, Midsomer Norton

Contents

Acknowledgements

In writing this book I am indebted to those teachers whose scholarship and enthusiasm have been so influential in pointing me down this road. In this respect I owe an enormous debt to three members of staff who taught me at the Grange Grammar School in Cheshire. Philip Weatherly introduced me to the study of history while devoting a great deal of his time and energy to creating a happy learning environment. Nigel Hatton encouraged me to apply to Cambridge and was a source of endless optimism. David Jones introduced me to the early modern period and I would not have studied history as a degree subject had it not been for his example. I could not have had finer teachers.

This volume is an expanded version of my Cambridge PhD thesis, 'The idea of the British empire in the Jacobean public theatre, 1603–c.1614', a project which in turn had its origins in the Cambridge Historical Tripos option 'The British Problem, c.1534–1707' which I studied in my final year as an undergraduate. I was immediately drawn to the wider themes and issues raised by the course, whose creators Brendan Bradshaw and John Morrill challenged the notion of early modern English history as a separate entity from the histories of Ireland, Scotland and Wales. Their seminal work lies behind many of the ideas I have explored in the following pages. Though research for the thesis between 1992 and 1995 was, sadly, carried out largely in isolation I am grateful for the counsel I received from Anne Barton, Glenn Burgess, Patrick Collinson, Kevin Sharpe and Jenny Wormald. During the subsequent period of research and writing for *Theatre and empire* I have been grateful for the opportunity to discuss Jacobean matters with David Smith, whose advice and support I continue to prize highly. At the University of Ulster, Keith Lindley has been enormously helpful and I have been extremely fortunate to benefit from Bob Hunter's encyclopaedic knowledge of Irish history, especially his thoughts on the Ulster plantation.

Over the past seven years the staff of the Rare Books Room in Cambridge University Library have continued to be enormously patient and utterly selfless in fetching books and microfilms, especially when they have made trips so that I could make a momentary check. My gratitude must also be extended to Vanessa Graham and Alison Whittle at Manchester University Press for their seemingly boundless patience.

I am also grateful for the patience of good friends, some of whom did not

share my twin enthusiasms for Jacobean history and rowing but endured them nevertheless – thanks to Nick Finnie, Kat Arney, Johan Khoo, Bernard Khoo, Shireen Khoo, Martin McGurrin, Toby Brundin and Juliet Mickelburgh. Paul Hughes, Peter Alexander and the rest of the members of Chester Aikido Club provided an alternative outlet for my energies during 1996–97. I would also extend my gratitude to the members of Selwyn College Boat Club for their conviviality during the academic year 1997–8 and indeed subsequently.

My greatest debt, however, is to my parents, Scott and Olivia Marshall, my brother Aaron and my aunt Elma, whose love and chequebooks made first my thesis and now this book possible.

Tristan Marshall
Portrush, Country Antrim

Introduction

―――◆―――

James VI and I and the re⁄invention of Great Britain

what man have you now of that weake capacity, that canot discourse of any notable thing recorded euen from *William* the Conquerour, nay from the landing of *Brute*, vntill this day, beeing possest of their true vse, For, or because Playes are writ with this ayme, and carryed with this methode, to teach the subiects obedience to their King.[1]

This study looks at the interrelationship between nationalism and theatre in the Jacobean period. More specifically, it looks at the creation of a British identity brought about by the accession of King James VI of Scotland to the English throne in 1603. This evocation of 'Britishness' is at the heart of our understanding of James's reign. If he indeed succeeded in inculcating a British identity among his subjects in England, Scotland, Wales and Ireland then his Union project needs to be considered a far greater success than has hitherto been appreciated.

Jenny Wormald has recently suggested that James's agenda for the creation of Great Britain was an extremely subtle piece of political manoeuvring designed to secure the acceptance of his fellow Scots in the English court. She describes him as having from the start the view that the creation of a greater Britain was an unrealistic aspiration, a higher bargaining position from which he would later retreat to secure his real aim of toleration. However, when she writes that 'he manifestly failed to achieve any sort of "British" kingship' we need to be wary because in one important domain he did.[2] According to James Stuart, the new king of England, Britain was 'the true and ancient Name, which God and Time have imposed upon this Isle, extant and received in Histories, in all Mappes and Cartes, wherein this Isle is described, and in ordinary Letters to Our selfe from divers Forraine Princes ... and other records of great Antiquitie'. He was not alone in thinking along these lines. At the same time that antiquarians were revealing the ancient past, a series of plays in London's theatres was staging the lives of a group of earlier British rulers,

among them Lear, Cymbeline and Elidure. What emerges from a study of these plays is the idea that James was actually extremely successful, whether he intended to be or not, in popularising the idea of 'Britain' as a cultural entity.

The most significant political legacy of James's national project was the creation of an emphatically British identity among the settlers from both England and Scotland who planted Ulster. These settlers took on the name of Britons as their common currency in the face of native Irish and old English Catholicism, testament to the notion that Britishness seemed to mean far more to those Britons not living on the British mainland than it did to those who were. The manner in which the plantation went ahead stands in marked contrast to the emphatically English cultural imperialism expressed by Sir John Davies, who had advocated the imposition of Englishness on the native population. The contemporary success of the wider, British dimension to the plantation is evinced – not without a great deal of irony for those Irish historians keen to diminish the British role in Ulster – by the fact that such Jacobean Scots planters as the Earl of Abercorn and Sir George Hamilton of Greenlaw settled Catholics extensively in Strabane. This would have been anathema to Elizabethan governors of Ireland.[3]

Then as now the notion of 'Britishness' was strongly, though not solely, defined in negative terms, deriving cohesion from its exclusion of others from its auspices. Not all Scots were to be accorded the distinction of being Britons. In a Scotland in which Highlanders remained alienated from their increasingly English-speaking Lowland cousins, John Mair had viewed the latter group as one which lived under the governance of reason and who, like the English, possessed a civic capacity.[4] Highlanders were thus firmly outside James's view of Britain, provoking him to refuse the request of Thomas Knox, Bishop of the Isles, for assistance in combating the Jesuits in Argyll, on the basis that anyone who could civilise the Highlanders, even if Catholic, could go ahead with his blessing.[5]

To perceive the origins of this new interest in the idea of the nation we need to look overseas for other examples. Kevin Sharpe has written of how the sixteenth century saw the Reformation produce a developed sense of nationality in France and Germany, an awareness which 'gave rise to a quest for knowledge about the native country and a desire to trumpet its glorious achievements to other realms'.[6] The legacy of the Henrician reformation in England was to advance England's self-definition towards its being a self-contained monarchy, independent of Rome's influence, something her Catholic neighbours were not. By the early seventeenth century the accession of a Scottish king facilitated the internationalisation of the English monarchy as James, married to a Dane, used the prospect of marriage alliances for his children to bring his kingdoms firmly onto the European stage. In Britain this

re-appearance of the use of marriage negotiations as a political tool occurred at the same time as a greater emphasis on scholarship in the education of those destined for the service of the realm. It was the growth in antiquarian study which facilitated the redefinition of the nation's boundaries, both justifying the idea of Great Britain while challenging the notion that the monarch was indeed the sole repository of the nation's identity.[7]

Over the past decade there has been a healthy amount of historical and literary study of the Stuart masques, those extravagant displays of Stuart power, so often full of subtle – and not so subtle – criticism of the *status quo*.[8] Yet in one of the most recent of these studies, Martin Butler wrote about the Stuart masque in the context of 'Whitehall's attempt to create a public symbolism of Britishness' while forgetting that the masques were not public at all. They were a court medium designed to be seen by a privileged few.[9] He also wrote: 'Given the dynastic character of the early Stuart Union, it may have been all but impossible for the iconography of the masques fully to accomplish those images of a coherent national identity towards which they seemed so often to be reaching. In this respect the problems into which Stuart court culture ran were directly symptomatic of the underlying structural weaknesses of Stuart kingship'.[10] Were he to study the Stuart theatre alongside the masques his conclusion would be very different, as the stage did put forward images expressing not only an interest in an emphatically British past, but support for it.

Interest in Britishness is not limited to literary studies. The ongoing historical debate regarding 'the British Problem', the relationship between the islands of Britain and Ireland in the early modern period, continues to prompt the question as to how Britain was conceived at the dawn of the seventeenth century.[11] It was not just a matter for courts and courtiers, or for politicians and (as we shall see) playwrights. Out in the English countryside, Adam Winthrop was writing a diary when James Stuart came to the English throne. He recorded everyday events, especially the criminal acts of his neighbours, varying from infanticide to random attacks on swine. But two entries in particular stand out. He wrote that on 29 May 1604 his cousin 'shewed me a nue booke in latine De Vnione Britaniae' and in his entry for 24 October he noted 'it was proclaymed that England and Scotland shoulde be called great Brittaine'. The book in Latin was Robert Pont's *De unione Britanniae, seu de regnorum Angliae et Scotie* (London, 1604).[12] That his cousin had bought a copy and was showing it off, coupled with Winthrop hearing of the king's proclamation of Great Britain suggests a dissemination of British ideas beyond the confines of the metropolis. Another diarist, Walter Yonge, reported without comment in April 1606 news of the proclamation enforcing use of the new union flag: 'such ships as were of South Britain should carry a red cross; the North part a white cross'.[13] Yet Great Britain didn't truly come

into being until the Act of Union in 1707 tied Scotland with England and Wales, and Ireland remained politically peripheral until nearly a century later. This Jacobean Great Britain was not then some flash in the pan, some chimerical flight of personal whimsy on behalf of a thirty-seven-year-old Scot suddenly in 1603 rich beyond his wildest dreams. To use Benedict Anderson's definition of a nation, Britain in the first quarter of the seventeenth century was indeed an 'imagined political community' first imagined by a group of writers and subsequently the subject of a process of redefinition and renego- tiation as royal aspirations mixed with literary and political ambitions.[14] While Linda Colley's work argued for the creation of an exclusively Protestant Britishness in the eighteenth and early nineteenth centuries, this study is deliberately confined to the early seventeenth century, that brief period when discourse of 'Britishness' was most intensive and modern ideas of a united kingdom were born, the reign of a king whose personal fortune in being a Scot on the English throne was the catalyst for a re-writing of the Scottish and English national past.[15] Consequently, it will be argued that Great Britain actually came to life for a short period at the beginning of the seventeenth century and that if subsequent developments such as Oliver Cromwell's skewing of relations with the Scots and Irish soured notions of British unity in this tumultuous century, we should be wary of assuming that there never was a moment when Britain was inclusive rather than exclusive, incorporating rather than excoriating.

This is also a historical study which uses primarily literary material, making it important to establish this writer's opinion of the role of the theatrical text, as it both reflected and was performed within the political culture of Jacobean England. There are problems inherent in bringing the disciplines of literature and history together. In the following chapters it will be contended that any reproduction on stage of, for example, authority, such as royal policy and its ramifications, could be interpreted by an audience as a potential alternative view to the motivations and principles of the hierarchy under which they live. At the same time, it is important to admit the problems inherent in taking a piece of stagecraft, conveyed in print, at face value. We might genuinely believe a playwright to be sincerely trying to convey one image, while all the time the manner in which it is performed might voice exactly the opposite opinion. Another caveat is that, as Sigmund Freud might have said, sometimes a play is indeed just a play. Iago, for example, is not a covert representation of King James and his words do not directly threaten the real-life monarch or anyone else for that matter. He does not advocate an alternative foreign policy and makes no claim to challenge the religious hegemony of his country. His only material foe is Othello. There is a danger that historians can be too zealous in trying to fit plays into convenient boxes in response to literary criticism's attempts either to fit square pegs into round

historical holes or ignore potential aspects of topicality altogether. Scholars attempting to join with Stephen Greenblatt circulating social energy are therefore prone to flounder on disagreements over methodology.[16]

Political commentary alone does not 'explain' plays in their entirety, nor does it intend to. In no sense does the introduction of historical contextualisation provide self-sufficient interpretations of plays – historians cannot subvert or supplant literary scholarship. Equally, as David Colclough has shown, historians often plunder literary resources as if texts are mere pieces of evidence there for the taking. In particular he argues that, by taking items out of manuscript miscellanies and crying *eureka*, historians are failing to look to the miscellanies as documents in themselves, robbing them of their connection to the mind, and political interests and affiliations, of their compilers.[17]

Playwrights had to face censorship requirements and while it often transpired that they were able to bypass censors with plays set in conveniently distant historical periods, there were nevertheless enough incidents of royal displeasure and consequent incarceration to make a playwright think twice before writing 'dangerous matter'. Yet by claiming that plays comment on contemporary issues this does not mean to suggest that they necessarily allow us to see in *every* case clearly identifiable persons and situations depicted. That said, there are a few instances where specific parallels within plays in the later years of James's reign do allow a more transparent relation of current affairs – *The Maid of Honour* stands out in this respect. Yet the danger faced by both literary critics and cultural historians in attempting a reductionist decoding of any play text in this manner is that one can find anything one seeks if one is prepared to read the text in a particular light. Interpretations of *The Tempest* remain the best examples of this within Jacobean theatre.[18]

The relationship between the two disciplines of history and literature is complementary: history puts literature in perspective while public theatre is an intrinsic part of the recording of the past which illustrates the thinking of a group of individuals writing not just for the entertainment of the literate, but for those who might not otherwise be able to leave a record for themselves. When playwrights wrote they did so knowing that, for their work to be successful, their audience would have to understand the material. Study of the manner in which the public theatre described, informed and ruminated on aspects of both foreign and domestic policy fundamentally challenges the way in which we should perceive Jacobean life. In the absence of the café society of later decades which proved so important in the dissemination of ideas beyond the printed word, the theatre served a crucial purpose. But such study has also thrown up much confusion over the intentions of the playwrights themselves regarding one matter then much talked about, namely King James's attempt to turn London into the capital of Great Britain.

According to Kendrick, in *British Antiquity*:

Shakespeare would have nothing to do with this notion that the British History was an ingredient in the greatness of Elizabethan England. He used plots that derive ultimately from Geoffrey of Monmouth, and he made Cymbeline refer to the Molmutian laws; but he saw no contribution to the glory of Tudor England in these remote British kings.[19]

In 1603 more than one turning-point had been reached: the fact that a new reign and a new regal agenda separated the writing and production of *Cymbeline* from the age of Elizabeth seems, however, to have passed Kendrick by. In a more recent study Richard Helgerson uses Jacobean material in a book ostensibly about how Elizabethan England was 'written'. One of the fundamental principles underlying this book is that we need to be wary of assuming the Jacobean period to be some kind of extension of the Elizabethan, a misapplication many literary scholars in the past have seemed happy to accept.[20] For most people in both England and Scotland life did indeed continue in much the same vein in 1603 as it had done a year earlier, but in the study of the writing of the nation and the manner in which an entity called 'Great Britain' was perceived there were significant changes which force us to draw a figurative line between the reigns. The Shakespeare who wrote in the Jacobean age wrote very different plays from his Elizabethan canon, plays which like those of his contemporaries would make the matter of Britain a far higher priority in terms of subject material. Indeed it would not be excessively polemical to stress the fundamental political differences of the pre- and post-Union Shakespearean canon.

But the theatre of the Jacobean period does not rest on Shakespeare alone: what emerges in the study of the London stages in this period is that his work fits into a wider framework of dramatic material discoursing on not just the Union, but on issues of war, religion and overseas exploration. This study will therefore be at odds with Parry's view that the claims of empire 'needed to be given to a far broader audience than the court, but they were not' and that 'the Stuart line was the less secure as a result of the limited proclamations of its virtues'.[21]

Most importantly, the plays discussed in the chapters below do not contain small, isolated examples of political commentary taken out of context. *Cymbeline, The Valiant Welshman, Hengist, King of Kent* and *Bonduca*, for example, all illustrate a strong central ideology in which shared themes emerge, of British unity and the need for strength in defence of the island. King James's re-creation of Britain was not a pipe dream used to throw English zealots off guard. It was a genuine interest. The fact that it was the project of an intellectual dilettante should not lead us to believe that its demise as a political project saw its demise as an ideological one. While lacking the permanence of a political reality, the existence of such an idea of a larger expanded realm united in Protestantism had just as much force over time as a

politically cohesive Britain. Scotland was not James's stepping stone to England so much as England was his stepping stone to Britain. If he failed to unite his northern and southern kingdoms in one law and one people he did give rise to the creation of something else, a British consciousness in Ireland and a template for combined expansion overseas in the eighteenth century. What began as a desire to recreate a British *imperium* became a groundswell favouring the expansion of a British empire. It is to such differing notions that we must first turn.

NOTES

1 Thomas Heywood, *Apology for Actors* (London, 1612), sigs. F3–F3ᵛ.

2 Jenny Wormald, 'James VI, James I and the identity of Britain' in Brendan Bradshaw and John Morrill (eds), *The British Problem c.1534–1707: State Formation in the Atlantic Archipelago* (London: Macmillan, 1996), pp. 164–5, p. 148.

3 Hans Pawlisch, *Sir John Davies and the conquest of Ireland. A study in legal imperialism* (Cambridge University Press, 1985); J. Michael Hill, 'The origins of the Scottish plantations in Ulster to 1625: a reinterpretation', *Journal of British Studies* 32 (1993), 24–43. For examples of toleration and support given to Catholics in Jacobean Ireland, see T. W. Moody, *The Londonderry Plantation 1609–41* (Belfast: William Mullan and Son, 1939), pp. 286–7 and Tristan Marshall, 'James VI & I: Three kings or two?' *Renaissance Forum* IV:2 (1999), http://www.hull.ac.uk/renforum/v4no2/marshall.htm

4 Arthur H. Williamson, 'Scots, Indians and empire: the Scottish politics of civilization 1519–1609', *Past and Present* 150 (1996), 60.

5 Jenny Wormald, 'James VI, James I and the identity of Britain', p. 168.

6 Kevin Sharpe, *Sir Robert Cotton 1586–1631: History and Politics in Early Modern England* (Oxford University Press, 1979), p. 9.

7 *Ibid.*, p. 48.

8 Martin Butler, 'Ben Jonson and the limits of courtly panegyric' in Kevin Sharpe and Peter Lake (eds), *Culture and Politics in Early Stuart England* (London: Macmillan, 1994), pp. 91–115; Martin Butler, 'Politics and the masque: *The Triumph of Peace*', *The Seventeenth Century* 2 (1987), 117–41; Martin Butler, 'The invention of Britain and the early Stuart masque' in R. Malcolm Smuts (ed.), *The Stuart Court and Europe: essays in politics and political culture* (Cambridge University Press, 1996), pp. 65–85; D. J. Gordon, 'Chapman's *Memorable Masque*' in Stephen Orgel (ed.), *The Renaissance Imagination* (Berkeley: University of California Press, 1975), pp. 194–202; D. J. Gordon, '*Hymenaei*: Ben Jonson's masque of Union', *Journal of the Warburg and Courtauld Institutes* VIII (1945), 107–45; E. A. J. Honigmann (ed.), 'The Masque of Flowers (1614)' in T. J. B. Spencer and S. W. Wells (eds), *A Book of Masques. In honour of Allardyce Nicoll* (Cambridge University Press, 1967), pp. 149–77; David Lindley, 'Embarrassing Ben: the masques for Frances Howard', *English Literary Renaissance* 16 (1986), 343–59; David Norbrook, '"The Masque of Truth": court entertainments and international Protestant politics in the early Stuart period', *The Seventeenth Century* 1 (1986), 81–110; David Norbrook, 'The reformation of the masque' in David Lindley (ed.), *The Court Masque* (Manchester University Press, 1984), pp. 94–110; Graham Parry, *The Golden Age*

Restor'd: the culture of the Stuart court, 1603–42 (Manchester University Press, 1981); Graham Parry, 'The politics of the Jacobean masque' in J. R. Mulryne and M. Shewring (eds), *Theatre and Government under the Early Stuarts* (Cambridge University Press, 1993), pp. 87–117; David Bevington and Peter Holbrook (eds), *The Politics of the Stuart Court Masque* (Cambridge University Press, 1998).

9 Butler, 'The invention of Britain and the early Stuart masque', p. 69.

10 *Ibid.*, p. 84.

11 See, for example, Brendan Bradshaw and John Morrill (eds), *The British Problem c.1534–1707: State formation in the Atlantic archipelago* (London: Macmillan, 1996) and Brendan Bradshaw and Peter Roberts (eds), *British consciousness and identity. The making of Britain, 1533–1707* (Cambridge University Press, 1998). For a review of the positions taken by both books see Tristan Marshall, 'Empire state building: finding the problem in the British problem', *Renaissance Forum* IV: 2 (1998), http://www.hull.ac.uk/renforum/v3no2/marshall.htm.

12 'The diary of Adam Winthrop, 1580–1630' in *Winthrop Papers*, ed. Allyn B. Forbes and others, 6 vols. (Massachusetts Historical Society, 1929), vol. I, p. 85, p. 87.

13 Walter Yonge, *Diary of Walter Yonge*, ed. George Roberts (London: Camden Society, 1848), pp. 6–7.

14 Benedict Anderson, *Imagined Communities: Reflections on the origin and spread of nationalism* (1991 edn), p. 6.

15 Linda Colley, *Britons: Forging the nation 1707–1837* (New Haven: Yale University Press, 1992).

16 Stephen J. Greenblatt, *Shakespearean Negotiations: the circulation of social energy in Renaissance England* (Oxford: Clarendon Press, 1988).

17 David Colclough, '"I meane to kill your Speaker": manuscript miscellanies and the politics of free speech in Jacobean England' (unpublished paper).

18 See Chapter 3 below and Tristan Marshall, '*The Tempest* and the British imperium in 1611', *Historical Journal* XLI:2 (1998), 375–400.

19 T. D. Kendrick, *British Antiquity* (London: Methuen, 1950), p. 132.

20 Consider, for example, the title and scope of Chambers' *The Elizabethan Stage*. Shakespeare especially is often lauded as an Elizabethan playwright in spite of the sizeable number of his plays written after 1603.

21 Parry, *The Golden Age Restor'd*, p. 62.

Chapter 1

———◆———

A Jacobean empire

There is almost no nation but hangs upon the beck and nod of one man, obeys one man, is ruled by one man: therefore in this respect at least the state of things in our time is ... like that of Rome under the emperors. And the more like their history is to ours, the more things we may find to study in it that we can apply to our uses.[1]

Diuine testimonies shew, that the honour of a king consisteth in the multitude of subiects, and certainly the state of the Jewes was farre more glorious, by the conquests of *Dauid*, and under the ample raigne of *Solomon*, then euer before or after.[2]

Hen the speaker of the House of Commons, Sir Edward Phelips, welcomed King James VI of Scotland to the English throne he spoke of how God 'in his divine distribution of Kings and Kingdoms ... hath magnified and invested Your sacred Person, in the imperial throne of this most victorious and happy Nation'.[3] James's arrival had staved off the spectre of domestic conflict over the succession and the country breathed a sigh of relief that the king and his family would ensure England's Protestant religion for another generation. Yet Phelips's words prompt us to look at one particular idea, one which was to challenge both parliament and public alike when the Scot came to proclaim his desire to be King of Great Britain. Whether Phelips used the word 'imperial' in the same sense as that used in England in the aftermath of Henry VIII's break with Rome, or with some new meaning in the light of the accession of the Scottish king, provokes us to ask what exactly the early Jacobean period meant by 'empire'.

The significance of the term lies not only in the fact that the period under James Stuart saw the first permanent settlement in the New World and the plantation of Ulster, but because it also bears a direct influence on the sense of a Jacobean national identity. The early Jacobean period saw the coalescing of sixteenth-century ideas of empire into a new form. This transition period had a momentum of its own, derived from the accession of a Scottish monarch

whose uniting of the kingdoms resulted in a spate of popular drama discoursing on the ancient entity of Great Britain. It was a matter very much in the public eye and, given that a play's subject matter had to be relevant for its audience, the move to plays with a British – rather than English – identity suggests that the historical construct of Great Britain was by no means on the decline in 1603–14. At the dawn of the Stuart age, the theatre described a vision of the British past as well as its future, drawing not only on the recent years of expansion into Ireland and Virginia, but on semi-mythical history too.

In her study of imperial thought and imagery during the reign of Queen Elizabeth, *Astraea*, Frances Yates showed how the Virgin Queen was associated with the idea of the return of the 'Golden Age', quoting from Ovid's *Metamorphoses* in explanation of this particular myth and illustrating how the queen became an emphatically *imperial* virgin.[4] Like the Holy Roman Emperor Charles V and Charles IX of France, Elizabeth took on much of the imagery of imperial rule as a just virgin ruling a chosen people. In 1603 the virgin died, but the imperial aspect of the monarch of England's rule did not.

The most significant hurdle facing the historian seeking to understand imperial thinking in the Jacobean period is that the term was used in more than the single sense in which we generally use it now. On the one hand we have the concept of imperium, the internal empire of the preamble to the 1533 Act in Restraint of Appeals, and on the other empire in our modern sense, that of colonisation and overseas expansion. The two can be and regularly are confused. Discussing from the imperial perspective the arrival of a Scot on the English throne, Jenny Wormald wrote that 'James could be neither British king nor British emperor, for the empire of England had closed in on itself'. In one sense she was indeed correct – James would never have agreed to the Elizabethan form of imperial thinking, the one dating from the reign of Edward VI which sought the reduction of Scotland to colonial status under the English throne. This ignores, however, the other equally topical meanings of the term.[5] At the death of Elizabeth, the literary conceit of the 'British Empire' changed. One form of imperial thought in England indeed 'closed in on itself', that which promoted Scottish integration into England, but there were to be new forms of discussion on Britain's imperial destiny to replace it.

Wormald's assertion that 'the kingdom of England restated Henry VIII's definition of "empire" as a kingdom free from outside influence or interference, not this time to resist the mighty claims of the Papacy, but to deal with a little domestic matter, the infiltration of the Scots', is useful in two respects. It illustrates that there *was* change in the perception of empire, as well as highlighting the nature of the split between the idea of the internal empire – the relationship of the Scots within an imperial Britain – and the external empire, defending British interests from overseas powers. She continues, however: 'In 1600, Sir Thomas Wilson listed the claimants to the

"absolute Imperiall Monarchy" of England. That, not the title Emperor of the Whole Island of Britain which graced the accession medal of the Scottish claimant, was what mattered'. This chapter will suggest that this was not in fact so.

DEFINITIONS

While the term 'empire' is used in the early seventeenth century as referring primarily to the internal sovereign national state and only later with the connotations of overseas colonising, I shall differentiate between the two meanings by referring to the former definition as imperium, allowing for the latter use the term empire. The *Oxford English Dictionary* distinguishes between the two as (1) 'A country of which the sovereign owes no allegiance to any foreign superior' and (2) 'The extensive territory (especially an aggregate of many separate states) under the sway of an emperor or supreme ruler'. Thus John Russell in his *A Treatise of the Happie and Blissed Unioun* talks of the 'tua imperiall crounes of Scotland and Ingland', recognising the sovereignty and integrity of the two realms, largely in the face of any English thoughts of Scotland becoming a colonial possession.[6]

Much of the confusion over James's intentions for the re-creation of the imperium of Great Britain is in fact caused by the oversimplification of the idea of empire. Under Elizabeth, the term 'Britain' was used as a patriotic extension of the term 'England', much in the same way today that the English tend to think of the two words as being synonymous. It is in this context that John of Gaunt's moving speech in Shakespeare's *Richard II* (written in 1595) is best understood:

> This royal throne of kings, this scepter'd isle,
> This earth of majesty, this seat of Mars,
> This other Eden, demi-paradise:
> This fortress built by Nature for herself
> Against infection and the hand of war;
> This happy breed of men, this little world,
> This precious stone set in the silver sea,
> Which serves it in the office of a wall,
> Or as a moat defensive to a house,
> Against the envy of less happier lands;
> This blessed plot, this earth, this realm, this England.
>
> (*Richard II*, II.i.40–50)

Most significantly he is made to associate 'This scepter'd isle', implying the island of Britain, with 'this England'.[7] With the arrival on the English throne of a king who proposed to re-establish the Kingdom of Great Britain proper, those who backed a strong English national assertiveness over the Scots could

no longer make the same association as before through referring to 'Britain'. Quite simply, the goalposts had shifted, as advocates of a British dimension to politics under James were now those who backed rapprochement with Scotland.

The basis for imperial thought, and what may be called the 'imperial theme', throughout this study lies within a corpus of ideas, insular in nature, largely though not exclusively dependent on Protestantism and increasingly militant. It was a thinking influenced by the Reformation's split with Rome and English fears of European Catholicism, especially following Mary's attempts to turn England's destiny back to Rome. The reign of the unmarried Elizabeth saw the Armada attempts of 1588, 1596 and 1597 which led to a myth not of victory but of deliverance, while the desire to secure England at home from the dangers of a Franco-Spanish alliance led to a royal approval of privateering against Spanish shipping in both the Old and the New World.[8]

British Protestantism remained a defensive religion in the early part of the seventeenth century, concerned primarily with defending the 'beleaguered isle' from European Catholicism, both physically and in scholarly debate. Ussher published the first of his works towards a large ecclesiastical history, the *Gravissimae Quaestionis De Ecclesiarum Christianarum ... Successione et Statu Historia Explicatio* in 1613, aiming to prove that the historical origins of British Christianity were independent of Rome, while Sir Robert Cotton collected the antiquaries' papers on the antiquity of the English church and bound them with other material as 'The State of the Church of Great Britain from y[e] First Plantation of Religion'.[9]

Sermons advocating the Virginia Company's project, however, frequently placed conversion of the natives as one of the highest priorities for the settlers. William Crashaw, for example, wrote that 'out of our humanitie and conscience, we will giue them ... 1. *Ciuilitie* for their bodies 2. *Christianitie* for their soules'.[10] Faced with Jesuit successes in converting souls to Catholicism in the Americas, English Protestantism fought back with rhetoric which, however genuinely it might have been felt by the preachers, was to be forgotten quickly by the majority of settlers.[11] They faced more important concerns in their dealings with the natives, and the scornful attitude of the Powhatans to the suggestion that they should convert to the newcomers' religion, the religion of those whose god had not told them how to feed themselves, pushed conversion off the agenda in the first years of settlement.[12] The theory of this religious mission remained alive back in London, however, along with the idea of the great benefits which James Stuart's rule could bring to other peoples. Though we should be aware of its ultimate failings when it was brought there, Protestantism was indeed to be the first of the commodities shipped to the New World.[13]

This drive was not, of course, at the instigation of James Stuart. Through

allowing himself to be depicted in imperial terms, James could withdraw into the mysteries of state, governing his older kingdom, as he liked to boast, by pen alone, and wrapping himself in the *arcana imperii*, a predilection reflected in the spectacle of the masque.[14] That is not to say that James was not interested in the wonders of the expanding world. His interest in the overseas ventures in Ulster and Virginia was tempered by their practical and fiscal value, rather than any sense of personal religious mission to save souls in the New World, and he was loath to advocate any expansion which might threaten the peace. James thought of empire in a defensive sense and used the threat of sanctioning overseas involvement as a bargaining stake, as with English mercantile activities in Guiana throughout his reign.[15] James was like his godmother Elizabeth when it came to foreign policy, with caution being ever on his mind if not on his lips.

IMPERIUM

The idea of the British imperium in the early modern period had its origins in the assertion made in the Act in Restraint of Appeals. Henry VIII thought of himself as *imperator in regno suo*, claiming the right to control the powers and liberties of the Church of England. More specifically, he sought the legal power of the Roman emperor within his own kingdom, having no temporal superior within his realm, an idea laid down by Roman law.[16] In defence of this claim, subsequent English monarchs looked to the legacy of the Emperor Constantine and his British wife Helena, establishing a precedent for the practice of sovereign national power in England. The idea of imperium was thus one which strongly asserted the power and right of the English crown to control of its own affairs, both spiritual and temporal, within its own boundaries. And it was this understanding of empire which therefore formed the basis of imperial thought by the late sixteenth century. What occurred in 1603, however, introduced a new and fundamentally different understanding of the term into political discourse. As England was an imperium, was not the newly 'united' realm of Great Britain, brought together in the person of James Stuart an imperium?

Proposals for the creation of such an empire had in fact been made by Somerset in 1548, a response to the death of James V in 1542 and the consequent minority of Mary Stuart. If the name of the newly formed state was indeed to be Great Britain it was to have been a creation in which England would have had the upper hand. In his 1547 *Epitome of the title that the Kynges Maiestie of Englande hath to the sovereigntie of Scotlande* Nicholas Bodrugan urged Scots to stop fighting 'against the mother of their awne nacion: I meane this realme now called Englande the onely supreme seat of thempire of great Briteigne'. Odet de Selve's version of Somerset's proposal to Huntly at the

beginning of 1548 for the suppression of England and Scotland was for their replacement 'en ung empire quy sera dict et nommé tousjours l'empire de la Grande Bretaigne et le prince dominateur d'icelluy empereur de la Grande Bretaigne'.[7] Out of the Edwardian moment was indeed to emerge 'the enduring notion of a British monarchy which was both Protestant and imperial', but it would be one whose concern with empire would be firmly rooted on this island and one whose *raison d'être* was the expansion of English power and influence.[18]

The argument in favour of this seemingly natural progression – from the king being head of the two imperiums of England and Scotland to being head of one united imperium – faced the barrier, however, of the English and Scots legal systems. The conclusion of the judges who debated the idea of the union of Scottish and English laws was that this kind of imperium was not actually possible without one legal system submitting to another, firmly denying that such a British imperium could exist. Yet it would be a characteristic of much of the writing in the period 1603–14 in support of union that Britain *was* such an imperium, that she could in fact act as a unified sovereign power, irrespective of the legal problems this actually posed. When early modern historians have looked at imperium they have seen only the sixteenth-century model perpetuated in the Jacobean period. Koebner writes that the concept of empire under James 'was essentially equivalent to that which one century earlier had been imported to England by Polydore Vergil'. He goes on to claim that it was an imperium 'as understood by the humanists – a term expressive of dignity and splendour but not of precedence over other kingdoms – not at all claiming world supremacy'. Yet he does not look at the whole picture. A concern with overseas empire did not necessarily mean the search for world domination.[19]

Both those who backed Union and those who did not accepted that there was a new imperium in existence. The difference occurred in their interpretation of where the power lay within it and what it should be called. We cannot dismiss James's view of a recreated Britain as a complete failure, because it succeeded at least in one critical respect: he did become King of England in 1603. This factor is missed by Keith Brown, who writes that 'within a year his dream of a British kingdom was dashed ... James moved too far too fast'.[20]

After 1603 James found himself having to deal not only with English hopes of imperial aggrandisement but also with his continuing difficulties with Presbyterians in Scotland. His response to the encroachment of Presbyterian clergy into the government of his northern kingdom was to embrace the very claims made by Henry VIII to monarchical power over church and state, the basis of Tudor imperial monarchy.[21] Yet the recreated empire of Britain, warned John Russell, should be the limit of James's aspirations:

The gude emperor affirmit that the sea and the impyre war the tua pleasant thingis to luik upon bot perilous to taist ... And thairfoir ane uyse prince sould not think himselff the happier becaus he succeides to ane greater impyre nor he had of befoir, bot rather to remember that he has the greter cair and paine imposit wpon his schulderis, in the gude ruling thairof. [22]

Russell would very quickly realise the quagmire into which he was wandering: a second, unprinted treatise warned James to be wary lest he should forget that the rule of Scotland was his first duty, a matter which was also of immediate concern to members of the Scottish parliament.[23]

As a result of the Union in 1603, those writings on empire which referred to the imperium split into two strands, corresponding to a pro- or anti-Union stance. Those who were recalcitrant over progress towards the Union and continued to express concern over the Scottish presence in England continued to think of imperium in anglocentric terms, while those 'Britons' who thought beyond the older loyalties began to figure the new Great Britain as in herself a new social and political unit. The latter group were to be less vociferous in terms of polemic, both inside and outside Parliament, though their views were in fact to reach far more into the public domain, as a study of the theatre of the period will show.

In an attempt to establish as a general principle that England was not the only imperium in existence in the British island, Russell wrote of Scotland as James's 'auldest impyir'. Even Ireland was 'ane ancienne impyir'.[24] Camden, in the pro-British camp, wrote of England and Scotland as being equally independent, citing the Tudor principle of empire: 'The kingdomes also are most auntient, helde of God alone, acknowledging no superiours, in no vassalage to Emperour or Pope'.[25] Against this more conciliatory line, the Commons in 1604 expressed a credo of empire along English lines: 'Unus Deus, una fides, unum baptisma; unus rex, una Britannia, unum imperium'. Facing this assertion of England's new power James did, however, manage to have the Great Seal amended so as to include the arms of Cadwallader and Edward the Confessor, in an attempt to introduce a more British element to the English symbol of royal authority.[26]

Where there did lie a degree of consensus was that uniting English and Scottish strength in some form could only be to England's advantage. Robert Pont wrote that:

The first fruit springing out of this roote [civil union], as to me seemeth, is the enlarging of the empire: that is, a compacting of all the British isles and reducing them within the circle of one diadem, whereby the renown and safety of the inhabitants and free denisons is encreased, the enemie's feare augmented, and his pride abated ... no traitor of what strength or force soever, within the iland or neighbouring places, is able to endure the least impression of the imperial conjoyned forces.[27]

Yet what exactly Britain *meant* remained a pressing matter. In his *Of The Union*, Sir Henry Spelman noted that the term was 'diversely taken' and he debated the meaning of Britain in terms of her possessions: 'The Auncyentes attributed the name of Brytane not only to this isle but also to Irelande and all other the neighboure islandes'. He proceeded to list changes in the meaning of the term, debating whether Ireland should be subsumed automatically within the British empire, though his discussion stayed within the confines of the two islands and did not make the kind of extensive imperial claims seen in Sir Henry Savile's contribution: 'Now for the word *Britania*, I find it in antient writers in two senses. Tacitus and the Roman writers before him take it in opposition to *Hibernia*, Ireland, and so to contain the continent of this iland, England and Scotland only'. Savile was doing no disrespect to the Welsh, as he viewed them as genuine Britons anyway, but Wales was effectively subsumed into England as a *fait accompli* by the time the wider issue of the inclusion of Scotland was being discussed.[28]

Even if Ireland were an imperium in her own right, yet her kingdom now, as Gordon affirmed, belonged to James, he being 'borne the lawfull and vndoubted heire of these three auncient Imperiall Crowns of the west'.[29] No longer did O'Neill maintain a political no-go area in the north and the Irish agreed in respect of James's legitimate right to the crown. They were quick to assign James a Gaelic pedigree, one Ulster poet writing 'The Saxons' land has been long – 'tis well known – prophesied for thee; so likewise is Ireland due to thee, thou are her spouse by all the signs'.[30] That Ireland should, however, be described in imperial terms is significant, in that her lands were being subsumed within this new British attempt at redefining imperium.[31] The concern that James should have the Irish crown did not mean, as Morrill notes, that the Catholic Irish and the descendants of Anglo-Norman settlers should be able to claim '*cives Britannici sunt*': the plantation of Britons among them did not make all the inhabitants of Ireland into Britons, nor was it meant to.[32]

The first years of James's reign do in fact provide plentiful examples of writers claiming the rebirth of a British imperial past. In 1605 John Thornborough found that

> many villages make one Shire, many Shires one kingdom, many kingdomes one Imperial Monarchy: all which is Brittaine, and Brittaine all these; and the King's Maiestie possessing & governing Brittaine, possesseth, and governeth al these.

Other writers also looking at the empire from the perspective of defining the imperium included Speed, who praised James as being the 'Inlarger and vniter of the British empire' and 'Restorer of the British name', as well as Harbert, who in his *Prophesie of Cadwallader* wrote:

> All Haile great Monarch of the greatest Ile,
> The Northerne worlds united lawfull King

Pardon my rudest reede vndecent stile,
Though I want skill in thy new Empires spring.

In the same vein, Samuel Daniel wrote of 'being subjects all to one imperiall Prince' while in 1610 George Marcelline wrote that Queen Anne's having three children 'thereby not only makes Scotland happy, but al *Great Brittaine* whereon dependeth their peace and freedom from strife ... which wanting before in that Empires felicity, makes it now an Empire abounding in felicity'.[33] But with the East India Company already establishing trade connections overseas by 1603 and continual reports of Spanish and Portuguese involvement in South America, empire was increasingly discussed in terms of overseas colonisation. James, like Elizabeth before him, claimed the crown of France, Parliament recognising James's title to the English throne and declaring that 'under one Imperial Crown, your Majesty is of the Realms and Kingdoms, of England, Scotland, France and Ireland, the most Potent and Mighty King'.[34] These horizons were about to be extended.

EMPIRE

English perceptions of America's potential had changed significantly towards the end of the sixteenth century. While reports of the New World before about 1591 had been concerned with the depiction of the natives as cannibal savages, based on the Spanish accounts meant to justify their harsh treatment of the natives in South America, in the aftermath of the first Armada attempt descriptions turned towards emphasising the good nature and hospitality of the native Indians. Those merchants and adventurers in whose interests a positive depiction of the natives now lay, and who were consequently responsible for this new view of North America, appreciated the necessity of a new source of raw materials and a market for English goods, faced with the possibility of a market in Catholic Europe which might be closed to them at any stage in the future. The Virginia Company had by 1610 drawn attention to the dual concerns of defending the realm and acquiring shipbuilding materials: 'So long as we are Lords of the narrow seas, death stands on the other shoares, and onely can looke vpon vs: but if our wooden wals were ruinated, death would soone make a bridge to come ouer, and deuoure our Nation'.[35] Though in this sense the imperial view was indeed concerned with potential overseas exploration and settlement, the failure of the Roanoke colony and the more lucrative attraction of privateering meant that, aside from the Elizabethan scholar John Dee, few actually placed great faith in the extension of English interests in Virginia until the organisation of the Virginia Company and the granting of its joint charter on 10 April 1606. Until that date the predominant mental picture conjured up by the use of the term 'empire' in its overseas context was one in which privateering and harassment

of the Spanish figured largely. The Virginia Company was thus ultimately responsible for turning imperial thinking away from imperium towards colonisation.

In this change of emphasis from imperium to colonial empire no image was to be as potent as that of imperial Rome. In the Commons in 1604 it was claimed that it was the British resistance to Rome which provided an equal legacy to the glories of England's past. The fear expressed that 'we should lose the ancient Name of *England*, so famous and victorious' was countered with the idea that 'the *Britaines* held tack with the Romans in their Greatness'.[36] In the theatre too it was with Rome's greatness that Britain's past was tied, while Britain was depicted as being equal within their relationship even after the subjugation of the British by Caesar.

Put simply, identification with Rome was a prelude to overseas expansion – the idea of overseas conquest being derived ultimately from Roman imperial rule over large territories. If Rome's might and civilisation were to be used as standards for the Jacobean Britons, it was also useful for a pre-Roman British imperium to have existed. The dedication to Prince Henry in Drayton's *Poly-Olbion* (1612) represented just such a concern:

> The ancient *Britans* yet a sceptred King obey'd
> Three hundred yeeres before *Romes* great foundation laid;
> And had a thousand yeeres an Empire strongly stood,
> Ere *Cesar* to her shores here stemd the circling Flood.

Along with the Roman comparison, the Biblical exhortation to go out and civilise was an extremely popular motivation, especially as a more 'gentle' Protestant Christianity was contrasted with Spanish Catholic violence against the natives of its South American possessions. 'We are a great people, and the lande is too narrow for us', wrote Robert Gray, a well-wisher for the Virginia colony in 1609, deriving his sermon from Joshua 17:15, which exhorted 'If thou beest much people, get thee up to the wood, and cut trees for thy selfe in the land of Perizzites, and of the Giants, if mount Ephraim be too narrow for thee'.[37]

James Stuart was depicted as having brought manifold benefits to England by his peaceful accession, as well as an end to the spectre of a Scottish military threat to England's northern borders. From 1606 the Virginia Company was indeed happy to suggest that the blessings brought to England and Scotland as a result of his rule should be extended to new lands and that there was a specific Biblical instruction for good government to spread itself. William Alexander, caught up in the euphoria of James's accession, made the expansionist claim in 1604 that Britain was

> As aptest so to rule the Realmes about,
> She by her selfe as most maiestick stands,

Thence (the worlds mistresse) to giue iudgement out,
With full authoritie for other lands,
Which on the seas would gaze attending still,
By wind-winged messengers their Soueraignes will.[38]

Alexander knew his king better than to assume that James would have any interest in such a project, but, as the reign progressed, mercantile interest turned towards overseas expansion, while propaganda found that old images of monarchy could be used to redefine the idea of empire. One piece of propaganda for the Virginia Company in 1610 noted that 'the same God that hath ioyned three Kingdomes under one Caesar, wil not be wanting to adde a fourth'.[39] Such propaganda implied that, with imperium having recreated the ancient British glory, that glory could and ought now to be exported to others, that they might share in the blessing of a Protestant king and his rule. It was a Constantinian legacy of conquest, with John Gordon writing in 1604 of Constantine: 'this Britaine King became Emperour, King, and Monarcke of the whole world'.[40] Purchas in his *Purchas his pilgrimage* (1613) recognised that the prerequisites for empire were met in King James, with a stable imperium leading to a successful empire: 'A Royall King, truely entituled Defender of the Faith: a learned Clergie, wise and Honourable Counsellers; peaceable and loyall Commons'.[41]

With the same emphasis on religious motivation, Thomas Cooper in an address to the Commissioners of the Virginia Company in 1615 suggested that the reason why the gospel had been restored to the English nation by the Henrician Reformation was so that England might in her turn propagate it to 'our posterity and brethren, the nations far and near'.[42] In the same year a broadsheet depicted two Indians appealing to an emphatically British audience for the benefits of conversion:

Once in a State, as of one Stem,
Mere strangers from Jerusalem,
As We, were Ye; till others Pity
Sought, and brought You to that City.
Dear Britons, now, be You as kind;
Bring Light and Sight to Us yet blind:
Lead Us, by doctrine and Behaviour,
Into one Sion, to one Saviour.[43]

For all this religious language, settlement in both America and Ulster would have a strong grounding in violence when the natives were slow in converting to the British version of 'civilised' Protestantism.[44] Munster in Elizabeth's reign showed how the English dealt with recalcitrant natives, Spenser arguing the legality of the plantation: 'all is the conqueror's as Tully to Brutus saith' and Gilbert telling Sidney 'no Conquered nacion will ever yelde willenglie

their obedience for love but rather for feare'. Sir John Davies made the analogy of colonisation to the husbandman sowing seeds:

> So a barbarous Country must be first broken by a warre, before it will be capeable of good Gouernment; and when it is fully subdued and conquered, if it bee not well planted and gouerned after the Conquest, it will eft-soones return to the former Barbarism.[45]

We should be wary of underestimating the powerful effects of Jacobean Protestantism. As Adams notes, the idea that foreign policy should be carried out in the interests of defending European Protestantism from the Catholic menace was widespread at the end of the sixteenth century. Even if the English people in the early part of the Jacobean period might be described as being actively Protestant only in the sense that they were actively patriotic, faced with the threat from Rome and Spain, their dislike of Catholicism was an extremely powerful motivating force behind the drive into America.[46] The Bible, suitably interpreted, could be and was a highly potent weapon in the justification of colonisation. Juricek has noted that verses from Psalm 72 were used in five tracts backing Virginia in 1609, the most pertinent being verses 8 and 9:

> He shall have dominion also from sea to sea, and from the river unto the ends of the earth.
> They that dwell in the wilderness shall bow before him; and his enemies shall lick the dust.[47]

There were, however, strong elements of military necessity in the expansions of 1607: Ulster was the closest part of Ireland to the Scottish mainland and a traditionally troublesome region, its inhospitable landscape coupled with an equally inhospitable and rebellious leadership until the Flight of the Earls and the end of O'Doherty's brief rebellion. The plantation combined a *tableau vivant* of James's aspiration for a truly British settlement with a security buffer against Spanish invasion and the extension of royal authority. Francis Bacon saw the plantation as but the first step in a greater plan of settlement, the remoter areas of Scotland as well as the Low Countries being the next stages.[48] He viewed the plantation as a progression from the Union of the Crowns, writing in his *Certain Considerations Touching the Plantation in Ireland* (1609), 'God hath reserved to your Majesty's times two works, which amongst the acts of kings have the supreme preeminence; the union, and the plantation of kingdoms'.[49] The destruction of the Ulster town of Derry in April 1608 by Sir Cahir O'Doherty had given way to the building of the city of Londonderry. However, far from being solely the child of the City of London, the character of the Ulster plantation from its inception was of a British migration.[50] If, as Canny notes, the character of this British settlement was to be more English than Scottish, in that the administration and state church were English, it should be recognised that Scots proprietors did enjoy

equal rights with their English counterparts. Indeed English settlers treated their Scots partners as second best, accepting Scots tenants on their estates only when English tenants were not available, but this kind of cohabitation was still a major step.[51]

The Scots were expected to play an integral part in the plans laid out by the 1609 settlement scheme. Two Scots, Sir James Fullerton and George Montgomery, sat on the committee appointed by the English government to apportion the land, while one of the most important of those involved in planting in the west of Ulster was James Hamilton, first Earl of Abercorn, who became chief undertaker of Strabane. Sir Alexander Hay wrote on 19 March 1609 to the Scottish council informing them of their inclusion in the plantation scheme, noting that it was the king's wish that the land should be distributed by lot, 'so as the whole people of the one natioun sall not be cast together all in one plaice'.[52]

This concern to avoid segregation of English and Scottish planters led to the development of the British identity of the Ulster migrants when the settlers differentiated between themselves and the native Irish. In the survey undertaken of Ulster lands by Captain Nicholas Pynnar in 1618/19, Pynnar used the term 'British' as his most frequent description. An English servitor in 1622 complained that his land in Tyrone was so bad that 'noe britishe tenents wilbe drawn to inhubytt *uppon* it upon any tearmes or condicions be the[y] never so reasonable'.[53] Furthermore, towards the end of 1620 a group of undertakers under the leadership of an Englishman, Sir John Fish, and a Scot, Sir James Craig, submitted a petition in which they refer to '36,000 British planted whereof 8,000 [are] able to beare Armes'.[54] In the Jacobean period, trade links between Ulster and Scotland were stronger than between Ulster and England. In the year 1614–15 trade leaving Londonderry for Scotland accounted for 44 per cent of the total, with that going to England being only 31 per cent and foreign European trade being 25 per cent.

The military potential of the county as a bulwark against Spanish power was recognised in the Domestic State Papers: 'Many motives and reasons are being alleged that the City of London shall undertake plantation in the north of Ireland, and especially of the late ruined city of Derry. This city, also Coleraine, may with little charges be made impregnable'.[55] Sir John Davies, writing to Salisbury on 4 September 1609, expressed the hope that agents of the city of London looking at what had been Derry 'will make report that it is a Land flowing with milk & honey' and went on:

> This plantation of the Citizens will bring great virtues, strength, civility, & security to this kingdome, & no small profit & honor to London it self. Rome, in the tyme of the rising of that empire, did deduce 300 Colonies; & our poore towne of Bristow, uppon the first conquest of this Iland, did replenish Dublin & Waterford with citizens.[56]

People from both parts of the British *imperium* were being used in an *imperial* scheme, with Roman expansion the precedent and Ulster depicted as no longer part of Ireland proper, the Ireland which was still technically a kingdom, as much as a wholly new departure, a colony in the Roman sense to be settled and civilised anew. Though Brady and Gillespie find that before 1641 Ireland was neither a kingdom (such as England was) nor a colony (as was North America), as a corollary and because of the nature of its emphatically British settlement, Ulster needs to be dealt with as a separate issue from the Pale and other English plantations in Ireland. As Perceval-Maxwell notes, the Scottish settlement in Ulster in the early seventeenth century was more a resettlement than an external colonisation, a movement from within the British imperium.[57]

There seems to have been as great an interest in the Ulster plantation as in Virginia in 1612. Samuel Calvert wrote to William Trumbull on 3 August of that year about Ulster and Virginia respectively: 'Our plantations go on, the one doubtfully, the other desparately. Ireland with all our money and pains [is] not yet settled in any fashion to assure us either profit or safety'.[58] Ireland was almost the safer bet, and following on from the building of Londonderry a plantation scheme began in Wexford in 1614, one in Longford and Ely O'Carroll (in King's County) during 1619 and in Leitrim in 1621. Part of the enthusiasm for plantation was doubtless due to the death of Tyrone in 1616 easing the threat of invasion from the continent. Before this a member of the Addled Parliament had complained that 'Ireland is not a thorn in our foot but a lance in our side. If [there is] a revolt there what a shame and disgrace would it be either to leave [it] or misery to recover it'.[59] Yet the Dublin government's fears of insurrection as a result of the colony and the reality in Ulster were very different. As Gillespie noted, the evidence suggests that in fact the plantation scheme provoked little hostility among the native Irish in Ulster.[60]

The hope remained in London that the outcome of this redistribution of British subjects would be peace and security and the extension of the *pax imperii*. As Camden wrote in the *Britannia*, with Rome's contribution to Britain in mind, 'the brightness of that most glorious empire chased away all savage barbarism from the Britons' minds, like as from other nations whom it had subdued'.[61] This comparison had strong currency, Thomas Smith noting 'how this contrey of England, ones as uncivill as Ireland now is, was by colonies of the Romaynes brought to understand the lawes and orders of thanncient orders'.[62] John Speed made several veiled references to the Irish as being of British extraction. 'So doubt I not', he writes, 'but that our *Britanes* passed thereinto themselues' and cites 'the testimonie of *Tacitus*; who saith, that their manners were fashioned to the *Britanes* ... and *Ptolomie* ... calleth that Iland by the name of little Britane'.[63]

In Virginia the British found a native governor whose rule they could

define most simply by calling him an emperor, for he like James ruled over more than one people. Powhatan's confederacy covered 6000 square miles of land occupied by at least 14,000 Algonquian speakers in 1607–8, and when the native Namontack visited England in April 1608 the Virginia Company paraded him as a son of 'the emperor of Virginia'.[64] John Smith used the term 'great emperor' to refer to Powhatan and one of the arguments propounded by the official pamphlet published in 1610 as to England's lawful possession of Virginia was that they had a 'real concession' from 'their rurall Emperour'.[65] The depiction of the social structure as being inherently similar to that of the English did of course make way for the replacement of the head of that system with King James, even if the ceremony crowning Powhatan as a tributary king was ultimately farcical.[66] Strachey noted that the native government was 'a *Monarchal government*: where one, as Emperor, ruleth over many kings', but then goes on to describe the natives holding their lands instead as 'free burghers and citizens with the English, and subject to King James, who will give them Justice, and defend them against all their enemies'. Clearly one empire was taking over another.[67]

Virginia was a palpable extension of the British experiment: a project in which both parts of the new nation could involve themselves: hardly surprising since the Virginia Company was not in a position to turn away anyone, Englishman or Scot, from financial investment. Thus Richard Crakanthorpe talked in terms of 'a new Britain in another world' in his sermon of 1609 and Daniel Price talked of Virginia as being 'the barn of Britain', in his *Sauls Prohibition staide*.[68] The explicit comparison between ancient Britons and native 'savages' was also made in the American context. Purchas wrote of the debt Britain owed to her Roman conquerors, writing in his marginal comments to an account of Sir Thomas Gates's misfortunes with the American natives:

> Can a Leopard change its spots? Can a Sauage remayning a Sauage be ciuill? Were not wee our selues made and not borne ciuill in our Progenitors dayes? and were not *Caesars Britaines* as brutish as *Virginians*? The *Romane* swords were best teachers of ciuilitie to this & other Countries neere vs.[69]

Robert Johnson also compared 'our present happinesse with our former ancient miseries, wee had continued brutish, poore and naked Britaines to this day, if *Iulius Caesar* with his Romane Legions (or some other) had not laid the ground to make us tame and ciuill'.[70] The title of his work, *Nova Britannia*, should indicate immediately that Virginia was an extension of the British imperium in the same way that the Ulster plantation was more than the politic settlement of dangerous ground. It was the extension of the new British power.

MAPPING GREAT BRITAIN

The most often cited paradigm for the notion of creating a kingdom of Great Britain was that it had existed in the past, that it had been then a greater entity than were the present states of England and Scotland, and that it would consequently be a very good idea were the two nations to return to that former state so as to regain some of their ancient glory. Wormald cites how Sir Robert Cotton used such a line of thinking when he claimed that the king's intention was 'to reduce theis two potent Kingdomes to that entier state wherein it stood of old'.[71]

Under James VI and I, the discourse on empire changed to meet not only the new expansion overseas, but also the practicality of a Scottish king whose person fulfilled the criteria of King of 'Great Britain' in a way that Elizabeth never could. The myth of the discovery of Britain by Brute was crucial to this alteration in thinking about the extent and degree of British power. It had always provided Britain with an origin myth as glorious and mysterious as that of Rome, Geoffrey of Monmouth having written that Brute had been told by an oracle:

> To reach that happy Shore thy Sails employ:
> There Fate decrees to raise a second *Troy*,
> And found an Empire in thy Royal Line,
> Which Time shall ne'er destroy, nor Bounds confine. [72]

Furthermore, according to Monmouth, Brute was also marked out by divine prophecy as the founder of an empire whose sons should have world-wide sovereignty: 'Ipsis / Totius terrae subditus orbis erit'.[73] The advent of the Tudors brought British blood to the English throne, Henry VII keen to stress his Welsh heritage and naming his first son Arthur, yet it was under Elizabeth that the Trojan myth re-entered the literary imagination. In Spenser's *Faerie Queene* Britomart is shown that 'From thy wombe a famous Progenee Shall spring out of the auncient Trojan blood ... *So shall the Briton blood their crowne agayn reclame*'.[74] If the Tudors brought a British royal heritage, all that was needed to complete the restoration of the ancient kingdom was the incorporation of the other half of the island. All of which thinking flies in the face of Kendrick's argument as to the 'eclipse' of the British history by the beginning of the seventeenth century. He wrote of 'an ever-growing contempt for the British History and a corresponding lack of interest in it' while discussing Speed's *Theatre of the Empire of Great Britain* and his *History of Great Britaine*.

The idea of empire appealed to James because it strengthened his kingship and gave him more authority – as in the case of Solomon, with more subjects and responsibility came more power – while for his Protestant subjects the influence which empire could afford, coupled with self-sufficiency free from the foibles of trading partners, strengthened Britain as an economic and

military force. Yet if James's brand of self-definition was akin to *l'état, c'est moi*, it was a credo which could not be reconciled with the increasingly extra-European mercantile economy and the division of interest in foreign policy. It was the notion that Britain was an entity in itself, distinct from the crown, that was increasingly voiced by the circle of antiquaries and poets including Browne, Drayton, Selden, Camden and Speed.[75]

The period from 1610 to 1615 saw a flood of writing concentrating scholarly attention on Great Britain as a physical entity. Helgerson has described those individuals responsible for this enterprise as being in effect part of an oppositionist bloc, attempting to sideline the contribution of the house of Stuart from both the writing and the visual depiction of Great Britain.[76] Yet we do not actually have much evidence that their motives in writing their individual works were so intended. While there were connections between them, there is no firm evidence that they shared a common political agenda. Fulke Greville, who published his nostaglic *Life of Sidney* in 1612, eulogising the reign of Elizabeth and pointedly glossing over Sidney's misgivings about her foreign policy, was the patron of Camden and Speed but the two chorographers did not seem keen to tear down – or even to snipe at – the Jacobean monarchy.

Celebrating Great Britain while marginalising Scotland's involvement in it cannot so easily be depicted as oppositional, either to James or to his Scottish people. Camden's *Britannia* (translated in 1610), Speed's *Theatre of the Empire of Great Britain* (1611) and Drayton's *Poly-Olbion* (1612) were parts of a chorographic canon discussing the form and structure of the nation, at a time when it was critical for the success of James's project for union that it be accepted as such. Sharpe has noted the importance attached to Sir Robert Cotton's opinions on precedent, and the great scholar showed from antiquity and etymology the validity of the title King of Great Britain at a time when the question of the name of the kingdom threatened the success of the whole project of union.[77]

The frontispiece to Speed's *Theatre of the Empire* shows the Roman, Dane, Saxon and Norman surrounding the Briton as the historical cornerstones to the island while *Poly-Olbion* has Brutus, Julius Caesar, Hengist and William the Conqueror framing Britannia herself, a woman bearing a cornucopia of plenty. If the monarchs were now marginalised, with the land taking the central position, this did not actually imply an attack on the monarch's position. Rather, the representation of such past creators of Britain reinforced the notion of the unity of the island and celebrated its ancient past. Thus when Helgerson writes that 'Britannia and the British monarch, so firmly identified with one another as to be virtually interchangeable through most of Elizabeth's reign, now occupied separate and mutually hostile camps', an alternative suggestion can be made.[78] Britannia and King James could not be

'oppositional' because he was responsible for her re-creation. Only in 1622, with the publication of the second part of Drayton's *Poly-Olbion*, do we see a truly critical piece of writing opposing many aspects of the king's foreign policy, celebrating the country's naval heroes and lamenting the weakening of Great Britain.[79]

Helgerson also failed to recognise that in writing about Britain in the Jacobean age, he was not writing about the same vision of Britannia as had been current a few years earlier under Elizabeth. The land may have been speaking but it had changed its accent. The pastoral poetics of the Spenserians identified by David Norbrook and Michelle O'Callaghan may indeed have been writing a version of Britain in many senses writ old, hearkening back to the idea of Britain as that idea existed at the end of the sixteenth century, newly assertive and Anglocentric, though not actively hostile to the notion of the involvement of the Scots within this British imperium. But it was done in a new context, one in which (I have already suggested) Britain no longer meant what it had done before 1603. The absence of the Scots from the mapping of the British world was, meanwhile, counterbalanced by their Protestantism, allowing them the status of silent partners within the new incarnation of Britannia.

So why was the British origins myth from the Brutus legend rejected by antiquarians just when it seemed to have political usefulness? The answer is that it wasn't. Camden's *Britannia*, like Norden's *Middlesex* (1593) had already cast doubts on the Brute myth while still showing themselves eminently content to advocate a British history for the island. Norden wrote of the origins of the city of London: 'Some will haue Brute the Troian to be first builder of it, but Brute, and his historie, is meerely reiected of manie in our daies' while Speed later dismissed Brutus as a 'vulgar received opinion'.[80] In the context of increasingly active and skilled European historical scholarship, chorographers and early historians replaced an origin myth which was increasingly difficult to prove with one based on Roman ancestry which was far easier to document. Such academic opinions did not, however, necessarily filter into the public consciousness at this time. Consider the ramifications of Prince Uter's warning in Rowley's play *The Birth of Merlin*:

> The Saxons which thou broughtst
> To back thy usurpations, are grown great,
> And where they seat themselves, do hourly seek
> To blot the Records of old *Brute* and *Brittains*,
> From memory of men, calling themselves
> *Hingest-men*, and *Hingest-land*, that no more
> The *Brittain* name be known, all this by thee,
> Thou base destroyer of thy Native Countrey.
>
> (*The Birth of Merlin*, IV.iii.12–19)

If late sixteenth- and early seventeenth-century academia was modifying its stance on the subject of Britain's past, then there is no reason to assume automatically that the rest of the population of both Scotland and England followed them. In subsequent chapters here, Kendrick's comment that 'absorbed as we have been in the matter of the ancient Britons, it is almost with a shock that we notice how little interested Shakespeare's England had been in the early history of the English themselves' will be proved a totally false assertion.[81]

The accession of James Stuart brought the ideal opportunity to assert a return not only to the true *state* within the island but also to the true *religion*. Stuart propagandists could cite the conclusion to Geoffrey of Monmouth's *History*: Cadwallader, the last King of the Britons, had been told by an angel 'that the people of the Britons should again possess the island by merit of their faith when the appointed time should come'.[82] The Trojan past was also highly appealing for those enveloped in the mantle of Protestant militarism. Peacham includes an emblem dedicated to Southampton telling how 'Troian youth went into the field, With courage bold, against the Greekes to fight'.[83] Much ink was also spilt in the opening years of James's reign by writers who appreciated the significance of Brute – as an image of the new king – from the perspective of the future of the reconstituted Britain. Indeed, the accession of James saw a rebirth of the Brute material, though it also partly derived from the interest in the matter provided by the *Faerie Queene*. Rumours of James possessing a lion-shaped birth mark on his body had evidently spread south of the border as Harington published a tract on the succession in 1602 in which he reported a Welsh prophecy: 'a King of British blood in Cradell Crownd, With Lyon markt, shall joine all Brutus ground, Restore the Crosse, and make this ile renown'd'.[84]

Harbert's 1604 *Prophesie of Cadwallader* likened James to '*Albions* mightie King Our second *Brute* like to the morning starre'.[85] In *The Triumphs of Re-united Britania* (1605) Anthony Munday wrote that 'The hand of heaven did peacefully elect By mildest grace, to seat on *Britaines* throne This second *Brute*, then whom there else was none'.[86] 1607 saw the publication of John Ross's *Britannica, sive De Regibus veteris Britanniae*, a version of the British History, from Brutus to Cadwallader, in Latin verse, in which the writer summons Cadwallader back to the earth in order to inform him of the Gunpowder Plot and then goes on to defend the traditional Brute myth.[87] By 1612 there were still those willing to back the Brute material, Dekker in the epistle dedicatory to *Troia Nova Triumphans* claiming 'we from Troy deriue' and 'ranckt next to Troy, our Troy-novant should be'.[88] Michael Drayton, another patriotic defender of British interests, wrote in his *Poly-Olbion* that 'arguments are there also drawne from some affinity of the Greek tongue, & much of *Troian* and *Greeke* names, with the British. These things are the more enforst by *Cambro-Britons*,

through that uniuersall desire, bewitching our Europe, to deriue their blood from *Troians*.[89] Further afield, the Trojan story was used in the entertainment in 1613 when Franckendal, the town given by the Palsgrave to Princess Elizabeth in jointure celebrated her arrival.[90]

Such was the desire to keep some grasp on the material that Edmund Howes inserted into his edition of John Stow's *Annales* (1615 and 1631) a chapter that was called 'A Briefe Proofe of *Brute*'. Herein he records 'although I dare not precisely defend that hee was descended of *Aeneas* or *Siluius* or came hither by Oracle accompanied with *Troians*, yet I dare boldly say that neere the time hereafter mentioned there was one *Brute* or *Brito* king of this Realme which left it to his posteritie'.[91] Though the myth was losing face as the Saxon history gained ground over the Trojan, Brute remained to the end of the Jacobean period a figurehead for British antiquity. Indeed, Brute may be the figure appearing next to James on the central panel of Rubens' Whitehall banqueting hall ceiling.[92]

THE INTELLECTUAL INHERITANCE

James VI had been brought up with the prophecies of the thirteenth century Thomas of Erceldoune, who predicted that a man in the ninth degree of the Bruce's blood would rule 'all Bretaine to the sey'. James's accession to the English throne led Robert Birrell to write in his diary: 'At this time all the haill commons of Scotland that had red or understanding, wer daylie speiking and exponing of Thomas Rymer has prophesie, and of uther prophesies quhilk wer prophesied in auld times'.[93] The Scottish contribution to renewed ideas of Britain was indeed significant. John Mair argued that because of their location in the same geographical land mass – Greater as opposed to Lesser Britain (that is, Brittany) – Scots and English were all also Britons. When confronted by Anglocentric notions of what the recreation of Britain would entail, however, not surprisingly Hector Boece followed John Fordun in arguing that the correct name for the whole island was Albion, with Britain referring only to that part of Albion inhabited by the English.[94]

The Scottish vision of Britain at the close of the sixteenth century was also heavily influenced by John Knox, whose *First Blast* was addressed to 'Great Britany'.[95] Other Scottish contributions included that of John Gordon who claimed that the name 'Britannia' meant 'there is the covenant of God' in Hebrew and indicated that 'in this island the covenant of God was to be established'. He concluded: 'Let all the subiects of this Iland thinke, that it is a great glory to them to be called Britannes, that is to say, the people of Gods couenant, which after the name of Christian is the most glorious and honorable name, that any man in the world may enioy'.[96] The religious aspect to the re-creation of Britain was thus paramount in the writings of the Scots,

many of whom saw in the return of the ancient kingdom the foreshadowing of the apocalypse. Thus William Cowper wrote: 'Have we not a Christian King going before us to fight the Lords battell, hazarding all that he hath for the welfare of Jerusalem?'[97]

The most assertive of the Scottish writers on imperial Britain was James Maxwell. A contemporary of Napier, he began a study of both Catholic and Protestant commentary on the Books of Daniel and Revelations at the age of nineteen and followed James south at the Union. It is his lost work, probably entitled *Sibylla Romana-Britannica* which may well have included much of the prophetic material then extant. In his *Admirable and Notable Prophecies* of 1615 he described *Sibylla* as

> a discourse of God's especiall providence for bringing to passe the beginning, continuing and setling of the Monarchie of Great Britaine: wherein is shewed by divers probabilities, old predictions and prophecies, that from thence is to spring the last Imperial Monarchie which should subvert Mahometisme and Iudaisme, convert both Jewes and Gentiles, especiallie the Turkes to the Christian faith, and restore both Church and Empire to the integrity they once had in the happie daies of Constantine the great borne in great Brittanie.[98]

James's accession and re-creation of Britain was seen as the first step towards the final Christian empire which would be ready to welcome Christ back to the earth.

Yet the Scottish inheritance profoundly affected the development of the project for a greater Britain in that the work of two of sixteenth-century Scotland's greatest thinkers, John Mair and George Buchanan, had a dramatic impact on the latter's pupil James Stuart. As Williamson demonstrated, the intellectual legacies of Mair and Buchanan brought with them to the early seventeenth century a distinctive set of beliefs about colonial expansion.[99] Buchanan was virulently anti-imperialist, having seen at first hand the manner in which the Portuguese treated the natives of the territories they colonised. As Williamson noted 'his view of the Iberian experience informed his distrust of a greater Britain in almost any form'. Buchanan recognised that greater Britain inherently implied an imperial expansion overseas, a view later shared by that great Scottish exponent of Great Britain, William Alexander, who indeed repeatedly emphasised the idea that the colonial project was a specific manifestation of the British age.[100] Just as James rejected everything else from his former tutor's teachings, so too he rejected Buchanan's distaste for imperial authority. For James the process of civilisation, whether it was of the inhabitants of the Scottish Isles or the natives in North America required an imperial authority. That factor underlay his commitment to a greater Britain and it was that which helped to drive the re-creation of Great Britain as an empire at home towards being an imperial power overseas.

Apart from the Scottish inheritance brought by the king, the idea of the island as playing a more assertive role beyond her shores had been put forward at Elizabeth's court by the enigmatic John Dee.[101] Dee saw the internal imperium and overseas empire as being fundamentally interconnected, and if his ideas were not immediately acted upon by James they still tell us much about one particular branch of thinking on the subject. What Dee urged was recovery. Britain had a past and it was this claim to the past – through James's being king of both England and Scotland – which gave the British matter such a newly emotive appeal; or rather which could have given it such an appeal had James been more comfortable with cultivating the love of his people. Dee had urged on Elizabeth his scheme at a time when she was too old, and perhaps too wise to implement it. Had he offered the same to Prince Henry, the evidence we have of the prince's interests suggests that Dee would have had a far greater measure of success.[102]

In his *Brytanici Imperii Limites* Dee had written:

> Nowe (at length) ame I come to my chiefe purpose, of some records settinge downe; which wilbe found sufficient, for to stire vpp yor Matis most noble hart, and to directe your Godlie conscience, to vndertake this Brytish discovery, and recovery Enterprise, in yor highnes immortal fame, and the marvailous Wealth Publick of yor Brytish Impire.[103]

Greatly in need of royal support, Dee sent a petition to James on 5 June 1604 styling him 'the most blessed and triumphant monarch that ever this Britysh Empire enjoyed'.[104] His formula for the British empire was based on both domestic and international security coupled with territorial expansion, the result of which would be an 'incomparable *Ilandish Monarchy*', the 'BRYTISH IMPIRE'.[105] Yet it was always a matter of reclaiming what was Britain's already. In his maritime writings Dee saw the history of the empire in terms of what it 'hath been: Yea, as it, yet, is: or, rather, as it may, & (of right) ought to be ...'[106] He was aware of the power of historical precedent in his arguments for the creation of a Royal Navy, hoping to convince his royal audience to 'valiantly recouer, and enioy, if not all our Ancient and Due Appertenances, to this Imperiall Brytish Monarchy, Yet, at the least, some ... Notable Portion therof', while in the course of the Northwest Passage he believed there lay 'Northern Iles, & Regions Septentrionall' which were, Dee claimed, 'fully appertinent to the Crown of this *Brytish Impire*'.[107]

Within Dee, however, we appreciate the concern that a vital prerequisite to overseas exploration was internal security: His *Thalattokratia Brettaniki* of 1597 records his imperial vision through a journey round Britain's boundaries which both enclosed Britain as an inner imperial domain while reaching out to the empire overseas. Dee's imperial vision saw that one form of empire would in fact lead to the other, resulting in 'the PERPETVALL POLITIK

SECVRITY and better preseruation of this famous Kingdom, from all Forrein danger, or Homish disorder ... and most needfull Publik Benefit'.[108] With the accession of James and the union of the British state in his person this particular idea progressed from theory into potential reality.

THE ICONOGRAPHY OF EMPIRE

In the same way that Dee found the means to legitimise the expansion of an emphatically British monarchy, writers keen to celebrate James's accession drew upon a corpus of images with which to associate the king. They drew upon a variety of sources, dating back in some cases to the period of Roman imperial rule, in an attempt to elevate the monarch of the north-western isle into a prince whose dominions could rival those of Spain and France. An underlying theme was that the reign of James was the Golden Age restored, alluding to the myth of Astraea which had preoccupied much of the Elizabethan writing about the Queen. Graham Parry showed how this was translated into the court culture of James and his son; but such literary devices fulfilled a more explicit programme of eulogy. In Ben Jonson's 1615 masque, *The Golden Age Restor'd* Pallas reveals her intention 'To settle ASTRAEA in her seat againe; And let downe in his golden chaine The age of better mettle' while Astraea herself announces at the close of the masque: 'This, this, and onely such as this, The bright Astræa's region is, Where she would pray to liue'.[109] A closer reading of the masque text suggests a hidden political subtext which used the implications of this return of Justice to satirise the court's earlier weaknesses.[110] It prompts us to question the supposed conservatism of Ben Jonson by 1615–16, especially as it is a late example of the Astraea material.

Like much of the specifically imperial iconography, references to Astraea occured during the first ten years of the reign, while James could still be optimistically depicted as a Christian emperor whose vigour, compared with the declining health of Elizabeth, would allow him to pursue a great course for his allegedly united kingdoms. In such a climate John Russell wrote of the Golden Age, noting how these periods resembled

> the monarcheis of the Babylonianes, Persianes, Gracianes and Romanes—the first of gold, the secound of sylver, the thrid of brass, the fourt of iron. Qhairby it hes bein aluyis estiemit that we, qha ar fallin in the last age, ar fallen in the decadence of the uarld; yit it may be justlie said to the inhabitantis of this ile, that we ar establischit in ane goldin age, all the properteis thairof cleirly schyning amangis ws.[111]

The Golden Age was that of the renewal of the Christian empire prepared for the return of Christ, a renewal in which the re-creation of Great Britain was seen as a natural part. John Thornborough wrote 'thus we say, and thus we

sing, *Redeunt Saturnia Regna*, even the golden age of Brittaines Monarchy is come againe'.[112]

The most common image with which James was associated, especially in the immediate aftermath of his succession, was that of the phoenix. A device with which writers had lauded Queen Elizabeth, it was one which could be used to celebrate the new king even as it remembered his predecessor.[113] A long-time imperial motif, its use dated back to the reign of the Roman Emperor Constantine.[114] The phoenix was also a symbol of rebirth with some specifically Protestant connotations. As James had returned to the throne of Britain as a Constantine so too was he like Britain reborn. There was also the religious symbolism of the phoenix as representing the return of Christ from death, the renewal granted to the world through his sacrifice and apocalyptic concerns with his imminent second coming.[115] The motif had been used in Roman history to epitomise the renewal of empire. Van den Broek notes how the Emperor Claudius had exhibited a so-called phoenix at the Forum during the celebration of the 800th anniversary of Rome. This exhibition was meant to support the idea that the beginning of the new century introduced an entirely new era that would be characterized, under the emperor's leadership, by the arrival of the Golden Age. This new era would specifically be one of peace, an idea expressed by both Lactantius and Claudian.[116]

In praising James, use of the phoenix began during the period of mourning for the queen. 'One Phenix dead, another doth suruiue' and 'thus is a Phœnix of her ashes bred' wrote the Cambridge contributors to *Sorrows Ioy* (1603), while Henry Campion described 'that Phœnix rare, whom all were loath to leaue'.[117] Sylvester's translation of Du Bartas's *Divine Weeks and Works* (1608) mused: 'from spicie Ashes to the sacred URNE Of our dead Phoenix (dear ELIZABETH). A *new true* PHOENIX lively flourisheth ... JAMES, thou just Heire'.[118] Welcoming James to his capital on behalf of its sheriffs the MP and wit Richard Martin effused how 'out of the ashes of this Phœnix wert thou, King James, borne for our good, the bright starre of the North'.[119] Henry Petowe's 1603 poem reporting James's coronation, *England's Caesar*, claimed that the king was 'the Phoenix of all Soueraignty' while Dekker's arch for James's welcome to London, *Nova Arabia Felix*, associated Britain with 'happy' Arabia. This was the land of peace and plenty, the biblical kingdoms of Sheba and Nabatea and legendary home of the phoenix. The king's arrival before the arch represented the phoenix arising out of the ashes of the dead queen in a device worth quoting at length:

> Great Monarch of the West, whose glorious Stem,
> Doth now support a triple Diadem,
> Weying more than that of thy Grandsire *Brute*
> Thou that maist make a King thy substitute,
> And doest besides the Red-rose and the white,

With the rich flower of *France* thy garland dight,
Wearing aboue Kings now, or those of olde,
A double Crowne of Lawrells and of gold,
O let my voyce passe through thy royall eare,
And whisper thus much, that we figure here,
A new *Arabia*, in whose spiced nest
A *Phoenix* liu'd and died in the Sunnes brest,
Her losse, made *Sight*, in teares to drowne her eyes,
The Eare grew deafe, Taste like a sick-man lyes,
Finding no rellish: euery other *Sence*,
Forgat his office, worth and excellence,
Whereby this Fount of *Vertue* gan to freeze,
Threatned to be drunke vp by two enemies,
Snakie *Detraction*, and *Obliuion*,
But at thy glorious presence, both are gone,
Thou being that sacred *Phoenix*, that doest rise,
From th'ashes of the first: Beames from thine eyes
So vertually shining, that they bring,
To *England's* new *Arabia*, A new Spring:
For ioy whereof, *Nimphes*, *Sences*, *Houres*, and *Fame*,
Eccho loud Hymnes to his imperiall name.[120]

James is not merely the great Western prince – possessing the three crowns of the British islands, a feat not achieved by his ancestor Brute – but he is a king 'aboue Kings now', while the reference to the 'Crowne of Lawrells and of gold' evokes the image of James as a triumphant Caesar. Reference to this Roman imperial legacy was also made by Marcelline: 'This howse of Steuart in Scotland, is as a Phoenix among the Nobility ... for euermore Royall Eagles doo produce Imperial Eagles, Eagles that haue continually made War with Dragons'.[121]

Use of the phoenix image was to be given new impetus when James's heir apparent died prematurely in 1612. The death of Prince Henry was lamented by Christopher Brooke – '... this Phoenix ... haue sacrificed his life in funerall flame' – while Protestant hopes were transferred to his sister and her husband, of which couple Robert Alleyne wrote:

As Phoenix burnes herselfe against the Sunne,
That from her dust may spring another one ...
So now, raise up a world of royall seed,
That may adorne the earth when ye are dead. [122]

It is no coincidence that Phineas Pett built and launched a ship named the *Phoenix* in honour of the Princess Elizabeth before her departure with her husband, while Donne refers to the couple repeatedly as being two Phoenixes in his *Epithalamion* for their marriage.[123]

The cedar tree too had a distinct imperial pedigree, being associated with

Solomon and regarded as the 'king of trees'. The cedar image was used in the biblical context of divinely appointed kingship – Psalm 104:16 notes that 'the trees of the Lord are full of sap; the cedars of Lebanon, which he hath planted'. Thus John Brinsley wrote of the Princes Henry and Charles as 'the flourishing branches, of that happy spreading Cedar' while Harbert recognized that 'the Cedar falles in time, so Kings decay'.[124] One of the most explicit discourses on the biblical significance of the cedar image occurs in Thornborough's 1605 discourse on the Union:

> Doubtlesse there is a deserued glorious garland due to the name of great Brittaine, bringing forth many goodly boughes, and branches, like to the faire, and wel spred Platan tree; or rather for the height of his honor, like the tall, and goodly Cedar, in whom, the dreame of *Nabuchodonoser* hath beene verified: for he saw a tree in the middest of the earth, great, & strong, whose height reached vnto the heaven, and the sight thereof to the end of the earth: whose leaues were faire, and the fruit thereof, much: in which was meate for al, yea the beasts of the field had shaddow vnder it, the fowles of the aire dwelt in the boughes thereof, and al flesh fed of it. But *Nabuchodonosor* heard also a watch crying out mightily, hew doone this tree, break of his branches, shake of his leaues, scatter his fruit, that both beasts and fowles may be put from him: nevethelesse leaue the stumpe of his rootes stil in the earth. So was the ancient honor, and glory, of great Brittaine: great, and mighty, high to heaven, faire, and fruitful, & of power over the whole Land from one end to the other: but the highest, who hath power over al, did (for the sin of the inhabitants) hew downe this goodly tree; yet left the Stumpe of the rootes in the earth. And out of it the tree is growne vp againe to former beautie, that we might learne to magnifie the King of heaven, as did *Nabuchodonosor* restored to the honor of his kingdome, to his glory, and beautie againe, to his Counsailours, and Princes, and to the establishment of his Throne with augmented glorie.[125]

Just as James was both phoenix, the British king reborn, and the mighty cedar so too he was Arthur, the greatest of the semi-mythical British kings and the unifier of the British peoples in the face of foreign invaders. Yet the association with Arthur went beyond merely the figure of the king himself, encompassing the entire chivalric canon. For Elizabethan historians the first period of history in which chivalry flourished among the Britons coincided with the rule of kings from Brutus to Arthur, a period of British history contemporary with the age of Rome.[126] Dee was proud of the Arthurian history in that it supported his own imperial vision. Indeed, at the outset of his *Brytanici Imperii Limites* he admitted that his precedents 'depende cheiflie vppon our kinge *Arthur*'. Consequently, as Sherman noted, 'he expressed his desire to separate the truth from the fiction', being keenly aware of 'the aboundance of their fables, glosinges, vntruthes, and Impossibilities, incerted in the true historie, of King Arthure'.[127]

Use of the Arthurian canon had been commonplace under the Tudors

since Merlin's prophecies could be used to justify their succession to the throne, a fact whose significance was not lost on James. His exorbitant bestowal of knighthoods on his way to London in 1603 was reported to be due to his wanting to make one thousand knights 'in imitation of King Arthur, who created that number'.[128] Yet it seems that use of the Arthurian image by James was predicated on the implications it would have for the re-creation of Britain. Scaramelli wrote to Venice within weeks of the death of Elizabeth:

> It is said that he is disposed to abandon the titles of England and Scotland, and to call himself King of Great Britain, and like that famous and ancient King Arthur to embrace under one name the whole circuit of one thousand seven hundred miles, which includes the United Kingdom now possessed by his Majesty, in that one island.[129]

John Thornborough wrote in 1605 that 'another *Arthur* king of all great Brittaines raigneth' while in the same year Camden cited the anagram '*Charles Iames Steuart*. CLAIMES ARTHVRES SEATE' which declared James's 'vndoubted rightfull claime to the Monarchy of *Britan*, as the successor of the valorous king *Arthur*'.[130] Also in 1605, William Warner wrote of the return of Arthur as being linked with Britain's destiny in his *Continuance of Albion's England*:

> And, that your *Arthure* comes againe, so far-forth we allow
> It Prophesie, as *Brutaine* dead with him reuiueth now:
> That is, *Brutes* Baptisme of this Ile, that ana-baptizd grew
> By diuers names in diuers parts, *Iames* doth through-out renew.[131]

Testimony, however, to the continuing popularity of the mythical king and his relation to the re-created Britain throughout the Stuart period were the two editions of the prophecies of Merlin by Alanus de Insulis in 1603 and 1608 and the publication in 1603, 1615, 1617 and 1639 of the anonymous *The whole Prophecies of Scotland, England, France, and Denmark. Prophecied by marvellous Merling.*

Imagery explicitly figuring James as an emperor was rare. This seems to have been partly at least because of a reluctance even among his supporters to accord the Scottish king such an emotive title. The medals which marked his accession were the most visible self-representation of imperial aspirations, James depicted wearing the laurel wreath of the Caesars.[132] It was the resolution of the Commons in a debate on the Union that 'the Name of Emperor is impossible:– No particular Kingdom can make their King an Emperor'. The exception seems to have been Sir William Morrice who on 31 March 1604 proposed in the Commons that James should be declared 'Emperor of Great Britain'. He introduced a motion on 22 November 1606 for the same purpose though he seems to have been a less than charismatic figure and the proposal went nowhere.[133]

The tradition of elevating the ruler to this lofty position had a greater pedigree in France where, as Vivanti writes, 'a whole political tradition extolled the special authority of the most Christian King—*Empereur dans son Royaume*, endowed with near-episcopal power—the idea of empire became associated not only with an intention to rule, but also with hopes of religious peace which was to be attained in a purified Christian climate such as the traditions of the Gallican Church must perforce restore beyond all schisms and controversies for the benefit and example of all the faithful'.[34] For the Jacobeans, the figure of the Roman emperor represented power, order, stability, prosperity and divinely ordained monarchy. Depictions of James connected him with several of the Roman emperors, but with the singular purpose of celebrating what he might achieve in the future, differing from the phoenix material which celebrated what he had already accomplished through his succession. It is a significant difference and over time the emperor imagery would be one of the first motifs to vanish from common usage, even as James himself would begin to dwell upon its aptness to his personal aspirations for a more absolute style of rulership.

In his welcoming entertainment for James, Ben Jonson had the gates of Janus close to reveal the inscription

> IMP. Jacobus Max.
> CAESAR AUG. P. P.
> Pace Populo Britannico
> Terra Marique Parta
> Ianum Clusit. S.C.[35]

What those who compared the king with Roman emperors most hoped he might achieve was the vigorous pursuit of the true religion: James was thus the inheritor of the mantle of that last emperor to defend Christianity, Constantine. Gordon wrote that the new British king might use his extended powers as monarch of England and Scotland

> for the deliuery of his church, from the barbarous tyranny wherewith shee hath beene long oppressed by Popes. And as *Constantine* the great, the protector and restorer of the auncient Christian Church, was borne in great *Brittaine*, and there beganne his Empire, obtayning afterward admirable victories against fowre Romaine Tyrantes persecutors of the Church of God, by means whereof he did abolish Gentilisme, and planted Christian Religion at Rome and throughout the Empire. In like sorte the same God hath raised your Maiestie to the height of greatnes, to be successor vnto *Constantine* in the saide Realmes, and to chase out of the same Rome the idolatry and abhomination of the Gentiles, the which Sathan hath sence brought in vnder the name of Christ, which is the true meanes to purchase you the iust title of protector and defender of the faith and restorer of Christianitie.[36]

In the same vein, Speed described James's entry into London:

> So that His entrance was another *Constantine*, whose person every man prayed for, and desired to see; and for peace another *Octavius*, having ruled peacefully a stout stirring Nation, even from his younger years, and lived in peace with all the Princes and Kings of the earth, in which peace now lastly he brought the Crown and Kingdome of Scotland to augment the glory, and strength of this Realme of England, in whose united body, as a fair branched tree, even at the first he began to engraft the Sciences of his princely virtues, which by the sappe and Sunne-shine of his just government still spread more and more, like unto the *cedars that grow upon Lebanon.*[137] (My italics)

When Augustus was used to extol James, it was because Augustus was the emperor in whose dominions Christ had been born. Augustus also had the reputation of being a peacemaker – as Drummond wrote, 'like *Augustus* palmie Raigne bee deem'd'. Joseph Hall remarked in 1613 that James 'like another *Augustus*, before the second comming of CHRIST hath becalmed the world and shut the iron gates of warre'.[138] James himself was aware of the significance of Augustus within the chronology of Christian history, viewing it as no accident that Christ was born at a time when the Roman empire was strong. In his *A Meditation Vpon the 27.28.29. Verses of the XXVII. Chapter of Saint MATTHEW* (1619) he wrote that 'as *Christ* himselfe was the Sonne and right heire by lineall descent of King *Dauid*; so was he borne vnder the first *Romane* Emperor, that euer established the *Romane* Empire.'[139] For King James, the rulership of a divinely ordained monarch with powers akin to those of the greatest of the emperors was the essential prerequisite for any kingdom prepared for the Second Coming. Imperial rule was a necessary extension of his prerogative and had been shown, in his reading of the Bible, to be favoured by God.

The peacemaking ruler did not, of course, have to remain within his own kingdom. Robert Johnson was keen to make the transition from imperium to empire very clear when he wrote that, just as the English should convert the heathen Indians 'imitating the steps of your wise and prudent sovereign', so too had it been

> under the peaceable reign of Augustus Caesar, who though an unbelieving heathen, yet of such excellent moral vertues as might set to school many Christian Kings and Rulers, whose care and study for the safety, peace and Common-wealth of his Empire gat him such honour in his life, and love of all his subjects.[140]

He was not alone in seeing the Virginia colony as a venture undertaken by a new Roman emperor. William Symonds, preaching at Whitechapel in 1609 wrote of James as being 'our most sacred sovereign, in whom is the spirit of his great ancestor Constantine, the pacifier of the world and planter of the gospel in places most remote, [who] desireth to present this land a pure virgin to Christ'.[141]

James held Julius Caesar in high esteem, writing that 'I haue euer beene of that opinion, that of all the Ethnick Emperors, or great Captaines that euer were, he hath farthest excelled, both in his practise, and in his precepts in martiall affaires'. Comparisons between the two men were based on the fact that Britain was the last part of Europe to fall to Rome's invading armies.[142] Writing about James, Harbert asked

> to whom shall I this Northerne starre compare:
> To *Caesar* which did first subdue the state
> [...]
> *Caesar* was twice repulst ere he could see
> This litle world from all the world remote.[143]

Other early Jacobean works celebrating James's succession also used Julius Caesar in the context of his having conquered his new kingdom, though not, of course, through force of arms. In Jacobean imagery, England received her Caesar with open arms – just as Rome had brought benefits to the ancient Britons, so would James benefit the reunited Britain.[144]

From his accession James was often depicted as wearing the closed crown, the imperial diadem representing the sovereign's absolute authority and central to the mystique of the reunited imperium, a practice which dated back to the coronation of Henry IV in 1399.[145] James had the Coronation Order changed so that 'the other crown' which the king was to don when changing vestments after the ceremony in Westminster Abbey was the 'Imperial Crown'.[146] James Henrisoun, the Scottish merchant whose 1547 *Exhortacion to the Scottes* advocated the removal of the terms 'English' and 'Scots', argued that the kings of England had always worn 'a close crown Emperiall, in token that the lande is an empire free in it self, & subject to no superior but GOD'. He believed that the whole island was Constantine's and consequently that Scotland was part of the kingdom: 'Al Britayn was under one Emperor, and beeyng under one Emperor then was Scotlande and Englande but one Empire'.[147] The title page of Johnson's *New Life of Virginia* shows an emblem depicting James wearing a closed crown, alongside it a badge of the royal crest adorned with a closed crown, the letters I[acobus] P[rimus] and the motto 'Pro Consilio Suo Virginiae'. James wasn't alone in wanting to celebrate British kingship in this manner. The pageants eulogising the inauguration of London's Lord Mayors depicted Majesty wearing an imperial crown on three occasions during James's reign, in 1609, 1620 and 1623.[148]

The use of two or more pillars surrounding the monarch or his heraldic crest was another image with specifically imperial connotations, alluding to the pillars of Hercules, the mountains on either side of the present-day straits of Gibraltar. These had originally represented the 'ends of the earth', so any monarch's sway which encompassed them indicated a claim to extensive

dominion.[149] The symbol of two columns twisted below a closed crown had been Charles IX's coat of arms – some depictions of the device had the added imperial motto *Plus Ultra* – while Herculean pillars were used to celebrate the imperial rule of Charles V, as illustrated by his device in Paolo Giovio's *Dialogo dell'imprese militari et amorose*.[150] In such a light it is highly significant that Crispin van de Passe senior placed Elizabeth between two pillars in his 1596 engraving, the Protestant queen within her English *imperium*.

England's queen was not to be outdone by her continental cousins, either in representations of her as a monarch or in her claims to dominion; and after 1603, English and Scottish panegyrists for King James did their best to replicate this.[151] George Chapman had urged Elizabeth to 'Forme then, 'twixt two superior pillars framed This tender building, Pax imperii nam'd' and the image was especially applicable to the peace-making James. It appeared on coins, with one depicting James enthroned, with the arms of the chair forming classical columns, while in the frontispiece to James's *Works* Corinthian columns carry markings evocative of British monarchy.[152] Use of the device occurs in *The Tempest*, when a delighted Gonzalo, seeing that Ferdinand is alive exclaims 'O rejoice Beyond a common joy, and set it down With gold on lasting pillars!' (V.i.206–8). A similar reference is made in Ben Jonson's *Bartholomew Fair* in which Overdo notes: 'Hearken unto my *labours*, and but observe my discoveries and *compare Hercules with me*, if thou dar'st of old; or Columbus Magellan or our countryman Drake, of later times'.[153] [The italics are mine.]

Of the various kinds of pillars depicted, those bearing vines twisted around them were especially associated with Solomon, since one of these in St Peter's in Rome was held to have come from Solomon's temple.[154] Solomonic columns were also to form one of the settings for the Rubens apotheosis of King James, and Solomonic imagery was of course significant in that it reflected both the king's concern to appear as a divinely blessed ruler as well as the idea that the Jews had prospered under Solomon's divinely sanctioned rule.[155] There was also the belief that Solomon was the father of navigation. Johnson wrote of Solomon that 'heauenly prouidence blessed his Nauigations and publike affayres, the chiefe meanes of their wealth' as well as expressing great hope in Britain's imperial future:

> I doe not doubt (by the helpe of God) that I may liue to see the dayes ... that the Wisedome, Maiestie and Honour of our king, shall be spread and enlarged to the ends of the world, our Nauigations mightily encreased, and his Maiesties customes more then trebled.

Samuel Purchas, the philosopher of colonisation in the Jacobean period, began his monumental *Purchas his Pilgrimes* with the voyages of Solomon to Ophir in the eleventh century BC, while the association of Solomon with great

wealth translated onto the stages. Sir Epicure in Jonson's *The Alchemist* imagines the munificence of the New World as 'the golden mines, Great Solomon's Ophir!'[156] Further testimony to the importance of the Protestant dynamic behind the imperial movement was the fact that, as Pennington notes, Purchas 'made use of the voyages of Solomon, and the later ones of Christ and the Apostles, to prove that trade and navigation could be squared with the law of God, and indeed were approved and commanded by Him'.[157]

CONCLUSION

The canon of imperial motifs was but part of the wider body of images used to celebrate the kingship of the Stuarts in the early seventeenth century; but those images alone did not constitute the imperial dynamic in the Jacobean period. We need to be aware of the importance of popular writings on the matter of Great Britain and on the British past. In this regard London provided plenty of its own examples on the public and private stages, depicting a series of characters for whom a British imperium was very much a reality. Some of the images described here were ignored – the cedar was rarely used – while the phoenix was more popular and Arthurian romance more popular still.

Yet Bruce Galloway dismissed as 'naive' the notion that James was 'spellbound by a vision of "Britannia Rediviva"'. He added that the king 'refused offers of "Empire"' and that 'theatre was one thing: politics, quite another'.[158] Such an interpretation is incompatible with the enthusiasm with which James worked to implement the Ulster plantation as a British project, an enthusiasm which often rode roughshod over the caveats of his own Lord Deputy there from 1605 to 1616, Sir Arthur Chichester, who urged a less invasive programme.[159] That James was interested in empire-building at home comes as no surprise. Like the Tudors before him, he valued the extension of royal authority throughout his kingdoms, and plantation was a palpable progression of that aim. Galloway's interpretation also prompts the question as to whether the idea of Britain as a political entity remained the prerogative of the Crown alone. 'Britain' meant many things, and if, for example, the argument over the origins of the Common Law drew Coke, Dodderidge and Popham to its banner, then playwrights such as Shakespeare, Rowley and Fisher were using it as a point of topical relevance by which to entertain. However, David Armitage has stated that 'the impress of Empire upon English literature in the early-modern period was minimal, and mostly critical where it was discernable at all'.[160] As the following chapters will show, theatre was to have a manifold impact on notions of a British nation and a British state in a fluid discourse notable significantly for its *lack* of criticism of the Jacobean monarchy.

NOTES

1 Antoine Muret, quoted in Blair Worden, 'Ben Jonson among the historians' in Kevin Sharpe and Peter Lake (eds), *Culture and Politics in Early Stuart England* (London: Macmillan, 1994), pp. 76–7.

2 Robert Johnson, *Nova Britannia. Offring ... fruits by planting in Virginia* (London, 1609), sig. C2.

3 Sir Edward Phelips, quoted in Howard Erskine-Hill, *The Augustan Idea in English Literature* (London: Edward Arnold, 1983), p. 130.

4 Frances Yates, *Astraea: The imperial view in the sixteenth century* (London, 1973. London: Pimlico, 1993), p. 33.

5 Jenny Wormald, 'The creation of Britain: multiple kingdoms or core and colonies?', *Transactions of the Royal Historical Society* II, 6th ser. (1992), 190.

6 Bruce R. Galloway and Brian P. Levack (eds), *The Jacobean Union: Six tracts of 1604* (Edinburgh: Scottish Historical Society, 1985), p. 75.

7 William Camden and John Milton were also guilty of the same form of 'literary imperialism', subsuming the rest of Britain under 'England': see D. Woolf, *The Idea of History in Early Stuart England* (Toronto, 1990), pp. 55–72, pp. 110–25.

8 See Alexandra Walsham, *Providence in early modern England* (Oxford University Press, 1999).

9 This collection is now in the British Library, Cotton MS Cleopatra E. I. John Gordon wrote of the genesis of the Union that 'the true and onely cause is the purity and truth of Christian religion'; and the belief that the Protestant church north and south of the border was inherently similar was one of the few things which most of those discoursing on the Union agreed upon. See John Gordon, *The Vnion of Great Brittaine* (London, 1604), p. 4 (sig. B2ᵛ). Anthony Milton notes that the first half of the Jacobean period was indeed one in which anti-papal writings were 'the most distinctive feature of English Protestant theology and occupied the energies of all the principal members of the Jacobean episcopate' yet there has been no study of the manner in which such anti-papal writings influenced thinking behind overseas expansion. See Anthony Milton, *Catholic and Reformed. The Roman and Protestant Churches in English Protestant Thought 1600–1640* (Cambridge University Press, 1995), p. 31; and Kevin Sharpe, *Sir Robert Cotton 1586–1631: History and Politics in Early Modern England* (Oxford University Press, 1979), p. 33, n. 95.

10 William Crashaw, *A sermon preached in London before the right honorable the Lord Lawarre, Lord Governour and Captaine Generall of Virginea ...* (London, 1610), sig. D4.

11 Although Hakluyt and Purchas advocated conversion as a reason for conquest, the letters patent issued by Queen Elizabeth did not make occupation of the land contingent upon conversion. See Patricia Seed, 'Taking possession and reading texts: establishing the authority of overseas empires', *William and Mary Quarterly* XLIX (1992), 188.

12 On the initial interaction between natives and colonists see Alden T. Vaughan, '"Expulsion of the Salvages": English policy and the Virginia massacre of 1622', *William and Mary Quarterly* XXXV (1978), 57–84; and Martin H. Quitt, 'Trade and acculturation at Jamestown, 1607–1609: the limits of understanding', *William and Mary Quarterly* LII (1995), 227–58.

13 See Carol Z. Wiener, 'The beleaguered isle. A study of Elizabethan and early Jacobean anti-Catholicism', *Past and Present* LI (1971), 27–62; Peter Lake, 'Anti-popery: the structure of a prejudice' in Richard Cust and Ann Hughes (eds), *Conflict in Early Stuart England* (London: Longman, 1989), pp. 72–106; Patrick Collinson, *The Birthpangs of Protestant England* (London: Macmillan, 1988), ch. 1; David Loades, 'The origins of English protestant nationalism' and Anthony Fletcher, 'The first century of English protestantism and the growth of national identity' both in S. Mews (ed.), *Religion and National Identity*, Studies in Church History 18 (Oxford, 1982), pp. 297–307, pp. 309–17.

14 'This I must say for Scotland, and I may trewly vaunt it; Here I sit and gouerne it with my Pen, I write and it is done, and by a Clearke of the Councell I gouerne Scotland now, which others could not doe by the sword.' *A Speach to both the Houses of Parliament, Delivered in the Great Chamber at White-Hall The last Day of March 1607* in C. H. McIlwain, *The Political Works of James I* (Harvard University Press, 1918), p. 301.

15 See Joyce Lorimer, 'The failure of the English Guiana ventures 1595–1667 and James I's foreign policy', *Journal of Imperial and Commonwealth History* XXI (1993), 1–30. For a Jacobean description of Guiana see Robert Harcourt, *A Relation of a Voyage to Guiana. Describing the Climate, Scituation, Fertilitie, Provisions, and Commodities of that country* (London, 1613). The conception of Guiana as being a source of great wealth led to Shakespeare's having Falstaff refer to Mrs Page in *The Merry Wives of Windsor* as 'a region in Guiana, all gold and bounty'. William Shakespeare, *The Merry Wives of Windsor* in Stanley Wells and Gary Taylor (eds), *Shakespeare: The Complete Works* (Oxford: Clarendon Press, 1988), I.iii.61–2.

16 See Walter Ullmann, '"This realm of England is an empire"', *Journal of Ecclesiastical History* XXX (1979), 176; Brian P. Levack, 'Law, sovereignty and the union' in Roger A. Mason (ed.), *Scots and Britons. Scottish political thought and the union of 1603* (Cambridge University Press, 1994), p. 226; Richard Koebner, '"The imperial crown of this realm." Henry VIII, Constantine the Great and Polydore Vergil', *Bulletin of the Institute of Historical Research* XXVI (1953), 48; Dale Hoak, 'The iconography of the crown imperial' in Dale Hoak (ed.), *Tudor Political Culture* (Cambridge University Press, 1995), pp. 54–103. Stephen Gardiner recognised that Henry was 'an Emperor in himself and hath no superior'. Quoted in Loades, 'The origins of English protestant nationalism', p. 299.

17 Roger A. Mason, 'Scotching the Brut: politics, history and national myth in sixteenth-century Britain' in Roger A. Mason (ed.), *Scotland and England 1286–1815* (Edinburgh, 1987), pp. 67–8. S. T. Bindoff, 'The Stuarts and their style', *English Historical Review* LX (1945), p. 201.

18 Roger A. Mason, 'The Scottish Reformation and the origins of Anglo-British imperialism' in Mason (ed.), *Scots and Britons*, p. 170.

19 Koebner, '"The imperial crown of this realm"', 51.

20 Keith M. Brown, *Kingdom or Province? Scotland and the Regal Union, 1603–1715* (London: Macmillan, 1992), p. 86.

21 Roger A. Mason, 'Imagining Scotland: Scottish political thought and the problem of Britain 1560–1650', in Mason (ed.), *Scots and Britons*, p. 10.

22 Appended to *The happie and blissed unioun* (1604). See Levack, 'Law, sovereignty and the union', p. 235.

23 See Jenny Wormald, 'The Union of 1603' in Mason (ed.), *Scots and Britons*, pp. 23–5.

24 Galloway and Levack (eds), *The Jacobean Union*, p. 121; p. 123.

25 William Camden, *Remaines of a greater worke, concerning Britaine, the inhabitants thereof* (London, 1605), p. 4 (sig. B2ᵛ).

26 *Commons Journal*, p. 177 (18 April 1604). Bruce Galloway, *The Union of England and Scotland 1603–1608* (Edinburgh: John Donald, 1986), p. 16.

27 Galloway and Levack (eds), *The Jacobean Union*, p. 17; p. 18.

28 Sir Henry Spelman, *Of the Union*, in *ibid.*, p. 148; p. 168. Sir Henry Savile, *Historicall Collections*, in *ibid.*, p. 209.

29 John Gordon, *The Vnion of Great Brittaine* (London, 1604), p. 4.

30 Breandán Ó Buachalla, 'James our true king. The ideology of Irish royalism in the seventeenth century' in D. George Boyce, Robert Eccleshall and Vincent Geoghegan (eds), *Political thought in Ireland since the Seventeenth Century* (London: Routledge, 1993), pp. 9–10. See also Tristan Marshall, 'James VI & I: Three kings or two?', *Renaissance Forum* IV:2 (1999), http://www.hull.ac.uk/renforum/v4no2/marshall.htm.

31 As Morrill notes, in 1649, 1660 and 1689 the kings of Ireland were removed without the consultation or confirmation of the Irish people. John Morrill, 'The fashioning of Britain' in Steven G. Ellis and Sarah Barber (eds), *Conquest and Union: Fashioning a British State 1485–1725* (New York: Longman, 1995), p. 15.

32 *Ibid.*, p. 17. See, for example, Ciaran Brady, 'England's defence and Ireland's reform: the dilemma of the Irish viceroys, 1541–1641' in Brendan Bradshaw and John Morrill (eds), *The British Problem c.1534–1707: State formation in the Atlantic archipelago* (London: Macmillan, 1996), pp. 113–16.

33 Galloway and Levack (eds), *The Jacobean Union*, p. 209. He goes on to speculate about the three options in royal style available to James as King of Great Britain. John Thornborough, *The ioiefull and blessed revniting the two mighty & famous kingdomes, England & Scotland into their ancient name of great Brittaine* (Oxford, 1605), p. 7. John Speed, *Theatre of the Empire of Great Britain* (London, 1611), sig. ¶1. In Speed's dedication James was 'of Great Britaine, France and Ireland King'. William Harbert, *A Prophesie of Cadwallader* (London, 1604), sig. Hᵛ. Samuel Daniel, *A Panegyrike Congratulatorie delivered to the kings most excellent maiestie at Buleigh Harrington in Rutlandshire* (London, 1603), sig. A3. George Marcelline, *The Triumphs of King James the First of great Brittaine, France and Ireland, King; Defender of the Faith* (London, 1610), p. 46.

34 S. T. Bindoff, 'The Stuarts and their style', *English Historical Review* LX (1945), 193.

35 Virginia Company, *A true declaration of the estate of the Colonie in Virginia, With a confutation of such scandalous reports as haue tended to the disgrace of so worthy an enterprise* (London, 1610), p. 63.

36 *Commons Journal*, p. 177 (19 April 1604).

37 Robert Gray, *A good speed to Virginia* (London, 1609), sig. B2ᵛ.

38 William Alexander, *The Monarchick Tragedies* (London, 1604), sig. Aiiiᵛ.

39 *A true declaration of the estate of the Colonie in Virginia ...* (London, 1610), pp. 66–7.

40 John Gordon, *Envtikon, or a sermon of the Union of Greate Britannie ...* (London, 1604), p. 46. (This is a different work from *The Vnion of Great Brittaine*, cited in n. 9.)

41 Samuel Purchas, *Purchas his pilgrimage. Or relations of the world and its religions observed in all places discovered, from the creation unto the present* (London, 1613–14, 1616, 1617). Quoted in John Parker, 'Samuel Purchas, spokesman for empire', in T. C. van Uchelen,

Koert van der Horst and Günter Schilder (eds), *Theatrum Orbis Librorum. Liber Amicorum presented to Nico Israel on the occasion of his seventieth birthday* (Utrecht: HES Publishers, 1989), p. 48.

42 See Collinson, *The Birthpangs of Protestant England*, p. 5.

43 Broadsheet of 1615 quoted in H. C. Porter, *The Inconstant Savage. England and the North American Indian 1500–1660* (London: Duckworth, 1979), p. 281.

44 David Beers Quinn, 'Sir Thomas Smith (1513–1577) and the beginnings of English colonial theory', *Transactions of the American Philosophical Society* LXXXIX (1945), 546–7. On the various projects for planting Ulster in the sixteenth century see Robert Dunlop, 'Sixteenth century schemes for the plantation of Ulster', *Scottish Historical Review* XXII (1924–5), 51–60, 115–26, 199–212.

45 Nicholas P. Canny, 'The ideology of English colonization: from Ireland to America', *William and Mary Quarterly* XXX (1973), 579. Martial law was introduced very quickly in Virginia: see William Strachey, *For the colony in Virginea Britannia. Lawes divine, morall and martiall* (London, 1612). Lisa Jardine, 'Encountering Ireland: Gabriel Harvey, Edmund Spenser, and English colonial ventures' in Bradshaw, Hadfield and Maley (eds), *Representing Ireland*, p. 64. Sir John Davies, *A discoverie of the trve causes why Ireland was neuer entirely subdued* ... (London, 1612), pp. 4–5. Lupton's argument that Spenser's *View* presents an image of Ireland as a wasteland adds to this notion. The 'barren' Ireland required the 'sowing' of English civility. See Julia Reinhard Lupton, 'Mapping mutability: or, Spenser's Irish plot' in Bradshaw, Hadfield and Maley (eds), *Representing Ireland*, pp. 93–115, especially p. 98.

46 Simon Adams, 'Spain or the Netherlands? The dilemmas of early Stuart foreign policy' in Harold Tomlinson (ed.), *Before the English Civil War* (London: Macmillan, 1983), pp. 79–80. On the religious impetus behind the settlement of Jamestown see, for example, Louis B. Wright, *Religion and Empire: The Alliance between Piety and Commerce in English Expansion, 1558–1625* (New York, 1965) and John Parker, 'Religion and the Virginia colony 1609–10' in K. R. Andrews, N. P. Canny and P. E. H. Hair (eds), *The Westward Enterprise: English activities in Ireland, the Atlantic, and America 1480–1650* (Liverpool University Press, 1978), pp. 245–70.

47 John T. Juricek, 'English territorial claims in North America under Elizabeth and the early Stuarts', *Terrae Incognitae* VII (1975/6), 16–17.

48 M. Perceval-Maxwell, 'Ireland and the monarchy in the early Stuart multiple kingdom', *Historical Journal* XXXIV (1991), 285.

49 Willy Maley, '"Another Britain"?: Bacon's *Certain Considerations Touching the Plantation in Ireland* (1609)', *Prose Studies* XVIII (1995), 7.

50 *CSP Ireland* 2 par. 686, 687, 689, dated 28 April 1608. *CSP Ireland* 2 par. 737, dated 12 June 1608. See also T. W. Moody, *The Londonderry Plantation, 1609–41: The City of London and the Plantation of Ulster* (Belfast, 1939) and Philip S. Robinson, *The Plantation of Ulster: British Settlement in an Irish Landscape, 1600–1670* (Dublin: Gill and Macmillan, 1984).

51 Nicholas Canny, 'The origins of empire: an introduction' in Nicholas Canny (ed.), *The Origins of Empire: British overseas enterprise to the close of the seventeenth century* (Oxford University Press, 1998), pp. 1–33. See also Tristan Marshall, 'Empire state building', *Renaissance Forum* 3:2 (1999) http://www.hull.ac.uk/renforum/v3n02/marshall.htm.

52 M. Perceval-Maxwell, *The Scottish Migration to Ulster in the Reign of James I* (Ulster Historical Foundation, 1990), p. 84.

53 *Ibid.*, pp. 165–6, p. 151. *Ibid.*, pp. 290–303 and R. J. Hunter, 'Ulster Plantation Towns 1609–41' in David Harkness and Mary O'Dowd (eds), *The Town in Ireland* (Historical Studies XIII, Belfast: Appletree Press, 1981), p. 75.

54 Perceval-Maxwell, *The Scottish Migration to Ulster*, p. 186. It would not be until *c.*1633 that the trickle of Scots settling in Ulster became a flood. See *ibid.*, p. 313.

55 *CSP Ireland* 3 par. 372, dated 28 May 1609.

56 F. W. Harris, 'The commission of 1609: legal aspects', *Studia Hibernica* xx (1980), 54.

57 Ciaran Brady and Raymond Gillespie (eds), *Natives and Newcomers: Essays on the Making of Irish Colonial Society, 1534–1641* (Dublin: Irish Academic Press, 1986), pp. 16–17. Perceval-Maxwell, *Scottish Migration*, p. 288.

58 *Ibid.*, p. 138.

59 Quoted in Raymond Gillespie, *Conspiracy: Ulster plots and plotters in 1615* (Belfast: Ulster Society for Irish Historical Studies, 1987), p. 6.

60 *Ibid.*, p. 25.

61 William Camden, quoted in Philip Edwards, *Threshold of a Nation: A Study in English and Irish Drama* (Cambridge: Cambridge University Press, 1979), p. 83.

62 Thomas Smith, quoted in Canny, 'The ideology of English colonization', 588–9. On the Flight of the Earls see Nicholas P. Canny, 'The Flight of the Earls, 1607', *Irish Historical Studies* xvii (1970–71), 380–99 and John McCavitt, 'The Flight of the Earls, 1607', *Irish Historical Studies* xxix (1994), 159–73.

63 Speed, *Theatre of the Empire*, p. 138. See also Andrew Hadfield, 'Briton and Scythian: Tudor representations of Irish origins', *Irish Historical Studies* xxviii (1993), 390–408.

64 Helen C. Rountree, *Pocahontas's People. The Powhatan Indians of Virginia Through Four Centuries* (University of Oklahoma Press, 1990), p. 3; p. 43.

65 Porter, *The Inconstant Savage*, p. 286; Virginia Company, *A true declaration of the estate of the Colonie in Virginia* (London, 1610), p. 14.

66 See the account in Rountree, *Pocahontas's People*, p. 47.

67 Porter, *The Inconstant Savage*, p. 338.

68 *Ibid.*, p. 351; Daniel Price, *Sauls Prohibition staide ... With a reproofe of those that traduce the Honourable Plantation of Virginia* (London, 1609). Cited in Porter, *The Inconstant Savage*, p. 345.

69 Samuel Purchas, *Hakluytus Posthumus. Purchas his Pilgrimes ... The Fourth Part* (London, 1625), p. 1755 (sig. Gggggggg3). See also Crashaw, *A sermon preached in London before the right honorable the Lord Lawarre*, sig. C4ᵛ.

70 Robert Johnson, *Nova Britannia. Offring ... fruits by planting in Virginia* (London, 1609), sig. C2.

71 Wormald, 'The creation of Britain', p. 178.

72 The originator – or at least the earliest known source – of the Brut myth was the eighth-century British priest Nennius. The Monmouth material is cited in George Gordon, 'The Trojans in Britain', *Essays and Studies by Members of the English Association* ix (1924), 11, 15.

73 Geoffrey of Monmouth, quoted in A. E. Parsons, 'The Trojan legend in England', *Modern Language Review* XXIV (1929), 258. He goes on to note (397) that the origin of the idea that English kings had a right to the thrones of Wales, Scotland, Brittany and the whole of France has its ultimate source in the Brut legend.

74 *Ibid.*, 399. The contrasting argument for the eclipse of British history is found in T. D. Kendrick, *British Antiquity* (London: Methuen, 1950).

75 For a full discussion of Browne and the Spenserians see David Norbrook, *Poetry and Politics in the English Renaissance* (London: Routledge and Kegan Paul, 1984) and Michelle O'Callaghan, *The Shepheard's Nation* (Oxford: Clarendon Press, 2000).

76 Helgerson, *Forms of Nationhood*, pp. 107–47.

77 Sharpe, *Sir Robert Cotton*, p. 152.

78 Helgerson, *Forms of Nationhood*, p. 131.

79 For a discussion of Drayton's work in relation to Britain see Tristan Marshall, 'Michael Drayton and the writing of Jacobean Britain', *The Seventeenth Century* XV:2 (2000).

80 Stan A. E. Mendyk, *'Speculum Britanniae': Regional Study, Antiquarianism, and Science in Britain to 1700* (University of Toronto Press, 1989), p. 62; p. 81. Richard White's *Historiarum Britanniae* (1597–1607) brought together the legendary material regarding Britain's ancient kings decended from Brutus. Written in Latin and aimed at a European audience, it enjoyed (according to Parry) a greater prestige in Europe than Camden's *Britannia*: Graham Parry, *The Trophies of Time: English Antiquarians of the Seventeenth Century* (Oxford University Press, 1995), pp. 52–3.

81 Kendrick, *British Antiquity*, p. 125; p. 116. He goes on to claim that 'Spenser did not believe in the British History' (p. 128), failing to consider that Spenser's *Faerie Queene* was not so much an affirmation of the origins of the British past, as a commentary on the British present.

82 Geoffrey of Monmouth, *History of the Kings of Britain*, trans. Sebastian Evans (London: Everyman, 1963), p. 262.

83 Henry Peacham, *Minerva Britanna or a Garden of Heroicall Deuises, furnished and adorned with Emblemes and Impresas of sundry natures, Newly devised, moralized and published* (London, 1612), sig. E4.

84 John Harington, *A Tract on the Succession to the Crown* (1602), ed. Clements R. Markham (London, 1880), p. 121.

85 Harbert, *A Prophesie of Cadwallader*, sig. Hv. Harbert had also mentioned Brute at sig. G4v.

86 Anthony Munday, *The Triumphs of Re-united Britania* (London, 1605), sig. B3v.

87 John Ross, *Britannica, sive De Regibus veteris Britanniae* (Frankfurt, 1607). See Kendrick, *British Antiquity*, p. 100.

88 Thomas Dekker, *Troia Nova triumphans. London triumphing* (London, 1612). London's origins in the Trojan history were also referred to by Bacon who referred to the city as being 'here where Brute did build his Troynouant' while Dekker had written 'Troynovant is now a sommer arbour' for James's entry in 1604. Cited in Vaughan Hart, *Art and Magic in the Court of the Stuarts* (London: Routledge, 1994), p. 159.

89 Michael Drayton, *Poly-Olbion* (London, 1612), p. 18.

90 Cited in Roberta Florence Brinkley, *Arthurian Legend in the Seventeenth Century* (Baltimore: The Johns Hopkins Press, 1932), p. 21.

91 John Stow, *The Annales, or Generall Chronicle of England, begun first by maister Iohn Stow* ..., ed. Edmund Howes (London, 1615), sigs. A3ᵛ–A4. Also see the same pages in the 1631 edition.

92 The suggestion comes from Roy Strong, *Britannia Triumphans. Inigo Jones, Rubens and Whitehall Palace* (London: Thames and Hudson, 1980), p. 28.

93 Robert Birrell's diary, quoted in Michael J. Enright, 'King James and his island: an archaic kingship belief?', *Scottish Historical Review* LV (1976), 38.

94 Roger A Mason, 'Scotching the Brut', p. 66. See also Roger A. Mason, 'Kingship, nobility and Anglo-Scottish union: John Mair's *History of Greater Britain* (1521)', *Innes Review* XLI (1990), 182–222 and Marcus Merriman, 'James Henrisoun and "Great Britain": British union and the Scottish commonweal' in Mason (ed.), *Scotland and England*, pp. 85–112.

95 Williamson, 'Scotland, Antichrist and the invention of Great Britain', p. 38.

96 *Ibid.*, p. 44; John Gordon, *Envtikon*, p. 29.

97 Williamson, 'Scotland, Antichrist and the invention of Great Britain', p. 44.

98 *Ibid.* and Williamson, *Scottish National Consciousness*, p. 103; p. 105.

99 Arthur H. Williamson, 'Scots, Indians and empire: the Scottish politics of civilization 1519–1609', *Past and Present* CL (1996), 46–83 and Arthur H. Williamson, 'George Buchanan, civic virtue and commerce: European imperialism and its sixteenth century critics', *The Scottish Historical Review* LXXV (1996), 20–37.

100 *Ibid.*, p. 25; Williamson, 'Scotland, Antichrist and the invention of Great Britain', p. 51.

101 Dee was not the first person to use the term the 'British Empire'. The phrase was used in Humphrey Llwyd's *Commentarioli Britannicae Descriptiones Fragmentum* (1568), an apology for the Brut history. See Bruce Ward Henry, 'John Dee, Humphrey Llwyd, and the name "British Empire"', *Huntington Library Quarterly* XXXV (1971–2), 189. Llwyd, like Dee, was a friend of Abraham Ortelius.

102 See Chapter 3 below.

103 John Dee's *Brytannici Imperii Limites*, quoted in William H. Sherman, *John Dee: The Politics of Reading and Writing in the English Renaissance* (Amherst: University of Massachusetts Press, 1995), p. 148.

104 C. H. Firth, 'The British Empire', *Scottish Historical Review* XV (1918), 186.

105 John Dee, *General and Rare Memorials pertayning to the Perfect Arte of NAVIGATION* (London, 1577), sig. A2ʳ.

106 *Ibid.*.

107 Sherman, *John Dee*, p. 161; p. 181. Sherman notes what he terms the 'extraordinary nature of Dee's imperial claims'; 'What he urged on the Queen was sovereignty over a considerable portion of the Northern hemisphere; a "title Royall to all the Coasts, and Ilands beginning at or about *Terra Florida*, and so alongst, or neere vnto *Atlantis*, going Northerly: and then to all the most Northen Ilands great and small, And so compassinge about *Groenland*, Eastward and Northen Boundes of the Duke of Moscovie his dominions ..."' (p. 187). On the subject of the supposed Welsh conquest of the New World and Britain's consequent right to settle there see Harold J. Cook, 'Ancient wisdom, the Golden Age, and Atlantis: the new world in sixteenth century cosmography', *Terrae Incognitae* X (1978), 25–43.

108 Sherman, *John Dee*, p. 156. 'Homish' is Dee's homely word for 'domestic'.

109 Ben Jonson, *The Golden Age Restored* (lines 9–12; 234–6) in C. H. Herford and P. and E. Simpson (eds), *Ben Jonson* (Oxford: Clarendon Press, 1952) vol. VII, pp. 419–29.

110 Martin Butler and David Lindley, 'Restoring Astraea: Jonson's masque for the fall of Somerset', *English Literary History* LXI (1994), 807–27.

111 John Russell, quoted in Galloway and Levack, *The Jacobean Union*, p. 78.

112 John Thornborough, *The ioiefull and blessed revniting*, pp. 42–3.

113 Marie Axton, *The Queen's Two Bodies. Drama and the Elizabethan Succession* (London: Royal Historical Society, 1977), p. 68; p. 70; pp. 116–130; p. 132; p. 144.

114 Graham Parry, *The Golden Age Restor'd: The culture of the Stuart Court, 1603–42* (Manchester: Manchester University Press, 1981), p. 18.

115 For a bibliography of Elizabethan secular prose works using the phoenix myth see W. M. Carroll, *Animal Conventions in English Renaissance Non-Religious Prose* (New York: Bookman, 1954), pp. 112–13. See also G. Wilson Knight, *The Mutual Flame* (London: Methuen, 1955) pp. 145–224 on *The Phoenix and the Turtle*.

116 R. Van den Broek, *The Myth of the Phoenix: According to Classical and Early Christian Traditions* (Leiden: E. J. Brill, 1972), p. 417; p. 229.

117 *Sorrows Ioy* (Cambridge, 1603), quoted in John Nichols, *The Progresses, Processions and Magnificent Festivities of King James the First*, vol. I (London: Society of Antiquaries, 1828), p. 8; p. 11.

118 Sig. A3ᵛ. Quoted in R. A. Foakes (ed.), *King Henry The Eighth* (Arden Shakespeare, 1966), introduction, p. xxxiv.

119 *A Speach delivered to The King's Most Excellent Majestie, In the Name of the Sheriffes of London and Middlesex by Maister Richard Martin, of the Middle Temple* (London, 1603). Quoted in Nichols, *The Progresses, Processions ...*, p. 129. On Martin's life see also Tristan Marshall, '*The London Oracle*: The life and times of Richard Martin MP (1570–1618)' (forthcoming).

120 Peggy Munoz Simonds, *Myth, Emblem and Music in Shakespeare's Cymbeline. An iconographic reconstruction* (Newark: University of Delaware Press, 1992), p. 228. Parry, *The Golden Age Restor'd*, p. 10. This poem is quoted in Fredson Bowers (ed.), *The Dramatic Works of Thomas Dekker*, vol. II (Cambridge University Press, 1955), p. 279.

121 Marcelline, *The Triumphs of King James the First ...*, pp. 65–6.

122 Christopher Brooke, *Two Elegies, consecrated to the never-dying Memorie of the most worthily admyred; most hartily loued; and generally bewayled PRINCE; HENRY Prince of Wales* (London, 1613), sig. B2. Robert Alleyne, *Teares of Joy shed at the ... departure ... of Fredericke and Elizabeth* (London, 1613), sig. B2ʳ.

123 John Donne, *Epithalamion or Marriage Song on the Lady Elizabeth and County Palatine being married on St. Valentine's day*, in C. A. Patrides (ed.), *The Complete English Poems of John Donne* (London: Everyman, 1985), pp. 192–7.

124 John Brinsley, *Ludud Literarius or, The Grammar Schoole* (London, 1612), sig. ¶2ʳ; Harbert, *A Prophesie of Cadwallader*, sig. D.

125 John Thornborough, *The ioiefull and blessed revniting ...*, pp. 24–5.

126 Parry, *The Golden Age Restor'd*, p. 75.

127 Sherman, *John Dee*, p. 188. The Arthurian history came under attack along with the Brute material at the same time by those advocating the Saxon origins of the country. See, for example, Brinkley, *Arthurian Legend*, chs. II and III.

128 Scaramelli continues, with great potential irony: '... but among those who had followed him to battle'. *CSP Venetian X* (1603–1607), p. 77, n. 106 (6 August 1603). A Roman observer noted the significance of the numbers involved too: 'He [James] has also the intention of bringing up the number to a thousand, as King Arthur had when he had conquered the kingdom'. See J. W. Legg (ed.), *The coronation order of King James I* (London: Church of England, 1902), p. lxviii.

129 *CSP Venetian X* (1603–1607), p. 5 n. 12 (17 April 1603).

130 Thornborough, *The ioiefull and blessed revniting ...*, p. 44. William Camden, *Remaines of a greater worke, concerning Britaine, the inhabitants thereof* (London, 1605), p. 153. (sig. X)

131 William Warner, *Continuance of Albion's England* (London, 1606), sigs. D3ᵛ–D4.

132 See Linda Levy Peck (ed.), *The Mental World of the Jacobean Court* (Cambridge University Press, 1991), facing p. 178.

133 *Commons Journal*, p. 183 (23 April 1604); Galloway, *The Union of England and Scotland*, p. 21; p. 94. Notestein called Morrice 'a tedious orator from Carnarvonshire'. See W. Notestein, *The House of Commons, 1604–1610* (New Haven: Yale University Press, 1971), p. 117.

134 Corrado Vivanti, 'Henry IV, the Gallic Hercules', *Journal of the Warburg and Courtauld Institutes* xxx (1967), 180.

135 Goldberg, *James I and the Politics of Literature*, p. 47.

136 John Gordon, *England and Scotlands Happinesse* (London, 1604), sig. B3ᵛ (p. 6). Maxwell too sought a return to the Church as it had been in the days of Constantine. See James Maxwell, *A New Eight-Fold Probation of the Church of Englands Diuine Constitution* (London, 1617), sig. A4.

137 Speed, *Theatre of the Empire ...*, p. 884.

138 William Drummond, *Forth Feasting. A Panegyricke to the kings most excellent majestie* (Edinburgh, 1617), sig. B3. On the importance of Augustus for the Elizabethans see J. Leeds Barroll, 'Shakespeare and Roman history', *Modern Language Review* LIII (1958), 327–43, esp. 341; Howard Erskine-Hill, *The Augustan Idea in English Literature* (London: Edward Arnold, 1983), p. 165.

139 James VI and I, *A Meditation Vpon the 27.28.29. Verses of the XXVII. Chapter of Saint MATTHEW OR A PATERNE FOR A KINGS INAVGVRATION* (London, 1619) in Johann P. Sommerville (ed.), *King James VI and I: Political Writings* (Cambridge University Press, 1994), p. 234.

140 Robert Johnson, *The New Life of Virginia: Declaring the former successe and present state of that plantation, being the second part of Nova Britannia. Published by authoritie of his Maiesties Counsell of Virginia* (London, 1612), sig. F.

141 Porter, *The Inconstant Savage*, p. 344.

142 McIlwain, *The Political Works of James I*, p. 40.

143 Harbert, *A Prophesie of Cadwallader*, sig. H4.

144 See also Henry Petowe, *England's Caesar. His majesties most royall coronation* (London,

1603) and Samuel Rowlands, *Ave Caesar. God save the king. The joyfull ecchoes of loyall English hârtes, entertayning his majesties late arivall in England* (London, 1603).

145 Philip Grierson, 'The origins of the English sovereign and the symbolism of the closed crown', *The British Numismatic Journal* XXXIII (1964), 129. See also Hoak, 'The iconography of the crown imperial', pp. 54–103.

146 Koebner, '"The imperial crown of this realm"', p. 49.

147 Mason, 'The Scottish Reformation and the origins of Anglo-British imperialism' in Mason (ed.), *Scots and Britons*, pp. 171–2; p. 173. In a letter of 28 March 1603, James had written of 'our Cittie of London, being the Chamber of our Imperiall Crowne' (BL Harl. MS 7021, fol. 236). Cited in Goldberg, *James I and the Politics of Literature*, p. 50.

148 In Anthony Munday's *Camp-bell or the Ironmongers Faire Field*, John Squire's *The Tryumphs of Peace* and Munday and Thomas Middleton's *The Triumphs of Integrity*. See David M. Bergeron, *English Civic Pageantry 1558–1642* (London, 1971), pp. 147; 204; 197.

149 The significance of the image is discussed fully in its architectural context in Hart, *Art and Magic*, ch. III, esp. p. 67.

150 Paolo Giovio, *Dialogo dell'imprese militari et amorose* (Lyone, 1574), sig. B2ᵛ; and see Earl Rosenthal, '*Plus Ultra, Non Plus Ultra*, and the columnar device of Emperor Charles V', *Journal of the Warburg and Courtauld Institutes* XXXIV (1971), 204–28, and Earl Rosenthal, 'The invention of the columnar device of Emperor Charles V at the court of Burgundy in Flanders in 1516', *Journal of the Warburg and Courtauld Institutes* XXXVI (1973), 198–230.

151 Vivanti, 'Henry IV, the Gallic Hercules', 187. See also Yates, *Astraea*, especially plate 3a.

152 See Goldberg, *James I and the Politics of Literature*, p. 45; Hart, *Art and Magic*, p. 67. Pillars representative of wisdom and knowledge were used in the frontispiece to Francis Bacon's *Instauratio Magna* (London, 1620).

153 Dennis C. Kay, 'Gonzalo's "lasting pillars": *The Tempest* V.i.208', *Shakespeare Quarterly* XXXV (1984), 322–4. Ben Jonson, *Bartholmew Fayre*, V.vi.36–9.

154 Hart, *Art and Magic*, p. 77.

155 Note also that Psalm 92:12 states that the righteous man 'shall grow like a cedar in Lebanon'. James was not, of course, the first king to be depicted as the biblical ruler. Henry VIII had been depicted as Solomon in window 12 (1526–31) of the chapel of King's College, Cambridge. See Michael Hattaway, 'Paradoxes of Solomon: learning in the English Renaissance', *Journal of the History of Ideas* XXIX (1968), 524 and Christopher Morris, *The Tudors* (London, 1955), plate 15. So too was Elizabeth in, for example, John Prime's *A Sermon ... Comparing the Estate of King Salomon and his subiectes with Queene Elizabeth and her people* (Oxford, 1585) and Thomas Morton's *Salomon or a treatise declaring the state of the kingdome of Israel* (London, 1596). Under James the masque *Solomon and the Queen of Sheba* was the source of Harington's famous letter of 1606 relating the drunkenness of the Court though the main thrust of comparison between the two rulers was made in sermons – see, for example, Robert Wakeman, *Salomon's Exaltation. A sermon preached before the kings majestie* (Oxford, 1605) and of course John Williams, *Great Britains Solomon. A sermon preached at the funerals of the late king, James* (London, 1625). Other examples of Solomonic praise include Andrew Willet, *An antilogie or counterplea to an Apologicall epistle* (London, 1603): 'You are our Salomon to judge betweene us: they that love division and to

contend causelesse, let them have the least part' (sig. **2ʳ); Francis Trigge, *The humble petition of two sisters, the church and commonwealth* (London, 1604): James was as 'a second *Salomon* in this our Israell … in your sacred session and high court of Parliament' (sig. A6ᵛ).

156 Johnson, *Nova Britannia*, sig. C4; sig. C2ᵛ. Ben Jonson, *The Alchemist* (London, 1610) in Herford and Simpson (eds), *Ben Jonson*, vol. V, II.i.3–4.

157 Loren E. Pennington, '*Hakluytus Posthumus*: Samuel Purchas and the promotion of English overseas expansion', *Emporia State Research Studies* XIV (1966), 11.

158 Galloway, *The Union of England and Scotland 1603–1608*, p. 165. The same claim is made in Galloway and Levack (eds), *The Jacobean Union*, p. xi: 'The general interpretation of the project included here makes more of other elements also to be found in James's writings and speeches: the resolute rejection of ideas of Empire …'.

159 See John McCavitt, *Sir Arthur Chichester. Lord Deputy of Ireland 1605–16* (Belfast: Institute of Irish Studies, 1998).

160 David Armitage, 'Literature and empire' in Canny (ed.), *The Origins of Empire*, p. 102.

Chapter 2

1603–10

'Britaine is now, Britaine was of yore'

by deuiding your kindomes, yee shall leaue the seed of diuision and discord among your posteritie; as befell to this Ile, by the diuision and assigement thereof, to the three sonnes of Brutus

James VI and I, *Basilikon Doron*

In an irate speech in 1607 to a parliament which was not backing his Union plans with the speed and confidence for which he had hoped, James VI and I was at pains to appeal to the inherently imperial benefits of his project.[1] He spoke of 'the weight of the matter, which concerns the securitie and establishment of this whole Empire, and little world' while dismissing the economic disadvantage which might be felt by a minority of English merchants: 'if the Empire gaine, and become the greater, it is no matter'. He then moved to more specifics, appealing not only to the internal hegemony of a British national state, but to the overseas potential which might come about through unity with Scotland: 'Shall not your Dominions bee increasid of Landes, Seas, and persons added to your greatnesse?' His closing remark, however, shows the power of the imperial motif. 'You are now to recede: when you meete againe, remember I pray you, the trueth and sincerity of my meaning, which in seeking Union, is onely to aduance the greatnesse of your Empire seated here in England'. Naturally James was not advocating the subordination of Scotland, but making a conscious effort instead to make his project more palatable to the English parliament. However, the direction he was taking, through tying union to the coat-tails of empire, does merit further consideration.

Within Jacobean historiography, studies of the Union have preoccupied scholars, the occasion of the Gunpowder Plot also contributing to the interest in the period 1603–08, often to the detriment of the rest of the reign until the 1620s. Most historians agree that the urgency of union between the British kingdoms was on the decline within five years of James's accession to the English throne. Joel Epstein pronounced an earlier death than others, writing

that as of June 1607, 'Union, as far as Parliament was concerned, was a dead issue'. Keith Brown argued that 'only James's personal interest kept the issue on the political agenda until 1607–8', while Jenny Wormald allowed it a slightly longer life, writing of the issue as being 'long dead' by the period 1611–12.[2] However, it may be productive in reconstructing the political milieu of James's first decade in London to identify his personal agenda. This means looking beyond union, towards the notion of *reunion*, tied to the historical precedent of the kingdom of Britain as it was at the time of the Roman invasion.[3] In his 1604 proclamation altering the royal style, James wrote of 'the blessed Union, *or rather Reuniting* of these two mightie, famous, and ancient Kingdomes of England and Scotland, under one Imperiall Crowne'.[4] [my italics] and in defending the new style he went on to emphasise: 'Wee do not Innovate or assume to Us any new thing, but declare that which is and hath bene evident to all'.[5] 'Britaine is now, Britaine was of yore' claimed one panegyrist in 1604, while another would later write 'to celebrate the re-union, after long separation, of a loving people and their king' in 1617. Wormald noted Sir Robert Cotton's efforts to introduce legitimacy for the king's union project and calm fears of the dissolution of England. James's intention, Cotton said, was 'to reduce theis two potent Kingdomes to that entier state wherein it stood of old'.[6]

Linda Colley wrote how in the eighteenth and early nineteenth centuries the English, Welsh and Scots became Britons through their common investment in Protestantism and in empire, with which God had entrusted them to further the spread of the gospel. This formula can actually be applied, albeit with some limitations, to the reign of King James. This period too saw Protestantism as a uniting force in forging this nascent British identity.[7] The exigencies of war as a uniting factor, another matter dealt with by Colley, powerfully reinforced English reactions to reports of Protestants being persecuted in the countries of mainland Europe. This threat honed the xenophobia of the Protestant English to a fine point, and the result was that in 1604 the absence of war could be just as emotive as its presence.[8] While war created a specifically English response to the perceived Spanish perfidy, one writer did see the potential strength of a united English and Scottish response to that threat. In a tract entitled 'Discourse whether it bee fitt for England to make peace with Spayne' he urged James to bind 'The Britanische kingdoms' to a league with France and the Dutch to conquer Spain.[9]

But parliamentary history would seem to tell a different story, as both English and Scottish MPs fought assiduously to prevent the implementation of any 'cross-border bodies' or 'all-Britain' institutions. In the English House of Commons in May 1607, Nicholas Fuller was attacking the title of the bill dealing with the repeal of the hostile Border laws, 'For the Continewance and Preservacon of the blessed Union', arguing that there was in fact no union to

continue. He wasn't alone in putting up legal barricades, the most influential MPs of the day lining up to prevent any diminution of the perceived liberties of the Commons. Ably assisted by Richard Martin, Sir Edwin Sandys fought a running battle with Union supporters but, in spite of their best efforts to coax their king into accepting England and Englishness as epitomising a more realistic political formulation, the death of the Union and Great Britain was in fact a long and protracted one.[10] There certainly were developments after 1607 which prolonged the debate. The second issue of the Unite coinage was made after 1607, while Calvin's [Colville's] Case was heard in June 1608 over the question of whether an infant born in Scotland after 1603 – the so-called Post-Nati – could inherit land in England.

In 1609 the Lord Mayor's inauguration pageant, a public display of city pride and pomp appropriated the language of British imperium. Anthony Munday's text began with a familiar setting: 'In a goodly Island styled *Insula Beata*, or the land of Happynes, we suppose that true *Majesty* holdeth her government ... In a rich Throane, which supporteth three imperiall Diademes, sitteth a beautifull Nymph, attyred aptly to her high state and dignity, in whom we presuppose the person of *Majestie*' (1–2, 13–15).[11] Importantly, this was no mere English vision. Later two paragons were described as 'great Brittaines two famous Champions, Saint *George*, and Saint *Andrew*, united now in ever-during amitie: Saint *George* worthily mounted upon his conquered Dragon, and Saint *Andrew* on a goodly Unicorn, armed at all pointes as best becommeth them' (93–6). The text of the 1610 show is not extant, though it was also written by Munday and we know that a boy was paid eight shillings for his portrayal of 'Merlin in the Rock'.[12] On this basis it seems likely that this piece too had a British setting and as will be shown in Chapter 4 below, this would not be the last time that British imagery was used on the London streets during a mayoral show.

By 1610 a British corpus of beliefs was still being utilised on the streets of London when Union itself was in dire straits. Yet this is not actually surprising if we look at the manner in which oppositional opinions shifted after the initial furore over the idea of the Union died down. The supreme irony of the debate is that those who were opposed to James's projects for the reconstitution of the island as a British state were those who would ultimately surround Henry, Prince of Wales as heir to the throne and invest in him the kind of distinction of imperial monarchy sought by his father. Much of the opposition in England consequently represented a vote of no confidence in *James* as an emperor figure, and the notion of Union as being inherently unpalatable to the English also needs to be modified. Irrespective of any patriotic preconceptions, English lawyers would never have conceded the destruction of their livelihood by a rewriting of the body of English law. When Sandys and Martin were pulling the rug from underneath James's feet by

exploiting the legal vagaries of the plan, they were also resisting any attempt by their king to undermine the concessions wrung out of Elizabeth in the latter parliaments of her reign. Indeed by far the best way to consider the Jacobean parliaments is with an eye to their Elizabethan predecessors. Therein we may see the origins of the Jacobean political grandees' mentality. Union as James planned it would have given the king too much power for MPs to stomach. This was the king whose *Basilikon Doron* and *The Trew Law of Free Monarchies* so worried readers interested in the royal prerogative, even if the works were not written for an English audience.[13] The circumstances of James's assertion of British kingship were therefore not conducive to parliamentary concessions. James gave the impression that he believed in more extensive royal powers than would have been acceptable to even his most loyal MPs. Prince Henry, by marked contrast, would show himself to be of a more sober disposition, attracting a cadre of men to his banner who would advocate British colonial expansion and military intervention overseas. Their representation of the prince incorporated much of the imagery and language of imperial sovereignty denied to James. The union of the crowns gave birth to Great Britain in the sense that a belief in unity – with the dangers of division as a corollary – fostered what would a few years later become a fully fledged movement encompassing the militant ideas of a more aggressive, colonial Britain.

Two interchanging national visions emerged from this early Jacobean period, one lamenting the halcyon days of Elizabeth's England and the other recreating a Britain which harked back to the days of the Roman invasion. Elizabethan martialism combined with a desire to emulate Roman imperial power, through a process of theatrical osmosis. The concentration of a group of playwrights on Britain's connections with ancient Rome powerfully challenges the notion that interest in Britain faded out of the public consciousness at the same time as concern for Union. James VI and I was a lot more successful in stimulating interest in Great Britain outside Parliament than he ever was inside, which suggests that we should be wary of continually looking to Parliament in our efforts to understand Jacobean politics.

BRITAIN STAGED

Stage depictions of ancient Britain could neatly circumvent the ban issued on 1 June 1599 by Archbishop of Canterbury John Whitgift and Bishop of London Richard Bancroft on satirical material which commented on contemporary politics. Maurice Lee Jr does not, however, give the power of the term 'Britain' justice when he claims that plays were situated in such an ancient time either to make their allusions 'oblique' or in order to avoid having to deal with the corruptions of the Jacobean Court.[14] Plays such as Jonson's *Sejanus*, *Eastward Ho!* and Chapman's *Charles, Duke of Byron* had provoked a hostile response

from Court, the latter play presenting a thinly veiled picture of contemporary France which angered the French ambassador.[15] We know from a letter written by de la Boderie of 8 April 1608 that, following performances of the play, all playing in London was banned by an irate King James.[16] Whether Chapman's play was fully to blame for the king's anger, or whether it was also anger at the now lost play ridiculing the royal plan for silver-mining in Scotland, the theatre companies facing the ban could find a new locale in which to set topical material by using the British past.[17]

Plays about characters from the British historical and mythical past were not by any means a new genre in the first years of James's reign. The end of Elizabeth's rule saw a flurry of 'British' plays, riding perhaps on the nationalist wave of the Armada failure but also appearing because of concerns over the succession question, the individual with the greatest claim to the English throne being the Scottish king. The anonymous *Lamentable Tragedy of Locrine the Eldest Son of King Brutus* was performed between 1591 and 1595. Day's *I The Conquest of Brute* and *II The Conquest Of Brute* were both first performed in 1598 though the latter was probably the same play as Henry Chettle's *Brute Greenshield* of 1599. The titles of the anonymous *Uther Pendragon* of 1597 and William Rankins' *Mulmutius Dunwallo* (1598) also reveal them to have British material though unfortunately all of these plays are lost.

In considering two of Shakespeare's most popular Jacobean works, *King Lear* and *Macbeth* of 1605–6, it will become apparent that *Lear*'s positioning within a 'British canon' is easier to justify than the Scottish play's, though it will be the argument of this section that *Macbeth* has a far greater importance when read in what might be termed a 'British context' than has hitherto been appreciated. The two works by Shakespeare, as well as the anonymous *Nobody and Some-body*, belong to a period in which discussion of Union permeated the political language and spawned a shoal of literature and sermons.[18] Within the context of the Union, both *King Lear* and *Macbeth* throw plenty of light on the problems of history and the search by playwrights for material likely to be of interest to the new monarch. Plays set in Scotland and in ancient Britain were fertile ground for commentary on James Stuart's rule. Galloway and Levack have noted that Union was something of a blank sheet for the writer: 'It was also a project whose ultimate scope was unclear, making an appeal to history, as an independent authority, the more attractive'.[19] What emerges from a brief survey of the two plays – whilst being aware of the possibility of commentary on England, Scotland and the joint bond of the two under the heading of Britain – is the degree to which they fit into the canon of 'British' plays which followed them. There is no single uniting image or motif in any of the plays, but instead recurring ideas resonant in the British myth and the British history.

THE TRAGEDY OF KING LEAR

The British king who divides his kingdoms is a fool. James Stuart implicitly recognised this and advised his son to be wary of it: 'by deuiding your king-domes, yee shall leaue the seed of diuision and discord among your posteritie; as befell to this Ile, by the diuision and assignement thereof, to the three sonnes of *Brutus, Locrine, Albanact,* and *Camber*'.[20] Harbert's 1604 *Prophecie of Cadwallader* also presented James in its conclusion as the 'second Brute' who would unite the kingdoms which the first Brutus had divided between his sons; and Craig in his *De Unione* dedicated a long section to prove 'the separation of the crowns of the island is the cause of all the calamities which have befallen Britain'.[21]

When we confront *King Lear* we need to be aware that, when Lear divides the kingdoms, he makes not one but two mistakes.[22] Firstly he diminishes his own power, and it is here that we come across the question of whether or not the play is an advocacy of absolute power being rested in the monarch, and secondly he consequently affects the social order in his unitary British kingdom. He cuts off the head from the body politic with the result that the king no longer has two bodies – he does not have even *one*. (To continue such an allusion, the two bodies politic now each have two heads, a logistic problem as well as a personal one.) This echoes Margot Heinemann's point that 'the play needs inescapably to be seen *both* as an individual's loss of power and control *and* as the breakdown of a social and political system'.[23] The price that Lear has to pay is the death of Cordelia: a new interpolation, which Shakes-peare did not extract from Holinshed. The tragedy of the play lies in the sense of despair and utter waste in Act V, throwing the blame in an apocalyptic manner onto Lear's shoulders. His actions have not been mere folly – they have been utter madness – and his personal insanity is but a reflection of the chaos he has brought upon his kingdom.

King Lear's relevance, putting aside for one moment this concern with divided kingdoms and the questions posed by the 1608 Quarto edition of the play (which represented the post-Union period most closely), lies in the questions it raises regarding the nation's integrity. What makes this an implicitly British play is the fact that, where Holinshed provides two of the corners of the island, Cornwall and Albany, Shakespeare adds the third. He effectively squares the triangle, not only making Lear's staunchest adviser the Earl of Kent, but also concentrating so much of the action near Dover. The matter of the play as written by Shakespeare is thus established as being British from corner to corner.[24] From the perspective of easing a Scottish succession he also implies, at least in the 1608 Quarto (henceforward Q), that it is Albany who will succeed Lear. Out of the chaos ensuing from the demise of the royal line a Scot will restore order.[25]

Like *Macbeth*, *King Lear* is filled with prophecy, a concern for the future and the destiny of the British island. Gloucester worries that 'These late eclipses in the sun and moon portend no good to us. Though the wisdom of nature can reason thus and thus, yet nature finds itself scourged by the sequent effects. Love cools, friendship falls off, brothers divide; in cities mutinies, in countries discords, palaces treason, the bond cracked between son and father' (I.ii.88–92). Edmund takes these astrological events, and reports on them sarcastically to his brother:

> EDMUND: I am thinking, brother, of a prediction I read this other day, what should follow these eclipses.
>
> EDGAR: Do you busy yourself about that?
>
> EDMUND: I promise you, the effects he writ of succeed unhappily, as of unnaturalness between the child and the parent, death, dearth, dissolutions of ancient amities, divisions in state, menaces and maledictions against king and nobles, needless diffidences, banishment of friends, dissipation of cohorts, nuptial breaches, and I know not what.
>
> (I.ii.113–20)

Any such troubles will, however, be his doing.

The play is not alone in linking British material with soothsaying and prophecy: as we shall see, *Cymbeline*'s Roman soothsayer predicts the future of Britain, even if it is wrongly interpreted by the Romans, and in Rowley's *The Birth of Merlin* much of the plot centres around the prophecy regarding Merlin's future glory for Britain. Yet in *King Lear* the Fool's prophecy in the Folio (henceforward *F*) is problematic:

> When priests are more in word than matter;
> When brewers mar their malt with water;
> When nobles are their tailors' tutors,
> No heretics burned, but wenches' suitors,
> Then shall the realm of Albion
> Come to great confusion.
> When every case in law is right;
> No squire in debt nor no poor knight;
> When slanders do not live in tongues,
> Nor cutpurses come not to throngs;
> When usurers tell their gold i'th'field,
> And bawds and whores do churches build,
> Then comes the time, who lives to see't,
> That going shall be used with feet.
> This prophecy Merlin shall make, for I live before his time.
>
> (III.ii.79–93)

It is not present in *Q*, yet from the perspective of imperial iconography in the 1620s it is still revealing. The prophecy most associated with Merlin was of

course that regarding the 'once and future king', Arthur, whose successor – as the propagandists were keen to point out – ascended to the English throne in 1603.

To say that the play has had much written about it is an understatement, but it seems that too much has cluttered our sense of what the play meant for the Jacobean audience.[26] Heinemann wrote of how there was to be no known repeat performance of *King Lear*: 'The chances are that this play, directly representing a king as foolish, the rich as culpable, and the poor as victims, may have been felt as altogether too disturbing and subversive'.[27] There is an alternative view: that the play deliberately illustrated a specific moment in the British reconstruction at the time and that it was not replayed simply because its message had become outdated; its internal-union dimension was replaced by the outward-looking imperial motifs portrayed in, for example, *Cymbeline* and *A shoo-maker a gentleman*. *King Lear*'s first performance at court occurred on 26 December 1606, during the Christmas recess of the parliamentary session which was debating the Union. It was a play whose primary political significance was for a specific moment.[28] As for the representations of the world being turned upside down, the message was that this was a result of the foolishness of division, of abrogating the royal power. The world had fallen because the dignity of the monarchy had done so. The play was therefore a great deal less subversive than we might think.

NO-BODY AND SOME-BODY

Lear was not the only king of England to have ruled as king of Britain. According to Holinshed, Elidurus was king of England 582 years after Lear (and 258 years before Cymbeline) and was a benevolent ruler.[29] At first glance there is nothing which marks the reign of Elidurus, King of Britain, as being in any way special. After all, that of Cymbeline saw the birth of Christ, that of Lear the division of the kingdoms. Elidurus's reign saw a goodly king ascending to the throne three times. If we are to look to the reasoning which led to this material being incorporated into a play the problems surrounding Elidurus's multiple accessions to the throne seem to offer the only explanation. Indeed it may seem that this was merely a good tale, a suitable piece of simple romance. Alternatively it may be that the story of another British king was pertinent to the new period of interest in things British.

The anonymous *No-body and Some-body. With the true Chronicle Historie of Elydure, who was fortunately three severall times crowned King of England* was first printed in 1606, and first performed between about 1603 and 1606.[30] The plot revolves around two concerns: the depiction of vice as being prevalent in London life, and the chaos ensuing from a succession crisis: in this case it is not that there is no-one to succeed but that those who do are not good rulers.

Ultimately the succession comes to King Elydure, whose goodness is such that he puts the candidacy of others before his own rather than bear the burden himself. This is, however, viewed as being less than wise as the country needs a firm king and one who can take the responsibility upon himself. This British crown is a game of high stakes, with sychophantic courtiers rewarded, tyranni- cal injustices perpetrated by kings against their subjects and money spent at court on 'masks, sports, reuells, riots, and strange pleasures'.[31] The prize to which the challengers for the crown aspire is made explicit in their continued reference to Britain's crown as being an imperial accolade, emphasis being drawn repeatedly to the fact that the kingdom is held together as an imperium. The overriding concern of one of the aspirants to the throne is to 'were a crowne, a crowne imperiall' and he later admits to having 'My princely thought inflam'd with Ardency Of this imperiall state' as well as promising 'Then they that lifts vs to the imperiall seate, Our powers and will shall study to make great'.[32] The corrupt Peridure and Vigenius stress their claim to the throne on the basis of Elydure's weakness: 'We are possest of thine imperiall seate', they tell him.[33] Elydure, having been made king, admits to the deposed Archigallo – whom he wishes to see restored to the throne – that 'The angry Peeres Will neuer let me reach the imperiall wreathe To Archigalloes head'.[34] Archigallo's queen threatens Lady Elydure with making her 'stoope at our imperiall side' and the aptly named Lord Sicophant addresses Lady Elydure as 'Your high imperiall Maiestie'.[35]

The British dimension to the play is never far away from its surface. When crowned again, Elydure announces: 'Once more our royall temples are ingirt With Brittaines golden wreath ... then to Troynovant weele speede, away'.[36] The imperial crown is rightly referred to in such Roman imperial terms – it was as the Roman emperor wearing a laurel wreath that James was depicted in medals of 1603 and 1604, as he was in Crispin van de Passe's 1613 portrait. The use of London's title of 'New Troy' meanwhile is especially evocative of ancient British imperial greatness.[37] Despite the turmoil through which Britain has gone in her search for a worthy king, the play ends happily. It was performed in a Britain which had been spared the nightmare of a contested succession, but concerns as to the character of one of James Stuart's progeni- tors cannot be taken as harmless. In the play Morgan is glad to see Elydure restored to the throne: 'Happy is Brittaine Vnder the gouernment of *Elidure*'.[38] The jury was still out on James Stuart.

MACBETH

Opinion on the 'Scottish play' seems divided between those who view it as being inherently critical of the Scottish king and those who view it as being a 'royal play'. Galloway stands as a good example of the former opinion: 'It is not

only significant that Shakespeare greeted the union with a play on Scotland— but equally notable that the tragedy was *Macbeth*, full of barbarous treachery and superstition, and of English suzerainty over Scotland'.[39] Maurice Lee Jr is another in this camp: 'Even the well-intentioned among the English were condescending. *Macbeth*, for instance, in the wake of the Gunpowder Plot and supposed to do honour to King James, made the Scots look barbarous, bloody and superstitious and suggested that James's ancestor, Malcolm Canmore, owed his crown to English support'.[40] David Norbrook too is drawn into this group who see in the play an inherently critical view of the Scots: 'The legitimists are shown to need the aid of the English, and Scotland is represented as a wild and lawless country'.[41]

Henry Paul stands at the other extreme, claiming the play to be a creation by Shakespeare not just to please the king but to be a specifically royal play from the onset, designed primarily for Court rather than public consumption.[42] The truth lies probably somewhere between these two parameters: the play's Scottish content was highly topical, but Shakespeare avoided, for example, the unpleasant consequences which could befall the dramatist overstepping the mark, such as that felt by Jonson, Chapman and Marston after writing *Eastward Ho!* and John Day following the performance of his *The Isle of Gulls*. Without marking him as an establishment figure, it would be fair to say that Shakespeare was shrewd enough to avoid censure for his work. Indeed, his intention in writing *Macbeth* may be said to be non-hostile to the Scots, as a closer look at the manner in which he represents them does not square with the view of them being barbarians. The Scottish noblemen with whom Shakespeare is preoccupied would not have been unrecognisable to those in Jacobean England.

The Scots in the play are preoccupied with war, with loyalty and with concerns over treachery. The majority of the characters in the play are of high or royal social standing and they all display in varying degrees what Clark has termed 'a temperament with an emotional mobility, an intensity of imagination, and a responsiveness to the mystery of things'. They are by no means ignorant of their world. The Scots in the play act with dignity and if the Porter is the exception he is not ridiculed. When Malcolm refers to Macbeth and his wife as 'this dead butcher and his fiend-like queen' (V.vii.99) we know otherwise, for whatever their actions they do indeed seem possessed of a certain grandeur.[43] The treatment afforded to Malcolm by the English during his exile – and discussed by Lennox and another lord – does not indicate the condescension which Lee feels is present. Instead it illustrates how every honour is accorded from one ruler to another. There is no talk of feudal vassalage here:

> LORD: The son of Duncan
> From whom this tyrant holds the due of birth,
> Lives in the English court, and is received

> Of the *most pious Edward*, with such *grace*
> That the malevolence of fortune nothing
> Takes from his high *respect*. Thither Macduff
> Is gone, to pray the *holy King* upon his aid
> To wake Northumberland and warlike Seyward,
> That by the help of these—with Him above
> To ratify the work—we may again
> Give to our tables meat, sleep to our nights,
> Free from our feasts and banquets bloody knives,
> Do faithful homage, and receive free honours—
> All which we pine for now.

> (III.vi.25–37) (my italics)

The speech indicates that Malcolm is accorded the dignity that becomes his title, rather than English scorn. The struggle against Macbeth is represented in terms of a divinely sanctioned crusade uniting the kings of England and Scotland in a Christian mission against a man who has, among other crimes, committed regicide.[44]

Macbeth's aside – 'Two truths are told As happy prologues to the swelling act Of the imperial theme' (I.iii.128–30) – and Malcolm's reference to kingship as being 'an imperial charge' (IV.iii.20) prove problematic in that 'imperial' seems to mean no more than 'sovereign' – as the nature of a monarch's rule was often assumed to be. However, since the play concerns one of James Stuart's ancestors, and James was lauded elsewhere as an emperor figure we must look to the other connotations of the term. Shakespeare was drawing inspiration from Robert Waldegrave's book *Scottish Prophecies* (1603), in which the author records one by 'Sibylla Regina':

> She maketh mention of two noble princes and emperors the which is called Leones, these two shall subdue and overcome all earthly princes to their diadem and crown, and also be glorified and crowned in heaven among saints. The first of these two is Magnus Constantinus. The second is the ninth king of the name of Steward of Scotland, the which is our most noble king.[45]

Matthew Gwinn in his *Tres Sibyllae* (1605), which relates from Holinshed the Banquo–Macbeth story, notes that the sisters foretold to Banquo 'Imperium sine fine tuae, rex inclyte, stirpis' [An endless empire, O renowned King, to thy descendants]. This imperial reference is not, however, gleaned from Holinshed: it is Gwinn's interpolation. Furthermore, one of the sisters goes on to address James: 'The world is the limit of thy dominion and the stars of thy Fame. Bring back great Canute with his fourfold kingdom; Greater than thy ancestors, O thou who hast been crowned with a diadem to be rivalled only by thy descendants'.[46]

The occurrence of this idea is of extreme importance in the years immediately following James's accession to the English throne. Despite this,

Kinney seized upon the idea of imperial ambitions as being the prime motivation behind Macbeth in his murder of Duncan. He refers to it as being 'self-aggrandisement turned evil' yet he does not find any explanation for the use of the term. He goes on to claim that: 'It is as if Shakespeare wishes to locate imperialist – and, by extension, absolutist and tyrannical – actions only in Macbeth and, by such a verbal connection, only in James. It is as if, then, Shakespeare is using his play to warn James VI and I of the inherent dangers of imperialist and absolutist thought'.[47] The idea that Shakespeare was using the term in a pejorative fashion (as it might be used in the later twentieth century) is simply not borne out by the use of the term in this play. If we compare *Macbeth* with the other work in the Shakespeare canon which comments on the idea of empire, *The Tempest*, we can appreciate the comparative neutrality of his position on empire.[48]

In the same vein, attempts by historians to find comparisons between James and Macbeth are equally awkward, for any commentary remotely offensive would not easily have passed by the king in a play whose subject matter was so close to him. It was James's ancestry being traced on stage when Macbeth saw a line of kings which 'stretch out to th' crack of doom' (IV.i.132). The problem posed by the play for those who seek to find parallels is that critics are too quick to indicate the problems depicted within Scotland in the play, whilst not looking at the *reasons* for these flaws. Hence, Norbrook writes: 'Duncan's Scotland is not, on closer examination, an ideal polity calculated to gratify James's national pride'.[49] Scotland is a state indeed in turmoil, but it is so because it is at war. As in *Henry V*, the portrayal of a country engulfed in turmoil is not necessarily the most satisfying, but it is the actions of those immersed in the conflict to which we should turn. Here too we find obstructions to a royal reading. Banquo, James's supposed ancestor is portrayed in a less than perfect light: his 'May they not be my oracles as well, And set me up in hope? But hush, no more' (III.i.9–10) suggests a certain complicity which a determined panegyrist would certainly have avoided. Indeed the only sense in which the play does show a decidedly royal resonance is in the inclusion of the character of Lennox: there is no such figure in Holinshed's account of the reigns of Duncan or Macbeth. The real Duke of Lennox, Ludovic Stuart, was not only kin to James and an old favourite but also a Privy Councillor and Steward of the Household.

The significance of the play is thus difficult to locate purely within Scotland, because to call it the 'Scottish play' misses the point that it has a critically important relevance for the audience of both England and Scotland. During a war a traitor seizes the throne and, since Shakespeare omits the ten years of good rule by Macbeth mentioned in Holinshed, is then undone by a just intervention from a friendly England. A young king who expresses his wise thoughts on the subject of the just ruler comes to the throne as a result.

The significance of Malcolm's marriage from the perspective of Britain's history was in fact appreciated as early as 1589 by William Warner, in his *Albion's England,* and Sir George Buc's *Daphnis Polystephanos* (London, 1605) presents the political alliance between Malcolm and Edward as specifically prefiguring the Union though he also, controversially, traces James's English ancestry on the English side back to Edward. When Speed gets to Malcolm's marriage in his *History of Great Britain* he notes that from this 'princely bed in a lineall descent, our high and mighty monarch, King JAMES the first, doth in his most roiall person unite the Britaines, Saxons, English, Normans, and *Scottish* imperiall Crownes in one'.[50]

Macbeth is thus a very British play, just as much so as *King Lear* and *Cymbeline,* because it comes at a time when a play about a Scottish king who belongs to a period of British harmony was highly politic. This is not to say that it is a royal play – the nature of the ruler is as much a public as a private affair. If Lear divides the kingdoms and suffers for it, Cymbeline (in Shakespeare's version of events) hearkens to the nationalist rhetoric of the past, and is nearly brought to ruin for it. Macbeth betrays his country, yet in so doing prefigures the union of the kingdoms.[51]

A SHOE-MAKER, A GENTLEMAN

Rowley's *A Shoe-Maker, A Gentleman* (written between 1607 and 1609) differs from its fellows in that its British setting at first reading seems awkward.[52] The play centres on the dignity of the shoe-makers in a manner more suited to the pageants celebrating the creation of London's Lord Mayors. Its British setting is not, however, diminished by this fact. Rather we are drawn to look at why the British setting is used, when Rowley could just as easily have set the play in the Jacobean present. What Rowley in fact does is to accentuate the glory of Britain through its associations with imperial Rome. By the events of the play Britain is shown to have had as glorious a past as the Roman emperors: indeed here two of them, Maximinus and Dioclesian, admit Britain's part in saving the empire from being overrun at the hands of the Vandals and Goths. It also allows the British to show themselves as willing participants in the process of acculturation which the Roman invasion of Britain was known to have afforded.

The play is also an exercise in British patriotic hagiography, dealing as it does with the martyrdom of St Alban (spelt Albon in the play) and St Hugh. It also begins with Britain in danger, the invasion, unlike that in *Cymbeline,* having already taken place. The British king enters wounded and urges his sons to flee. They do so, unwillingly, while their mother stays with the body of her dead husband and is captured by the Romans. Taking on the names Crispinus and Crispianus as well as apprenticeships with a shoe-maker and

his wife, the destinies of the two brothers are acted out. Crispinus meets and fathers a child on Leodice, the Emperor Maximinus's daughter, while Crispianus leads conscripted British forces into battle in France on behalf of the Romans and wins the day for them. Thus by the end of the play British strength at arms and an heir to the imperial throne have both been assured, and if Britain has been conquered by the Romans, as in *Cymbeline*, it is a conquest in which Britain has gained, not lost.

The play positively revels in imperial imagery, as befits one which deals with the power of Rome and Britain's association with it. The dying king Allured refers to his sons as 'you Phænix of my age' (I.i.17), and the figure of the eagle standard is continuously noted as the symbol of Roman strength. Allured laments: 'Those bloody Persecutors Maximinus and Dioclesian, Display their by-neckt Eagle over Brittaine' (I.i.25–6) and the imperial standard is rescued from the hands of Huldricke, King of the Goths, in Act III scene iv by Crispianus. Having saved the standard as well as the Emperor Dioclesian, Crispianus insists 'Ile keepe your Eagle till the battaile's wonne' (III.iv.58). The eagle thus becomes the British symbol, as the boundary between that which is Rome's and that which is Britain's becomes smoothed over. It is as an equal that Crispianus chooses to return the standard: 'Now to the Royall hand of Cæsar I resigne The high Imperiall Ensigne of great Rome' (III.v.17–18). Other potent iconography is used when, in referring to their fall from nobility through their having to flee, Offa/Crispianus notes: 'With constant hope, That though vaild honor beare an Ecliptick staine, Our sunne will passe it, and shine bright againe' (I.i.143–5). Equally, and using a motif regularly associated with kings, Dioclesian speaks of Crispianus: 'He like a Lyon on the vandall runne' (V.ii.18).

The play is geared towards evoking a patriotic response through this association with the Romans. Rodericke, King of the Vandals, provides the audience with something to cheer when he rages:

> This Brittaines are all Divells,
> And amongst them there's one master Divell,
> That beares the face of a base Common souldier;
> Yet on his hornes he tosseth up our Vandals.
>
> (III.v.1–4)

Dioclesian too recognises the British contribution to imperial victory: 'And yet our conquest had not spread such wings But for those Brittaine forces you sent o're' (V.ii.8–9). As part of this patriotic theme in the play, Rowley incorporates Wales in a harmonious and pious manner through the characters of the virgin Winifred and the noble Sir Hugh, 'a Prince of Wales'. Hugh offers charity and courtesy in urging the queen to flee to Wales, and his martyrdom along with Winifred is especially pious. The British are depicted throughout

the play as being virtuous. The Shoemaker is an honest, noble craftsman, however comically cowardly his apprentice Barnaby might be.

The individual who plays the most subtly significant role in the play is, however, the noble Albon. It is impossible to tell whether Rowley was attracted to the saint because Albon could be taken as Albion – nowhere in the text is the spelling altered to make this association. Yet it is Albon who is elected for special praise by the two invading emperors: 'The shout and full applause was onely Albons, For which unto thy Knighthood late given in Rome, We adde the stewardship of Great Brittaine' (I.i.165–7). Albon, it is noted, has been knighted in Rome, as was Cymbeline and as too is Crispianus (III.v.46–7). Britain is given over to one whose nobility and courage is established as being without parallel and tied to the glory of Rome, and one who in turn will convert to the British religion and eventually be revered as a saint. Thus the British myth envelops another character for the purposes of ennobling the British dynasty. He recognises the power he is given by the emperors: 'Albon shall still as substitute to Rome Observe, and keepe her high imperiall Doome' (I.i.174–5).

The martyrdom of Albon, Amphiabel, Hugh and Winifred might seem out of place in a play which illustrates the coming of Romano-British unity. The deaths are, however, necessary to illustrate another dimension to the British myth, that of the development of the Christian religion. If the play is set in pre-Protestant times, there are few overt references to Catholicism. Winifred might have decided to become a nun, but there are no priests in this play. It seems at times almost a proto-Christianity, yet it is this age of religious simplicity to which those looking for the origins of the Protestant religion, without the medieval trappings of Catholicism, looked. Maximinus is keen to order Bassianus 'with severity, through the conquer'd Cities persue The Christians to their Martyrdomes' (I.i.177–8) while Albon, facing death, knows what he is destined to become: 'Of me: my Countrey may thus much boast: Albon, Stood firme and fixt, in spight of tyrants wrath, Brittaines first Martyr for the Christian faith' (IV.ii.22–4).

Destiny is all-important in the play. The religious origins of the British state have been shown to be noble and pious in the face of a tyranny, yet the imperial destiny of Britain is also emphasised. The offspring of Crispinus and Leodice is used to illustrate part of the Stuart genealogy: it is an ancestry born from the union of Roman imperial power and British valour, as Crispianus notes:

> A Princely babe,
> The eye of heaven looke on thee, and maist thou spread
> Like to the Bay Tree, which the whole yeare springs,
> And through this land plant a whole race of Kings.

> (V.i.209–12)

For the Jacobean audience this hope had already turned to reality, as their king's rule now indeed stretched through the whole isle. Indeed, if there is any doubt as to whether the play has any significance for its audience, one need only look to the manner in which the two emperors divide the kingdom between Crispinus and Crispianus. 'This in the North shall rule' proclaims Maximinus, with Dioclesian adding: 'This in the South' (V.ii.177–80). The two sons inherit the type of Britain James was seeking, in exactly the same terminology.[53]

Furthermore, the emperors' concluding decision is one of conciliation as well as an implicit recognition of Britain's religious integrity: 'Build what Religious Monuments you please, Be true to Rome, none shall disturb your peace' (V.ii.190–91). *A Shoe-Maker, A Gentleman*, like *Cymbeline*, becomes a history lesson: the reference to the traditions of the shoe-making trade are but a tie to the past, as Rowley justifies the Jacobean present by recourse to the past. He does so by looking to a historical setting most akin to that of the present. Throughout the play are placed points of historical reference: note that Maximinus orders signal beacons to be built on the 'conspicuous promonts of our Land' (I.i.218), still an important part of the British defences in 1607. Ultimately, Roman references to her power are represented as being part of Britain's shared heritage: 'Say like to Ioves, when our Dread Thunders hurl'd, Our sable Eagle strikes through all the world' (I.i.228–9). It is as much an expression of British aspirations for future glory.[54]

CYMBELINE, KING OF BRITAIN

In his *Troia Britanica or great Britaines Troy*, a poetic work published in 1609 and covering the history of the world from Adam to King James, Thomas Heywood wrote of the lives of all the ancient British kings. Brute, Lear, Mulmutius and Elidure all feature in an extensive 446-page tribute to the strength of the British material. Also included is a passing mention given to one Cloten, father of Mulmutius, and five pages later a section on King Cymbeline.[55]

The significance of imperium and empire has been dealt with in Chapter 1, yet it is necessary to emphasise that the struggle which is presented in Shakespeare's *Cymbeline* is specifically between the *external* conquering empire of Rome and the *internal* imperium of Britain. What this part of the chapter will illustrate is how Shakespeare reflects on the Jacobean perception of empire here in *both* senses, illustrating the coming to terms of the two empire states in a show of British national pride, and how the play closes with the return to friendship of the two rulers. By defeating the empire of Rome, Britain's acquiescence to tribute reiterates the unity of the kingdom as a single entity whilst placing it firmly within the wider framework of Europe, just as

James Stuart planned for his Great Britain. In the play it is the failure of the characters of the Queen and her son Cloten to recognise that Britain's internal empire must nonetheless live within the framework of a European concert of states that leads to their downfalls. Their outdated British nationalism, predicated on the Elizabethan model of Britain as representing an English empire, is the cause of this fall.

Cymbeline was performed at court in 1610–11 and at the Globe during the February–June 1610 hiatus of plague.[56] Critics have hitherto made no comment on the fact that the play is entitled *Cymbeline, King of Britaine* in the index to the 1623 First Folio. This title is significant as there is another play of the same period which may well have been on the same theme, the lost *Madon, King of Britain*. Kawachi dates it as being first performed between 1605 and 1616 and suggests Beaumont as a potential author. One of the two plays may have been written in response to the other, and it is no large leap in the dark to imply that the popularity of the subject matter may have been the reason for the existence of the second of the plays.[57]

David Bergeron has suggested that there is 'a consistent concern for two kingdoms in the Romances, representative of the ongoing attempt to define the nature of the links between England and Scotland'.[58] Indeed, *The Tempest*, for example, focuses on Naples and Milan, *The Winter's Tale* on Sicily and Bohemia, and *Cymbeline* on the relations between Britain and Rome. Parallels between the latter play and politics are, on the surface at least, easy to come by. King James was trying to bring about the reuniting of Christendom through peace with Rome, but the play also glorifies the state of Britain through a divinely sanctioned marriage, and the fortitude and virtue of the characters of Posthumus and Imogen. Posthumus Leonatus, given a sur-name which might connect him in the minds of the observant with James, whose emblem was the lion, is reunited with the noble princess of Britain whose strength of character has been shown not only in her desire to flee to her husband no matter what, but in her bravery in standing up to her father's wishes.[59]

Imogen is a superbly patriotic figure, though only recently has this received any scholarly attention.[60] Her very name associates her with the ancient British nobility, as the wife of Brutus was reputedly named Innogen. Indeed there is evidence that the character in the play was called Innogen from the start, but for a misprint in the First Folio which has left us with Imogen.[61] She is sensible enough to see the 'Dissembling courtesy' (I.ii.15) of her stepmother when her father does not, and as Iachimo realises 'a lady So fair, and fasten'd to an empery Would make the great'st king double' (I.vii.119–21).

Such imperial reference and imagery is present in *Cymbeline* at every turn. Imogen is described by Iachimo as 'alone th'Arabian bird' (I.vii.17) – the 'imperial' phoenix – while references to the eagle, the king of birds, likewise

occur throughout the play. 'I chose an eagle, and did avoid a puttock' claims the princess in describing her choice of Posthumus over Cloten for a husband (I.i.141–2). Belarius refers to 'the full-wing'd eagle' (III.iii.21) and the Soothsayer to 'Jove's bird, the Roman eagle' (IV.ii.348). As Simonds notes, 'the Roman Soothsayer ... misinterprets his own dream in 4.2. of *Cymbeline* because he understands the eagle only as a Roman symbol':[62]

> Last night the very gods show'd me a vision
> (I fast, and pray'd for their intelligence) thus:
> I saw Jove's bird, the Roman eagle, wing'd
> From the spongy south to this part of the west,
> There vanish'd in the sunbeams, which portends
> (Unless my sins abuse my divination)
> Success to th' Roman host.
>
> (IV.ii.346–52)

The eagle in the play therefore represents *all* imperial power.

When Jove finally makes a personal appearance, the stage direction has him 'sitting upon an eagle' (V.iv) which the ghost of Sicilius Leonatus specifically refers to as 'the holy eagle' and 'royal bird' (V.iv.115–17).[63] Though a posthumous addition to the visual splendour of James's kingship, the Rubens portrait of his apotheosis on the ceiling of the Banqueting Hall, Whitehall, has James depicted in exactly the same manner, seated on an eagle. The final scene of the play sees the culmination of this particular image, as Lucius affirms how 'our princely eagle, Th'imperial Caesar, should again unite His favour with the radiant Cymbeline, Which shines here in the West' (V.v.474–7).

This passage also introduces the idea of the British king as being 'monarch of the west'. The same conceit occurs in Rowley's *The Birth of Merlin* (see Chapter 3), where Merlin refers to Arthur not being content in war 'till *Romes* Imperial Wreath hath crown'd his Fame With Monarch of the West' (III.v.109–110). 'Monarch of the West' is a title applied to James by Dekker in the 1603 *Magnificent Entertainment* (1.849) and Jonson's 1603 *Panegyre* notes 'againe, the glory of our Westerne world Vnfolds himself' (3–4). In Campion's masque for the marriage of Lord Hay with Honora Denny on 6 January 1607, the marriage is described as taking place 'in this happy western isle' (239) and in Jonson's *Love freed from Ignorance and Folly*, performed on 3 February 1611, James is referred to as 'The sun thronèd in the west' (362).[64]

Another imperial image, that of the cedar, is mentioned four times in the play, with the most direct bearing on the person of the monarch occurring when Cymbeline is told 'The lofty cedar, royal Cymbeline, Personates thee' (V.v.454). The king's two sons are described as 'To the majestic cedar join'd' (V.v.458).[65] The cedar is used in the same vein in *Henry VIII* when Cranmer, having told of Elizabeth's greatness, moves to her successor:

> His honour and the greatness of his name
> Shall be, and make new nations. He shall flourish
> And like a mountain cedar, reach his branches
> To all the plains about him.
>
> (V.iv.51–4)

Implicit within this praise is a specific reference to King James. He created a 'new nation', Great Britain, when he came to the English throne in 1603, as well as presiding – at the time of the first performance of the play – over the external expansion of his kingdom 'to all the plains about him' into North America and Ulster.

In its thematic content, *Cymbeline*'s concentration on marriage is indeed strongly reminiscent of the reunion of the kingdoms of England and Scotland. James's desire to encourage marriages between his subjects and his match-making were well known, particularly when it came to promoting matrimony uniting English and Scottish families at court. Thus he wrote to Sir Hugh Bethell in March 1606 expressing his support for the marriage of Bethell's daughter to the son of Sir William Auchterlony and in 1607 he arranged for the match between James Hay and Honora Denny.[66] One of the new coins he issued in honour of Great Britain bore an inscription from the marriage service – 'Quae Deus conjunxit nemo separet' – while he compared political union to a wedding in his speech to Parliament on 31 March 1607.[67]

The first play to allude to the Union of the Crowns was in fact Heywood and Rowley's *Fortune by Land and Sea*, first performed between 1607 and 1609, at a time when the tide had finally turned against James's Union scheme in Parliament.[68] The play's topicality derives not only from its passionate defence of England's maritime strength against her Spanish enemy but also from its concern with two families, the Hardings and the Forrests. The former are rich, the latter poor; and when Old Harding's son Phillip marries Susan Forrest against his father's will, the old man notes: 'I vow if e'r he match into that family, the Kindred being all begger'd, that forc'd union shall make a firm divorce 'twixt him and mine'.[69] The use of the term 'beggar' in the same breath as the word 'union' is significant as the Scots too were frequently described in such terms. Dudley Carleton informed John Chamberlain that one MP in the 1606 debate on the Union 'came soone after with a bitter word against our neighbours, calling them beggarly Scots, for which he is in danger to be shrewdly hunted' while another claimed that 'the Scots in other countreys were more like pedlars then marchants'.[70] In the play, Old Harding in fact continues to lament Susan's poverty, and it is his main objection to the marriage.[71] Their poverty is, however, revealed to be a recent misfortune, and their heritage is shown to be one of equal dignity and fortune. When Old Forrest and Old Harding meet, the former notes: 'You knew me in my pride and flourishing state, have you forgot me now, as I remember we two were

bred together, Schoole fellows, boorded together in one Masters house, both of one forme and like degree in School'.[72] The idea of two individuals having been in a state of parity in the past, nourished by one institution, is reminiscent of arguments for the two countries of England and Scotland having been one realm in the ancient period.

What seems to have been brushed aside too quickly by those critics who have written on *Cymbeline* is the specific nature of the English nationalism expressed in the raging of Cloten and the Queen in Act III, scene i. Lucius, emissary from Caesar Augustus, has arrived in Britain to request that King Cymbeline continue to pay the tribute to Rome which has lapsed in recent times. When confronted by the request the Queen and Cloten are indignant: 'Britain's a world by itself', says Cloten (III.i.13) and the Queen continues in much the same vein with a use of naval imagery which would doubtless have brought to memory the failure of the Spanish Armada:

> QUEEN:　　　　　　　　　　Remember, sir, my liege,
> The Kings your ancestors, together with
> The natural bravery of your isle, which stands
> As Neptune's park, ribb'd and pal'd in
> With oaks unscaleable and roaring waters,
> With sands that will not bear your enemies' boats,
> But suck them up to th'topmast. A kind of conquest
> Caesar made here, but made not here his brag
> Of 'Came, and saw, and overcame:' with shame
> (The first that ever touch'd him) he was carried
> From off our coast, twice beaten: and his shipping
> (Poor ignorant baubles!) on our terrible seas,
> Like egg-shells mov'd upon their surges, crack'd
> As easily 'gainst our rocks. For joy whereof
> The fam'd Cassibelan, who was once at point
> (O giglot fortune!) to master Caesar's sword,
> Made Lud's town with rejoicing-fires bright,
> And Britons strut with courage.
>
> 　　　　　　　　　　　　　　　　　　　　(III.i.17–34)

Of note is the idea of Britain as 'Neptune's park' (III.i.20) and the bravado of Caesar's failure to overcome the British. Philip Edwards talks of the audience not having 'to jettison its patriotic responses', whilst using in the same sentence the expression 'a gear change' to describe the shift in British nationalism.[73] Given the significance of the new monarch, with the new relevance of the term 'Britain', what occurs within the ideology of the nation at this time is far more significant than a mere gear change. We are observing instead the metamorphosis of the underlying Elizabethan British consciousness into its new Jacobean forms – and the use of the plural is significant. English militant

imperial aspirations to control of Scotland do not go away, but are instead joined by new forms of concern with Britain's imperial rôle, from both Scotland *and* England. Thus, when he describes the Queen and Cloten as 'British and the upholders of *Britain's* integrity', Knight goes too far.[74]

The references to Britain expressed in this exchange between Cloten, the Queen, Cymbeline and Lucius are a direct harking back to the use of the term 'Britain' under Elizabeth. The Armada of 1588 and the continuing naval threat from Spain throughout the 1590s produced the type of staunch English nationalism to be seen in the pages of Spenser's *Faerie Queen* and in parts of Shakespeare's *Henry V*. What Shakespeare does therefore in giving these lines to the Queen and Cloten is to set them up for a fall. True, the Jacobean audience may well have found themselves cheering on some of the patriotic, xenophobic and isolationist sentiment expressed here, but ultimately this vision is thrown down to be replaced with the reunion of the two empires of Britain and Rome, a reconciliation based on mutual respect and trust, and the blessing of the marriage of Posthumus and Imogen which (ultimately) epitomises it.[75] Thus the British, until rescued by Posthumus and the princes, are doing their country little justice in the fight against the invaders.

In response to the type of insular nationalist rhetoric espoused by Cloten and the Queen, Imogen, in marked contrast, has no such illusions about Britain's past glory. She responds to Pisanio's pessimism when he laments, 'If not at court, Then not in Britain must you bide' with the globally aware

> Where then?
> Hath Britain all the sun that shines? Day? Night?
> Are they not but in Britain? I' th'world's volume
> Our Britain seems as of it, but not in't:
> In a great pool, a swan's nest: prithee think
> There's livers out of Britain.

<div align="right">(III.iv.136–42)</div>

Thompson finds this expression puzzling. She notes: 'This slighting reference to her own country is the more remarkable given that the notion of Britain as "a world beyond the world" occurs elsewhere in this text and in other texts of the period as a wholly positive, even sentimental saying'.[76] A useful comparison is a stanza from Giles Fletcher's *Christ's victorie and Triumphs In Heaven* (1610):

> And if great things by smaller may be ghuest,
> So, in the mid'st of Neptunes angrie tide,
> Our Britain Island, like the weedie nest
> Of true Halcyon, on the waves doth ride,
> And softly sayling, skornes the waters pride:
> While all the rest, drown'd on the continent,

And tost in bloodie waves, their wounds lament,
And stand, to see our peace, as struck with wonderment.

<div align="right">(stanza 21)</div>

Thompson fails to accept the important nature of Imogen's remark, as it is this implicit cosmopolitan sentiment which epitomises the leanings of James VI and I towards peace and harmony in both his own domains and in those on the continent. It is this attitude which differentiates between Shakespeare's writing of Britain as an island nation and Fletcher's. Imogen represents the new kind of Briton, one who recognises that if Britain is an island empire, it cannot exist in the real world without reference to the outside world. The British empire exists at its best when placed alongside the Roman.

Cymbeline deliberately reassures the audience that the invasion of the Roman forces in Act IV, scene ii is never a threat to Britain's integrity. Rather, the forces sent by the noble Augustus are there to reunite a lapsed kingdom with the glory of its past. Cymbeline admits that 'Thy Caesar knighted me; my youth I spent Much under him; of him I gathered honour' (III.i.70–71), and the Roman ethos of honour would seem to have been imported to Britain as a result of the past conflicts between the two empires. As Lucius notes, Cassibelan, the British king conquered by the Romans, and Cymbeline's uncle, was not a foe to be scorned, but instead 'Famous in Caesar's praises, no whit less Than in his feats deserving it' (III.i.6–7).

As Emrys Jones indicated, it is significant that the Roman forces land at Milford Haven, familiar to the Jacobean audience as the place where the future Henry VII landed to begin his rebellion against Richard III.[77] Indeed Shakespeare stresses this point by the fact that the Roman army has gone considerably out of its way to do so. Milford Haven in South Wales is not the most direct landing place for an army from Rome, but Imogen is indeed right when she exclaims, 'Accessible is none but Milford way' (III.ii.83). It was thus a site with a special place in English iconography. The fact that the noble Posthumus is among the Roman forces should also make this invasion seem less a threat, but perhaps the most significant factor in piecing this event together in the consciousness of the Jacobean audience is the presence of the Roman commander, and the man who had been the emissary sent to Cymbeline in the first place, Caius Lucius.

Lucius is not the first character to be sent to these shores for the collection of lapsed tribute. Claudius sends Hamlet on a similar errand: 'he shall with speed to England For the demand of our neglected tribute' (III.i.170–71). Lucius therefore follows a noble precedent. In the play, his qualities stand out at every turn. Cymbeline calls him 'A worthy fellow, Albeit he comes on angry purpose now' (II.iii.54–5) and Pisanio terms him 'noble Lucius' (III.iv.174), adding 'he's honorable, And, doubling that, most holy' (III.iv.178–9). Cymbeline then terms him 'noble Lucius' (III.v.12) and four lines later 'the worthy Lucius'.

For an exploration into the significance of the character of Lucius for the Jacobean audience we have one specific source – the notes taken by Simon Forman on a performance of the play, which he probably saw between 20 and 30 April 1611.[78] He writes: 'Remember also the storri of Cymbalin king of England in Lucius tyme, howe Lucius Cam from Octauus Cesar for tribut, and being denied, after sent Lucius with a greate Arme of Souldiars who landed at Milford hauen, and Affter wer vanquished by Cimbalin, and Lucius taken prisoner'. Forman goes on, relating most of the episodes of the plot, though Posthumus is not mentioned by name, and Imogen is mentioned throughout as Innogen, making her name all the more likely associative of the Brut legend. Lucius gets a further mention as being the one who found the lamenting Innogen, but the crucial rôle given to him in this account should be immediately observable.

There is of course the possibility that the actor playing Lucius was a very good one, that the actor stole the show and hence made an impression on the audience, but the fact that Lucius is the name of the first Christian King of England according to Foxe's *Book of Martyrs* would seem to make this character particularly representative of Britain's Christian past.[79] Foxe notes that Lucius was the king 'with whom the faith first began heere in this realme'.[80] The implications of the man's religious significance were not, however, limited to the Elizabethan period. Lucius was an integral part of Jacobean pro-Union discourse. In his *England and Scotlands Happinesse* of 1604 John Gordon wrote that James had restored the true Christian religion

> as it was in the oulde time planted by *Lucius* your fore-runner, the first Christian King of great *Brittayne*, who became so affectionate and zealous of the aduancement and propagation of the trueth, and so great an enemie to Idolatrie and the worship of Creatures and visible formes, that of a King he became a Preacher (as some Histories say) And as during the persecutiõ of the Christians vnder *Dioclesian* and *Maxentius* which were the most bloudie of all, God vsed your Ilands and kingdomes as a refuge for the true Christians which fled from the saide persecutions.

The connection being made between one great learned Christian visionary of the past and one of the present could not be clearer, but Gordon goes on: 'Euen so the same God hath made your most happie raigne to be a safe harbour for the Christians of our age, who haue been forced to abandon houses, goods, and inheritances, rather then to bow to the Romish worship'.[81]

John Russell in his *A Treatise of the Happie and Blissed Unioun* is also emphatic in connecting Lucius to the British present, echoing Gordon practically verbatim:

> The ancienne chronographeris hes observit that about the yeir of God 180 Britanie ues the first place of the uarld quhilk publictlie ressavit the faith of Christ (to the

great honour of this ile): for Lucius, the first King of Great Britanie, prediccessor and forerronner to his Majestie, in thais dayes deposit the preistis of the gentillis, and substitut in thair places bischopis and Christiane pastoris The said Lucius become sua zealous to the propagatioun of the treuth, and great enemie to idolatrie, and uorschip of creatures of visible formes, that of ane king, (as the historie makis mentioun) he become ane preacher: and in the persecutioun of the Christianes undir Diocletiane and Maxentius, maid this kingdom as ane refuge to the afflictit Christianes—as it has bein thir fourtie yeiris bygane in this age, to the lait afflicit Christianes of all our nichtbour countreyis.[82]

The references to Diocletian and Maxentius by both Gordon and Russell are significant since they are the two emperors staged in Rowley's *A Shoo-maker, a Gentleman.* Russell goes on to make a further reference to Constantine as being a similar paragon of the early British Church:

For as undir Lucius, Britanie ues the first pairt that banischit pagane idolatrie, In lyk maner God raysit up of the same Ile Constantine the great, qha expellit the same Romaine idolatrie furth of all the uther provinces of the habitable warld ... the aeternall God hes raysit his Majestie in this age to be the vive image of Lucius and Constantine ... to banisch paganisme and idolatrie furth of this impyir.[83]

Gordon and Russell developed the idea that the Union as personified by James was the work of God, and that opposition to it was consequently opposing the divine plan. They attributed to James and to Britain itself a divine mission to purify all of Christendom. As Galloway and Levack have noted 'Lucius symbolised the religious purity of Britain. Gordon explicitly represents British churchmen like Bede and Wycliff as zealots struggling on behalf of the true religion against Roman tyranny... Effectively, Gordon is trying to do for Britain what Foxe's *Book of Martyrs* did for Elizabethan England: create a belief among the inhabitants that they constituted an Elect Nation, singled out for great deeds and salvation'.[84]

It is thus the character of Lucius in the play which forms the link between the pagan state of Britain under Cymbeline and the Christian, and, more explicitly, Protestant state of Britain under James. If the idea of the British Church being established by Joseph of Arimathea was being abandoned by the late sixteenth and early seventeenth centuries, the idea of Lucius as the earliest Christian ruler in Britain had a longer life, surviving into the nineteenth century.[85] Lucius acts as the iconographic core of the play, a historical beacon guiding its audience towards a sense of greater ease within this setting. Imogen, whose wisdom, fortitude and bravery have been apparent throughout the play, associates with Lucius as his page when, disguised as Fidele, she believes her husband to be dead. Lucius is a figure of nobility, honour and justice. He is a character who seems to have been recognised by Simon Forman – who saw *Cymbeline* in 1611 – as one who was by no means Britain's enemy.[86] As Shakespeare had been careful to render incongruous the invasion

of a French army under Cordelia and her husband the King of France to the rescue of her father Lear, so is this invading army no threat.[87]

Some critics have stressed the topicality of *Cymbeline* by looking for specific parallels between characters in the play and those of the Jacobean court. Most often it is James himself whom the critics have sought to find in the play.[88] As Bergeron notes: 'Shakespeare has a special identification with Leontes, Pericles, Prospero and Henry VIII, and perhaps Cymbeline. Somewhere, at least on the edges of his consciousness, is the link to James, also a father of a similar age'.[89] Wickham muses on how 'James, like Cymbeline, was in a position to refuse or sanction the marriage of his children to the heirs to Europe's crowns'.[90] Jones is more specific: 'It seems to me likely that the character of Cymbeline – at any rate, in the final scene, with its powerful peace-tableau – has a direct reference to James I'.[91] To substantiate this claim he notes that Cymbeline – in Shakespeare's version of history, though not in Holinshed's – has one daughter and two sons, as did James I. After this assertion that James is the model for Cymbeline, however, Jones then has to admit the fundamental weakness of the character of Cymbeline, and in so doing points to the inherent difficulty of this association. He calls Cymbeline's nature 'thoroughly unsatisfactory' and goes on: 'he is largely neutral and passive while the Queen is alive but comes to no harm, for the author officiously protects him from the consequences of his weak nature and ill-judged actions'. Jones is then of course faced with the problem of associating Queen Anne with the evil Queen of the play. Having backed himself into this corner, Jones counters: 'The Queen is made conventionally grotesque after a fairy tale fashion in order to counteract the temptation to find a real-life analogue'.[92] This is wholly unacceptable. The Queen is the same kind of schemer as Lady Macbeth and her lack of development as a character should not allow her to be written off as a mere caricature.

Equally problematic is Leah Marcus's assertion that the appearance of the all-powerful Jupiter in Posthumus' dream shows how 'Jove is clearly to be identified with King James I'.[93] Having made such a claim that '*Cymbeline*'s vision of Jupiter shows forth the royal will "clear" and "without obscuritie"', Marcus then finds herself writing that: 'If King James I made a practice of beating off the subversive proliferation of meaning in order to communicate his "clear" political intent, Shakespeare in *Cymbeline* can be seen as one of those jangling subjects who scatter language and signification, dispersing the king's painstaking crafting of a unified whole nearly as fast as the royal author can put it together'.[94] Her argument would appear to be that Shakespeare is making a very clear unclear association.

Hamilton has gone the furthest yet in this process of identification. Belarius becomes the epitome of the English Catholic subject faced by the Oath of Allegiance published on 25 June 1606.[95] The Queen, Cloten and Iachimo

become 'the play's three Antichrist figures', whilst Imogen becomes the True Church and the Queen is revealed as none other than 'Shakespeare's version of the Whore of Babylon'.[96] Though Hamilton's study fully explores the play within the context of the politics of religion at this time, she makes *Cymbeline* a play *about* religion, rather than one which admittedly appears to have *undertones* of the religious controversies of the day.

The greatest problem inherent in any search for parallels remains that Cymbeline as a character is not a very strong one. What we see of him is the father who brings up a young orphaned Posthumus Leonatus to adulthood at his court, then rages at him when Imogen and he are married, and promptly banishes him. He is absent from the stage for most of the play and he is, furthermore, a man who has made a bad choice in his second wife. She plots to poison him and only at the end of Act V does Cornelius inform Cymbeline that 'she confess'd she never lov'd you: only affected greatness got by you: not you: Married your royalty, was wife to your place: Abhorr'd your person' (V.v.37–40). The king has shown little wisdom in the play, his response to Cornelius' revelation being the feeble 'Who is't can read a woman?' (V.v.48). He has also instigated much heartache for his daughter, sole heir to the British throne following the theft of his two sons, and yet the play bears his name. It would be apposite to ask where is the royal, never mind the 'imperial' ruler in this matter?

There is little case for a personal parallel between James and Cymbeline: the only significant connection between the two lies in the fact that they are both styled as kings of Great Britain. For the reasons cited above, however, most significantly over the identification of the queen in the play and in Queen Anne, the similarity stops there. Cymbeline is due respect, despite his limited appearance on stage and his various failings, because he is the king – as Knight indicates, 'Cymbeline is less a man than a centre of tensions due to his royal office'.[97] Simonds's assertion that 'in *Cymbeline* both the king and his stepson Cloten are portrayed as fools, while the Wild Men in the Welsh mountains show themselves to be more pious, more courageous, and wiser than anyone at court', is counter-productive.[98] Cymbeline is a king who has been deceived by others and who has deceived himself, but he is no fool. His form of blindness to the truth is that of Lear when he believes his daughters will tell him of their love for him from their hearts. In *Cymbeline*, themes relevant to the Jacobean Court are far more significant than most of the characters. Knight is thus correct to assert Imogen's specific centrality in the play. He describes her as 'not merely a single lady, but Britain's soul-integrity'.[99] Marcus too comments how 'Imogen is far too full and complete a character to be reduced to the level of allegory'.[100] The only 'being' in danger therefore of misrepresentation on stage in *Cymbeline* is the state of Britain.

When Imogen and Posthumus meet again in Act V, scene v of the play it is

not to marry, as would be the case in for example, comedies such as *A Midsummer Night's Dream, Twelfth Night* or *Much Ado About Nothing*. The two lovers in *Cymbeline* are already married, their wedding having occurred before the play even begins. The final act of the play brings them back together again, restoring the natural *status quo* of man and wife being together as one. Equally Cymbeline is *reunited* with his errant daughter, with his sons and with Belarius. Most significantly for the purpose of illustrating the imperial motif in the play is of course the return to amity of Britain and Rome, and the re-entry of the former into the latter's imperial sway. To conclude this list of reunions at the close of the play, Imogen's restoration with the brothers she apparently never knew before their abduction is itself a reunion too. She had in fact met them in Wales when disguised as Fidele. Reunion and, with that, *peaceful* reunion is of paramount importance in the play. Cymbeline would be all the more human were he to exact some punishment on Belarius, the man who had, after all, stolen the royal princes, but in this British state, as in that of James VI and I, peace and harmony are paramount political maxims.[101]

'There is no moe such Caesars' (III.i.37), claims a confident Cloten, but the play of *Cymbeline, King of Britaine* proves both how wrong he is and consequently how very much alive is the concept of empire. This British imperium has four young people whose worth has been demonstrated in their separate trials of battle, loyalty and in long-sufferance, while Rome has the greatest Emperor alive; he whose reign would be sanctified by the birth of Christ. The point of *Cymbeline* then, is that there *will* be another Caesar. For James VI and I, Shakespeare's play was a celebration of the British imperium that seemed secure in the figures of Henry, Prince of Wales, Prince Charles and the Princess Elizabeth. As the 'royal play of *Macbeth*' had strongly-defined iconography in the form of, for example, the scene in which are shown a line of Stuart kings stretching out to 'th' crack of doom' (IV.i.132), so too this play shows an imperial past and an imperial future.

CONCLUSION

The first years of James's reign were not bereft of cynicism regarding the notion of a united kingdom, of Scots and English living together in amity. While *Eastward Ho!* is the most frequently cited example of a play touching dangerously on the subject of the Scottish presence in London, it is by no means the only example. John Marston's *The Dutch Courtesan* (1604) pokes fun at James's countrymen, and they are ridiculed in lines from the first quarto of Marston's *The Malcontent* (1603) deleted from subsequent editions.[102] Less well known, however, is the humour at the expense of the Scots within Sharpham's 1607 comedy *The Fleire*, in which the north Britons were the butt of several bawdy jokes.[103] One character observes:

> I did pray oftner when I was an Englishman, but I
> haue not praid often, I must confesse since I was a Brittaine:
> but doost heare *Fleire?* canst tell me if an Englishman were
> in debt, whether a Brittaine must pay it or no?
>
> (II.i.1258–61)

The legal wrangling over the Union was entertaining the Blackfriars clientele, with Sharpham also refering to the pretensions of those who, like Bacon, sought to define themselves as these new Britons. Fleire notes that the first gallant to visit his mistress is 'Maister *Gallant* your Britaine', as opposed, for example, to an Englishman or Scot.[104]

'Gone was the patriotic enthusiasm of the 1590s that produced a *Henry V*', writes Maurice Lee Jr of the Jacobean theatre, but the type of patriotism that produced that play was in the process of being replaced by another.[105] England would never be totally replaced by Britain in the theatre, yet the playwrights could and did make much of the opportunity for entertainment afforded by the interest in Great Britain as a result of the new king's style. As Britain looked to Europe for marriage partners it became clearer than ever before that a firm line would have to be taken if the country were not to become reduced to a political cipher. The idea of a united Protestant Britain was taken up as a political ideal by those who hoped to take the country to war, a direction James himself could not countenance until after he had unwittingly given Gondomar every indication that he would pay the price of peace at all costs.

The project for union may have been 'long dead' by the second half of James's reign in England, but the concept of Britain having an imperial destiny continued unabated throughout these first few years.[106] More specifically, Britain is shown by Shakespeare, Rowley and Fisher to have had a glorious past, and its links with imperial Rome are presented not as ignominious defeat, but as part of an imperial scheme in which Britain adds Roman virtues to her own. For the country looking to 'civilise' the natives of the New World and arguing that these 'savages' were in a similar state to those ancient Britons civilised by the Roman invaders, these plays are powerful testimony to an imperial thinking in the early part of the seventeenth century.[107] Taking the view that Union's demise took the Kingdom of Great Britain with it is, therefore, to ignore vital evidence to the contrary. 'My Lord, I fear, has forgot Britain', says a worried Imogen (I.vii.12–13). She was not the only one with such a concern for the survival of the name.

NOTES

1 *A Speach to both the Houses of Parliament, Delivered in the Great Chamber at White-Hall The last Day of March 1607* (London, 1607). Cited in Charles Howard McIlwain, *The Political Works of James I* (Harvard University Press, 1918), p. 290; p. 299.

2 Joel J. Epstein, 'Francis Bacon and the issue of union, 1603–1608', *Huntington Library Quarterly* XXXIII (1970), 121–32; see esp. 131. Keith M. Brown, *Kingdom or Province? Scotland and the Regal Union, 1603–1715* (London: Macmillan, 1992), p. 86. Jenny Wormald, 'James VI and I: two kings or one?', *History* LXVIII (1983), 207.

3 See, for example, the tracts contained within Bruce R. Galloway and Brian P. Levack (eds), *The Jacobean Union: Six tracts of 1604* (Edinburgh: Scottish Historical Society, 1985).

4 *A Proclamation concerning the Kings Majesties Stile of King of Great Britaine, &c.* [Westminster 20 October 1604], cited in James F. Larkin and Paul L. Hughes (eds), *Stuart Royal Proclamations* vol. I (Oxford: Clarendon Press, 1973), pp. 94–5.

5 *Ibid.*, p. 97. Note also the record in the *Commons Journal*: 'It was said, The King, deliciæ humani generis, desireth no Innovation, but a repetition of an ancient Name' (p. 182).

6 William Harbert, *A Prophesie of Cadwallader* (London, 1604), sig. G4ᵛ. Robert Cummings, 'Drummond's *Forth Feasting*: a panegyric for King James in Scotland', *The Seventeenth Century* II (1987), 12. Jenny Wormald, 'The creation of Britain: multiple kingdoms or core and colonies?', *Transactions of the Royal Historical Society* 11, 6th ser. (1992), 178. For historiography concerning the sixteenth-century rebirth of Britain see Arthur H. Williamson, 'Scotland, Antichrist and the invention of Great Britain' in John Dwyer, Roger A. Mason and Alexander Murdoch (eds), *New Perspectives in the Politics and Culture of Early Modern Scotland* (Edinburgh: John Donald, 1982), pp. 34–58; Arthur H. Williamson, *Scottish National Consciousness in the Age of James VI: The Apocalypse, the Union and the Shaping of Scotland's Public Culture* (Edinburgh: John Donald, 1979).

7 Linda Colley, *Britons. Forging the Nation 1707–1837* (Yale University Press, 1992). See pp. 367–9.

8 Tristan Marshall, 'English public opinion and the 1604 peace treaty with Spain' (forthcoming) and Louis B. Wright, 'Propaganda against James I's 'appeasement' of Spain', *Huntington Library Quarterly* VI (1942–3), 149–72.

9 Albert J. Loomie, 'Toleration and diplomacy. The religious issue in Anglo-Spanish relations 1603–1605', *Transactions of the American Philosophical Society* LIII:6 (1963), 11. On Anglo-Spanish relations see also J. Duncan Mackie, 'James VI and I and peace with Spain, 1604', *Scottish Historical Review* XXIII (1926), 241–9.

10 Galloway, *The Union of England and Scotland*, pp. 120–21.

11 'Camp-Bell, or The Ironmongers Faire Feild. A pageant at the installation of Sir Thomas Campbell in the office of Lord Mayor of London, 29 Oct. 1609' in David M. Bergeron (ed.), *Pageants and entertainments of Anthony Munday* (New York: Garland, 1985).

12 *Ibid.*, p. 148.

13 Jenny Wormald, 'James VI and I, *Basilikon Doron* and *The Trew Law of Free Monarchies*: the Scottish context and the English translation' in Linda Levy Peck (ed.), *The Mental World of the Jacobean Court* (Cambridge University Press, 1991), pp. 36–54.

14 The bishops issued the ban to the master and wardens of the Stationers' Company, prohibiting further publication of certain works and providing for the destruction of extant copies of the named works. Though two of the clauses of the ban were aimed at the theatre – 'That noe Englishe historyes bee printed excepte they bee allowed by somme of her majesties privie Counsell' and 'That noe playes bee printed excepte they bee allowed by suche as have aucthorytie' – there is no evidence that theatre was the

main target. The ban has previously been seen as an attack on works of an obscene nature, but as McCabe shows, it appears more likely that Whitgift and Bancroft were acting as ministers of state, and not as clergy, in seeking to halt the flow of satire as the queen's health declined. See Richard A. McCabe, 'Elizabethan satire and the Bishop's Ban of 1599', *Yearbook of English Studies* XI (1981), 188–93. Maurice Lee Jr., *Great Britain's Solomon: James VI and I in his three kingdoms* (Urbana: University of Illinois Press, 1990), p. 152.

15 George Chapman, *The Conspiracy and Tragedy of Charles Duke of Byron* (London, 1608). The play was of course also notorious for its parallels between Byron and Essex. See Janet Clare, *'Art made tongue-tied by authority'. Elizabethan and Jacobean Dramatic Censorship* (Manchester University Press, 1990), pp. 138–45.

16 E. K. Chambers, *The Elizabethan Stage*, vol. III (Oxford: Clarendon Press, 1923), p. 258.

17 See Clare, *'Art made tongue-tied by authority'*, p. 141.

18 The most comprehensive list of Union tracts is in Galloway and Levack (eds), *The Jacobean Union*. On sermons see Peter E. McCullough, *Sermons at Court. Politics and religion in Elizabethan and Jacobean preaching* (Cambridge University Press, 1998), pp. 101–67.

19 Galloway and Levack (eds), *The Jacobean Union*, p. xli.

20 James VI and I, *Basilikon Doron* in McIlwain, *The Political Works of James I*, p. 37.

21 Craig, *De Unione*, quoted in Galloway, *The Union of England and Scotland*, p. 32.

22 All references to the play are from William Shakespeare, [*The First Quarto of King Lear*], ed. Jay L. Halio (Cambridge University Press, 1994) unless otherwise stated.

23 Margot Heinemann, '"Demystifying the mystery of state": *King Lear* and the world upside down', *Shakespeare Survey* XLIV (1992), 75.

24 Richard Dutton, '*King Lear, The Triumphs of Reunited Britannia* and "The matter of Britain"', *Literature and History* XII (1986), 143.

25 On the idea of *King Lear* as a play complementary to James and the Union project, see Glynne Wickham, 'From tragedy to tragi-comedy: *King Lear* as prologue', *Shakespeare Survey* XXVI (1973), 33–48.

26 Annabel Patterson notes: 'What we know "about" *King Lear*, its "sources", its circumstances of production, its most plausible sociopolitical and cultural contexts, not only fails to resolve its internal ambiguities but actually seems to create new contradictions, to highlight new ambivalences in the text'. See her *Censorship and Interpretation. The Conditions of Writing and Reading in Early Modern England* (University of Wisconsin Press, 1984), p. 59. Numerous theories abound on the content of the play. On suggestions that Lear voices symptoms of James's supposed mental illness, see Margaret Hotine, 'Lear's fit of the mother', *Notes and Queries* CCXXVI (1981), 138–41.

27 Margot Heinemann, 'Demystifying the mystery of state', 83.

28 In this sense *King Lear* was akin to *Gorboduc*, which James and Walker have recently argued was played to urge Elizabeth not only to marry, but to marry Dudley and not the King of Sweden. See Henry James and Greg Walker, 'The politics of *Gorboduc*', *English Historical Review* CX (1995), 109–21; and Marie Axton, *The Queen's Two Bodies. Drama and the Elizabethan Succession* (London: Royal Historical Society, 1977).

29 Raphael Holinshed, *The third Booke of the historie of England* in *The first and second*

volumes of chronicles ... Newlie augmented and continued ... by John Hooker aliàs Vowell gent and others [Historie of England] (London, 1587), p. 21.

30 Anon., *No-body and Some-body. With the true Chronicle Historie of Elydure, who was fortunately three severall times crowned King of England* (London, 1606).

31 *Ibid.*, sig. B3ᵛ. The suggestion of 'strange pleasures' has the implicit sexual connotation, and would not have been lost on those aware of James's homosexuality.

32 *Ibid.*, sig. B2ᵛ; sig. F3; sig. F3ᵛ.

33 *Ibid.*, sig. G2.

34 *Ibid.*, sig. E.

35 *Ibid.*, sig. E3; sig. E4ᵛ.

36 *Ibid.*

37 *Ibid.* See Chapter 1 above for the significance of Troynovant within the British material.

38 *Ibid.*, sig. Eᵛ. Malgo subsequently refers to 'Britaines throne' (sig. E3).

39 Galloway, *The Union of England and Scotland*, p. 164. All references to the play will be to William Shakespeare, *Macbeth*, ed. Nicholas Brooke (Oxford Shakespeare, 1990).

40 Lee Jr., *Great Britain's Solomon*, p. 300.

41 David Norbrook, '*Macbeth* and the politics of historiography' in Kevin Sharpe and Steven N. Zwicker (eds), *Politics of Discourse. The Literature and History of Seventeenth-Century England* (University of California Press, 1987), p. 94.

42 Henry N. Paul, *The Royal Play of Macbeth* (New York: Octagon Books, 1971).

43 Arthur Melville Clark, *Murder Under Trust, or the Topical Macbeth and other Jacobean Matters* (Edinburgh: Scottish Academic Press, 1981), pp. 30–31. Clark's theory that instead of the conventional dating of the play in 1606, we ought to look to 1601, in the immediate aftermath of the Gowrie Conspiracy, challenges fundamentally the way we look at the play. Another scholar came up with the same idea at approximately the same time: see Stanley J. Kozikowski, 'The Gowrie conspiracy against James VI: a new source for Shakespeare's *Macbeth*', *Shakespeare Studies* XIII (1980), 197–212. As Wormald has noted in her review of Clark's book, his theory might not be easy to prove, but it cannot be disproved either. See *English Historical Review* XCIX (1984), 609–10.

44 Norbrook notes: 'Shakespeare presents English aid to a Scottish king in a favourable light but does not bring Edward on stage; consequently Malcolm's exact relationship to him remains ambiguous'. See '*Macbeth* and the politics of historiography', p. 96. The absence of Edward from the stage may well be due to censorship, since the Doctor confirms that he is coming forth at IV.iii.141. See Clare, '*Art made tongue-tied by authority*', p. 137.

45 Quoted in Arthur F. Kinney, 'Scottish history, the union of the crowns and the issue of right rule: the case of Shakespeare's *Macbeth*' in Jean R. Brink and William F. Gentrup (eds), *Renaissance Culture in Context. Theory and Practice* (Aldershot, Hants: Scolar Press, 1993), p. 23.

46 Noted in Paul, *The Royal Play of Macbeth*, pp. 163–4.

47 Kinney, 'Scottish history, the union of the crowns and the issue of right rule', p. 22. He notes (p. 28): 'Whatever *imperialism* comes to mean in *Macbeth*, it is thus clear that the "imperial theme" is the signifying subtext of this very political play and that somewhere

between "the imperial theme" and "an imperial charge" there lies encoded Shakespeare's real purpose in writing his only Scottish play'.

48 Tristan Marshall, '*The Tempest* and the British imperium in 1611', *Historical Journal* XLI (1998), 375–400.

49 Norbrook, '*Macbeth* and the politics of historiography', p. 95.

50 William Warner, *Albion's England* (London, 1589), pp. 101–2; John Speed, *Theatre of the Empire of Great Britain* (London, 1611), p. 384.

51 On the Scottish context Norbrook notes: 'Shakespeare chose to set his play in a period that both sides in the controversy over Scottish history agreed was a key turning point, a crucial moment for the destiny of monarchy' and that 'the opening of the play presents the disorder that was seen in Boece and Buchanan as springing from rejection of the elective system and implies that the real cause is the weakness of the principle of legitimacy. And the strengthening of this principle will require pragmatism as well as piety, cunning tactics in order to procure virtuous long-term ends. James proceeded in his project of strengthening royal authority in precisely this way, and even his theoretical writings acknowledged the need for cunning as well as holiness' (p. 95). While I agree that the play does indeed represent a turning point, to express it solely in Scottish terms and as a matter of Scottish concern ignores the significance of the play for a London audience for whom Scottish politics and history would not have been so familiar. See '*Macbeth* and the politics of historiography', p. 83.

52 William Rowley, *A Shoo-maker, A Gentleman* (London, 1637) in Charles Wharton Stork (ed.), *William Rowley his All's Lost by Lust, and A Shoe-Maker, A Gentleman* (Philadelphia: University of Pennsylvania Press, 1910).

53 The division of Britons into northern and southern subjects was being used in 1615, Fulke Greville referring to an acquaintance as a 'northerne briton' in a letter to Sir John Coke. See Norman Farmer, 'Fulke Greville and Sir John Coke: an exchange of letters on a history lecture and certain Latin verses on Sir Philip Sidney', *Huntington Library Quarterly* XXXIII (1969/70), 218.

54 Rowley's *A Shoo-Maker, A Gentleman* would seem to have given Shakespeare several ideas for his play. Compare, for example, the stage direction in *Shoo-Maker* at III.iv. [Rodericke hath Dioclesian downe: Crispianus fights with Rodericke and rescues him; and beats off Rodericke] with Posthumus' rescue of Cymbeline from the Romans. The sentiment of peace between the British and the Romans at the close of both plays is also markedly similar.

55 Thomas Heywood, *Troia Britanica or great Britaines Troy* (London, 1609), p. 415, p. 416, p. 418, p. 423. The poem concludes 'where he [James] begins I make my pause, and onely pray that he may still supply Great *Brittaines* Empyre with the Lands applause' (p. 446).

56 Leeds Barroll, *Politics, Plague, and Shakespeare's Theater* (Cornell University Press, 1991), p. 205. All references to the play will be from William Shakespeare, *Cymbeline*, ed. J. M. Nosworthy (London: Arden Shakespeare, 1986).

57 Yoshiko Kawachi, *Calendar of English Renaissance Drama 1558–1642* (New York: Garland Press, 1986).

58 David Bergeron, *Shakespeare's Romances and the Royal Family* (Lawrence: University Press of Kansas, 1985), p. 181.

59 'I beseech you sir, Harm not yourself with your vexation, I am senseless of your wrath' (I.ii.64–7).

60 Ann Thompson, 'Person and office: the case of Imogen, Princess of Britain' in Vincent Newey and Ann Thompson (eds), *Literature and Nationalism* (Liverpool University Press, 1991), pp. 76–87.

61 For his production of *Cymbeline* at the National Theatre in 1988 Peter Hall chose to restore the name 'Innogen'. See Roger Warren, *Staging Shakespeare's Late Plays* (Oxford: Clarendon Press, 1990).

62 Peggy Munoz Simonds, *Myth, Emblem and Music in Shakespeare's Cymbeline. An iconographic reconstruction* (Newark: University of Delaware Press, 1992), p. 227.

63 Simonds cites Isaiah 40:31: 'But they that wait upon the Lord shall renew their strength; they shall mount up with wings as eagles'. *Ibid.*, p. 224. On the significance of the phoenix as an imperial image, see Chapter 1 above.

64 Thomas Campion, *Lord Hay's Masque* in Stephen Orgel and Roy Strong (eds), *Inigo Jones and the Theatre of the Stuart Court*, vol. I (Berkeley and London: University of California Press, 1973). Note that in an epigram to the masque, Campion hails James as he who would fulfil the prophecy that Arthur would return to 'wield great Britain's state More powerful tenfold and more fortunate'. The reference to *Love freed from Ignorance and Folly* is also from Orgel and Strong, *Inigo Jones and the Theatre of the Stuart Court*.

65 The other two occasions are at V.iv.140–41 and V.v.439, when the 'stately cedar' is referred to. The cedar is also referred to in *2 Henry VI* (V.i.205), *3 Henry VI* (V.ii.11), *Coriolanus* (V.iii.60) and *Henry VIII* (V.v.54).

66 Levack, *The Formation of the British State*, pp. 186–7.

67 Johann P. Sommerville (ed.), *James VI and I. Political Writings* (Cambridge University Press, 1994), p. 163.

68 Thomas Heywood and William Rowley, *Fortune by Land and Sea* (London, 1655).

69 *Ibid.*, p. 9.

70 David Harris Willson (ed.), *The Parliamentary Diary of Robert Bowyer 1606–1607* (New York: Octagon, 1971), pp. 203–4n, p. 208n.

71 Heywood and Rowley, *Fortune by Land and Sea*, p. 10. Old Harding calls Susan 'a beggar' (p. 11) and 'the beggars brat' (p. 24).

72 *Ibid.*, p. 25.

73 Philip Edwards, *Threshold of a Nation: A Study in English and Irish Drama* (Cambridge University Press, 1979), p. 93.

74 Knight, *The Crown of Life*, p. 137.

75 See also Jodi Mikalachki, 'The Masculine Romance of Roman Britain: *Cymbeline* and Early Modern English Nationalism' *Shakespeare Quarterly* XLVI:3 (1995), 301–22. Mikalachki has written of the Queen as articulating 'British nationalism and patriotism' (303) while then seamlessly introducing the specific *English* nationalism of the play as if it refers to the same thing (304). Most disturbingly she begins her discussion on sixteenth-century thinking on the nation but then proceeds to use a seventeenth-century play (302).

76 Ann Thompson, 'Person and office', p. 80. Giles Fletcher, *Christ's victorie and Triumphs*

In Heaven, and Earth, over and after Death (London, 1610). Cited in Bernard Harris, '"What's past is prologue"', p. 218.

77 Emrys Jones, 'Stuart *Cymbeline*', *Essays in Criticism* XI (1961), 93–5.

78 Dating according to E. K. Chambers, *William Shakespeare. A Study of Facts and Problems*, vol. II (Oxford: Clarendon Press, 1988), pp. 338–9. The *Cymbeline* entry forms part of Forman's *Booke of Plaies* (Bodl. Ashm. MS 208, fos 200–213).

79 In her *Shakespeare and the Politics of Protestant England* (New York: Harvester Wheatsheaf, 1992), Donna Hamilton touches briefly on the significance of the figure of Lucius in the Protestant mind at pp. 151–2.

80 *Ibid.*, p. 151.

81 John Gordon, *England and Scotlands Happinesse* (London, 1604), p. 23. See also Frank Brownlow, 'George Herbert's "The British Church" and the idea of a national church' in Newey and Thompson (eds), *Literature and Nationalism*, pp. 111–19.

82 In Galloway and Levack (eds), *The Jacobean Union*, pp. 79–80.

83 *Ibid.*, p. 80.

84 *Ibid.*, p. xxx. They go on to note (p. xxxvii) that 'George Saltern tried to establish a common, antique origin of the laws of both kingdoms in the law of God, which the British King Lucius had adopted, but his proposal had little practical value'. In his *Politics and Ideology in England 1603–1640* (London: Longman, 1986) Johann Sommerville derides the strength of the lobby which backed the idea of a legislative inheritance from ancient British days, calling Saltern an 'ignorant populariser' (p. 91).

85 See G. Williams, 'Some Protestant views of early British church history' in G. Williams, *Welsh Reformation Essays* (Cardiff: University of Wales Press, 1967), pp. 207–19.

86 The character of Lucius continues to play a role in the national mythology. Delariviere Manley's 1717 play *Lucius, The First Christian King of Britain. A Tragedy* (Los Angeles: University of California, 1989) illustrates that the character was certainly known to her audience. In their introduction to the above edition, Jack M. Armistead and Debbie K. Davis note the unifying 'British' context of the play (p. viii).

87 For a discussion of the ramifications of this event see Taylor, 'The war in King Lear', pp. 27–34.

88 Simonds moves onto decidedly shaky ground on this issue. In a discussion of the mythological references in the play she claims: 'the myth of Philomela could thus suggest the presence in *Cymbeline* of a veiled political criticism not only of the player king, overtly called a tyrant by his daughter, but also of the real King James I, who might be tempted to rape his recently acquired English kingdom' (*Myth, Emblem and Music*, p. 75).

89 Bergeron, *Shakespeare's Romances and the Royal Family*, p. 9.

90 Glynne Wickham, 'Riddle and emblem: a study in the dramatic structure of *Cymbeline*' in John Carey (ed.), *English Renaissance Studies Presented to Dame Helen Gardner* (Oxford: Clarendon Press, 1980), p. 100.

91 Jones, 'Stuart *Cymbeline*', 96.

92 *Ibid.*, 97.

93 Leah S. Marcus, '*Cymbeline* and the unease of topicality' in Heather Dubrow and Richard Strier (eds), *The Historical Renaissance* (Chicago, 1988), p. 135.

94 *Ibid.*, p. 155.

95 Hamilton, *Shakespeare and the Politics of Protestant England*, p. 130.

96 *Ibid.*, p. 138, p. 141.

97 Knight, *The Crown of Life*, p. 130.

98 Simonds, *Myth, Emblem and Music in Shakespeare's Cymbeline*, p. 50.

99 Knight, *The Crown of Life*, p. 148.

100 Marcus, '*Cymbeline* and the unease of topicality', p. 145.

101 There is a case for seeing in some of Shakespeare's last plays a distinctive overlord figure, a ruler never given the power of an emperor, but one who nonetheless seems to have a far greater control over others than the rulers of Shakespeare's previous plays. Jove watches over Imogen and Posthumus just as Prospero watches over the destinies of not only the 'three men of sin' (*The Tempest* III.iii.53), but indeed of all the inhabitants of his island; and a confidently powerful Henry VIII muses "Tis well there's one above 'em yet' (*Henry VIII*, V.ii.26) as, like some angel of justice, he watches his ministers from a balcony as they mistreat the humble Cranmer.

102 See Albert H. Tricomi, *Anticourt Drama in England 1603–1642* (University Press of Virginia, 1989), p. 44. In Marston's play Beancha asks, 'And is not sinnior S *Andrew* a gallant fellow now', to which Maquerelle replies 'By my maiden-head la, honour and he agrees as well together as a satten sute and wollen stockings'. John Marston, *The Malcontent* (London, 1604) (Aldershot, Hants: Scolar Press Facsimile, 1970), sigs. I–Iᵛ. For the mockery of the Scots in *Eastward Ho* see Joseph Quincy Adams, '*Eastward Hoe* and its satire against the Scots', *Studies in Philology* XXVIII (1931), 689–701.

103 Edward Sharpham, *The Fleire* (London, 1607) ed. Hunold Nibbe (Louvain, 1912), II.i.166–9 and III.i.171–7.

104 *Ibid.*, III.i.339. On Bacon's contribution to the Union debate see Joel J. Epstein, 'Francis Bacon and the issue of union, 1603–1608', *Huntington Library Quarterly* XXXIII (1970), 121–32.

105 Lee, *Great Britain's Solomon*, p. 152.

106 Wormald, 'James VI and I: two kings or one?', 207.

107 See Marshall, '*The Tempest* and the British imperium in 1611'. John White's drawings of native Americans, published in Hariot's *A brief and true report* (1588), had included a series of pictures of Picts; and White had also drawn ancient Britons whose dress and poise were markedly similar to the Americans'. The idea was that the natives were in a state of civilisation akin to that of the Britons before the arrival of the Romans. See Thomas Hariot, *A brief and true report of the new found land of Virginia* (London, 1588). Paul Hulton notes the likelihood that the pictures of the Picts were taken from the work of Jacques Le Moyne, not John White; 'Images of the new world: Jacques Le Moyne de Morgues and John White' in K. R. Andrews, N. P. Canny and P. E. H. Hair (eds), *The Westward Enterprise: English activities in Ireland, the Atlantic, and America 1480–1650* (Liverpool University Press, 1978), p. 211.

Chapter 3

1611–13
'The true Panthæon of Great Britaine'

Voicy L'Alexandre de la grande Bretaigne ... Le voicy les armes à la main, face et pointe tournées ver L'ennemy de Dieu ...[1]

The role played by James's eldest son, Prince Henry, in the inculcation of an imperial mentality was critical. The period from 1611 to 1613 saw the apotheoses of theatrical material relating to the new Britain, coinciding as it did with Henry's investiture as Prince of Wales and the marriage of the Princess Elizabeth to the Elector Palatine. These years also witnessed the accretion of imperial notions of expansionism and martialism; and if the Union period had established interest in a reunited kingdom, the following years saw public support for an expanded and extroverted monarchy reach dizzying heights, before the death of Henry and the departure of his sister brought popular enthusiasm for an interventionist Britishness down to earth.

Before his death at the age of eighteen on 6 November 1612, Henry Stuart had developed keen interests in chivalric martialism and overseas expansion, as well as advancing Protestant ideals that left behind his father and the *via media* of the Hampton Court conference. His closest friends included former members of the Elizabethan war party and he was receptive to calls for an investment of resources in war with Spain, wider military commitments abroad and an extended naval assault on the Spanish empire.[2] When Mervyn James wrote that 'Sidney's synthesis of honour, humanism and religion was to find its closest parallel in the official Stuart court ideology of heroic kingship, courtly love and Platonic idealism', he referred to the wrong court. It is Henry's circle which provides the nearest example of a Sidneian renaissance in Jacobean London.[3]

Critically, the prince's schemes were not the preserve of a few, the machinations of a small band of religious extremists. The 'myth of the conqueror' has been expounded in detail by Jerry Williamson, though he finds it 'paradoxical that those left-wing religious forces in England, which generally

87

favoured the republican inclinations of Parliament against the prerogative of monarchs, should construct an image of a prince who was, by the working of his myth, illimitable'.[4] Williamson is not alone in making Henry the victim of others, a passive figurehead. The idea that Henry was the victim of a party, of a religious faction in England, is to play down the strength of anti-Habsburg sentiment in England, especially in the aftermath of the signing of the 1604 Treaty of London.[5] In looking at the plays performed during the greatest period of the prince's public life, this chapter will suggest that Henry himself played a far more controlling role than has hitherto been appreciated, and that the militant ideas he espoused were derived less from the minds of a few than from the wider spectrum of imperial visions and aspirations of the British peoples.[6] The personal opinions of the prince may remain clouded by the fact that practically none of the evidence used in reconstructing this imperial agenda comes from his mouth. Yet what emerges from a study of all the evidence that is available to us is the sense that he was indeed intensely interested not only in his personal military and colonial schemes but, importantly, in the encouragement of theatre as a medium. He paid for the Cockpit at court to be converted for playing in 1611.[7]

IMPERIAL IDEOLOGY

While his father showed a single-minded addiction to pacifism, Henry was constantly being urged to ensure that a strong united Britain be used as a weapon overseas. Nicholas Morgan wrote of 'your victorious resolutio[n] against hostile inuasions ... the maintenance of that whereby all your Hereditary Kingdomes must be walled and enlarged' while the dedicatory epistle of George More's *Principles for yong Princes* concluded by asking 'God to blesse your Highnes with all vertue and perfection fitting for a Prince, wherby your renowne and honour may bee increased, and your Empire enlarged'.[8] This and other literature surrounding Henry reveals an implicitly imperial vision of both internal unity within the kingdoms of England and Scotland, and the stretching out of the British mantle to cover the new colonies in Ulster and Virginia. The anonymous writer of *Propositions of War and Peace delivered to His Highness prince Henry by some of his Military servants* believed that it was the unity of imperium which gave Britain a new military strength: 'The facility to effect this [war] being now more than ever by the addition of strength, and subtraction of diversions, in this happy union of the Britain Empire'.[9]

Henry had received martial eulogy from a tender age, Andrew Melville looking forward to the day when 'having laid low proud Spain, bright from your triumph over anointed Geryon, you trample under foot the triple diadem of the Cerberus of Rome, who duplicates the din of Hell with fearsome thunderings from the Capitoline crag'.[10] By July 1604 James had given the

prince St James's Palace as a residence, and those within it were singing its praises: 'I recommend in particular the *Academie* of our Noble Prince, where young Nobles may learne the first elements to be a *privie Counseller*, a *Generall* of an Armie, to rule in peace, & to commande in warre' effused James Cleland, the less than impartial tutor to the prince; yet Henry's court was one to which all those who looked for the future glory of Britain free from what they saw as immodest excess could turn for inspiration. Cleland's opinions about the educational nature of the court were more specific: 'Here is the true *Panthæon* of Great Britaine, where Vertue her selfe dwelleth by patterne, by practise, by encouragement, admonitions, & precepts of the most rare persons in Vertue and Learning that can be found'.[11]

Members of this pantheon and supporters of the militant line around the prince included Sir William Alexander, later Earl of Stirling, who was granted Nova Scotia by Charles I.[12] Also within the household was Sir Philip Carey, later to be a member of the Virginia Company, and an addition of 1611 was the poet Sir Arthur Gorges, whose mother was Raleigh's first cousin and a man who had gone on the Azores expedition in 1597, and wrote an account of it for the prince in 1607.[13] Gorges's prose works indeed bear signs of Raleigh's involvement. These included *Observations and Overtures concerning a Royall Navye and Seaservice* and *A Breefe Discourse tendinge to the wealth, and strength of ... Great Brittayne*.[14] Other kindred spirits included Robert Devereux, 3rd Earl of Essex, and John Harrington, 2nd Baron Harrington of Exton, whom Henry referred to as 'mon petit chevalier'.[15] Among the older group of friends with whom Henry increasingly associated the martial connection ran strongly. Edward Cecil, later 1st Earl of Exeter, was sent in command of 4000 troops to aid the States-General of the Dutch Republic over the Cleves-Jülich crisis in April 1610 and took part in the siege of Julich in July. As well as being an accomplished soldier, Henry Wriothesley, 3rd Earl of Southampton, concerned himself with colonial enterprise at the same time as Henry during the period 1609–12.[16] But he was also the head of a group with an emphatically patriotic reputation in 1604–10, Sir Julius Caesar, MP describing them as being 'held amongst the common people the best patriots ... ever'. The Earl of Southampton may well have been far more representative of popular opinion than has hitherto been accepted, and representative of that group of MPs which James said had combined 'for the protection of all extravagant humours and conceipts among the people'.[17] Perhaps the most important member of the circle was, however, Raleigh. Though imprisoned, he stood as an icon of all that was possible for the prince, and wrote 'discourses of a maritimal voyage, and the passages and incidents therein' for Henry's benefit. His *History of the World* was also both dedicated to and inspired by the prince.[18]

Henry as the Protestant crusader against Rome and its allies was a most

popular imperial conceit from the onset, though it should be noted that Henry made a distinction between Catholics and Catholicism. Dr John Hawkins noted that the Prince 'would now and then use Papists very kindly, Shewing that he hated not their persons but their opinions'.[19] Those around Henry were adamant, however, that the prince should prepare for war. William Willymat expressed the hope that Henry would live 'to the terror of all your, and our forreigne enemies, and home-borne conspirators' but by far the most belligerent writer was William Alexander. A Scot who would later write in support of the Virginia plantation, Alexander was not just writing what the Prince wanted to hear. He genuinely believed in the benefits to be accrued from an expansionist Britain, writing that 'this united yle should once aduance, And, by the Lyon led, all Realmes o'er-come'.[20] His was a view of peace through strength, though with definitive ideas of exporting peace over-seas: 'In peace prepare for warre, in warre for peace: For as all feare a Prince who dare attempt, The want of courage brings one in contempt ... Then let us ... spend our fury in some forraine place: There is no wall can limit now our bounds'.[21] The ultimate picture he presents is thus world domination:

> Methinkes I see all the earth glance with our Armes, And groning Neptune charg'd with many a sayle; I heare the thundring Trumpet sound th'alarmes, Whilst all the neighbouring Nations doe looke pale, Such sudden feare each panting heart disarmes, To see those martiall mindes together gone, The Lyon and the Leopard in one.[22]

If Alexander's was the most explicit call to arms there were other writers who shared at least a measure of his enthusiasm. Philip de Mornay expressed the hope 'that I may liue to march ouer the Alpes, and to trayle a pike before the walls of Rome, under your Highnesse Standard' as well as offering his text, *The mysterie of Iniquitie*, 'till my sword may doe you service'.[23] Cleland wrote a treatise which urged Henry to cross the Alps and lead the final war against Rome, and George Marcelline too was emphatic: 'As one of yours, you shall finde me readier to lay hand on my sword for you, then on my pen, and would rather spend my blood then mine Inke, for your honour and seruice, in al, and by all, *My young CAESAR, and great ALEXANDER*'.[24] The anonymous author of *The French Herald* believed that the war had begun already: 'To horse, to horse, the quarter is broken, the bloody Trumpet hath sounded; true & mortall warre is open'.[25] With these sentiments in mind, Edmond Richer added fuel to the fire:

> I conclude still with the French Herald to a generall Croisade against him that is now become the great enemy of Christendome ... Up then, up, braue Prince; the eyes of Christendome are now cast upon you, to see you beginne; you shall not want friends and followers, even more then you thinke, even more then perhaps you looke for. Those that now dare not shew their heads for want of a Generall, will

mount upon the tallest coursers they can finde to shew their whole body, and draw with more hast to bee nearest to you.[26]

He then urged the Prince not to waste time: 'To the sword then, to the sword, I durst almost say even at this instant'.[27]

From the pulpit William Crashaw urged Henry to 'go forward, Princely Solomon ... [and] give the Whore of Babylon that foil and fall from which she shall never rise, even that deadly blow whereof she shall never recover'.[28] Even Ben Jonson, in an uncharacteristic foray into eulogy, wrote as a parting word to the prince in his entertainment at Althorp:

> And when slow Time hath made you fit for warre,
> Looke ouer the strict Ocean, and thinke where
> You may but lead vs forth, that grow vp here
> Against a day, when our officious swords
> Shall speake our action better then our words.[29]

Among Peacham's devices in his *Minerva Britanna*, Henry is urged to greatness:

> That whether TURKE, SPAINE, FRAVNCE, or ITALIE,
> The RED-SHANKE, or the IRISH Rebell bold,
> Shall rouse thee vp, thy Trophees may be more,
> Then all the HENRIES ever liu'd before.[30]

Within the context of the crusader for the cause of religion, Henry was frequently accorded the title of Caesar. It was used as such by Alexander, who wrote 'There be many Cesars within thee'.[31] Marcelline addresses the Prince:

> Yours shall bee the arme and strength, but his the head and Counsel; Yours the paine and endeauour, his the effect ... to the end, that al the world may see you in effect after the same manner, as one figured Caesar, aloft, deposing or treading a Globe vnder him, holding a book in one hand, and a sword in the other: so that it may be saide of you, *That for the one & other you are a* Caesar.[32]

The Jacobean revival of chivalry united a body of minds behind the prince. As John Adamson noted, from the perspective of men like William Gouge, Thomas Scott and Samuel Ward in the 1620s and 1630s, 'to be chivalric was to be generally anti-Habsburg, anti-Spanish, and of course anti-Catholic. In the specific context of English political debate during the first decade of the Thirty Years War, to be "chivalric" was to be associated with support for English military intervention against the Catholic forces of the Empire'.[33] While such intervention would have been of prime concern to the Prince had he lived to see the events in Europe in the years after his death, when alive he – like many around him – very much lived up to that 'chivalric' definition. The popularity of martialism is revealed not only in the plays discussed below but in daily life too. Howes records that on 30 June 1610

the ancient use of the Artillery Garden, fallen into disuse since 1588, has been revived this present year through the exertions of divers citizens and gentlemen of the City of London; and here is held a weekly exercise of arms and military discipline after the modern and best instruction. Further they have erected a strong and well-furnished armoury with arms of several sorts and excellent goodness.[34]

Henry needed little encouragement when it came to naval matters.[35] Wilks's assertion that 'The *Prince Royal* was conceived in part to entice the prince to patronise the navy faction, and in this it succeeded' fails to provide any evidence that it was so intended.[36] In the rush to find conspiracy, there is a danger that the obvious might be overlooked: Henry saw in the navy the means to act out his plans for British expansion. In this too he had the backing of many writers; he was urged by Chapman in his *De Guiana, Carmen Epicum* to 'let thy sovereign Empire be increased And with Iberian Neptune part the stake'.[37] The urge for naval conflict was in fact one of Henry's major military pre-occupations and was a fundamental part of his imperial vision. Michael Drayton was emphatic in the dedication to Henry of *Poly-Olbion*:

> He like great Neptune on three Seas shall roue,
> And rule three Realms, with triple power, like Ioue;
> Thus in soft Peace, thus in tempestuous Warres
> Till from his foote, his Fame shall strike the starres.[38]

Henry quickly immersed himself in the politics of the navy and 'to advance the Affairs of the Navy, to his Power, now and then got Leave of his Majesty to go in Person to view the Ships, and Store-Houses, which divers Time he did'.[39] He had taken shipbuilder Phineas Pett under his wing, after Pett built him the ship which Henry later christened the *Disdain* (on 22 March 1604), and from Pett's biography we gain a picture of a prince with specific plans for what he saw as *his* navy. According to Pett, Henry summoned all the royal shipwrights to Greenwich in January 1612 'about a resolution of building ships in Ireland'.[40] The mystique surrounding the navy gave rise to the sentiments of religious mission in the process of colonising savage lands to the Christian faith. A strong navy would be the spearhead of Henry's Protestant forces, seeking to bring the reformed religion and British culture to the New World.[41]

Henry was to be frustrated in his desire to have the post of Lord High Admiral in the years following the acquisition of the *Prince Royal*. Charles Howard, Earl of Nottingham, had held the office from 1588, though King James himself was to be the major opposition. Venetian ambassador Antonio Foscarini wrote on 21 October 1611:

> The Prince ... aspires to the post of Lord High Admiral, and has managed so cleverly with the King that he has got his word for it, in spite of the fact that the King designed to make the Duke of York Admiral. A gentleman in the confidence of the Prince told me that in the time of the late Queen the post of Admiral was worth one

hundred and fifty thousand crowns a year ... In time of war it is undoubtedly the greatest post in the kingdom. The Prince with his diligence and authority will regulate many abuses which the present Admiral, who is decrepit, can hardly do. [42]

Henry seems to have gone into action with a vengeance: Domestic State Papers reveal a scheme for timber acquisition across nine counties, and there is also evidence that it was sought from as far away as the Munster plantation. A letter from the Earl of Pembroke to Salisbury dated 13 December 1611 noted that James had approved the project put forward by Henry for the reformation of the navy, and expressed his wish that the prince should be present when the Council discussed the matter.[43] Thanks to Foscarini, we know it was Henry who was setting the agenda: 'The Prince in Council has dealt with the reform of the Navy and proposed some new orders on which he has several times spoken at length'.[44] This was not the end of Henry's naval changes, as the opportunity arose at the beginning of 1612 to pardon a large number of pirates: 'The Prince has lent his authority to this scheme as he wishes to see the mariners of this Kingdom augmented by those who are now buccaneering and whose number is put down at three thousand men'.[45] This is an interesting development in the light of what happens to the pirates Purser and Clinton in V.i of Heywood and Rowley's *Fortune by Land and Sea*. Taken off to execution, they lament the fact that Britain will lack their expertise to defend her in times of war.[46]

An outlet was needed for Henry's enthusiasm for chivalric Protestantism and naval reform. The most apparent object of all this activity was Virginia. Drayton saw the colony as being a heroic venture, his ode to the expedition addressing colonisers as

> You brave Heroique Minds,
> Worthy your countries Name;
> That Honour still pursue,
> Goe, and subdue,
> Whilst loyt'ring Hinds
> Lurke here at home, with shame. [47]

While there were many who expressed a hope that the Virginia colony would be undertaken by the prince in order that the gospel might be spread among the heathen natives, Henry's personal interest lay in the challenge which it afforded to Spanish dominion in the New World.[48] Correr believed that Henry's interest was a proprietary one and indeed, given the prince's jealous regard for the navy, it is plausible that he sought to make Virginia part of his political domain. However, it is more likely that the establishment of an English military presence in the New World and the opportunities it gave for attacks on Spanish shipping were the overriding concerns for the prince.[49] Raleigh certainly believed that the Spanish could easily be removed from the

New World, and that they were 'subject to invasion, expulsion, and destruction; so as ... an easy force will cast them out'.[50]

Perhaps indicative of the military preoccupation Henry had with the Virginia colony is the fact that he sent over Robert Tindall, later to become his gunner in 1610, to report on the land, and Tindall duly sent back a sketch of the James River and a journal. Henry invested in the Virginia Company, becoming a shareholder and was given the title 'Patron of the Virginia Plantation'.[51] Other ties between him and the colony included the Governor Sir Thomas Dale, a former servant of his, who served first as marshal in the colony from 1609 under De la Warre before assuming the governorship in 1611.[52] The importance of the association between Prince and colony was also reflected in a plethora of early place names: Cape Henry, Fort Henry, Henricopolis and Henrico College.[53]

Virginia, however, was not the only imperial scheme Henry had on his mind. The Northwest Passage Company was given its charter – with Henry as its 'Supreme Protector' – following the death of Henry Hudson on his fourth voyage to find the elusive channel. Before dying, Hudson added to the list of geographical landmarks bearing Henry's name, with Prince Henry's Foreland, one of the capes in Hudson's Straits. In granting the charter King James wrote: 'It shalbe countenaunced by or most deare and welbeloved sonne, *Henry, Prince of Wales*: KNOWE yee that wee doe first of all constitute and ordaine that or said deare sonne ... shalbe ... called Supreme Protector of the said Discovery and Company'.[54]

Henry tried to move the naval refit ever further along, Foscarini reporting in a letter dated 31 December 1611 that the prince had proposed in the Council that eight galleons should be fitted out. He went on to elaborate on the prince's plans:

> The Prince as patron of the North-West passage intends to send out four ships to explore. Hopes are very high, and it is thought it will be a blow to Spain. There are those who tell the Prince of the discovery of a continent much more handy and much richer than Virginia. The Prince listens graciously and guides all his actions towards lofty aims.[55]

In 1610 Henry had urged Sir Thomas Roe, later to distinguish himself as an ambassador of trade and commerce at the Court of the Great Mogul, to go to South America in search of gold and places for colonisation. During 1610–11 Roe travelled 300 miles up the Amazon River and decided that the territory offered alluring prospects for colonisation. To hold the country for England he left a forlorn group of twenty men at the mouth of the Amazon.[56]

But these were minor projects when compared with what seems to have been Henry's most covert imperial scheme. Published in 1641, Cornwallis's *A Discourse of the most Illustrious Prince, HENRY* has some interesting revelations

about what may have been part of the Prince's wider vision regarding harassment of Spain:

> To publish particulars agrees not with the rules of State, but two especiall thinges being propounded, which were the preparation of a Navy, consisting of a certaine number of Ships to bee sent into the West Indies, and another to prohibit all entry or issue of Ship's either into or out of the same ... Hee openly protested to such as were present, that should the King his Father bee pleased upon any future occasion to breake with Spaine, himselfe ... would in person become the executor of that Noble attempt for the West Indies.[57]

Henry probably knew well enough that a war against Spain in Europe was not feasible. It was in the West Indies that a safer and more lucrative blow could be struck against the Habsburgs, and aside from any purely financial motivation there was the religious consideration that such attacks could weaken Catholicism in Europe through the loss of revenue.

Explicitly imperial motifs involving Henry occur in print mainly after his death, though the Arthurian myth was proudly used early in his lifetime. One of the prince's tutors, Walter Quin, expressed the hope in 1600 that Henry would be the heir to Arthur: 'Ille tibi ARTHVRI sceptrum, cum sede, parabit' [Arthur's sceptre, with his throne, shall be prepared for you]. On Henry's arrival in England, John Davies urged him to come to Wales, with the promise that 'Caerleon, where king *Arthure* liu'd of yore, Shall be rebuilt, and double gilt once more'.[58]

The wide-ranging set of interests espoused by Henry combined to create a culture alien to that of the king's court. While theatrical interest in the re-creation of Britain had hitherto centred around notions of unity and expansion palatable to James, from about 1611 the tenor of Britishness on the stages would undergo a profound change in direction. The first play to consider colonial expansion did so by illustrating how peace – James's priority – could be brought about through increased power and resources. It was a compromise position in that it gave its public audience a glimpse of the mysteries and excitement of acquiring strange new lands – Henry's interest – while remaining firmly fixed within a familiar Jacobean world.

THE TEMPEST

Concerns with an American setting have led to a great deal of confusion regarding Shakespeare's play about a special island realm.[59] As critics have looked to locate Prospero's domain elsewhere, the strength of the ideological conceit of Britain as an island nation has been overlooked. A 1587 English translation of Solinus's *Polyhistor* described how 'The Sea coast of Gallia had beene the end of the worlde, but that the Ile of Brytaine for the largenesse

thereof every way, deserveth the name almost of an other Worlde'. Publius Virgil too had Britain as 'wholly sundred from all the world', and 'in the ends of the earth'.[60] Indeed, the conceit makes its entry onto the stage during Elizabeth's reign in Act II, scene i of Greene's *Friar Bacon and Friar Bungay* (*c.*1587): 'Welcome, my lords, welcome, brave western kings, To England's shore, whose promontory-cleeves Show Albion is another little world'. By the beginning of James's reign the conceit had lost none of its force. William Harbert, in *A Prophesie of Cadwallader* (1604) noted how 'Cesar was twice repulst ere he could see This litle world from all the world remote'.[61] Part of Britain's semi-mythical history centred specifically around the nature of Britain as an island world by destiny placed apart from the rest of the earth, and thus perhaps singled out for a special role in history.

The references to this ancient conceit abound, Horace speaking of Britain as *in ultimos orbis*: 'in the ends of the earth'. Solinus had claimed that on the northernmost tip of Scotland was 'an altar engraven with Greeke letters for a vowe' which 'beareth witnes that Ulysses arrived at Calydon'. This linked Britain and Ogygia (the island of Ulysses and Calypso) with the Fortunate Isles.[62] If we also consider Selden's notes to Drayton's *Poly-Olbion* regarding the idea of Saturn's island, and Homer's placing of the Elysian Fields at the 'utmost ends of the earth', then indeed, as Bennett notes, 'by this series of associations, the geographical "otherworld" of Britain becomes identified with the mythological Otherworld, the land of spirits'.[63] If all this seems too fanciful, we need to remind ourselves that we are investigating a play first performed in 1611 about an island separated from the rest of the Renaissance world, ruled by a magus whose servants include two extremely 'otherworldly' beings. What we are seeing in *The Tempest* is a stage representation of this particular ideological conceit of Britain as a distinct island kingdom replete with a past steeped in ancient history.

As such the play represents an important extension of the British myth extant in plays such as *Cymbeline* and *A Shoe-maker, a Gentleman*. Here *The Tempest* illustrates the thinking by which the Jacobean audience pictured their country as having a great and glorious past, but a past which emphasised Britain's separate history. *The Tempest*'s island is, like Britain, a place unlike any other, a space by no means perfect, but one which has a magical, mythical identity and whose corruptions come about as a result of intrusion from overseas. If the Armada expedition of 1588 had reinforced this notion of separation, of divine providence, of a chosen Protestant state destined to survive, the Union of the Crowns caused the concept to move rapidly forward. The Scot John Russell noted in 1604, 'That notable saying of the famous poet is verray remarquable, *et penitus toto divisos orbe Britannos*; qhairof it felloues, giff the ile of Britanie be devydit from all utheris, sould it not import ane perfyit unioun amangis ourselffis?'[64]

Shakespeare's play is picking up the varied strands of the British myth under King James and if John Norden in his *Speculum Britanniae* in 1593 was quoting Josephus on the Romans having extended their Empire by conquering another world, the significance of this concept becomes much more pronounced when James Stuart actually styles himself 'King of Great Britain' in 1604.[65] Suddenly the island previously divided does indeed become 'another world', and if it was known by 1611 that Britain was not at 'the ends of the earth' then she could and did extend her boundaries to encompass that territory discovered to the west. We need only look to James's speech to Parliament in 1603 to appreciate the ideological significance linking his Union project with the British past. Here he claims that his new kingdom 'is now become like a little World, within it selfe, being intrenched and fortified round about with a naturall, and yet admirable strong pond or ditch, whereby all the former feares of this Nation are now quite cut off'.[66] In his speech to Parliament in 1605, James refers to 'This little world of my Dominions, compassed and seuered by the Sea from the rest of the earth'.[67]

In the same year Ben Jonson picked up on this idea in *The masque of blackness*, his first court masque:

> With that great name Britannia, this blessed isle
> Hath won her ancient dignity and style,
> A world divided from the world, and tried
> The abstract of it in his general pride.

Dekker too makes reference to it in *The Whore of Babylon* (1606–7) when the Empress – representing Rome, and contemplating invasion – laments the defences of Elizabethan England:

> Her kingdom wears a girdle wrought of waves
> Set thick with precious stones, that are so charmed
> No rocks are of more force; her Fairies' hearts
> Lie in enchanted towers, impregnable:
> No engine scales them.

> (I.i.112–16)

Titania (representing Queen Elizabeth) sagely plans 'To be safe from foreign wildfire balls We'll build about our waters wooden walls' (I.ii.64–5).[68] Francis Bacon too wrote that 'Britain was said to be another world'.[69] Furthermore, King James appears in the 1613 engraving by Crispin van de Passe wearing a laurel wreath, with the portrait including the words 'Qui regis imperio divisos orbe Britannos, Rex tot virorum fortium'.[70] Peter Hulme's suggestion that the island in *The Tempest* is merely 'an interlude, a neutral ground between extirpation and resumption of power' therefore ignores the inherent ideological force behind this island association.[71]

Notwithstanding its imperial subtext, the play also has its fair share of

specifically imperial imagery. When confronted by the sight of the banquet, Sebastian comments:

> Now I will believe
> That there are unicorns; that in Arabia
> There is one tree, the phoenix' throne; one phoenix
> At this hour reigning there.

<div align="right">(III.iii.21–4)</div>

The most immediate of imperial references in the play is Gonzalo's wishful claim that 'I would with such perfection govern, sir, T' excel the Golden Age' (II.i.163–4). Those looking for reference to the Golden Age in colonial literature need go no further than Robert Johnson's work advocating the imperial expansion of Britain to America, *Nova Britannia,* when he describes the colonising project as 'being in a golden dream'.[72] James in his speech to Parliament in 1607 had already referred to the union of Scotland with England as being 'by a Golden conquest, but cymented with loue'.[73]

The notion of the distinctive island ruled by a strong, though not infallible, man is part of Shakespeare's highly romanticised depiction of Jacobean Britain. Just as Imogen in *Cymbeline* refuses to accept the idea of total insularity for her country, so the recognition at the end of *The Tempest* that the outside world has its place in the destinies of the characters is critically important. The fact that most of the protagonists leave is neither a graphic depiction of some colonising failure, nor Shakespearean angst about the legality of colonial expropriation. What the play is 'about' is left far more oblique. There are no simple answers waiting to be uncovered but *The Tempest* does illustrate how *ideas* in the romances are far more important than coded representations or hidden messages. Put in the context of the other plays that Shakespeare and his fellow playwrights were writing at this time – and ignoring our preconceptions about what we would *like* to see – *The Tempest* becomes a lot simpler than the multitude of literary criticism would seem to imply.

TOM A LINCOLN

The manuscript for the anonymous and untitled play known as *Tom a Lincoln* was discovered among the papers of Sir John Coke (1563–1644) at his country home, Melbourne Hall in Derbyshire, in 1973. The play has been given the same title as Richard Johnson's prose romance published in two parts, probably in 1598–9 and 1607, as the play follows Johnson's tale closely. On this basis the play cannot be earlier than 1607, but with the play's allusions to *The Winter's Tale* and *The Tempest,* a date of c.1611 seems more likely.[74]

Whoever might be the author, the play is a witty piece of bawdy on one level, but it is also another example of the crossover between the British

mythical past and the British present, wrapped in the language of an aggressive imperialism. Here the point of historical cross-reference is the great bell of Lincoln Cathedral – the bell was recast on 3 December 1610 and re-hung on 27 January 1611. In the play Tom a Lincoln himself orders money to be given for its casting:

> three thowsand more
> I giue for to compose of perfecte mettall
> a massy bell stilde by succeedinge tymes
> Great Tom a Lincolne
>
> (593–6)

and the playwright seems to be at pains to establish the play within a recognisable location, the restoration of the bell supporting the view that the play dates from *c.*1611.

Another perhaps more subtle point of connection is revealed by the quip from the clown Rusticano: 'I am æs sober as as as [*sic*] yoʳ greatest puritan in Banbury' (1459–60). As Patrick Collinson has shown, a Puritan faction headed by the Wheatley (or Whately) family was involved in demolishing two market crosses in Banbury in 1600. He notes how this particular event seems to have found its way as late as 1614 into Jonson's *Bartholomew Fair*, as the Puritan Zeal-of-the-Land Busy calls out, 'Down with Dagon, down with Dagon' in haranguing a puppet show in the play, when in real-life Banbury one of those pulling down the crosses called out 'God be thanked, Dagon the deluder of the people is fallen down'. The evidence from both plays suggests that Banbury's Puritan problems were attracting attention in the capital.[75]

The plot of *Tom a Lincoln* tells of the exploits of an illegitimate son of King Arthur who, contrary to the 'accepted' story of Arthur, goes on the imperial conquest of most of Europe instead of his father. He does so in the hope of finding out the identity of his father, a device reminiscent of that used in the first half of Rowley's *The Birth of Merlin*. In the play, however, unlike Johnson's romance, Tom does not learn of his father's true identity and takes on the name of the Red Rose Knight, a name which immediately brings to mind Spenser's *Faerie Queene*. Norbrook dated the first major revival of Spenserian poetry to the period 1612–14, but this play suggests it began a year earlier, as this piece of theatre takes the most radical line of any Jacobean play in lauding the Spenserian ideals of knighthood.[76] War is depicted not only as being glorious, it is positively glamorous, chauvinistic and adrenalin-charged as Tom, born with royal blood claims:

> wee
> are rather borne to wield the branded sword
> [...]
> wth Bellona sound the drumme & phife

> Oh I am ravisht, now me thinks I heare
> the armies clangor sowndinge in myne eare.

<div align="right">(217–18, 225–7)</div>

Yet its imperial theme is visible from early in the play. The character of Time reflects on the ages of man, while noting the move away from the fabled golden age with its Astraean connotations:

> I that have bene ere since the world began
> I that was since this orbed balls creation
> I that have seen huge kingedomes devastacons
> Doe heare p^rsent my selfe to yo^r still viwve
> Ould, aunciant, changinge, eu*er* runninge time
> first clad in gowld, next silver, next that brasse
> And nowe in Iron, Inferiour to the rest
> and yet more heard than all

<div align="right">(123–30)</div>

Unlike the other British plays which discourse on Britain's relations with the rest of Europe, *Tom a Lincoln* depicts Britain as the *invader*, not the *invaded*. The play is unique in this period in figuring ancient Britain as having a direct claim to rule over France. Though the text is interrupted by the absence of two folios (14a and 14b) the action resumes with a speech, obviously by a French ambassador, in which he proclaims:

> Toe Englands quondam kings, wee are borne free
> from servile bondage & base slau*ery*
> further hee doth comaund in his name
> to send him tribute w^{ch} if thou deniest
> hee will orerunne thy land wth hostile armes
> & forsee to it then preuent such harmes

<div align="right">(832–7)</div>

Here we see not only the same type of claim to national self-determination as given in *Cymbeline* and *The Birth of Merlin*, but the threat of counter-invasion being thrown back at the conqueror.

Thus in this play we have the extra point of nationalistic rhetoric in that Britain (and not Rome) is established as the imperial state, though still under threat herself. The response of the Red Rose Knight is predictably indignant, yet thoroughly patriotic:

> RED: Embassador returne vnto thy lord
> tell him king Arthur hath such knights will daunt
> the proudest hee that caused him to reuolt
> looke to yo^r townes, & see them strongly guarded
> for such an armie shall arriue in france
> sent from this Iland for to fright rebellion

as that false Leues shall tremble at the name
of conquering Arthur; for yo^r strongest forts
best guarded holds weele batter to the ground
when hartles Lewes yo^r king for dead shall sound.

(842–51)

The echoes of *Henry V* sound loudly. The ahistorical reference to Lewes [Louis] and a later one to a Duke of Aniows [Anjou] (line 919) draw the play firmly within the Jacobean present. Here the playwright moves away from establishing Britain's greatness through connection with imperial Rome towards bringing the play into the contemporary political milieu.[77] France was figuring largely in the news from the continent after the assassination of Henry IV in July 1610 and the marriage alliance between France and Spain in 1611 which brought fears of French machinations against Britain even more into the public eye. The shout by the assembled crowd of British soldiers and knights: 'when the ffrench rebell Thus lett the brittaines theyre prowde fury quell' (1004–5) thus has a special urgency. The imperial theme within the play is further established by the character of Time recounting the crusade undertaken by the Red Rose Knight and his followers beyond France into Africa:

> they fore past
> Many a monarchs Court & potentate
> Coastinge ore Spaine and frutefull Italy
> Europ & TurKey, wth great Affrica
> In wich stands auncient Carthage; Barbary
> Numidia, Mauritania, wich is parted
> In Tyngitania, that hath one the west
> The Curled Ocian, on the north the straights
> of stowte Morocco sowth——Getulia
> Cæsariensis—Mauritania hath
> the sea Sardoü leaninge to the North
> the mountayn Libia bendinge to the sowth
> ye all the spacious orbe he and his mates
> had well nigh Coasted, Countreys, kingedomes, states
> all, ye all.

(1118–32)

These latterday Argonauts go under the British, as opposed to the English, flag: 'they stile themselves knights of kinge Arthures Cort the Brittaine Monarch' (1255–6).

Prester John ultimately congratulates the Red Rose Knight after he defeats the dragon plaguing his kingdom, in terms redolent of imperial iconography: 'Thankes worthy brittaine after tymes shal see insculpt in brasse thy magnanimity. thy self shall stand in marble pillar framed' (2242–4). These were the marks of enduring greatness.[78] Though Arthur's son is illegitimate, it

is a plot device that allows a sub-plot featuring one born of the greatest champion of ancient British kingship. Making specific parallels with Henry is difficult, but *Tom a Lincoln* brings the martial aspirations of a young British prince very close to the fore.

THE WHITE DEVIL

We know John Webster's opinions of Henry from the elegy which he dedicated to the dead prince in his *Monumental Column* (1613). He wrote that people had hoped to be able to wear garlands of laurel in honour of a victorious prince,

> when as the Prince return'd a Conquerer
> From Forraine Nations; For men thought his star
> Had markt him for a iust and glorious war.
> And sure his thoughts were ours.[79]

The White Devil, Webster's vitriolic condemnation of power and corruption, which he depicts as being endemic to both the governors and governed, was first performed early in 1612 and contains a scene in which a very young prince has a highly different idea of warfare from that of his elders. They mock him for it: and yet we know of their corruption, and it is the young prince's simpler idea of honour and martial dignity which does survive the closing violence in the play. The prince, Giovanni, enters saying, 'Lord uncle you did promise me a horse And armour' (II.i.6–7) and is taken out to receive his promised gift. He returns dressed in this garb to be announced by Monticelso:

> MONT: No more my lord, here comes a champion
> Shall end the difference between you both,
> Your son the prince Giovanni,—see my lords
> What hopes you store in him, this is a casket
> For both your crowns, and should be held like dear:
> Now is he apt for knowledge, therefore know
> It is a more direct and even way
> To train to virtue those of princely blood,
> By examples than by precepts: if by examples
> Whom should he rather strive to imitate
> Than his own father? be his pattern then,
> Leave him a stock of virtue that may last,
> Should fortune rend his sails, and split his mast.
> BRAC: Your hand boy—growing to a soldier?
> GIOV: Give me a pike.
> FRAN: What practising your pike so young, fair coz?
> GIOV: Suppose me one of Homer's frogs, my lord,
> Tossing my bulrush thus,—pray sir tell me

	Might not a child of good discretion
	Be leader to an army?
FRAN:	Yes cousin a young prince
	Of good discretion might.
GIOV:	Say you so,—
	Indeed I have heard 'tis fit a general
	Should not endanger his own person oft,
	So that he make a noise, when he's a'horseback
	Like a Dansk drummer,—O 'tis excellent!
	He need not fight, methinks his horse as well
	Might lead an army for him; if I live
	I'll charge the French foe, in the very front
	Of all my troops, the foremost man.
FRAN:	What, what,—
GIOV:	And will not bid my soldiers up and follow
	But bid them follow me.
BRAC:	Forward lapwing.
	He flies with the shell on's head.
FRAN:	Pretty cousin,—
GIOV:	The first year uncle that I go to war,
	All prisoners that I take I will set free
	Without their ransom.
FRAN:	Ha, without their ransom,—
	How then will you reward your soldeirs
	That took those prisoners for you?
GIOV:	Thus my lord,
	I'll marry them to all the wealthy widows
	That fall that year.
FRAN:	Why then the next year following
	You'll have no men to go with you to war.
GIOV:	Why then I'll press the women to the war,
	And then the men will follow.
MONT:	Witty prince.
FRAN:	See a good habit makes a child a man,
	Whereas a bad one makes a man a beast:

(II.i.95–138)

We need little reminding that great hopes were stored in Henry Stuart too. He practised the pike from a young age and possessed several sets of armour by 1612, and such a chivalric gesture as releasing prisoners taken in a first encounter would have been of appeal to him.[80] In a recent performance of the play by the Royal Shakespeare Company at Stratford upon Avon this scene was cut.[81] It is a strange exchange of wit whose banter contributes little to the plot; but the excision may have been less due to this than because it stands as a singular moment in the play when honourable thought is expressed.

Removing it makes the play an emphatically more sombre depiction of con-
temporary vice – the play depicts events in Italy dating from the late sixteenth
century – and Webster pulls no punches in suggesting that England too was
scarcely ignorant of the viciousness of men such as Bracciano or Francisco.

It is not surprising that the scene has been largely ignored. In his treatment
of the play Mulryne considers only the scene in which Bracciano is murdered
during a 'barriers' (tournament), citing it as an example of the decadence of
chivalry and pointedly failing to cite this earlier extract altogether. Giovanni's
scene in fact suggests that, far from being decadent and extremely far from
being dead, chivalry is being inherited by a younger generation whose elders
have already forgotten its teachings.[82] In the play courtly lasciviousness and
lavish spectacle fail to provide a moral backbone to counter the corrupting
influence of power. When Marcello admits that he has done 'faith poorly' as a
soldier, Francisco is quick to identify how superficiality counts more than
honest martial labour:

> That's the misery of peace. Only outsides are then
> respected: as ships seem very great upon the river,
> which show very little upon the seas: so some men i'th'
> court seem Colossuses in a chamber, who if they came
> into the field would appear pitiful pigmies.

<div align="right">(V.i.117–21)</div>

Webster is at pains to show a scene with no romantic trimmings, no sugges-
tion of honour; and not even the put-upon women are sympathetically drawn.
Any feeling of pity for the characters is short-lived with the notable exception
of lines given to Giovanni. He tells Francisco that his mother is dead: 'They
wrapp'd her in a cruel fold of lead, And would not let me kiss her' (III.ii.334–
5). There are few lines in Jacobean tragedy so filled with compassion; and the
matter of Giovanni's centrality within the play explains why his is the last
word: he enters accompanied by his guards to charge the murderers present
and orders 'Let guilty men remember their black deeds Do lean on crutches,
made of slender reeds' (V.vi.300–301). The prince's brand of justice brings the
only ray of hope in the play.

THE VALIANT WELSHMAN

With the cessation of hostilities in Ireland and the peace with Spain in 1604,
James I's England was certainly 'no longer the England of Sidney or Spenser'.
Yet Arthur Ferguson characterised England at this time as being 'no longer
threatened from without', adding that 'the London stage, still a barometer of
sorts, no longer reflected the buoyant patriotism so apparent, for example, in
Shakespeare's earlier plays'.[83] Official statements of peaceable relations aside,

the nation continued to be threatened from without; and however much James might have hoped for a more widespread sentiment of *bonhomie*, popular feeling was not content with his version of peaceful co-existence with Spain. However, in its concerted interest in the depiction of chivalric martialism, the public theatre remained a 'barometer of sorts' and most emphatically did reflect a 'buoyant patriotism'.[84] That a group of plays performed during these years have martial themes – which continually mock the idea of peace as being the most noble course open to a country – flies directly counter to Michael Hattaway's claim that by 1608 'the age of the world of the man of war, of Spenser's "gentle knight" was ... long gone'.[85] The desire for war expressed on the stage was in fact far more prevalent than has been previously accepted.

The play which had the most direct bearing on Henry's ideas of a revived and expanded form of chivalry was that written, according to its title-page, by one 'R. A'., *The Valiant Welshman, or the True Chronicle History of the life and valiant deedes of Caradoc the Great, King of Cambria, now called Wales.*[86] Robert Armin and 'R. Anton' have been proposed as authors of the play, yet – given the content of the play in relation to militant Protestant imperial thinking – it seems that someone closer to the prince was responsible.[87] A far more likely candidate is Robert Alleyne, the man responsible for two books printed in London in 1613, one lamenting Henry's death, the other celebrating the Palatine marriage. Both of these bear on their title pages the credit 'by R A' and the political leanings and language of Alleyne as evinced by these two texts certainly agree with those in *The Valiant Welshman.*[88]

The play is almost a manifesto of the prince's specific beliefs and aspirations, strewn with celebrations and illustrations of the chivalric nobility of Caradoc, one of Henry's predecessors as Prince of Wales. *The Valiant Welshman* was published in 1615, though the title-page notes that it was 'sundry times Acted by the Prince of Wales his seruants'. The plot revolves around the fortunes of Caradoc, who becomes Prince of Wales through service to the king, Octavian, and is given the hand of Guiniuer, Octavian's daughter. When Rome invades neighbouring Britain, Caradoc and his fellows go to Britain's aid, yet when betrayed Caradoc's clemency to the traitors is returned by further betrayal. Caradoc, his wife and child are finally freed from Rome through Caradoc's having shown mercy to Caesar on the battlefields, and all ends happily.

The topicality of the play is revealed by the character of the Druid, brought to life so as to relate the tale. Like Merlin, he awakens from sleep, to tell the audience of the Welsh setting: 'Before faire Wales her happy Vnion had, Blest Vnion, that such happinesse did bring'.[89] Chivalric themes of courtesy and hospitality merge with political orthodoxy in the character Cadallan's comment:

> I know, dread liege, that each true man should know,
> To what intent dame nature brought him forth:
> True subiects are like Commons, who shoud feede
> Their King, and Country, and their friends at need.[90]

Historical accuracy is thrown to the winds, however, in the play, with the thoroughly evil Monmouth urging Caradoc: 'Reade Machiavell: Princes that would aspire, must mocke at hell', having admitted his damned nature: 'My soule is drown'd in rage'.[91]

The play, like *Cymbeline*, centres on the integrity of the island as an imperium, free from the paying of tribute to Rome.[92] Gederus (like Cymbeline) refuses to pay, while asking for the support of Octavian:

> Now mighty King, since Brittayne, through the world,
> Is counted famous for a generous Ile,
> Scorning to yeeld to forraine seruitude,
> Gederus humbly doth desire your ayde,
> To backe him gainst the pride of Romane Cesar,
> And force his Forces from the Brittish shores
> [...]
> The Bryttaynes are a Nation free and bold,
> And scorn the bonds of any forrayne foe,
> A Nation, that by force was ne're subdude,
> But by base Treasons politikely forst.
> Claudius forgets, that when the Bryttish Ile
> Scarce knew the meaning of a strangers march,
> Great Julius Cesar, fortunate in arms,
> Suffred three base repulses from the Cliffes
> Of Chalky Douer:
> And had not Bryttayne to her selfe prou'd false,
> Cesar and all his Army had beene toombde
> In the vast bosome of the angry sea.[93]

It is this type of language which was at the heart of the public theatre's expression of patriotism. Indeed, Gederus proudly notes that 'Brittaines would rather die, than be outdared' and that 'Now Brittaynes fight, Like Brutus sonnes, for freedome and for right'.[94] The Roman Marcus Gallicus laments 'That such a petty Iland should repulse So huge an army of the Romane strength' and, if the traitor Codigune believes that it is Rome 'Whose fame for honour, cheualry and armes, Out-shines all Nations with her glorious rayes', they are both likely to be disappointed. Britain, 'this famous land' is the more noble for its Welsh ally.[95]

Having thus asserted the power and strength of the British nation in no uncertain terms, the play turns to the character of Caradoc. Octavian notes of the Prince: 'He that loues honour, must his honour winne'.[96] With an eye to

both the sun iconography referred to in Chapter 1 and the pun on 'son', Caradoc is also described as 'this worthy Sunne That shines within the firmament of Wales'.[97] He is accorded further praise: 'Fame hath not left a man, more fit for talke Or disputation in bright honours scholes Then is thy noble Master', a description which Henry would no doubt have been pleased to receive.[98] If we were left in any doubt as to who is truly being described, the character of Caradoc stands revealed as Henry in a speech in which he discloses his indignation at being denied the right to fight for the British forces. He is instead sent to a hill to wait for the conclusion of the battle (the italics below are mine):

> Set punies to keepe hils, *that scarce haue read*
> *The first materiall Elements of warre,*
> That winke to see a *Canoneere* giue fire,
> And like an Aspin, shakes his coward ioynts,
> At *musket shot*. Within these noble veynes,
> There runnes a current of such high-borne bloud,
> Achilles well may father for his owne.
> These honourable sparkes of man wee keepe,
> Descended linially from Hectors race,
> And must be put in action. Shall I stand,
> Like gazing figure-flingers on the starres,
> Obseruing motion, and not moue my selfe?
> Hence with that basenesse I am a starre,
> Must moue, although I moue irregular,
> Goe you vnto the hill, in some disguise
> Ile purchase honour by this enterprise.[99]

Caradoc reveals that the armies are in fact using ahistorical weaponry, and notes that he has read about war yet is not allowed to practise what he has learned. We know that Henry was frustrated for a time in his desire to become Lord High Admiral, and that throughout his life he was denied the opportunity to make war on Spain. The desire to purchase honour would have been entirely in keeping with his goals. The military sagacity of Caradoc/Henry is emphasised again later in the play:

> He, well instructed in true fortitude,
> A graduate in Martiall discipline,
> And needs no Tutour: for in pupill age
> He was brought vp in honours rudiments,
> And learnde the elements of warlike Arts.[100]

There is also another point of comparison in the fact that, just as Henry was reputed to have disliked bribes, Caradoc spurns Claudius' offer when the latter is defeated in the midst of the ensuing battle:

> Know Romane, that a Bryttane scorns thy gold
> [...]
> Souldiers haue mines of honourable thoughts,
> More wealthy then the Indian veynes of gold
> [...]
> the wealth we craue,
> Are noble actions and an honoured graue.

Note that the supposedly Welsh Caradoc has suddenly become a 'Bryttane'.[101] Though the Welsh historically *were* the Britons, Wales is a kingdom apart from Britain in this play. Gederus, King of Britain, is accorded great respect: Octavian tells a messenger: 'Thy Master is a Prince, whom we affect, For honourable causes knowne to vs'.[102] It is a blatant historical inaccuracy but the play illustrates the coming-together in a common need of the two kingdoms. Thus the Welsh Caradoc can *become* British, can be welcomed into the fold of Britain even though technically Britain should not exist as a separate political entity in this ancient period. The playwright has his cake and eats it, the nobility of the Welsh prince aligned with the British monarch, mirroring the strength of Prince Henry joined to the recreated Britain brought together by his father. Ultimately, the message of the play is that this nobility of Caradoc's warfare in the service of Britain leads to peace through his strength: '[I] Haue brought a glorious triumph to his Crowne, And hung sweet peace about his palace gates. True honour should doe that, which enuy hates'.[103]

THE BIRTH OF MERLIN

An exceptional defence of the British history occurs in William Rowley's *The Birth of Merlin, or the Child Hath Found His Father* (from the period 1611–13). This play is steeped in the iconography of British conquest, glory and martial aspirations, and paves the way for Middleton's later *Hengist, King of Kent* (see Chapter 4) in that it makes clear the connection between an incursive foreign enemy and a new religion. Concerned with the conception, birth and magically rapid growth of Merlin to adulthood, the play is able to devote plenty of time to speeches proclaiming the good that will come from a child whose destiny is to play such a key role in British history. Even the Devil proclaims Merlin's power and significance, claiming that all will be well while he lives, that Britain will be defended from her enemies. In spite of its burden of British propaganda the play never takes itself too seriously: the Clown introduces himself and his pregnant sister (Merlin's mother) as 'A couple of Great Brittains, you may see by our bellies, sir' (III.i.60). But it is this humour which endears us to the sentiment being expressed. Merlin's mother is a simple girl whose son starts to sport a beard shortly after birth, becoming transformed into the popular figure of the Renaissance magus. The world into which he

appears is established quickly by the printed text, which begins with 'The Scene Brittain' as its location, while the list of characters includes 'Aurelius, King of Brittain', 'Vortiger, King of Brittain' and 'Uter Pendragon the Prince, Brother to Aurelius', as the first three.[104] There are also plenty of reminders for the audience throughout the play that this is ancient Britain.

The Birth of Merlin is set during a period when there are in fact two kings of Britain, between the period of Aurelius's return from exile and the death of Vortiger, and the action continues up to the coronation of Uter. As its most recent editor, Joanna Udall noted: 'The playwright has prolonged the dual reign by making Vortiger live as long as Aurelius, and has altered the chronology so that the first appearance of Merlin, the building of Vortiger's castle, and the dragon prophecy take place after, rather than before, Aurelius's arrival in Britain'.[105] Indeed this type of condensation serves to intensify the stream of events, allowing the playwright to give his audience enough of the sense of magical destiny which surrounds the character of Uter so as to make Merlin's prediction at the close all the more potent.

As in Shakespeare's *Henry VIII* the play seems to move towards the moment when history can move to the present, and in the case of *The Birth of Merlin* ancient British history can move to present British history. In *Henry VIII* it is Cranmer who prophesies the death of Elizabeth and the rise of her successor:

> As when
> The bird of wonder dies, the maiden phoenix,
> Her ashes new create another heir
> As great in admiration as herself,
> So shall she leave her blessedness to one
> (When heaven shall call her from this cloud of darkness)
> Who from the sacred ashes of her honour
> Shall star-like rise, as great in fame as she was,
> And so stand fix'd. Peace, plenty, love, truth, terror,
> That were the servants to this chosen infant,
> Shall then be his, and like a vine grow to him;
> Wherever the bright sun of heaven shall shine,
> His honour and the greatness of his name
> Shall be, and make new nations. He shall flourish,
> And like the mountain cedar, reach his branches
> To all the plains about him: our children's children
> Shall see this, and bless heaven.

$$(V.iv.39–55)^{106}$$

In Rowley's play the prediction comes from Merlin himself and both looks to the birth of the Emperor Constantine and heaps imperial honours on Arthur – though he is never called that, only 'A King in Armour':

> But of your Son, thus Fate and *Merlin* tells,
> All after times shall fill their Chronicles
> With fame of his renown, whose warlike sword
> Shall pass through fertile *France* and *Germany*,
> Nor shall his conquering foot be forc'd to stand,
> Till *Romes* Imperial Wreath hath crown'd his Fame
> With Monarch of the West, from whose seven hills
> With Conquest, and contributory Kings,
> He back returns to inlarge the Brittain bounds,
> His Heraldry adorn'd with thirteen Crowns
> [...]
> He to the world shall add another Worthy,
> And as a Loadstone for his prowess, draw
> A train of Marshal Lovers to his Court:
> It shall be then the best of Knight-hoods honor,
> At *Winchester* to fill his Castle Hall,
> And at his Royal Table sit and feast
> In warlike orders, all their arms round hurl'd,
> As if they meant to circumscribe the world.

(IV.v.104–13, 115–22)

A conquering king overseas will reach Rome before returning to ensure unity at home in Britain. The idea is the same as that depicted in *Tom a Lincoln*. What is extremely significant about the character of Merlin here is that, if in the *Barriers* (see below, p. 123) he represents the past, here he represents the future.[107] The play thus makes repeated assertions as to the importance of Arthur and the country's British heritage in terms of its future glory, and if it makes little attempt to hide eulogy for the Stuart monarchy it does so with one particular court in mind.

It is difficult to ascertain the Jacobean reaction to the Saxon invasion of Britain as staged in Rowley's play. John Bale in his *Acts of the English Votaries, Part I* (1548) had connected the historical Saxon invasion with Britain's subjection to the Church of Rome:

> The diademe of Brute is thee princelye power of this whole region, immediately geuen of God wythoute anye other meane mastrye worker to Antychrystes behoue. Fre was that power from the great whores domynyon (which is the Rome church) tyl the vyolent conquest of the Englysh Saxons, which they had of the Brytaynes for theyr iniquities sake.

(sig. F4)

In the play Donobert, a nobleman, is incredulous of Aurelius's actions in falling for the Saxon Princess Artesia, expressing his distaste in religious terms: 'Death! he shall marry the devil first, Marry a Pagan, an Idolator' (I.ii.152–3).

Making direct comparisons between stage characters and real-life persons is, as has been noted above, tendentious. In *The Birth of Merlin*, however, are some interesting resonances of contemporary concerns regarding anti-Spanish and anti-Catholic feeling. The play revolves around the fact that the King of Britain, Aurelius, is seduced by the enemy of his country into letting them settle in his kingdom (and, presumably, practise their religion), against the advice of his general, Edoll, Earl of Chester. Indeed he is reduced to a gibbering wreck by the beauty of Artesia, sister to the Saxon General Ostorius: ''s death her beauty mazes me, I cannot speak if I but look on her—What's that we did conclude?' (I.ii.93–5). This king of Britain also makes a decidedly careless assumption of his country's national integrity:

> AURELIUS: My word dear Love, may my Religion,
> Crown, State, and Kingdom fail, when I fail thee,
> Command Earl Chester to break up the camp,
> Without disturbance to our Saxon friends,
> Send every hour swift posts to hasten on
> The King her Brother, to conclude this League,
> This endless happy Peace of Love and Marriage.
>
> (I.ii.211–17)

The king has sold his country for a marriage to another country and another religion, all in the name of 'endless happy Peace of Love and Marriage'. English and Scots alike were concerned in the period before the Palatine match with the future of the Princess Elizabeth and, until his death, with the bride destined for Prince Henry. Any play dealing with a marriage to a foreigner who proves indeed still an enemy despite claims to the contrary – and deceiving someone pictured as a foolish, weak-minded king – must have had a certain immediacy for the Jacobean audience. There is hope, however, in the play in the form of men like Edoll. This Earl of Chester (a city connected, of course with the Prince of Wales) is a no-nonsense soldier, concerned with his 'Honor, Fame, and hopeful Victories' (II.ii.84) as well as offering to fight ''gainst all the devils in hell To guard my country' (II.ii.91–2).

If we are left in any doubt as to Jacobean perceptions of the significance of ancient Britain, note that when Aurelius wishes to see conjurations from the past he asks to see

> The two great Champions of the Trojan War,
> Achilles and brave Hector, our great Ancestor,
> Both in their warlike habits, Armor, Shields,
> And Weapons then in use for fight.
>
> (II.ii.197–200)

As has been noted in Chapter 1 above, the veracity of the Trojan legend of Brute was one of the most paramount concerns in the semi-mythical British

history, and subsequent references to that genealogy are significant pointers to a concern with Britain.[108] We need have no doubt, however, that the *future* of the British state is being emphasised by Rowley. The Devil himself prophesies:

> but be of comfort,
> Whilst men do breath, and Brittains name be known,
> The fatal fruit thou bear'st within thy womb,
> Shall here be famous till the day of doom.

<div align="right">(III.i.153–6)</div>

Lucina, 'Queen of the Shades' knows of the significance of Merlin for the future:

> In honor of this childe, the Fates shall bring,
> All their assisting powers of Knowledge, Arts,
> Learning, Wisdom, all the hidden parts
> Of all-admiring Prophecy, to fore-see
> The event of times to come, his Art shall stand
> A wall of bras to guard the Brittain Land

while the Devil adds 'And Merlins name in Brittain shall live, Whilst men inhabit here' (III.iii.24–9, 35–6). A scene later the Devil again returns to stress Merlin's role: 'No matter whence we do derive our Name, All Brittany shall ring of Merlin's fame, And wonder at his acts' (III.iv.91–3). He reminds the audience once more in Act V: 'Kings shall have need of written Chronicles, To keep their names alive, but Merlin none' (V.i.19–20).

There is also a strong visual British element in the play. The red dragon as an Arthurian trope, and a symbol representing Wales to this day, dominates many stage directions. Act IV, scene ii is interrupted by two of them:

[Merlin strikes his wand. Thunder and Lightning, two Dragons appear, a White and a Red, they fight a while and pause] (IV.i.foll. 208)

[Thunder: The two Dragons fight agen, and the White Dragon drives off the Red] (IV.i.foll. 214)

Merlin warns that the invading Saxons' intent is 'to rout the Brittains out, and plant the English' (IV.i.241). The irony here is that the English, being descended from those Saxons, are actually the invaders themselves, at a time when there had been (and was) concern that the Scots were the invading element in the British family. This is compounded by Prince Uter's warning:

> The Saxons which thou broughtst
> To back thy usurpations, are grown great,
> And where they seat themselves, do hourly seek
> To blot the Records of old Brute and Brittains,
> From memory of men, calling themselves

> Hingest-men, and Hingest-land, that no more
> The Brittain name be known, all this by thee,
> Thou base destroyer of thy Native Countrey.
>
> (IV.iii.12–19)

Britain is figured as being under threat from those who would deny its name, much as those who had opposed the full Union as envisaged by James were seen by his supporters. The dragon motif occurs again in the next scene in the shape of a 'Blazing Star' (IV.v, opening stage direction). As the Prince notes: 'See in the beam above his flaming ring, A Dragons head appears' (IV.v.4–5).

Perhaps one of the most awkward images to decipher, even with Merlin's interpretation, is another dragonly appearance:

> The Dragons head
> Is the Herogliphick that figures out
> Your Princely self, that here must reign a King,
> Those by-form'd fires that from the Dragons mouth
> Shoot East and West, emblem two Royal babes,
> Which shall proceed from you, a son and daughter:
> Her pointed constellation Northwest bending,
> Crowns Her a Queen in Ireland, of whom first springs
> That Kingdoms Title to the Brittain Kings.
>
> (IV.v.94–102)

Justifying Ireland justified collective security, legitimising the extension of a British presence into the north of Ireland at a time when propaganda for the settlement of Ulster was being produced in London. In 1609 Bacon wrote of Ireland 'being another Britain'.[109]

The play also demonstrates the creation of the iconographic heart of the British monarchy, representing the Stuarts' descent from Welsh blood:

> EDOLL: The DRAGON is your Emblem, bear it bravely,
> And so long live and ever happy styl'd
> Uter-Pendragon, lawful King of Brittain.
> PRINCE: Thanks Edol, we imbrace the name and title,
> And in our Sheild and Standard shall the figure
> Of a Red Dragon still be born before us,
> To fright the bloody Saxons.
>
> (IV.v.151–7)

As if to emphasise this point, men enter in Act V, with the stage direction recording: 'Oswold bearing the Standard, Toclio the Sheild, with the Red Dragon pictur'd in em' (V.ii.37, stage direction).

The imperial imagery continues in the final scene in which the Pendragon is crowned King of Britain. Gloucester sums up the spirit of the Play's close:

> Happy Restorer of the Brittains fame,
> Uprising Sun let us salute thy glory,
> Ride in a day perpetual about us,
> And no night be in thy thrones zodiack,
> Why do we stay to bind those Princely browes
> With this Imperiall Honor.

<div align="right">(V.ii.42–7)</div>

Although the project for Union was fast fading from the political agenda, it is difficult to accept the idea that Rowley is writing of a dead or dying idea here. The sumptuous glamour of the Britishness he describes with such relish takes up *Cymbeline*'s comparatively restrained assertions of modern British kingship and pushes the boundaries forward considerably. Henry, as the future King Henry IX, played both a symbolic and an active role in this set of ideas which could have led to a 'New Britain' in terms of culture and foreign policy, and in context we can see the play as a clarion call for ambitious patriotism. Visually and verbally the play advocates a redirection of English culture towards a bold reassertion of British national power. The depiction of Merlin, with red dragons and blazing stars, lends the play a fantastical quality; at the same time the play points to an individual who will take action and lead in response to the nation's collective concern. The alien presence being allowed to take root would have been clearly recognisable to an audience who perceived an increasing Spanish influence over the king.

<div align="center">THE TRUE TROJANS</div>

Jasper Fisher's play – conventionally dated between 1611 and 1633, the former date being that of his graduation from Magdalen College, Oxford, and the latter that of publication – also takes as its subject matter events in ancient Britain.[110] It too concentrates on Britain's Roman heritage while postulating that Britain is not conquered by Rome in the same manner as the rest of Europe, making instead a peace which is equitable. As will be noted below, the tone of the play and the presence of one character in particular both suggest that a more precise dating can be made, placing the piece firmly in the mid-Jacobean period.

The scant literary attention paid to the play has meant that the significance of its full title has gone unnoticed. 'Fuimus Troies' was the family motto of the Lyte family of Lytescary, and Henry Lyte (1529?–1607) in particular took a very assertive line when it came to defending the origins of Britain. In 1592, still convinced that the noble Britons were the posterity of Mars and Hercules, he said that Camden, 'beinge stroken blinde withe the Chaffe and duste of Wheathamstedes barne or grange' had done so much harm with the scepticism of his *Britannia* that the book ought to be called in.[111] Lyte had written *The*

Light of Britayne; a Recorde of the honorable Originall and Antiquitie of Britaine in 1588 and dedicated it to Elizabeth whose portrait the volume includes.[112]

Its object was to trace the descent of the British from the Trojans and he presented a copy to the queen on 24 November 1588 when she went in state to St Paul's to return thanks for the defeat of the Armada. In 1592 Lyte wrote two small works on the same subject, which have never been printed: 'Records of the true Origin of the noble Britons' and 'The Mystical Oxon of Oxenford, alias a true and most ancient Record of the Original of Oxford and all Britain'. He also drew up 'A table whereby it is supposed that Lyte of Lytescarie sprange of the Race and Stocke of Leitus … and that his Ancestors came to Englande first with Brute' and also a roll containing a poem, 'A description of the Swannes of Carie that came first under mightie Brute's protection from Caria in Asia to Carie in Britain'.[113] The connection between the title of the play and the man who so clearly espoused the same historical beliefs does not seem mere coincidence.

The play looks at Caesar's first invasion of Britain, depicted at this time as a realm of minor kings under the benevolent rule of Cassibellanus.[114] Throughout the play, however, is a running concern that the historical events being portrayed are a conflict between empires. As with *Cymbeline* the Roman power is depicted in the overseas sense, while the British is depicted in terms of its national integrity. The dramatis personae notes that Cassibellanus is 'Imperator Britannorum' and the character of Mercury introduces the events of the play:

> Loe, now the blacke Emperiall Bird doth claspe
> Vnder her winges the continent, and Mars
> Trampling downe nations with his brazen wheeles,
> Fights for his Nephewes, and hath once more made
> Britaines and Romanes meete
> [...]
> Neuer two Nations better matcht. For Ioue
> Loues both alike.

The ghost of the Roman hero Camillus then provocatively argues that 'Ioue rules the Spheares, Rome all the world beside: And shall this little corner be denide?'.[115]

As the play makes clear, the basis for this earlier meeting has been British assistance rendered to the Gauls in fighting Rome:

> Thus much I know, Great Caesar, that they lent
> Their secret ayde vnto the neighbour Gaules;
> Fostering their fugitiues with friendly care:
> Which made your victory flye with slower wing.

In 1612 the Huguenot Duc de Bouillon began secretly negotiating military co-operation between England and the Huguenots. He had as early as 1611 become the leading influence on James's policy towards France and was

appointed by the Palatine court as their chief negotiator in the marriage of Frederick and Elizabeth. His friendships – with, among others, Sir Thomas Edmondes, the British ambassador in France from May 1610, Sir Ralph Winwood, ambassador to the States-General, Prince Henry and Pembroke – gave Bouillon a considerable circle of allies upon whom to call, yet none was more important than James himself. The king issued a declaration in May 1612 in which he 'did very strongly state his intention to protect them [the Huguenots] if the edicts were broken so that the world might see that they were being persecuted for the cause of their religion'. It may not be a coincidence that *The True Trojans* is a play in which the forces of the Roman empire lament that Britain, through secret military support and allowing sanctuary, has assisted Gaul in preventing Rome's desired expansion.[116] In Britain is the character Rollano, described as being French, not a Gaul, an ahistorical slip strongly suggesting that the play has indeed a connection with the British intention to defend the Huguenot cause in the period 1611–13.

The language and imagery used is highly similar to that of *Cymbeline* and the play has two significant references to imperial iconography. Nennius laments, 'When Cedars fall whole worlds are crusht', and Hulacus makes a prophecy to Caesar, 'Search out 'Mong Cedars tall the Arabian Phaenix nest'.[117] As in *The Tempest*, Britain is constantly depicted in *The True Trojans* as being an island nation separated from the rest of the world. At the beginning of the play the stage direction has the Roman forces on the northern coast of Gaul bearing 'A two-neck'd Eagle displayed sable' (I.ii) while Comius informs Caesar of the land he can see when he thinks he has reached the boundaries of the known world: 'It is the Britaine shoare, which ten leagues hence Displaies her shining clifts vnto your sight'.[118]

When Cassibellanus realises the danger posed by the Roman invasion he is quick to look to the other minor kings of the island for their aid:

> Come Sirs, To armes, To armes: Let speedy poasts
> Summon our petty Kings, and muster vp
> Our valourous nations from the North, and West.
> Androgeus hast you to the Scots and Pictes,
> Two Names, which now Albaniaes kingdome share:
> Entreat their aide, if not for loue, yet feare:
> For new foes should imprint swift-equall feare
> Through all the arteries of our Ile
> [...]
> Fire the Beacons, strike alarums loud.

The nation having arteries is an extremely vivid image, and one used by several other writers at this time. Drayton in his highly pro-British *Poly-Olbion* (1612) figured Britain's rivers as being nymphs, Samuel Daniel depicted Anne of Denmark in *Tethys Festival* (1610) as the Queen of the Ocean and her ladies

as those same British water-nymphs, and Christopher Brooke refered to 'Thestis raues, And bids her waues Bring all the Nimphes within her Emperie' in his *Two Elegies* (1613).[119] Summoned by the British emperor, the British realm does indeed heed his call – forces from Scotland are secured 'with willing sympathy' as well as from the 'Pictish Court'.[120] United at home when danger threatens, Britain is also depicted as a refuge from the ills of the world. Rollano praises 'this soft Halcyons neast, this Britaine Ile'.[121]

The idea of Britain's isolation is best expressed by Nennius, Cassibellanus's brother:

> Now royall friends, the Heires of mighty Brute ...
> Death is but Charon to the Fortunate Iles ...
> We haue a world within our selues, whose breast
> No Forainer hath vn-revenged prest
> These thousand yeares
> [...]
> If we our selues are true,
> We may despise, what all the earth can doe.[122]

Caesar calls the Britons 'You hid in the Sea', while Great Britain is again referred to as the 'Iles Fortunate' in the masque scene at the close of the play and, according to Belinus, Britain is 'Our Ile Rounded with Nereus girdle'. Compare such thinking with William Alexander's assertions of Britain's national integrity in 1604: 'For this faire world without the world, no doubt Which Neptune stronglie guards with liquid bands' as well as Drummond's confidence that through James's reign 'this Isle should yet her ancient Name regaine, And more of Fortunate deserue the Stile'.[123]

Perhaps the strongest expression of the idea of Britain's insularity emerges, however, from Holland's translation of Camden's *Britannia*:

> Now after 800 yeeres, or thereabout come and gone; even whiles we are perusing this work, King James invested in the Monarchie of the whole Isle, by the propitious favour and grace of God ...; to the end that this said Isle, which is one entire thing in itselfe, encircled within one compass of the Ocean; in his own person under one imperial crown, and diadem, in one communitie of language, religion, laws and judiciall processes; to the increase of perpetual felicitie, and oblivion of old enmitie, should bear also one name: hath ... assumed the name, title, and stile of King of Great Britain.[124]

The reference to the Trojan ancestry of the British in Fisher's play is crucial in defending the antiquity of the island and so justifying the belief that the two 'empires' of Britain and Rome have a common glorious past. Cassibellanus' letter to Caesar rejecting his imposition of tributary status on Britain states: 'Defend this Ile we must; Which from the world cut of, and free from her first day, Hath Iron more for swords, than Gold for tributes pay

... As you from Troy, so we; Our pettigree do claime: Why should the branches fight, when as the roote's the same?' Caesar immediately regrets the conflict which will result: 'I grieue to draw my sword against the stocke Of thrice-renowned Troy'.[125] From this point continual references are made to the Brute legend. The British druid Lantonus prays to the moon, 'O thou first guide of Brutus to this Ile' and the poetic Chorus which follows at the beginning of II.viii notes 'How Brute did Gyants tame And by Isis current A second Troy did frame'.[126]

When the inevitable conflict finally arrives Caesar, in the middle of the fighting, admits that 'we may confesse, they come of Troiane kind, An hundred valiant Hectors here we find' and later rhetorically asks if he is not winning because 'Troy gainst Troy doth fight'.[127] London is throughout the play referred to by the name given to her by Brutus, Troynovant. Cassibellanus gives the rule of 'our Lady-City Troynovant' to Androgius, and when the British king does agree to pay £3000 of silver a year as a form of recognition to Caesar the latter is seen to give something in return:

> So let these decrees
> Be straight proclaim'd through Troynovant, whose Tower
> Shall be more fairely built at my charge, as
> A lasting Monument of our arriuall.[128]

Caesar's main victim in the conflict depicted in the play is the noble Nennius who, mortally wounded, talks of the need for Britain to be protected from her enemies:

> I long euen to behold those glorious Cloysters,
> Where Brutus, great Dunwallo, and his sonnes,
> Thrice noble Spirits walke.
> [...]
> Thou mighty Enginer of this wondrous Globe,
> Protect this Ile, confound all forraine plots
> Grant Thames and Tyber neuer ioyne their chanells
> [...]
> Before this land shall weare the Romane yoke;
> Let first the adamantine axell cracke,
> Which bindes the Ball terrestriall to her poles,
> And dash the empty aire; Let Planets drop
> Their scalding gelly, and all flame being spent,
> Entombe the world in euerlasting smoake.[129]

In marked contrast to this concern with the island empire is Caesar's expression of hope in his reference to the Channel:

> I long to stride
> This Hellespont, or bridge it with a Navy,

Disclosing to our Empire vnknowne Landes,
Vntill the Arcticke Starre for Zenith stands.[130]

When the Roman envoy and spy Volusenus reads out Caesar's letter to Cassibellanus – which notes that 'Since Romulus race by will of Ioue, Haue stretcht their Empire wide' – the imperial ambitions of Rome are manifest.[131] The play shows, however, that since both Britain and Rome are specially loved of Jove, neither can defeat the other. The concluding peace sees Caesar telling Cassibellanus 'Raigne as the totall Monarch of this Ile', while the ghost of Brennus notes that in this conflict 'Both do weary stand On equall termes'.[132]

And yet the play does not rest content with maintaining the *status quo* of a defensive Britain. Those 'equall termes' are the result of fate, rather than deriving from a strong united Britain. Duke Nennius laments the life of ease he sees around him:

Think ye the smoaky mist
Of Sunne-boyld Seas can stop the Eagles eye?
Or can our watry walles keepe dangers out,
Which flye aloft? That thus we snorting lye
Feeding impostum'd humours, to be launch'd
By some out-landish Surgion:
As they are now: whose flaming townes, like Beacons,
Giue vs faire warning, and even guild our Spyres,
Whilst merrily we warme vs at their Fires.
Yet we are next: who charm'd with peace and sloath,
Dreame golden dreames. Goe, warlike Britaine, goe,
For Olive bough exchange thy Hazell bow.[133]

Eulinus too is less than happy with the laxity of Britain's martial valour:

Let Caesar come: Our land doth rust with ease,
[...]
It grieues me see, Our Martiall spirits trace
The idle streetes, while weapons by their side
Dangle and lash their backes, as t'were to vpbraid
Their needlesse vse.[134]

Nennius and Eulinus speak for all those who espouse a martial vision of foreign policy. By criticising complacency and pacifism, they point to the dangers for Britain under a king whose laudable desire to avoid war sends a message to the country's enemies that his kingdoms are weak. As in Fletcher's *The Captain* (from the period 1609–1612), warriors are depicted as being an essential component in a secure state.[135] In Fletcher's play, Jacomo – the eponymous captain – uses similar language to Eulinus, lamenting 'This cold dull rusty peace makes us appeare Like empty Pictures, onely the faint shadowes Of what we should be' (II.i.8–10).

Like *Cymbeline*, *The True Trojans* has a prophetic mystery predict the destiny of the two empires. Only at the end of the play is the prophecy

> Loud doth the King of Beasts roare,
> High doth the Queene of Birds soare:
> But her wings clipt soone grow out:
> Both repent they are so stout.
> Till C. gainst C. strike a round,
> In a perfect Circle bound

interpreted as meaning that 'The Lyon and the Eagle doe designe The Britaine and the Romane states' and that the two Cs are Caesar and Cassibellanus.[136]

The underlying message of the play is, however, that Britain is defeated only through internal division, caused by factionalism after Cassibellanus's nephew is accidentally killed in front of him by Eulinus. Union and unity are not only desirable but part and parcel of Britain's security. This message sits alongside the historical fact of the Roman conquest, justified (not for the first or last time, theatrically) in terms of the manifest destiny of Britain as a willing partner in the Roman empire. This great past symbolises the even greater future that might be built on this civilised foundation, especially given the re-creation of the British monarchy and the union of the kingdoms.

BONDUCA

Continuing the sequence of plays linking the Roman empire and ancient Britain, Fletcher's *Bonduca* (c.1613) describes the wars between Rome, represented by the noble Suetonius, and the British led by Caratach.[137] The formula of noble Roman invader and equally noble British defender follows exactly the same lines as in *Cymbeline*, *A Shoe-Maker, A Gentleman* and *The True Trojans*.

The play depicts the positive outcome of a change in leadership style in Britain, since Bonduca and her daughters, though dying nobly, are portrayed as less than capable military commanders. With Caratach rising to predominance, even a tragic event is rendered a stepping stone to glory in the greater scheme of history. While Bonduca is called 'a brave Virago' in the list of characters, the essential message behind the play seems to be that the enemy of Britain is to be respected as a worthy foe for Caratach and one to whom he is prepared to surrender after the death of Hengo, his nephew. Notably this play too occasions a highly pertinent appraisal of the idea of pacifism (the italics are mine):

NENNIUS: Is not Peace the end of Arms?
CARATACH: Not when the cause implies a general Conquest:
 Had we a difference with some pettie Isle,
 Or with our neighbours (Lady) for our Land-marks,

The taking in of some rebellious Lord,
Or making a head against Commotions,
After a day of Blood, Peace might be argued:
But when we grapple for the ground we live on,
The Libertie we hold as dear as life,
The gods we worship, and next those, our Honours,
And with those swords that know no end of Battel:
Those men beside themselves allow no neighbour;
Those mindes that where the day is claim inheritance,
And where the sun makes ripe the fruits, their harvest,
And where they march, but measure out more ground
To adde to Rome, and here i' th' bowels on us;
It must not be; no, as they are our foes,
And those that must be so until we tire 'em,
Let's use the peace of Honour, that's fair dealing,
But in our ends, our swords.

<div align="right">(I.i.152–71)</div>

The war to be fought and the conflict for which these British soldiers prepare themselves is for the defence of liberty, religion and honour; and if they ultimately surrender to Rome – a historical accuracy – it is done on terms fair to Britain achieved through not only military prowess but adherence to chivalric practices.

This point about honour and nobility is re-emphasised in Act III, scene i when Bonduca and her daughters pray that the gods might avenge the woes suffered by the British. The response from the gods is '*A smoak from the Altar*', an inauspicious sign. Caratach then steps forward to make a very different invocation:

Divine *Andate,* thou who hold'st the reins
Of furious Battels, and disordred War,
And proudly roll'st thy swarty chariot wheels
Over the heaps of wounds, and carcasses,
Sailing through seas of bloud; thou sure-steel'd sternnesse,
Give us this day good hearts, good enemies,
Good blowes o' both sides, wounds that fear or flight
Can claim no share in; steel us both with angers,
And warlike executions fit thy viewing;
Let *Rome* put on her best strength, and thy *Britain,*
Thy little *Britain,* but as great in fortune,
Meet her as strong as shee, as proud, as daring;
And then look on, thou red ey'd god: who does best,
Reward with honour; who despair makes flie,
Unarme for ever, and brand with infamie:
Grant this, divine *Andate,* 'tis but Justice.

<div align="right">(III.i.59–74)</div>

He specifically does not want a slaughter. He seeks a chivalrous display of valour on both sides through which he hopes the British will ultimately emerge triumphant. In answer to his prayer a flame rises from the altar, signalling that this valiant bravado, rather than the women's whining cries for redress, will decide the outcome of the battle. As Caratach subsequently notes, 'Our valours are our best gods' (III.i.82).

The Roman Suetonius' designs are all concerned with acquiring land, imperial Rome's designs being the expansion of their empire, a project which always carries the disturbing notion of suppressing regional liberties: 'ere this day run, We shall have ground to add to *Rome*, wel won' (III.ii.89–90). Yet misogyny allows the British to feel aggrieved that the women soldiers' meddling in matters of strategy has been as disastrous as that of Cleopatra at Actium, when in Act III, scene v Bonduca orders the British chariots to attack while the British footsoldiers are in the way. Rome is victorious yet Bonduca is allowed to regain her dignity in her dying words to Suetonius: 'If you will keep your Laws and Empire whole, Place in your Romane flesh a Britain soul' (IV.iv.152–3).

However, the event to which the play has been leading is another outcome of this particular conflict. The close of the play sees Caratach mourn the loss of his beloved nephew Hengo with this eulogy:

> Farewell the hopes of *Britain*,
> Thou Royall graft, Farewell for ever. Time and Death
> Ye have done your worst. Fortune now see, now proudly
> Pluck off thy vail, and view thy triumph: Look,
> Look what thou hast brought this Land to. Oh fair flower,
> How lovely yet thy ruines show, how sweetly
> Even death embraces thee! The peace of heaven,
> The fellowship of all great souls be with thee.

<div align="right">(V.iii.160–67)</div>

Lamenting the passing of an important son in whom so many of Britain's hopes were based has clear echoes with the hopes placed in Prince Henry and it strongly suggests that the date of the play's writing and first performance can be made more specific than the more general 1611–14 dating accorded to it by Kawachi.[138] As will be seen in Chapter 4, Henry's death had a profound effect on Jacobean theatrical culture.

THE MASQUES

The masques present a totally different picture of Henry's aspirations, largely because those who wrote them were doing so at the command of the king or queen, because they were performed specifically for the royal audience, and because, if Henry's agenda differed from that of his father, he was relatively powerless to act on it while his father ruled. With one notable exception the

masques were at odds with the public theatre in that while recognising Henry's aspirations the masque writers attempted to deflect him away from those plans. Yet they still retain value for our understanding of how an imperial mentalité could be negotiated via these more 'official' channels. Recent studies of the Stuart court masques have been at pains to illustrate that material performed at court did not follow a single agenda and that more oppositional material was frequently staged.[139]

PRINCE HENRY'S BARRIERS

This is a good starting point, being the most overt of the masques in its depiction of chivalric spectacle. The event took place on 6 January 1610, staged indoors by a high-born cast, with Henry joined by challengers Lennox, Southampton, Arundel, Hay, Sir Thomas Somerset and Sir Richard Preston. The prince was said to have sustained thirty pushes of the pike and 360 strokes of the sword and if Hawkins wrote that the prince conceived the event so 'that the World might know, what a brave Prince they were likely to enjoy', then this event was a very clear indicator of the kind of future the prince had in mind for Britain.[140]

The *Barriers* is an inward-looking depiction of chivalric revival with Jonson's text looking towards civic responsibility and the defence of the British imperium. Yet the main concern of Ben Jonson and Inigo Jones was in celebrating *James* as a revived hero and, by extension, his son for following in his father's footsteps. Jonson clearly seems to be trying to have the best of both worlds in the piece. It is unsurprising that he should take this view as he was very much a follower of the king first and foremost, and had no intention of shifting his loyalties to Henry's court. The *Barriers*, however, acts as a visual manifesto of the prince's thinking, with the theme being that of the rebirth of chivalry under Henry. Merlin's speech recounts 'the conquests got, the spoils, the trophies reared' by fierce medieval kings, and is followed by a bloodthirsty account of the victory over the Armada – yet with the codicil of praise to James for his peacemaking diplomacy.

By this speech Henry is subsumed within a culture of heroes dating back to the ancient world, individuals representative of the highest tenets of chivalry. As its present incarnation Henry is figured as not only a mirror of this ancient heritage, but its successor. He is the focus of the glory of Britain. Thus, while the Lady of the Lake accords the standard honour to the king –

> When the island hath regained her fame
> Entire and perfect in the ancient name,
> And that a monarch equal good and great,
> Wise, temperate, just and stout claims Arthur's seat

(18–21)

alluding to the well known anagram 'Charles James Stuart = Claims Arthurs Seate' (if i and j are interchangeable) – no-one is in any doubt as to who is being celebrated.[141] The Lady of the Lake then turns to wish the prince greatness in suitably chivalric terms:

> Let him be famous as was Tristram, Tor,
> Launc'lot and all our list of knighthood or,
> Who were before or have been since
> [...]
> Beyond the paths and searches of the sun
> Let him tempt fate and when a world is won,
> Submit it duly to this state and throne,
> Till time and utmost stay make that his own.
>
> (87–9, 91–4)[142]

Merlin too calls for the return of chivalry: 'From the shores Of all the world come knighthood like a flood' (389–90). Reference to Arthur was not a conceit which appealed to Jonson, given his scepticism about the whole Arthurian canon, yet he clearly recognises the fact that the prince sought to travel 'Beyond the paths and searches of the sun' so as to expand his domains. His codicil that Henry should with all obeisance submit it to his father's throne is a steady reminder, however, that the prince should remember who is king.

Jonson continues in the educational vein:

> His acts must be to govern and give laws
> To peace no less than arms. His fate here draws
> An empire with it, and describes each state
> Preceding there that he should imitate.
>
> (169–72)[143]

Jonson is quick to remind Henry that his British heritage already provides him with an empire, and he proceeds to extrapolate on the merits of this imperium:

> Here are kingdomes mixed
> And nations joined, a strength of empire fixed
> Conterminate with heaven; the golden vein
> Of Saturn's age is here broke out again.
>
> (333–6)

His doing so seems almost to suggest that should the prince fail in any overseas venture, he has still his imperium to come home to. That failure is not deemed to be likely, however, as Henry's contributions to naval reform are duly praised:

> The wall of shipping by Eliza made,
> Decayed (as all things subject are to fade),

> He hath new built, or so restored that men
> For noble use prefer it afore then
>
> (343–6)

and the military heritage reflected: 'Is this the land of Britain so renowned For deeds of arms, or are their hearings drowned, That none do answer?' (369–71).[144] The potential for glory is, however, of prime concern, with Jonson envisaging Henry's aptitude for conquest:

> Whilst you sit high,
> And led by them behold your Britain fly
> Beyond the line, when what the seas before
> Did bound, shall to the sky then stretch his shore.

The problem faced by Jonson was this dual loyalty he had to overcome, praising both king and prince. Europe was in a delicate situation following the assassination of Henri IV of France, and James would not have been comfortable with his heir proclaiming himself the leader of British Protestantism at its most militant revived. Despite the negotiations with the Duc de Bouillon and the Palatine marriage, James was committed to balancing this with a Catholic marriage for Henry.[145] As the tone of his later masques suggests, however, Jonson was not comfortable with the promotion of the prince's imperial vision, being perhaps forced into it by Henry for the *Barriers*.

TETHYS FESTIVAL

In a similar vein, Samuel Daniel's masque for the queen, *Tethys Festival, or the Queen's Wake* (5 June 1610) illustrates how both he and Anne wished her son to think not of ranging overseas but staying very much at home.[146] Indeed there is reference to the Tudor heritage in the masque, with Milford Haven referred to as

> The happy port of union, which gave way
> To that great hero Henry and his fleet
> To make the blessed conjunction that begat
> A greater and more glorious far than that.
>
> (127–30)

This is, however, the extent of its vision. It is James, not his son, who is called 'great monarch of Oceanus' (133) in this masque. The concession to Henry here, as in the *Barriers*, lay in the recognition of martial aspirations – albeit contained. Pertinent to this aim to channel Henry's energies are the gifts presented in Daniel's masque to the young prince from his mother, a sword and a scarf.

In presenting the sword, the narrator comments how the queen has instructed Zephyrus (Prince Charles) to turn to Henry:

> And therewithal she wills him greet the Lord
> And Prince of th'isles, the hope and the delight
> Of all the northern nations, with this sword,
> Which she unto Astraea sacred found,
> And not to be unsheathed but on just ground.
>
> (136–40)

The sword apparently used in that peroformance of June 1610 is still extant, though the connection between blade and masque has not been made until now. The hilt, probably of English workmanship, bears elaborate decoration, with heads of Roman emperors on the pommel and *quillons*. The blade, fashioned by Clemens Horn of Solingen, has the inscription 'ASTREE SACRVM' engraved on it in two places. Along with a celebration of imperial Rome, this clear allusion to the goddess of justice epitomises the prince's thinking, and represents the continuation of the Astraea myth of the return of the Golden Age. Here we can appreciate the gulf which separated the aspirations of the prince from those of his mother. If the sword used in the masque was indeed the Clemens Horn sword, decorated with the trappings of Roman imperial iconography, then it was not enough for the young Prince to have such an item as a mere toy, a substitute for real imperial glory.[147]

The sword was but one of two gifts, however. The other was a scarf given to Henry by the masquers:

> Wherein he may survey
> Infigured all the spacious empery
> That he is born unto another day
> Which, tell him, will be world enough to yield
> All works of glory ever can be wrought.
> Let him not pass the circle of that field,
> But think Alcides' pillars are the knot;
> For there will be written the large extent
> Of these my waves and wat'ry government
> More treasure and more certain riches got
> Than all the Indies to Iberus brought:
> For Nereus will by industry unfold
> A chemic secret, and turn fish to gold.
>
> (143–55)

Staying at home and encouraging the fishing industry was hardly the prospect envisaged by a prince with plans for further discovery in the New World, and harassment of Spain. If the masque did celebrate Britain's glory through the ancient motif of the river nymphs, it was not a vision which Henry shared.[148]

OBERON, THE FAIRY PRINCE

William Trumbull states that the masquers in *Oberon, the Fairy Prince* – performed on New Year's Day 1611 – appeared 'as Roman emperors are represented'.[149] The masque looks to the Tudor heritage of the Stuarts, especially relevant to the Prince of Wales, but it moves decisively away from glorification of Henry on his own terms to those of his father. The masque's vision is insular, and if the entry of the Prince was 'akin to a Roman imperial triumph', it seems that he is almost a prisoner in his own kingdom: there is an interesting use of the past tense in the lines 'Yonder with him live the knights Once the noblest of the earth' (110–11). Of the masque, Graham Parry has written: 'It may be that as a result of the murder of Henri IV and the defusing of the larger European conflicts that followed, Prince Henry's impetus to embark on some idealistic project of godly war or colonisation diminished and *Oberon* is the expression of a heroic youth temporarily becalmed'. Yet he fails to appreciate both the fact that the conflicts in Europe were not pacified by the death of Henri IV but exacerbated by it, as the Thirty Years War would reveal; and that it is possible that James was placing a firmer grip on his son's public behaviour. Henry had wanted to ride a horse in *Oberon* but was denied permission from his father.[150] Lines such as

> That all that shall tonight behold the rites
> Performed by princely Oberon and these knights
> May without stop point out the proper heir
> Designed so long to Arthur's crowns and chair
>
> (295–8)

have the element of chivalry, the reference to the rites of 'these knights' qualified, however, by obeisance to the fact that King James is awkwardly figured as Arthur.[151]

THE MASQUE OF FLOWERS

Two later masques took as their subject material the new worlds being discovered overseas and their purported riches. The anonymous *Masque of Flowers* was performed by the gentlemen of Gray's Inn in the Banqueting House at Whitehall on Twelfth Night, 1613 for the marriage of Robert Carr and Frances Howard.[152] The Device of the masque talks of 'the Sun, willing to do honour to a marriage between two noble persons of the greatest island of his universal empire'.[153] Its content is extremely revealing, not so much in terms of its Americanisms, but in marked contrast with *The Tempest*'s lack of them. Perhaps the most interesting of the American references, in that it is the most obscure, is the character of Kawasha. He is a comic figure representing tobacco in the debate with Silenus, who represents alcohol. In the anti-

masque they debate the merits of each vice with song and dance, a topical matter given King James's thoughts on tobacco. Yet Silenus notes that Kawasha 'is come from a far country To make our noses a chimney' (211–12) and the character indeed has a distinct native American pedigree.

It is interesting to compare Kawasha in the masque with the description of 'Kiwasa' in *Purchas his Pilgrimage* (1613): 'Their Idol called *Kiwasa*, is made of wood fower foote high, the face resembling the inhabitants of Florida, painted with flesh colour, the brest white, the other parts blacke, except the legges which are spotted with white; hee hath chaines or strings of beades about his necke'. In the masque Kawasha enters 'borne upon two Indians' shoulders attired like Floridans' (166–7) and his physical description is quite specific: 'His body and legs of olive-colour stuff, made close like the skin; bases of tobacco-colour stuff cut like tobacco leaves, sprinkled with orsidue; in his hand an Indian bow and arrows' (176–9).[154] The text of the masque is so specific as to point to the writer having seen the drawings of John White and Jacques Le Moyne de Morgues, specifically the depiction of Kawasha on the frontispiece of Hariot's 1590 *Briefe and true report*.[155] What emerges is the idea of the character as being a composite formed from several of the descriptions and illustrations of the Virginia colony.

It is, however, in the conclusion, as the assembled singers turn to address the king, that we find the masque's vision of greatness of the newly reformed Britain:

> *Cantus IV*
> All things return with time,
> But seldom do they higher climb;
> Yet virtue sovereign
> Mends all things, as they come again.
> This isle was Britain in times past,
> But then was Britain rude and waste;
> But now is Britain fit to be
> A seat for a fifth monarchy.

(376–84)

The Fifth Monarchy, the last of the five great empires referred to in the biblical prophecy of Daniel (II.44), followed on from the reigns of gold, silver, brass and iron. It connects with the conceit of the return of the Golden Age, but it also turns away from that idea, looking not to an earlier age of prosperity but to the last great age to come, concluding with an emphatic espousal of the reborn Britain's future imperial destiny.[156] In fact, this masque is not alone in mentioning the metallic ages at this time. In 1612–13 Thomas Heywood's *I The Iron Age* and *II The Iron Age* were staged, concluding parts to his earlier *The Brazen Age* (1610–11) and *The Silver Age* (1610–12). In 1613 Joseph Hall wrote that King James, 'like another *Augustus*, before the second comming of

CHRIST hath becalmed the world and shut the iron gates of warre'.[57] Significant here is not only the reference to Augustus Caesar, but the use of 'iron gates' at a time when the image of the return of the Golden Age to triumph over those of Brass and Iron ages was so strong.

THE MEMORABLE MASQUE

Less than six weeks after the *Masque of Flowers*, Chapman too was figuring a piece in which elements of the American plantation could be colourfully brought onto the streets of London. Written for the Palatine marriage *The Memorable Masque* is preoccupied with sun worship and gold, suggesting a greater affinity with Guiana.[58] On the stage is a rock veined with gold whose summit is also golden. As the priests of the sun enter, this metallic peak opens, revealing the Virginians sitting in a gold mine. Behind them the sun sets in the sky, being the time of their sun worship. Of course it is James who is personified as the sun, Eunomia telling the Virginian princes to renounce superstition and look to 'this our Briton Phoebus' (599) for an example of a true object of admiration. However, the fact that the sun is figured as setting, not rising, may well emphasise that it is the prince to whom this display is most relevant.

The masque is not alone in figuring the wealth to be obtained from a Guiana expedition. In Dekker's *The Whore of Babylon* the King of Spain boasts:

> The Indian and his gold are both my slaves.
> Upon my sword, as on the axletree,
> A world of kingdoms move; and yet I write
> *Non sufficit*. That lusty son of Jove
> That twelve times showed himself more than a man
> Reared up two pillars for me, on whose capitals
> I stand Colossus-like striding o'er the seas
> And with my head knock at the roof of heaven.
>
> (I.ii.94–101)[59]

The idea of the Spanish king astride the imperial pillars and yet not content with his possessions (*non sufficit*) would have been highly emotive. Other references occur in Rowley's *A Shoe-Maker, A Gentleman*, where Hugh claims 'Could I give Indian Mines, they all were yours' (IV.ii.160) and in *Tom a Lincoln*: 'Were yt not for him wee showld surpasse in wealth The Indian Monarch for he keeps a tree of purest gowld, was once posest by mee' (1852–4).[60]

Though it assures the spectators of a hoard of wealth (known by 1700 to be non-existent), the *Memorable Masque* synthesises everything positive about the overseas potential of the Americas, as represented in propaganda dating from the earliest period of Elizabethan expansionism. The masque is quite explicit

in the manner in which it deals with imperial ideas: we are told that 'Poets (our chief men of wit) answer that point directly, most ingeniously affirming that this isle is (for the excelling of it) divided from the world (*divisus ad orbe Britannus*) and that, though the whole world besides moves, yet this isle stands fixed on her own feet and defies the world's mutability' (285–90). As Britain is a distinct island territory, so too is the Virginian island which floats across the sea towards Britain: 'In which island (being yet in the command of the Virginian continent) a troop of the noblest Virginians inhabiting, attended hither the god of riches' (299–302). Honour crosses 'The Briton ocean' (480), we are told that of the unity of love and beauty 'thus the golden world was made' (652) – referring to the Palatine marriage, a triumph for militant Protestantism – and, in the form of the benediction, Honour announces: 'may the blessings of the golden age Swim in their nuptials' (656–7). Not only has Britain become united at home, and is gaining glory from her ability to pass on her blessings to those living in erstwhile ignorance of the true religion, but the ocean is now recognised as being part of her preserve too.

THE MASQUE OF TRUTH

We do not know who wrote the last Jacobean masque of this period to comment directly on the politics of British imperialism. It was never performed: but there is a strong probability that it was based on a draft prepared by Henry himself as a contribution to the festivities surrounding the marriage of his sister. The *Masque of Truth* is certainly the most militant of the masques. It explicitly advocates a dynamic Protestant foreign policy, presenting the marriage of the Princess Elizabeth to the Elector Palatine as a means towards the conversion of the Catholic monarchies of Europe to the true faith. As Norbrook notes, the major difference between this and other masques is that whoever was the author of the *Masque of Truth* makes no effort to control overt religious imagery and political comment, the symbolism being apocalyptic, rather than classical or mythological; and there is little sense in which it represents the monarch as one with divine overseeing power. Here, the theme is of European reconciliation in religion, but on British terms.[161]

The idea behind the plot is that the Catholic states of Europe are called upon to enter into the chosen kingdom of Britain wherein may be found the true religion.[162] The muses in the masque urge these states, figured by masquers:

> Voue Empires & Republiques,
> Amenez tous vos heretiques
> Aux pieds de ceste VERITE.
> Assin qu'ayant sa cognoissance
> Ils soynt touchez de Repentance,
> Et recherchent la Pureté.

This they do, but here – instead of the masque closing with some form of homage to the king – a very different scene takes place:

> Et lors soudain le MONDE s'ouvrant en deux, & disparoissant, l'on vit comme vn PARADIS: au devant du quel estoit vng Ange avec vne Espée flambāte & vne teste de mort à ses pieds: mais la Verité assise au milieu de plusieurs Estoilles, Anges & Cherubins. Qui avec l'armonie de Violes, de Luths, & de Voix, inviterent ces Roynes & leur suite, d'entrer en leur PARADIS.[163]

The apocalyptic nature of this scene is immediately apparent, the Archangel Michael complete with flaming sword, standing at the entrance to Paradise, with its stars, angels and cherubim, and voices singing to a musical accompaniment. Truth's apocalyptic song overcomes death and leads all nations from the earth to their final home. The trope is unique within a Stuart masque, though hardly tactful, with the powerful French and Spanish states being depicted as proselytes to the British religious cause. Henry's death may have been the prime reason why the masque was never performed, but it may also have been the victim of royal suppression.[164]

An aspect of the imperial thinking behind the *Masque of Truth*, and one also present in *Cymbeline*, is the idea that Britain is no longer a 'world separated from the world'. In the masque the idea of British insularity is dead, while separation and isolation from the rest of Europe is pictured as a weakness to be remedied by strong moves towards alignment with the Calvinist Palatinate. Norbrook notes that the huge globe around which the masque takes place may have been a compliment to Frederick, whose coat of arms bore a golden globe. The masque may thus be seen in the light not just of a dynastic marriage, but part of a movement towards religious reformation in Europe. On the other hand, however, the division is still drawn between Britain, which has the true religion, and other European states which do not.

What the masque in fact suggests is that it is not a question of whether Britain is divided from the world, but the fact that *the world is divided from Britain*. Britain separated from the rest of the world as the 'Fortunate Isles' continued as an imperial motif well after 1613, as indicated by the title of Jonson's *The Fortunate Isles and their Union*, published in 1625. Yet, appropriately, at Henry's death it was an image to which Christopher Brooke turned: 'Brittaine was whilome knowne (by more than fame) To be one of the Ilands fortunate'.[165] As noted in Chapter 4 (below), some of the apocalyptic imagery of *The Masque of Truth* occurs in Webster's mayoral pageant of 1624, *Monuments of Honor*. Not surprisingly, the culmination of that show features Henry Stuart, his status as a British Protestant icon assured.

CONCLUSION

Henry, dying and in great pain, is said to have called for Sir David Murray, 'the onely man in whom hee had put choise trust' on the evening of 5 November to burn a number of letters in a certain cabinet in the royal closet; and contemporary rumour had it that Henry's papers 'shewed him to have many straunge and vast conceits and projects'.[166] Whatever speculation may devolve from this, Henry did have plans which would in all likelihood have brought Britain into conflict with Spain at some point. He was not, however, a *cause* of conflict. He was a catalyst. Theatre had been a place in which all the sense of glory and excitement of Henry's schemes had been displayed and we might excuse Webster's choice of words when mourning him: 'Wee stood as in some spacious Theater Musing what would become of him'.[167] With the navy at his hand and the feelings of his people geared towards a strong dislike of Spain, he would have had the means to undertake such an attempt at empire so as indeed, in Rowley's words to 'circumscribe the world'. Had Henry's vision of Britain's future been his alone, or that of a select group of people among the political élite in Britain, hopes of imperial greatness and feelings of national assertiveness would have died a quick death along with the prince. The elegies written in his memory tell a different story, because those who wrote espousing this militancy in the country looked to new leaders.

But they did so where historiography traditionally paints a picture of dark times, years of corruption, of the Overbury murder, the Somerset marriage, the rise of Gondomar and the fall of James Stuart into dependency on first one favourite and then on another, eminently more capable one.[168] The latter half of James's reign saw the drive for a more aggressive form of national identity lose some momentum as thinking on the subject became more complex. The ideas brought together in Henry's last years were still current but, without any clear leader to advocate them, they began to show a satirical edge.

NOTES

1 A remark about Prince Henry made by the French Huguenot, Lesdiguières, recorded in Roy Strong, *Henry, Prince of Wales and England's Lost Renaissance* (London: Thames and Hudson, 1986), p. 67.

2 *CSP Venetian*, XII (1610–1613) par. 692; See Mervyn James, *Society, Politics and Culture. Studies in Early Modern England* (Cambridge University Press, 1986), pp. 308–465.

3 *Ibid.*, p. 392.

4 J. W. Williamson, *The Myth of the Conqueror. Prince Henry Stuart: A Study of 17th Century Personation* (New York: AMS Press, 1978), pp. 78–9. It is not paradoxical when comparative studies are undertaken. See, for example, Mary Fulbrook, *Piety and Politics: Religion and the Rise of Absolutism in England, Württemberg and Prussia* (Cambridge University Press, 1983), esp. ch. 8 and Blair Worden, *The Sound of Virtue: Philip Sidney's*

Arcadia *and Elizabethan Politics* (Yale University Press, 1996).

5 See Chapter 2 above and Tristan Marshall, 'English public opinion and the 1604 peace treaty with Spain' (forthcoming). Henry's advocation of anti-Habsburg policies and military preparedness coincided with his interest in Tacitus. See Thomas Birch, *The Life of Henry Prince of Wales* (London, 1760), p. 121; J. H. M. Salmon, 'Seneca and Tacitus in Jacobean England' in Linda Levy Peck (ed.), *The Mental World of the Jacobean Court* (Cambridge University Press, 1991), pp. 177–8; and Malcolm Smuts, 'Court-centred politics and the uses of Roman historians, c.1590–1630' in Kevin Sharpe and Peter Lake (eds), *Culture and Politics in Early Stuart England* (London: Macmillan, 1994), pp. 21–43. Smuts has noted (p. 37) that 'a Tacitean outlook, with its emphasis on the role of deception and conspiracy in politics, was highly compatible with fears of Spanish intrigues and infiltration of the English court'.

6 Timothy V. Wilks, 'The Court culture of Prince Henry and his circle 1603–1613' (Unpublished Oxford DPhil thesis, 1987), p. 52. Only very recently has any revision at all been made to the view of Henry being a pawn of others: see Pauline Croft, 'The parliamentary installation of Henry Prince of Wales', *Historical Research* LXV (1992), esp. 181, 185.

7 Andrew Gurr, *The Shakespearean Stage 1574–1642*, 3rd edn (Cambridge University Press, 1992), p. 165.

8 Nicholas Morgan, *The Perfection of horse-manship* (London, 1609), sig. A4ᵛ. George More, *Principles for yong Princes* (London, 1611).

9 William Fennor, in his *Pluto his travailes* (London, 1611) describes Henry (sig. A2ʳ) as 'Heire apparant to the Imperiall Diadems of England, Scotland, Fraunce, and Ireland'. Anon., *Propositions of War and Peace delivered to His Highness prince Henry by some of his Military servants* in Sir Robert Cotton, *An Answer to such motives As were offer'd by certain Military-Men to Prince Henry, Inciting Him to Affect Arms more than Peace* (London, 1665), sig. B2ᵛ.

10 Barbara N. Lindsay and J. W. Williamson, 'Myth of the conqueror: Prince Henry Stuart and Protestant militancy', *The Journal of Medieval and Renaissance Studies* v (1975), 204.

11 James Cleland, *The institvtion of a yovng noble man* (Oxford, 1607), pp. 35–6 (sigs. E2–E2ᵛ).

12 William Alexander was made a Gentleman Extraordinary of the Privy Chamber in or before 1607. He was knighted sometime between 1608 and 1609.

13 Wilks claims that there is no evidence that Gorges sat in the Privy Council, only evidence that Salisbury was hostile to that ambition yet he provides no convincing proof of this. 'The Court culture of Prince Henry and his circle 1603–1613', p. 3 n.3.

14 Strong, *Henry, Prince of Wales*, p. 41.

15 *Ibid.*, p. 43.

16 Southampton was a shareholder in the East India Company, to which he was admitted in 1609. He invested £41 13s. 4d. in additional stock in the company in 1620 and 1621. He also helped to finance Hudson's last voyage. G. P. V. Akrigg, *Shakespeare and the Earl of Southampton* (London: Hamish Hamilton, 1968), p. 165. Like the prince, the young Henry Wriothesley had divided his time between martial practice and martial study, Camden writing in *Britannia*: 'He, in his youth, fortifies his noble descent with the defence of humane studies and knowledge of the art of war, so that at a riper age he

may pour forth fruits for his country and his sovereign' (quoted in Akrigg, p. 186). See
also Margot Heinemann, 'Rebel lords, popular playwrights and political culture: notes
on the Jacobean patronage of the Earl of Southampton', *The Yearbook of English Studies*
XXI (1991), 63–86.

17 Quoted in Neil Cuddy, 'The conflicting loyalties of a "vulger counselor": the third Earl of
Southampton, 1597–1624' in John Morrill, Paul Slack and Daniel Woolf (eds), *Public
Duty and Private Conscience in Seventeenth Century England* (Oxford: Clarendon Press,
1993), p. 139.

18 See Charles H. Firth, 'Sir Walter Raleigh's History of the World', *Proceedings of the
British Academy* VIII (1917–18), 430–31.

19 Quoted in Wilks, 'The Court culture of Prince Henry and his circle 1603–1613', p. 78.

20 William Willymat, *A loyal subiects looking-glasse, or A good subiects Direction, necessary and
requisite for every good Christian* ... (London, 1604), sig. A2ᵛ. William Alexander, *A
Paraenesis to the Prince* (London, 1604), sig. Bʳ.

21 *Ibid.*, sig. C3ᵛ, sig. C4ᵛ.

22 *Ibid.*

23 Philip de Mornay, *The mysterie of Iniquitie*, trans. Samson Lennard (London, 1612), sig.
¶iijʳ.

24 John Cleland, 'Le pourtraict de Monseigneur le Prince' (British Library MS Royal 16E
XXXVIII). Marcelline, *The Triumphs of King James the First*, sig. A2ʳ.

25 Anon., *The French Herald. Summoning all True Christian Princes to a generall Croisade, for
a holy warr against the great Enemy of Christendome, and all his Slaues* (London, 1611), sig.
A2ᵛ. The author is emphatic that Henry is the only one who can lead such a force: 'If it
be not your selfe ... then I see no Generall in the world, when our Christian Army must
come into the field' (sig. A2ʳ). The text is signed D with a crusader cross within.

26 Edmond Richer, *A Treatise of Ecclesiasticall and Politike Power* (London, 1612), sig. A4ᵛ.

27 *Ibid.*, sig. B1ʳ.

28 William Crashaw, *Sermon Preached at the Cross* (London, 1608), sig. ¶2ᵛ.

29 Quoted in Strong, *Henry, Prince of Wales*, p. 10.

30 Henry Peacham, *Minerva Britanna or a Garden of Heroicall Deuises, furnished and
adorned with Emblemes and Impresas of sundry natures, Newly devised, moralized and
published* (London, 1612), p. 17.

31 Alexander, *A Paraenesis to the Prince*, sig. C4.

32 Marcelline, *The Triumphs of King James*, pp. 72–3 (sigs. M2ᵛ–M3).

33 J. S. A. Adamson, 'Chivalry and political culture in Caroline England' in Kevin Sharpe
and Peter Lake (eds), *Culture and Politics in Early Stuart England* (London: Macmillan,
1994), p. 169.

34 On popular martialism see Tristan Marshall, '"That's the misery of peace":
representations of martialism in the Jacobean public theatre, 1608–1614', *The Seven-
teenth Century* XIII (1998), 1–21. John Stowe, *Annales, or a General Chronicle of England.
Begun by John Stowe ... Continued ... until 1631*, ed. Edmund Howes (London, 1631);
pagination is erratic. G. B. Harrison quotes the passage in his *A Second Jacobean
Journal. Being a record of those things most talked of during the years 1607 to 1610* (London:

Routledge and Kegan Paul, 1958), p. 211. On the annual artillery sermons see John Hale, 'Incitement to violence? English divines on the theme of war 1578 to 1630' in J. R. Hale, *Renaissance War Studies* (London: Hambledon Press, 1983), pp. 487–517. I am grateful to Patrick Collinson for this reference.

35 Henry's library contained many of the most important books of the day on the subject of exploration. He had copies of Cornelius Wytfliet's *Histoire des Indes Occidentales* (Douay, 1607), Girolamo Benzoni's *Novi Orbis Historia* (Genoa, 1600), early editions of Jesuit missionary letters from Japan as well as Joseph de Ariosta's *De Natura Novi Orbis* (Cologne, 1596), a proto-cultural anthropological study of the New World. See T. A. Birrell, *English monarchs and their books: from Henry VIII to Charles II* (London: The British Library, 1987), pp. 30–40, esp. p. 40. For a related discussion of those scholars at Henry's court whose interests lay in the science of geography, see Lesley B. Cormack, 'Twisting the Lion's tail: practice and theory at the court of Henry Prince of Wales' in Bruce T. Moran (ed.), *Patronage and institutions. Science, technology and medicine at the European court 1500–1750* (New York: Boydell, 1991), pp. 67–83.

36 Wilks, 'The Court culture of Prince Henry', p. 21.

37 Parry, 'The politics of the Jacobean masque', p. 104. Graphic naval imagery occurs in Willymat's *A loyal subiects looking-glasse*: the dropped capital letter T on sig. A4r has a Triton with trident and sea-horses.

38 Michael Drayton, *Poly-Olbion* (London, 1612). Of note is the significance of the Welsh subject material of *Poly-Olbion*. This may well be further honouring of Henry's unofficial patronage. Lindsay and Williamson note that, of the elegies published in Latin in 1612 by the universities of Oxford and Cambridge: 'A fairly sizeable number took advantage of the fact that Henry as a patron of the Virginia plantation had adopted for his slogan the words of Aeneas: *Et nos fas extera quaerere regna* (it is right that I too seek foreign kingdoms), but they go on to indicate that 'at no time are the words *extera quaerere regna* (inviting as they might appear for such a purpose) construed to mean the seeking of foreign kingdoms on the continent, possibly because they were firmly linked with Virginia in the contemporary mind' (Lindsay and Williamson, 'Myth of the conqueror', p. 216). They fail to consider that the continued development of the Virginia colony, however, still makes the motto relevant. I think it unlikely that Henry ever entertained realistic notions of British imperial possessions in Europe, and there is no record of any of those closest to him having made reference to such concerns. Instead, we have evidence such as the letter written on 27 February 1613 to Lord Gray from Sir John Holles, in which he claims that Henry was 'wise, just and secret' and that 'all actions profitable or honourable for the kingdom were fomented by him, witness the North West passage, Virginia, Guiana, The Newfoundland, etc., to all of which he gave his money as well his good word' (Strong, *Henry, Prince of Wales*, p. 8).

39 BL. Add. MS 30075.

40 See Strong, *Henry, Prince of Wales*, p. 60.

41 Edward Wright, the prince's librarian, in his dedication to his *Certaine Errours in Navigation* (1611) writes of the voyages of colonisation: 'for the discouerie of strange and forraine lands and nations unknowne, whereby the poore people living in darknesse and in the shadow of death ... may in short time grow to some acquaintance and familiaritie with this our Christian world, and in the end come to the saving knowledge of the true God'. The relation of Henry's progress *en route* to his investiture as Prince of Wales in Anthony Munday's *London's love to the royal prince Henrie* (London, 1610) notes

that the firing of cannon played its part in that celebration (pp. 24–5) and the text bears two pictures of ships (sigs. A1 and A1ᵛ). Naval matters did not run as smoothly as Henry would have liked, however. The launch of the *Prince Royal* – which eventually took place at 2 a.m. on 25 September 1610 – was a fiasco, the rest of the royal party having left in disgust when the ship stuck fast as it was launched, with only Henry and a few close followers returning for the next high tide to see the matter through.

42 *CSP Venetian*, XII (1610–1613) par. 355.

43 *CSP Domestic 1611–1618*: 'Nov 8 Westminster: Warrant for felling 1,800 oaks for the Royal Navy in the New Forest, Shotover, Stowe Wood, and Barnwood' (p. 85), 'Nov 8 Warrant for felling 2,000 loads of crooked timber for the Royal navy, in cos. Norfolk, Suffolk, Essex, Kent, Sussex, Harts, Berks, Bucks, and Oxford, besides 200 trees out of the manor of Sunning, co Berks' (p. 86). See also *ibid.*, p. 99. On the Munster timber acquisitions, see David B. Quinn, 'The Munster plantation: problems and opportunities', *Journal of the Cork Historical and Archaeological Society* LXXI (1966), 37.

44 *CSP Venetian*, (1610–1613), par. 404.

45 *Ibid.*, par. 428, dated 4 February 1612.

46 The two men were real life criminals, commemorated in a tract and ballad in 1583. See Heinemann, 'Rebel lords, popular playwrights, and political culture, 74.

47 Quoted in Strong, *Henry, Prince of Wales*, p. 61.

48 On the idea of a Christian empire, note the hope expressed by Pierre Erondelle: 'For who may better support, and manage magnanimous actions, such as be the peopling of lands, planting of Colonies, erecting of ciuill Gouernementes, and propagating of the Gospell of Christ, (which are Royall and Princely foundations) than those whom the King of Kings, hath established as Atlasses of kingdoms & Christian common weales?' and 'Christian charitie inuiteth you to be cheife worker in the sauing of millions of soules: The necessitie of your Countrie of Great BRITAINE, (ouer populous) doth require it: And lastly your poore Virginians doe seeme to implore your Princely aide, to helpe them to shake of the yoke of the diuel, who hath hitherto made them liue worse then beasts'. Marc Lescarbot, *Nova Francia*, trans. Erondelle (London, 1609), sig. ¶¶ᵛ.

49 'The Prince has put some money in [the Virginia Plantation], so that he may, some day, when he comes to the Crown, have a claim over the Colony'. *CSP Venetian* XI (1607–1610), par. 449.

50 Williamson, *The Myth of the Conqueror*, p. 57. By the end of the first decade of James's rule it was becoming increasingly evident that the only way Britain could afford a war was through co-operation with mercantile enterprise. As Adams notes, it was an idea born during the war with Spain in the 1590s, with the Spanish Indies being seen as the battleground and the interception of the Silver Fleet as the prize: 'It was for such a campaign, combined with a land attack on the Spanish Netherlands – and not a simple open season for privateers – that parliamentarians like Sir Dudley Digges and John Pym in November 1621 or Sir John Eliot in March 1624 called, when then advocated a "war by diversion".' See Simon Adams, 'Spain or the Netherlands? The dilemmas of early Stuart foreign policy' in Harold Tomlinson (ed.), *Before the English Civil War* (London: Macmillan, 1983), p. 81, p. 83.

51 Williamson, *The Myth of the Conqueror*, p. 51. 'Those who are interested in this Colony show ... that they wish to push this enterprise very earnestly and the Prince of Wales lends them very warmly his support and assistance towards it' (Don Alonso de Velasco

to King Philip, 14 April 1612, quoted in *ibid.*, pp. 169–70).

52 De la Warre returned home to England ill, and Dale was replaced when Sir Thomas Gates arrived at the colony in August 1611. Dale succeeded Gates in 1614. See Sir Thomas Dale's entry in the *DNB*.

53 Ralphe Hamor, in his *A true discourse of the present estate of Virginia* (London, 1615) noted (sig. E3ʳ) that Henrico was founded by Gates from seven acres of land: 'In honour of the noble Prince Henrie (of euer happie and blessed memory, whose royall heart was euer strongly affected to that nation)'.

54 The charter is quoted in *The Voyages of Captain Luke Foxe and Captain Thomas James in Search of a North-West Passage*, ed. Miller Christy (London: Hakluyt Society, 1894), vol. II, p. 644.

55 *CSP Venetian* XII (1610–1613), pars. 373, 404.

56 See Louis B. Wright, 'Colonial developments in the reign of James I' in Alan G. R. Smith (ed.), *The Reign of James VI and I* (London: Macmillan, 1973), pp. 126–7. Along with another of those supportive of the prince's ventures, Christopher Brooke, Roe was one of five men charged with drafting a constitution for Virginia. The others were John Selden, Edward Herbert and Philip Jermyn.

57 Sir Charles Cornwallis, *A Discourse of the most Illustrious Prince, HENRY* (London, 1641), sigs. C3ʳ and C3ᵛ.

58 See Tristan Marshall, 'The idea of the British empire in the Jacobean public theatre, 1603–c.1614' (Cambridge PhD, 1995), pp. 143–4, 219–20. John Davies, *Microcosmos. The Discovery of the Little World, with the Government thereof* (Oxford, 1603), sig. G2. The anagram HENRICVS FREDERICVS STEVARTVS to ARTHVRI IN SEDE FVTVRVS CRESCIS was also coined by those seeking to divine the prince's destiny. The fact that Henry came to England already bearing the title 'Lord of the Isles' gave a predestined ring to his position as heir to the thrones united by his father's person. On the ancient title see John Bannerman, 'The Lordship of the Isles' in Jennifer M. Brown [Wormald] (ed.), *Scottish Society in the Fifteenth Century* (London: Edward Arnold, 1977), pp. 209–40.

59 Tristan Marshall, '*The Tempest* and the British imperium in 1611', *Historical Journal* XLI (1998), 375–400.

60 Josephine Waters Bennett, 'Britain among the Fortunate Isles', *Studies in Philology* LIII (1956), 114.

61 William Harbert, *A Prophesie of Cadwallader* (London, 1604), sig. H4.

62 Bennett, 'Britain among the Fortunate Isles', 117.

63 *Ibid.*, 121.

64 John Russell, *A Treatise of the Happie and Blissed Unioun* (1604) in Bruce Galloway and Brian Levack (eds), *The Jacobean Union: Six tracts of 1604* (Edinburgh: Scottish Historical Society, 1985), p. 101.

65 Bennett, 'Britain among the Fortunate Isles', 116.

66 *A Speach, as it was Delivered in the Vpper Hovse of the Parliament to the Lords Spiritvall and Temporall, and to the Knights, Citizens and Burgesses there Assembled, On Mvnday the XIX. Day of March 1603. Being the First Day of the First Parliament*, in Charles Howard McIlwain, *The Political Works of James I* (Harvard University Press, 1918), p. 272.

67 *A Speach in the Parliament Hovse, As neere the very words as covld be gathered at the instant* (1605) in McIlwain, *The Political Works of James I*, p. 281.

68 Thomas Dekker, *The Whore of Babylon*, ed. Marianne Gateson Riely (New York: Garland, 1980).

69 Francis Bacon, *The Letters and the Life of Francis Bacon*, ed. J. Spedding (London, 1868), vol. IV, p. 119.

70 Jonathan Goldberg, *James I and the Politics of Literature. Jonson, Shakespeare, Donne and Their Contemporaries* (Baltimore: Johns Hopkins University Press, 1983), p. 46.

71 Hulme, *Colonial Encounters*, p. 124.

72 Johnson, *Nova Britannia*, sig. Cr.

73 *A Speach to both the Houses of Parliament, Delivered in the Great Chamber at White-Hall The last Day of March 1607*, in McIlwain, *Political Works*, p. 305.

74 Its sole editor, G. R. Proudfoot, does not establish the authorship, though the Sotheby's sale catalogue description written by P. J. Croft has it as one of the unknown plays by Heywood. See Anon., *Tom a Lincoln*, ed. G. R. Proudfoot (Oxford: Malone Society Reprints, 1992). The allusion to *The Winter's Tale* is at lines 206–7 when Time relates how sixteen years have passed: 'thinke the babe hath fully passed sixteen years of age'. Compare with Shakespeare's use of his character Time who notes: 'Impute it not a crime To me, or my swift passage, that I slide O'er sixteen years' (IV.i.4–6). The reference to *The Tempest* is in Caelia's description of a storm seen from afar: 'Then did I shout, & Cry flamde all the beacons, filde each place with fire' (2729–30). Compare with Ariel's 'Now in the waist, the deck, in every cabin, I flamed amazement' (I.ii.197–8). See also Muriel C. Bradbrook, 'A new Jacobean play from the Inns of Court', *Shakespearean Research and Opportunities* VII–VIII (1972–4), 1–5. Proudfoot has written (p. xxiv) that 'Its self-parodying heroics, smart cynicism and adolescent sexual humour are not at all difficult to reconcile with the notion that *Tom a Lincoln* was written as a Christmas entertainment for one of the Inns of Court'.

75 See Patrick Collinson, '*Bartholomew Fair*: the theatre constructs Puritanism' in David L. Smith, Richard Strier and David Bevington (eds), *The Theatrical City: Culture, Theatre and Politics in London, 1576–1649* (Cambridge University Press, 1995), pp. 160–63 and Patrick Collinson, *The Religion of Protestants* (Clarendon Press: Oxford, 1982), p. 145.

76 David Norbrook, *Poetry and Politics in the English Renaissance* (London: Routledge and Kegan Paul, 1984), p. 202.

77 In the play the strength of Roman power is not totally forgotten. Guinivere notes that among Arthur's victories was one over 'the lofty Romanes whoe excell in feats of armes as historyes can tell' (2901–2).

78 For the significance of the pillars as an imperial motif see chapter 1 above.

79 John Webster, *A Monvmental Colvmne, Erected to the liuing Memory of the euer-glorious* HENRY, *late* Prince of Wales (London, 1613), sig. B.

80 For the prince's armour see Strong, *Henry, Prince of Wales*, plates 18–23. Henry is depicted practising with the pike in the frontispiece to Drayton's *Poly-Olbion* (1612).

81 The Royal Shakespeare Company's production of *The White Devil* ran from 17 April to 5 October 1996, directed by Gale Edwards.

82 Mulryne, '"Here's Unfortunate Revels": war and chivalry in plays and shows at the time of Prince Henry Stuart', pp. 186–7.

83 Arthur B. Ferguson, *The Chivalric Tradition in Renaissance England* (Washington: Folger Books, 1986), p. 143.

84 The theatre of the last years of Elizabeth's reign had seen such plays as the anonymous *A Larum for London* (c.1598–1600) and Robert Wilson's *The Cobbler's Prophecy* (c.1589–1593) represent the dangers of peace and the need for military preparedness. Equally, chronicle plays such as Peele's *Edward I* (1591) and the anonymous *Edmund Ironside* both have warrior–king figures as heroes, threatened by Spanish treachery or papal clergy. Heinemann noted of *The Cobbler's Prophecy* that it 'is remarkable for the emotional power with which it represents a national *disunity* that almost allows foreign invasion to succeed'. The cobbler of the title not only succeeds in warning the nation of the danger of the imminent invasion but also warns of the coming Day of Judgment. See Margot Heinemann, 'Political drama' in A. R. Braunmuller and Michael Hattaway (eds), *The Cambridge Companion to English Renaissance Drama* (Cambridge University Press, 1990), p. 175.

85 Michael Hattaway, 'Blood is their argument: men of war and soldiers in Shakespeare and others' in Anthony Fletcher and Peter Roberts (eds), *Religion, culture and society in early modern Britain: Essays in honour of Patrick Collinson* (Cambridge University Press, 1994), p. 101.

86 R. A. Gent, *The Valiant Welshman, or the True Chronicle History of the life and valiant deedes of Caradoc the Great, King of Cambria, now called Wales* (London, 1615). It was not, however, the first play in the Jacobean period to take chivalry as its theme. Beaumont's *The Knight of the Burning Pestle*, first performed c.1607 is foremost a pastiche on the Spenserian chivalric ideal, in which the servant Rafe takes on the mantle of knighthood, praising those knights who 'neglecting their possessions, wander with a squire and a dwarf through the deserts to relieve poor ladies'. His vision of knight errantry is ahistorical, optimistic and ridicules the absence of traditional, romantic knightly *mores* from many of those bearing the title as a result of James's widespread sale of the honour (1161 men were newly raised to knighthood by the end of James's first year in England). *Eastward Ho!* had done the same in 1604, with the newly knighted Sir Petronel Flash the subject of derision, but Beaumont's play differs from the latter in that it was a flop in the theatre. See Ben Jonson, George Chapman and John Marston, *Eastward hoe* (London, 1605) in C. H. Herford and P. and E. Simpson (eds), *Ben Jonson* (Oxford: Clarendon Press, 1952), vol. IV, V.i.29–46. With the success of other plays which comment on the idea of knighthood in the early Jacobean period, and the fact that if *The Knight of the Burning Pestle* is not Beaumont's best play, it is not totally without merit, it is tempting to surmise that the lack of success was due to its overstepping the mark in its ridicule of the martial life. However much it mocks the idea of knightly wanderings in the vein of *Don Quixote*, it nonetheless illustrates the degree to which knighthood had permeated British society by this time, and shows that the subject was very much *au courant*. The tone of the play is thus best described as a sharing of common taste than an outright rejection of the values of chivalry. See Francis Beaumont, *The Knight of the Burning Pestle*, ed. Sheldon P. Zitner (Manchester University Press, 1984). On one of the more dramatic effects of the play's subject material, see David Stevenson, 'What was the quest of the Knights of the Mortar? An indelicate suggestion', *Scottish Historical Review* LXVIII (1989), 182–4. An extremely useful discussion of the play is in Philip J. Finkelpearl's *Court and Country Politics in the Plays of Beaumont and Fletcher* (Princeton University Press, 1990), pp. 81–100.

87 Their names are suggested in Pollard and Redgrave's *Short Title Catalogue*: See 'A, R'.

88 For the title pages see Robert Alleyne, *Funerall Elegies upon the most lamentable and untimely death of the thrice illustrious Prince Henry* (London, 1613), sig. A, and *Teares of joy shed at the happy departure from Great Britaine, of the two Paragons of the Christian world, Fredericke and Elizabeth, prince and princesse Palatines of Rhine* (London, 1613), sig. A2. The *DNB* has no entry for Robert Alleyne, though there is, of course one for the actor Edward Alleyne (1566–1626). He married on 22 October 1592, yet according to the *DNB* had no children. It is interesting to speculate whether Robert was Edward's son from this, or Alleyne's earlier marriage. If from the 1592 marriage, a son could have been twenty years old in 1613, and 22 by the time *The Valiant Welshman* was published. We also know that 'Alleyn's Boy' appeared as a page in a production of *The Battle of Alcazar* in about 1600 or 1601. Had this indeed been the young Robert, following the above timescale he would have been about seven or eight at the turn of the century. See Edwin Nungezer, *A Dictionary of Actors and of Other Persons Associated with the Public Representation of Plays in England before 1642* (New Haven: Yale University Press, 1929), p. 13. Following this line of speculation Edward Alleyne counted among his friends the Earl of Arundel and Sir William Alexander.

89 R. A. Gent, *The Valiant Welshman*, sig. B1r.

90 *Ibid.*, sig. B2r.

91 *Ibid.*, sig. B4r, sig. B3r.

92 See Chapter 2 above.

93 R. A. Gent, *The Valiant Welshman*, sigs. C3r–C3v.

94 *Ibid.*, sig. D1v.

95 *Ibid.*, sig. F1v, sig. F2r, sig. H1r.

96 *Ibid.*, sig. C3v.

97 *Ibid.*, sig. D1.

98 *Ibid.*, sig. H2v.

99 *Ibid.*, sig. D2r.

100 *Ibid.*, sigs. H1v–H2r.

101 *Ibid.*, sig. D2v. The prince had made his position clear regarding bribes when assembling his household. The token which the defeated Claudius exchanges for his freedom from Caradoc is a golden lion medallion, the lion being the royal motif (see Chapter 1).

102 R. A. Gent, *The Valiant Welshman*, sig. C3.

103 *Ibid.*, sig. D3r.

104 William Rowley, [*A Critical, Old-Spelling Edition of*] *The Birth of Merlin (Q 1662)* ed. Joanna Udall (London: The Modern Humanities Research Association, 1991). On the dating of the play see Mark Dominik, *William Shakespeare and 'The Birth of Merlin'* (Oregon, 1991), pp. 163–5.

105 Rowley, *The Birth of Merlin*, ed. Udall, p. 36.

106 William Shakespeare, *King Henry the Eighth*, ed. R. A. Foakes (Arden Shakespeare, 1966). At the close of Rowley's play Artesia makes a thinly veiled threat regarding Uter when she notes that 'Pleasure is like a Building, the more high, The narrower still it grows, Cedars do dye soonest at top' (III.vi.11–13).

107 Rowley, *The Birth of Merlin*, ed. Udall, p. 97.

108 See Chapter 1 above.

109 See John McCavitt, *Sir Arthur Chichester. Lord Deputy of Ireland 1605–16* (Belfast: Institute of Irish Studies, 1998), pp. 149–89; Francis Bacon, *The Letters and the Life of Francis Bacon*, ed. J. Spedding (London, 1868), vol. IV, p. 119; Willy Maley, '"Another Britain"? Bacon's *Certain Considerations touching the Plantation in Ireland* (1609)', *Prose Studies* XVIII (1995), 14. See also Tristan Marshall, 'James VI & I: three kings or two?', *Renaissance Forum* IV:2 (1999), http://www.hull.ac.uk/renforum/v4no2/marshall.htm.

110 Jasper Fisher, *Fuimus Troes Æneid 2. The True Trojanes, being a story of the Britaines valour at the Romanes first invasion* (London, 1633). The title-page notes that the play was 'Publikely represented by the Gentlemen Students of Magdalen College in Oxford'.

111 Henry Lyte, quoted in T. D. Kendrick, *British Antiquity* (London: Methuen, 1950), p. 100.

112 Henry Lyte, *The Light of Britayne. A Recorde of the honorable Originall and Antiquitie of Britain* (London, 1588; reprinted 1814).

113 See the *DNB* entry for Henry Lyte (1529?–1607).

114 Volusenus, reading Caesar's letter demanding tribute, notes that the realm has a single leader: 'By me great *Cæsar* greetes the Britaine state'. *Fuimus Troes*, sig. C.

115 *Ibid.*, sig. A3v.

116 *Ibid.*, sig. A4r. S. L. Adams, 'The road to La Rochelle: English foreign policy and the Huguenots, 1610–29', *Proceedings of the Huguenot Society of London* XXII:5 (1975), 417, 418.

117 *Fuimus Troes*, sig. E2v, sigs. H3–H3v.

118 *Ibid.*, sig. A4v.

119 *Ibid.*, sig. B2r. Michael Drayton, *Poly-Olbion* (London, 1612); Samuel Daniel, *Tethys Festival* in Stephen Orgel and Roy Strong (eds), *Inigo Jones and the Theatre of the Stuart Court*, vol. I (Berkeley and London: University of California Press, 1973). Christopher Brooke, *Two Elegies, consecrated to the never-dying Memorie of the most worthily admyred; most hartily loued; and generally bewayled PRINCE; HENRY Prince of Wales* (London, 1613), sig. E.

120 *Fuimus Troes*, sig. Dv.

121 *Ibid.*, sig. B2.

122 *Ibid.*, sig. C2.

123 *Ibid.*, sig. C2, sig. F3, sig. E3v. William Alexander, *The Monarchick Tragedies* (London, 1604), sig. Aiiiv. William Drummond, *Forth Feasting. A Panegyricke to the kings most excellent majestie* (Edinburgh, 1617), sig. B3.

124 This extract from Holland's translation of Camben's *Britannia* is quoted in Dutton, '*King Lear, The Triumphs of Reunited Britannia* and "The Matter of Britain"', p. 148.

125 *Fuimus Troes*, sig. C4v.

126 *Ibid.*, sig. D3 (wrongly ascribed as D2), sig. D4.

127 *Ibid.*, sig. E2, sig. E4.

128 *Ibid.*, sig. Bv, sig. I3.

129 *Ibid.*, sig. E4v.

130 *Ibid.*, sig. B.

131 *Ibid.*, sig. C.

132 *Ibid.*, sig. I3, sig. I4ᵛ.

133 *Ibid.*, sig. A4.

134 *Ibid.*, sig. Cᵛ. The assembled British lords swear on Cassibellanus's sword to revenge the wrongs done to the country and then swear fealty to him.

135 See Marshall, 'That's the misery of peace', 14–16.

136 *Fuimus Troes*, sigs. E3–E3ᵛ, sig. I3ᵛ.

137 John Fletcher, *Bonduca* (London, 1647), ed. Cyrus Hoy in Fredson Bowers (ed.), *The Dramatic Works in the Beaumont and Fletcher Canon*, vol. IV (Cambridge University Press, 1979), pp. 149–259.

138 Yoshiko Kawachi, *Calendar of English Renaissance Drama 1558–1642* (New York: Garland Press, 1986).

139 See, for example, J. R. Mulryne and Margaret Shewring (eds), *Theatre and government under the early Stuarts* (Cambridge University Press, 1993), pp. 87–156, and David Bevington and Peter Holbrook (eds), *The politics of the Stuart court masque* (Cambridge University Press, 1998).

140 For an excellent survey of the masque see John Peacock, 'Jonson and Jones collaborate on *Prince Henry's Barriers*', *Word and Image* III (1987), 172–194.

141 Willson suggests that this anagram was coined in 1594 by the Irish poet Walter Quin: see D. H. Willson, *King James VI and I* (London, 1956), p. 141. It is used by Camden in his *Remaines of a greater worke, concerning Britaine, the inhabitants thereof* (London, 1605), sig. X1ʳ.

142 Orgel and Strong (eds), *Inigo Jones and the Theatre of the Stuart Court*, vol. I, p. 160.

143 *Ibid.*, p. 161.

144 *Ibid.*, p. 162.

145 Adams, 'The road to La Rochelle: English foreign policy and the Huguenots, 1610–29', 414–29. Lee sees James's actions in signing the 1612 Protestant Union as being 'in part to blunt the dangerous rivalries among the various claimants to the Cleves–Jülich inheritance' so as to minimise English involvement in the problem. See Maurice Lee Jr, *James I and Henri IV. An Essay in English Foreign Policy 1603–1610* (Urbana: University of Illinois Press, 1970), p. 172.

146 Samuel Daniel, *Tethys Festival* in Orgel and Strong (eds), *Inigo Jones and the Theatre of the Stuart Court*, vol. I, p. 194.

147 Sir J. Mann, *Wallace Collection Catalogue. European Arms and Armour*, vol. II (London, 1962), pp. 263–4.

148 Parry notes of *Tethys Festival*: 'The motif of the river nymphs was derived from *Poly-Olbion*, which Daniel's friend Drayton was then writing, and behind *Poly-Olbion* lay Camden's *Britannia*, so the subliminal theme of the masque is the celebration of the glory of Britain, with Henry as the inheritor of that glory. The Neptune–Thetis line provided an opportunity for ambitious thoughts about the nation's power by sea' ('The politics of the Jacobean masque', p. 97). The significance of the masque for the prince, however, must be seen in light of the fact that his mother's Catholicism and her desire

that he marry a Catholic bride did little to foster an atmosphere of trust when she urged him to stay at home, and the masque, when compared with his *Barriers* does little to represent him in a strong light. John Pitcher's analysis of the Brotherton Manuscript, containing an epistle to Henry which he convincingly argues to be by Daniel, maintains the same thinking as in *Tethys Festival*. In the manuscript Henry is strongly warned against traversing the pillars of Hercules, overseas exploration is depicted as an utter folly and the British imperium is lauded as being empire enough for the prince. See John Pitcher, *Samuel Daniel: The Brotherton Manuscript. A Study in Authorship*, Leeds Texts and Monographs New Series 7 (University of Leeds School of English, 1981), esp. pp. 131–7.

149 Quoted in Strong, *Henry, Prince of Wales*, p. 171.

150 Parry, 'The politics of the Jacobean masque', p. 99.

151 Orgel and Strong (eds), *Inigo Jones and the Theatre of the Stuart Court*, vol. I, p. 209. Of the representation of Henry and James in *Oberon*, Strong finds awkwardness in that 'the convention of the masque required him to be cast as Arthur's son, and James in the unlikely role of the Ancient British warrior king. The king sat in his "chair", but Jonson fails to take the parallel any further, and here the structure of the masque collapses'. *Henry, Prince of Wales*, p. 172.

152 All references to the masque will be to E. A. J. Honigmann (ed.), 'The Masque of Flowers (1614)' in T. J. B. Spencer and S. W. Wells (eds), *A Book of Masques. In honour of Allardyce Nicoll* (Cambridge University Press, 1967), pp. 149–77.

153 *Ibid.*, p. 160.

154 Samuel Purchas, *Purchas his Pilgrimage* (London, 1613), p. 638, Honigmann (ed.), 'The Masque of Flowers', p. 165.

155 Thomas Hariot, *A briefe and true report of the new found land of Virginia* (London, 1590). See also Paul Hulton, 'Images of the New World: Jacques Le Moyne de Morgues and John White' in Andrews, Canny and Hair (eds), *The Westward Enterprise*, pp. 195–214, and Paul Hulton, *America 1585. The Complete Drawings of John White* (University of North Carolina Press, 1984).

156 The *OED* lists the usage of the term 'Fifth Monarchy' as being from 1657.

157 Quoted in Howard Erskine-Hill, *The Augustan Idea in English Literature* (London: Edward Arnold, 1983), p. 165.

158 George Chapman, *The Memorable Masque of the two honourable houses, or Inns of Court, the Middle Temple and Lincoln's Inn* (15 February 1613). All line references are to the text printed in Orgel and Strong (eds), *Inigo Jones and the Theatre of the Stuart Court*, vol. I.

159 Thomas Dekker, *The Whore of Babylon*, ed. Marianne Gateson Riely (New York: Garland, 1980). On the martial ramifications of the play for the post-Union period, see Marshall, 'English public opinion and the 1604 peace treaty with Spain' (forthcoming).

160 Proudfoot (ed.), *Tom a Lincoln* .

161 *Les triomphes, entrées, cartels, tournois, ceremonies, et aultres Magnificences, faites en Angleterre, & au Palatinat, pour le Mariage & Reception, de Monseigneur le Prince Frederic V. Comte Palatin du Rhin … Et de Madame Elisabeth* (Heidelberg, 1613). The masque was not published in England. Another edition of *Les triomphes* – published by Jaques Mallet in Lyon in 1613, under the title *Les triomphes, entrées, cartels, tournois, ceremonies, et autres Magnificences, faites en Angleterre, & au Palatinat, pour le Mariage & Reception, de*

Monseigneur le Prince Frideric V. Comte Palatin du Rhin ... Et de Madame Elizabeth – makes no mention at all of the *Masque of Truth*, spending most of its 28 pages in describing the European reception of the married couple. For the Heidelberg edition see David Norbrook, '"The Masque of Truth": Court entertainments and international Protestant politics in the early Stuart period', *The Seventeenth Century* I (1986), 81–110. Wilks claims that Joshua Silvester was the author, though there does not appear to be conclusive evidence of this. See 'The Court culture of Prince Henry', p. 250.

162 *Les triomphes ...* [Heidelberg edition], sig. H1ᵛ: 'L'ARGVMENT de leur Ballet estoit: Que la Religion avoit joint le Monde avec l'Angleterre. Car encor que les Poëtes disent, *divisus ab orbe Britannus*: toutesfois le mariage, faict au Ciel, & consomé en Terre, de la fille vnique de ce Sage ROY de la grand Bretagne, avec le Serenissime Prince FRIDERIC V. Electeur Palatin (qui porte en ses Armes, & en son office Electoral, le Monde d'or: qui est maintenant joint aux Armes d' Angleterre) a donné occasion de contredire le Poëte, & de croire, qu'un jour, s'il plaist a Dieu, le Monde (quittant ses erreurs) se viendra rendre à la cognoissance de la Verité, qui est purement preschée en Angleterre & au Palatinat. Ce qui les a meu de faire venir Atlas, pour se descharger du Globe Terrestre entre les mains d'Alithie, c'est à dire la Verité, qui a choisy sa demeure en ceste Isle. Duquel Globe sortent les trois parties du Monde, asçavoir l'Europe, l'Asie, & l'Afrique, estans sommées par les Trompettes de la Verité, qui sont les Muses diuines, & par son Lieutenant Atlas, de venir apprendre d'Alithie, & de son Protecteur, le ROY de ceste Isle heureuse, le droit chemin de Salut, par lequel chacun doit aller consacrer son Ame à la gloire du Grand DIEV'.

163 *Ibid.*, sig. H4ʳ.

164 Interestingly, the same image was used by John Williams in his *Great Britains Solomon* (London, 1625) in his eulogy for James: 'I say, beside these *Adventures* of his *person*, he was unto *his people*, to the houre of his *death*, another *Cherubin* with a flaming sword, to keepe out *Enemies* from this *Paradise* of ours; wherein above all neighbouring Nations, grew in abundance those Apples of peace' (p. 56).

165 Brooke, *Two Elegies*, sig. E.

166 Quoted in Wilson, *Prince Henry and English Literature*, p. 126. N. E. McClure (ed.), *The Letters of John Chamberlain* (Philadelphia: University of Pennsylvania Press, 1939), vol. I, p. 391.

167 John Webster, *A Monvmental Colvmne*, sig. B.

168 Interestingly, the epilogue to a tract of 1616 lamenting the death of Overbury chose to remember him as one 'Who, like a star in Britain's court did shine'. Quoted in Anne Somerset, *Unnatural murder. Poison at the court of James I* (London, 1997), p. 385.

Chapter 4

<div align="center">◆</div>

1614–25
Brute, force and ignorance?

victory obtayned by the joint valour of English and Scots will more indelibly Christen your Majesties Empire greate Brittaine, then any act of Parliament or artifice of State.

<div align="right">Anon., Tom Tell Troath</div>

In the period following the death of Prince Henry in 1612 and the departure of Frederick and Elizabeth in 1613 there was a palpable sense of hiatus for those advocating a strong British Protestantism. With no great figureheads around whom to rally it is tempting to surmise that, until the return of Charles and Buckingham in 1623, those who saw a united Britain as a force for change in Europe were sorely disappointed. Yet the later Jacobean years were ones in which the ramifications of the Palatine crisis threatened the British mainland and – faced with this threat – people were more receptive to the notion of military involvement overseas.[1] Concerns with an emphatically British patriotism were subdued but still present – at least one writer in 1622 was willing to advance Brutus as a British king in tracing James's ancestry.[2]

In the aftermath of Henry's death Charles gave some hope to writers concerned that Britain should not continue with James's pacifism and drift towards a Catholic match. Daniel Price therefore turned to him in the hope that he would follow Henry's lead, making the connection between Charles and the great emperor Charlemagne in both his *Lamentations for the death of Prince Henry* and his *Prince Henry, the first anniversary*. With similar hopes James Maxwell lamented the death of the prince in 1612:

> One thing there is our sorrow may asswage
> And heale our heart-breake, which is, when we see
> Heau'n fauord *Charles* of such hope in prime age
> Borne to prolong this Ilands vnitie:
> So oft as I behold braue HENRIES brother,
> Me thincks I see a *Phoenix* from his Cinder.

A year later in his *A Monument of remembrance* he expressed the hope 'That CHARLES shall beare *Constantines* crowne away'.[3] Such hope bore little fruit, as Charles was more interested in withdrawing completely into the fantasy of the masque.[4]

Even though Webster's next play after *The White Devil*, *The Duchess of Malfi* was first performed in 1614, there remain signs of his writing with Prince Henry's interests in mind. Antonio is asked what he thinks of riding skills:

> Nobly, my lord: as out of the Grecian horse
> issued many famous princes: so out of brave horsemanship,
> arise the first sparks of growing resolution, that raise the
> mind to noble action.

> (I.ii.64–7)

Henry not only rode a great deal, both at the tilt and otherwise, but also had a fine collection of equine art. When seeking to marry Henry to his sister Caterina de'Medici, Cosimo II, Grand Duke of Tuscany, sent the prince a number of equine bronzes.[5] Even after death, Henry's influence never truly dissipated but when it became increasingly apparent that Charles was totally unlike his brother, attention turned to the heirs and fortunes of Frederick and Elizabeth. This hope is illustrated by the reception Peacham gave to the birth of a son to Elizabeth, in his *Prince Henry revived* (1615) and by William Fennor's optimism in his *Fennor's descriptions* (1616):

> From *Henry's* ashes, there is sprung,
> A second *Henry*, who eare long
> We hope shall in the Land arriue,
> The hearts of all men to reuiue.[6]

Furthermore, in Campion's *The Lord's Masque*, the words spoken by the Sybil to Elizabeth (in translation from the Latin) address her as:

> The mother of kings, of emperors. Let the British strength be added to the German: can anything equal it? One mind, one faith will join two peoples, and one religion and simple love. Both will have the same enemy, the same ally, the same prayer for those in danger, and the same strength. Peace will favour them, and the fortune of war will favour them; always God the helper will be at their side.[7]

If the Catholic powers of Europe would not return to the fold of the supposed true church, then Britain and the Palatinate would form a greater empire in the shape of the offspring of the Palatine marriage.

The frontispiece to William Slatyer's *The history of Great Britanie to this present raigne* (1621) has pictures of Samothes, Gygas, Mulmutius, Hengist, Albion, Brutus, Caesar, Swanus, William the Conqueror and King James on its cover, though a more central position is given to the land itself, personified as a woman holding the cornucopia of plenty, a motif reminiscent of the cover

of Drayton's *Poly-Olbion*. While James thus seems to be marginalised he is in notably illustrious company. These are not just random figures but conquerors, those who had made and, in James's case, re-made Britain. The book's dedication to James is as King of Great Britain and, alongside a reference to his Britain as being the Fortunate Isles, a note informs the reader: '*Under which name of* beatarum Insularum & Fortunatæ, *alluding to Hesiods words and other Fables of the* Greekes, *it seemes the ancient* Romanes *pointed out these* Bryttish *Iles*'.[8] It is not an isolated example of the recurrence of the British material, but those writers who did appeal to Britain at this time usually did so with an explicit political agenda – intervention in the Palatinate crisis.

More specifically, Britain was something which, its propagandists hoped, might draw the two realms of England and Scotland together in war. John Taylor called upon 'true borne Britaines' to 'Resume your ancient honors once agen' in defence of Frederick and Elizabeth.[9] English ambassadors overseas, such as the English agent in Mainz, referred to Great Britain as being their state of origin as the slide into war on the European continent made expedient a show of English and Scots unity in the face of potential Catholic alliances.[10] Writers wishing to encourage involvement in the Palatinate crisis stressed the necessity of an emphatically British reaction to the tumultuous events in Europe. Thomas Scott was one of them, keenly emphasising the existence of a 'Brittish Nation' in opposition to the Spanish threat. His dedication of *The Belgicke Pismire* (1622) was '*To the true hearted* British *Readers*' and he went on to urge 'the necessarie dependancie betwixt our Kingdome of *Great Brittaine* and the *united* Provinces'.[11] In *Vox Coeli* (1624) John Reynolds addressed the members of Parliament as 'great Brittaines greatest Palladines and Champions' while in the same year Spain was, for one poet, 'great Brittaines enemy'.[12]

Public pageantry had certainly not dispensed with British material. A good example is Anthony Munday's mayoral pageant 'Sidero-Thriambos' of 1618.[13] The piece is set on 'an imaginary Island' on which is seen a mine, appropriate for the celebration of a member of the Ironmongers' Company. Also fitting is the representation in this mine of three nymphs – figuring 'the *Golden-Age*, the *Silver-Age*, and the *Brazen-Age*' – who give way to another nymph representing the Iron Age. This island is ruled over by Jupiter, 'mounted upon his Royall Eagle', reminiscent of his appearance in *Cymbeline*. Indicative of London's martial awareness, the island features a cannon complete with gunners, 'certaine gallant Knights in Armour, well mounted on their Coursers for service' and 'a brave troupe of Musketiers'.[14] To this model of the well-governed city of London is added a further British component. A leopard is depicted, upon which 'rideth an ancient *Brittish Barde*; for *Bardes* were esteemed as *Poets* or Propheticall *Sooth-Sayers*, and (in those reverend times) held in no meane admiration and honour'.[15] This Bard has two speeches, both

of which are delivered in a Scottish accent, as can be seen from the opening part of the text:

> Blithe and bonny bin yee aw,
> And meckle blissings still befaw
> Upon so faire and gudly meany,
> As thilke like, nere sawe I eny.
> A *Brittish Barde*, that long hath slept,
> And in his Grave would still ha kept:
> But that the spirit of Poesie
> (Which haudeth highest Soveraigntie)
> Hath raisde me from my silent rest,
> To make ene in this Joviall Feaste.[16]

That being British is associated with a Scottish accent is revealing, though the Welshness of the Britons had certainly not disappeared, as *The Welsh Embassador* would roundly prove (see below). Being delivered in so public a display it is extremely unlikely that these words could have been rendered comically. Instead, the Scots were being brought firmly into a new British nation, even if historical accuracy was being sidelined.

Other aspects of British imperialism also remained intact: Middleton's mayoral show of 1623, *The Triumphs of Integrity*, showed 'the three Imperial Crowns cast into the form and bigness of a triumphal pageant'. But by far the most complex mayoral pageant in terms of imagery was Webster's 1624 *Monuments of Honour*.[17] That Webster should provide an entertainment with a martial bent is hardly surprising, given his previous work; but this show was as huge a step forward in imperial pageantry as the *Masque of Truth* was in its radical depiction of an interventionist Protestantism. The pageant begins with Thetis and Oceanus talking of the honour of English sailors, in a spectacle known as the Sea Triumph. The action then moves to Paul's Church Yard where the Temple of Honour is depicted:

> the Pillars of which are bound about with Roses, and other beautiful Flowers, which shoot vp to the adorning of the Kings Maiesties Armes on the top of the Temple. In the highest seate a Person representing *Troynouant* or the City, in throned in rich Habilaments, beneath her as admiring her peace and felicity, sit fiue eminent Cities.[18]

This spectacle, obviously redolent of imperial grandeur is still not the most important scene. This Webster saves till last. The Monument of Gratitude not only has as a device Prince Henry's three-feather badge but it is backlit for added effect.[19] Webster then lists the many virtues and interests possessed by Henry in a tableau in which four pyramids are shown with precious stones suggesting 'the riches of the Kingdome Prince *Henry* was borne Heire to'. But surmounting this is an apocalyptic scene, for a 'Celestiall Globe' is depicted,

'in the middest of this hangs the Holy Lambe in the Sun-beames, on either side of these, an Angell; upon a pedestall of gold stands the figure of Prince *Henry*'. Amadis de Gaule is there to tell the new mayor, 'Of all the Triumphs which your eye has view'd This the fayre Monument of Gratitud; This cheefly should your eye, and *eare* Imploy'.[20] Webster's valediction to Henry is almost messianic. The prince, along with a heavenly host, watches over his country.

Not all references to Britain were immediately positive. While consistently caustic in his appraisal of Jacobean life, the writer using the name Tom Tell Troath does have much to say about James's Great Britain. He begins his *Free discourse* by suggesting that the people (he assures his reader that these are other people's opinions, not his own) are less than kind in their opinions of James's project to expand England's horizons: 'They make a mock of your word, Great Brittaine, and offer to prove, that it is a great deale lesse, then Little England was wont to be, lesse in reputation, lesse in strength; lesse in Riches; lesse in all manner of vertue, and whatsoever else is required to make a state great and happy'.[21] Having established that the public think little of the effects of the Union on the nation's prestige, the writer goes on: 'they wonder you wil call your selfe King of France, and suffer your best subjects there to be ruined, for Ireland, they say, you content your selfe with the name, and let others receive the profit'.[22] Overseas, too, James is perceived to have failed to make Great Britain mean anything.

Tom has a remedy, however, as his work is didactic. He knows that there is a course of action which would do great things to unite the people of Britain under a common banner. He informs the king that 'in your Majesties owne Tavernes, for one healthe, that is begun to your selfe, there are ten drunke to the Princes your forayn Children'.[23] Scotland, he feels, is up to the challenge of this great endeavour. The Scots are after all, 'the onely nation of the earth, that could compare with us in valour, to be our fellowe souldiers'.[24] British unity will therefore come about as a result of this joint crusade:

> If any thing on earth do it, it will be theire freindshipp at armes in some fortunate warre, wher honour and danger may be equally devided, and no jealousie or contention rise, but of well doing, and victory obtayned by the joint valour of English and Scots will more indelibly Christen your Majesties Empire greate Brittaine, then any acte of Parliament or artifice of State.[25]

Clearly, the evocation of a British realm and empire remained a political weapon, a lever by which those advocating an interventionist Protestantism hoped to achieve their aim of overseas intervention so as to safeguard Britain at home. Martial aspirations were also depicted on the stage without a specifically British context, yet while Margot Heinemann and Jerzy Limon have both done a great service to the historian wishing to understand the significance of theatre in the 1620s, their studies have placed too great an

emphasis on Middleton's *A Game at Chesse*. Indeed it is an extremely important play, right at the heart of public anger and resentment at Spain and royal vacillation over Gondomar's promises, but it is not alone in figuring the public discontent with King James's foreign policy.[26]

We should ask where audience enthusiasm for the theatrical representation of the foreign policy crisis in *A Game at Chesse* came from, and establish the extent to which the play was a theatrical novelty by looking at the stage in the ten-year period preceding it. From 1614 to 1625 a series of plays discussed Spanish incursions into the English Court and events on the European mainland that encroached upon James's *arcana imperii*. Playwrights may well have been given encouragement by the thought that the anti-Spanish faction at Court still had its adherents, no matter how strong the pro-Spanish position might seem to be. After all, Gondomar was absent from 1618 to 1620, the strongly Protestant Ralph Winwood's grasp on the position of Secretary of State lasted until his death in October 1617 and his eventual replacement at the beginning of 1618, Sir Robert Naunton brought with him a 'heartfelt loathing for the French' and 'profound fear of the Spanish'. Lest it appear that Gondomar always got his way, and though it was to be an ill-fated release, Raleigh finally saw the light of day in March 1616. In the same year Henry Wright wrote asking the ways in which a kingdom might be acquired and kept as well as 'how a new-got Kingdome may be enlarged'.[27]

We need to be suitably wary about how we interpret James's *via media* between negotiations for a Spanish match and his concerns for Protestantism in Europe, between his sending of Sir John Digby back to Madrid in 1614 and his strong support for the Synod of Dort's pronouncements against Arminianism in 1619.[28] If we look for them we can find several instances of behaviour not at all in keeping with the picture of a king slowly sinking into dependency on the hopes of a Spanish alliance. In 1616 James bought the tapestries by Cornelius Vroom commemorating Queen Elizabeth's victory over the Spanish Armada for the sizeable sum of £1628, hardly the action of one keen to forget the event or play down its significance to the Spanish. Such was the climate meanwhile that *The History of Amadis de Gaule*, one of the most famous works of the medieval chivalric canon, was published in its first English edition in 1619 and dedicated to Pembroke.[29] As Lord Chamberlain from 1615, a position of critical importance for the control of the theatre, Pembroke attracted dedications from some of the most significant writers of the age, including encomiums in the second part of William Browne's *Britannia's Pastorals* in 1616 and Shakespeare's First Folio.[30]

The buoyant theatrical patriotism of the first years of James's reign was replaced on the stage by plays conveying a universal sense of concern, rarely optimistic and increasingly vociferous by 1620. After 1620, the public theatre grew more brazen in its depiction of martial themes and directly advocated a

return to Elizabethan England's firm anti-Spanish stance. Yet Margot Heine-mann unfairly glossed over the public theatre of the period 1620–23 in favour of the more substantial politics of 1623–24. She claimed that:

> If there is relatively little political criticism or subversion in the drama from 1620 to later 1623, this is scarcely evidence of 'consensus' in society. After the King's Men got into trouble over the topical *Sir John Van Olden Barnavelt* ... the dramatists did not again appeal to the intense interest in European politics by direct documentary staging of contemporary events. Indeed, from 1620 to 1623 the clamp-down of royal censorship under James's proclamation would have made it impossible to do so.[31]

This statement is simply not borne out by the facts. Massinger did *not* cease to write topical material after *Barnavelt*: as illustrated below, his collaboration with Dekker in *The Virgin Martyr* (1620) and his *The Maid of Honour* (1621) are at times blatant pieces of political parallel, replete with direct caricaturing of real-life Court figures, satire of a kind and extent which had not been pre-viously seen on the Jacobean stage. If anything this three-year period marked an *increase* in topical political satire, not a diminishing of it.

While dramatists played on fears that the court was becoming Hispanicised in spite of the presence of Naunton, Pembroke and Archbishop Abbott, there were those who presented an alternative form of spectacle at a suitable distance from London. The masque performed in honour of the marriage of Essex's sister Frances to Sir William Seymour in 1618 had distinctly chivalric overtones, with the assembled masquers taking on the roles of such figures from the *Faerie Queene* as Artegall and Calidore.[32] This was a private masque, one of very few such glimpses we have into the theatrical life of those trying to reside away from the corruption of the court whenever possible, and makes a nonsense of the idea of theatre being disparaged by those of a more extreme Protestant persuasion. Equally suggestive of a continuation of interest in Spenserian imagery is the lost Dekker and Ford collaboration, *The Fairy Knight*, licensed by Pembroke on 11 June 1624, which may well have been a dramati-sation of some part of the *Faerie Queene*.

Our knowledge of politics outside parliament in the last years of James's reign has suffered from longstanding neglect; but when we leave Westminster it is evident that the problems the Commons had in commenting on the king's foreign policy were not being felt by playwrights. As the reign began, dramatists echoed concerns about continued vigilance in the face of Spanish aggression, and such sentiments remained highly visible throughout the second half of James's reign.[33]

THE PALATINATE

On 7 February 1618 the Venetian envoy Orazio Busino wrote to the Doge and Senate detailing the English perception of Roman Catholic foreigners:

> The English deride our religion as detestable and superstitious, and never represent any theatrical piece, not even a satirical tragi-comedy without larding it with the vices and iniquity of some Catholic churchman, which move them to laughter and much mockery.
>
> On one occasion my colleagues of the Embassy saw a comedy performed in which a Franciscan friar was introduced, cunning and replete with impiety of various shades, including avarice and lust. The whole was made to end in a tragedy, the friar being beheaded on the stage. Another time they represented the pomp of a Cardinal in his identical robes of state, very handsome and costly, and accompanied by his attendants, with an altar raised on the stage, where he pretended to perform service, ordering a procession. He then re-appeared familiarly with a concubine in public. He played the part of administering poison to his sister upon a point of honour, and moreover, of going into battle, having first gravely deposited his cardinal's robes on the altar through the agency of his chaplains. Last of all, he had himself girded with a sword and put on his scarf with the best imaginable grace. All this they do in derision of ecclesiastical pomp which in this kingdom is scorned and hated mortally.[34]

The second play is undoubtedly Webster's *The Duchess of Malfi*, though Busino misreports the manner in which the Cardinal's sister is killed. We know that the play was first performed between 1612 and 1614 and that it was performed twice before it was printed in 1623. We also know that it was revised between 1619 and 1623 so the question remains as to whether it was revised *before* a production, in which case Busino does not refer to a recent performance, or whether it was revised because something in the performance he saw was deemed offensive and subsequently failed to appear in the printed version of the play. Whatever the case, this commentary reinforces the notion that Webster was keen to advocate an anti-Spanish position. The depiction of a Roman Cardinal putting aside his robes and taking up his sword would indeed have had an emotive effect on the London audience, the true colours of Catholic clergy revealed in their willingness to murder their enemies.

At the end of the same year Piero Contarini also wrote of the invective coming from the stage towards the papacy: 'There is mortal hatred against the pope on the score of religion, and anyone who opposes the apostolic see can always count upon help from England. In their theatres and public comedies they constantly speak of the papacy with contempt and derision, and they never lose an opportunity of speaking slanderously about it'.[35] It was to King James's extreme irritation that the public had such an opinion regarding the foreign policy which, he maintained, was among the *arcana imperii*. Rushworth

recorded 'the King being jealous of uncomptrolled Soveraignty, and impatient of his Peoples intermedling with the Mysteries of State ... for he observed the affections of the People to be raised for the Recovery of the *Palatinate*'.[36] A proclamation issued on 24 December 1620, and reissued in stronger terms on 26 July 1621, inveighed against those concerning themselves 'with causes of State, and secrets of Empire'.[37]

But increased overseas expansion complicated the politics of foreign policy. By these years the English factory at Hirado in Japan had begun to trade and would do so uninterrupted until 1623.[38] Anglo-Dutch relations between 1614 and 1616 were concerned with problems of the Merchant Adventurers and still-flickering hopes of a union of the two East India Companies, as well as the redemption by the Dutch of the English cautionary towns.[39] London in the period 1614–19 was far more cosmopolitan than it had ever been; and just as James could not control the stories being told by sailors and travellers now returning from both the far East and the American West, so too the stage began to expand its horizons.

London was informed of the events in the Palatinate in 1619 and 1620 via a series of lurid news-sheets; but the London stage provided another method of disseminating information not only about Ferdinand's campaign in Germany – which culminated in Catholic victory in November 1620 on the White Mountain – but also about Frederick and Elizabeth's subsequent plight.[40] Ideas as to exactly how the Palatinate could be retaken varied greatly. Parliament in 1621 had its own set of opinions but the debacle over James's supposed desire that Parliament debate foreign policy made the expression of these views difficult.

The suspension from office of Naunton in January 1621 and the arrest of Southampton in the summer of that year should be considered alongside the discussions among lieutenants and in Parliament about standardising arms and training, and government orders with the same aims. On 13 January 1621 James appointed a council of war of experienced military and naval officers, and instructed them to compute the size and expense of an army strong enough to defend the Palatinate. Within two years there was official stress on the need for modern weapons, as well as an attempt to attain more 'exact' training by means of a new book of military orders based on continental methods. This was not therefore a period of inaction so much as one in which confusing signals were sent out regarding official policy.

The repertoire of the theatre companies suggests that in terms of public opinion there was a great deal of consensus regarding the direction of foreign policy.[41] The plays discussed in this chapter have at their heart an overriding concern with the defence of British interests through overseas intervention and – in the case of *The Welsh Embassador* – a specific desire to unify British identity behind a monarch acting secretly but, it was hoped, for the good of his

subjects. Whereas the British setting was not used to the same extent in these later years, the related themes of British imperialism – martialism, patriotism, unity and a defiance of foreign intervention – all occur.

Other plays of this period share the same resonances of topicality in foreign policy, though lacking such an extensive political subtext. Middleton's city comedy *Anything for a Quiet Life* (1621) discourses on one father's concern with domestic peace and with securing such a state of affairs at any cost. In the play Sir Francis Cressingham marries for the second time, to a young wife who proceeds to dominate him. Lord Beaufort tells Cressingham:

> I fear that in the election of a wife,
> As in a project of war, to err but once
> Is to be undone for ever
> [...]
> and what follows then?
> Your shame and the ruin of your children; and there's
> The end of a rash bargain.
>
> (I.i.17–19, 30–32)

The language is astonishingly transparent, especially when we couple it with our understanding of the political viewpoint advocated by Middleton, not only in his pageants but in *Hengist, King of Kent* (see below). 'Election', 'a project of war', the 'shame and ruin of your children' and 'the end of a rash bargain' all point directly to James's failure to support his daughter and her husband so as not to prejudice a Spanish marriage for Charles. Cressingham has three children from his previous marriage but his new wife has insisted that he board out the younger two. When his eldest son George complains about this he is told by a third party: 'Be rul'd, do anything for a quiet life! Your father's peace of life moves in it too' (I.i.138–9).

It is another highly visible attack on James for letting the new wife – here representing the Spanish influence – force him to abandon his children in the name of the peace he covets so greatly. The young wife spends Sir Francis's money extravagantly and, we are told, she 'will not suffer [her husband's] religion be his own, but what she pleases to turn it to' (V.i.267–8). We know the play is set in Jacobean Britain because George's friend Franklin Junior says that he has been on 'the late ill-starr'd voyage To Guiana' (I.i.171–2), a reference to Raleigh's ill-fated 1617 voyage. Through the guise of a citizen comedy the play voices highly critical views of James's inaction and his willingness to be ruled for the purposes of securing a peace which is shown to be so utterly divisive. It would not be Middleton's only foray into the field of foreign policy during these years.

The appearance of Anglo-Spanish grammars and dictionaries in London bookshops during 1623 may have been an attempt to cash in on the feared influx of Spaniards into England – since the progress of marriage negotiations

suggested the Infanta would be the future Queen of England – but the theatre clearly did not pander to this spirit of free enterprise. There were running battles in London between English and Spanish during 1623, resulting in a fatality in September when a brawl in Drury Lane left an English baker dead; and the Privy Council ordered a close guard around the embassy to prevent revenge being taken.[42] King James had in 1618 already issued a proclamation pardoning an assault on the Spanish embassy at the specific request of the Spaniards. The ambassador's house at the Barbican had been attacked.[43]

One popular option was to confront and defeat Spain – and so rescue the Palatinate – by means of the 'Blue Water' policy in which Prince Henry had had an interest, a policy based on attacking the Spanish treasure fleet in the West Indies and cutting off the source of Spain's wealth before it reached Europe. This necessitated a strong navy, a matter with which Massinger's *The Bondman* and *The Maid of Honour* both deal, the former play depicting all the ships of Syracuse as lying 'vnrig'd Rot[ting] in the harbour, no defence preparde' (I.iii.205–6). In this, Massinger was following William Browne, who had already sailed close to the wind in satirising the decline of the navy during the Jacobean peace in the second book of his *Britannia's Pastorals* (1616).[44] King James meanwhile sought to limit his enemies to those actively fighting against the Palatine interest, prompting one MP in November 1621 to pray that rather than limiting his enemies to Maximilian of Bavaria, the Catholic League, and Emperor Ferdinand II, James 'would rather thinke of Queene Elizabeths course and the West Indies' – and confront the King of Spain.[45] Solicitor-general Heath had been one of the first two members of the House to advocate a general war against Spain when he recommended sending ships abroad to seize the Spanish West Indies treasure.[46]

This concern was voiced in a session during which the Commons made the unfortunate error of assuming that they had the king's permission to discuss foreign policy. Recorder Finch was fundamentally misreading the situation when he argued against the idea that the Commons petition of 3 December was presumptuous, 'for originally it comes from the king who tells us there is no hope of peace'.[47] By 1623, when recovery of the Palatinate on land was increasingly viewed as an untenable option, Fairfax saw the need 'to seeke the Palatinate in America' while Frederick himself proposed that the Danes, the Dutch and the Germans should occupy the Austrian Habsburgs while England and the Low Countries joined in a naval assault on the Indies. Such a policy he described in December 1623 as 'le seul et unique moyen pour faire tomber en terre la puissance effroyable d'Espagne'.[48]

The policy did not lack the support of Charles and Buckingham, the favourite installing at Newhall a mural depicting Drake at sea, while one of the three books that Charles had purchased in Spain dealt with her Caribbean empire.[49] But such a policy was anathema to James Stuart. Whether it was

financial weakness that prevented him from providing aid to Frederick, as Limon suggests, James still managed to find the finances to build his new Banqueting House in Whitehall in 1619.[50] If he disliked seeing his son-in-law, a legitimate monarch, removed by his subjects, he did not dislike it enough to risk antagonising Spain. British royal power was his priority and though two potential Protestant figureheads were kept out of England the theatre proved to be a considerable friend to the Winter King and Queen, beginning with an early piece which strove firmly to ally Britain and Germany in common cause.

THE HECTOR OF GERMANY

That *The Hector of Germany or the* Palsgraue, *Prime Elector* was not censored when it was first performed about 1614–15 is surprising.[51] Its content is highly topical and if at this date Frederick, Elector Palatine was not yet in dire straits the play still reveals a profound concern with the state of Europe and makes little effort to conceal a continued lament for the loss of Henry, Prince of Wales.

The play is ostensibly set in fourteenth-century Europe in the aftermath of the death of Edward, Prince of Wales and Aquitaine in June 1376, and reference to this death is made several times. The period in which the play was being written and first performed was one in which conflict in Europe was ongoing and bloody. May to September 1614 saw the second Cleves–Jülich crisis, while civil war in France raged from January to May of that year. The next year, 1615, brought Lutheran rioting in Brandenburg, and the Dutch fleet attacked the Pacific coast of Spanish America; then there was further civil war in France from August until May of 1616 and the Uzkok war began in December 1616 and lasted until February 1618.

The story told in Wentworth Smith's play is of the involvement of the Palsgrave in the wars of Europe following the deposing of Peter the Hermit – in reality Pedro I, King of Castile (also known as Pedro the Cruel) – who was exiled in 1365. The usurper responsible for this state of affairs was Henry of Spain – most often called the Bastard in the play – the real life Enrique Trastamare, who became Enrique II, King of Castile 1369–79.[52] To this complement of real historical figures must be added ahistorical additions, the Dukes of Bohemia and Savoy. Significantly, both of these figures were playing major roles in European events in the early seventeenth century – Bohemia, under Matthias since 1611, had been granted under the terms of the 'Letter of Majesty' the legal right for its people to choose between Catholicism or one of the Protestant faiths, a bastion of confessional liberality amid a sea of intolerance.[53] Meanwhile, the conflict between Spain and Charles Emmanuel of Savoy over Montferrat, between 1613 and 1617, encouraged King James to hope that Charles Emmanuel might be willing to join an anti-Habsburg alliance.[54]

With such a complement of characters it is not without a certain degree of *chutzpah* that, at the beginning of the play, the Prologue enters to make a pointed denial of any topicality:

> Our Authour for himselfe, this bad me say,
> Although the Palsgraue be the name of th' Play,
> Tis not that Prince, which in this Kingdome late,
> Marryed the Mayden-glory of our state:
> What Pen dares be so bold in this strict age,
> To bring him while he liues vpon the Stage?
> And though he would, Authorities sterne brow
> Such a presumptuous deede will not allow:
> And he must not offend Authoritie,
> Tis of a Palsgraue generous and high,
> Of an undaunted heart, an Hectors spirit,
> For his great valour, worthy royall merite;
> Whose fayre achieuements, and victorious glory,
> Is the mayne subiect of our warlike story.
> Mars gouerns here, his influence rules the day,
> And should by right be Prologue to the Play.[55]

Immediately following this claim occurs the following stage direction: 'A bed thrust out, the Palsgraue lying sicke in it'. [56] A sick Prince would have revived recent memories in 1615, and any doubt that it is he is dispelled through the language used by Bohemia to describe the ill Palsgrave:

> The strength of *Germanie* is sicke in him,
> And should hee die now in the prime of life,
> Like *Troy* wee loose the *Hector* of our Age:
> For hee alone, when he was strong and well,
> Curb'd all their pride, and kept the worst in awe.[57]

This is a thinly veiled eulogy for Prince Henry, and we are reminded that the Prince of Wales in R. A'.s *The Valiant Welshman* claims to have been 'Descended linially from Hectors race'.[58] Throughout *The Hector of Germany* the character of the Palsgrave is moulded less by the real-life Frederick, though it is in him that Protestant hopes lie, but rather by a romantic image of what glory Britain's prince might have found in Europe had he lived. Furthermore, England in the play, as in the Jacobean present, was still lamenting a dead Prince of Wales – Peter the Hermit talks of 'the decease of *Englands* royall Sonne'.[59]

The Black Prince had brought France to her knees at Cressy and Poitiers and played a key role in the balance of European power, and here we are reminded at several points of his legacy. The Palsgrave himself notes of the English:

> Since I came to vnderstand their valour,
> I held them the Prime *Souldiers* of the world:
> And thinke no Martiall Tutor fittes a prince,
> But hee that is a true borne *Englishman*.[60]

All of course highly patriotic, though Henry of Spain remembers past defeats at the hands of the Prince of Wales: 'Ten thousand such [German troops] had I bene Leader of When the *Blacke-Prince*, lately my greatest Foe, Opposde me at *Mazieres*, and wonne the day'.[61] The Bastard is aware of the English propensity for victory in war: 'For of all the Nations in the world, I hate To deale with Englishmen, they conquer so'.[62]

Yet the play treads a fine line between specific anti-Spanish narrative and more cautious, balanced depictions of Spain. A wary approach towards portraying the Spanish may well have kept the censor at bay. The Spanish king is, after all, named Henry, so Smith could claim with impunity not to have intended a hostile depiction lest the name of England's late lamented prince be connected with it. In the play, however, rather than 'Henry', the name 'Bastard' for the King of Spain is more prevalent; and there is little doubt that it would have been, in the eyes of the London audience, an appropriate appellation for the hated enemy. Savoy promises

> Ile guide you where the greatest danger dwells:
> And like an Emperour fright it from the field:
> The Bastards but a Coward, and a *Spanyard*,
> Coward and *Spanyard* oft-times goe together.[63]

We also need to note that, whereas the more illustrious real-life campaigns of the Black Prince were in France, the play concentrates on conflicts involving – and indeed revolving primarily around – Spain.

The Palsgrave is portrayed as a no-nonsense man of war, the antithesis of King James. On hearing that his allies are prisoners and the Bastard has been crowned emperor, the Palsgrave, still ill, laments his condition:

> More blood increases, & some more ill newes
> Would make me cast my Night-cap on the ground,
> And call my Groome to fetch mee a Warre-horse,
> That I may ride before an Army royall,
> And plucke the Crowne from off the *Bastards* head,
> That is anothers right.[64]

Later in the play his enemies recognise that the Palsgrave is a formidable foe, who, with typical chivalric gusto, challenges any of his enemies to single combat to decide their quarrel:

> TRIER: He beares himself, as he were sure to cõquer.
> MENTZ: And looks more like a *Ioue* then like a man.

PALSGRAUE: I hold my thunder here, & my right arme
Has vigor in it, when you feele my blowes
To giue you cause to call them Thunderboltes,
If there be any in this Martiall Troope
That with a Soldiours face, has a bold heart,
And dares auerre that this religious prince
Is not the lawfull and true King of *Spaine*,
I will make good his Title by the sword,
And against that prowde combattant oppose
My selfe as challenger to fight for him.[65]

Not surprisingly, the unchivalrous Bastard refuses this offer. With the exception of the English king, those around the Palsgrave are shown to be far from his equals. When he entrusts Pedro with the captured Bastard the latter is able to escape, much to the Palsgrave's anger, while the idea of the French becoming involved in the conflict only drives the hero to thoughts of further conquest:

PAL: But say from me my sword were drunke *French*
And therefore it is thirstie for their liues:
That ere I leaue the Continent of *France*,
Without good satisfaction from the King,
None of his Caualieres shall were a locke,
Ile haue them all cut off, and euerie yeere
Be payd in such a tribute for my wrongs.
As for proud *Saxon*, Say my word is kept,
And bid him warily respect his owne:
The French Kings Palace shall not saue his life,
Nor the best rampierd Bulwarke in the Land,
Except he answere me as fits a Peere.[66]

Not since *Tom a Lincoln* had there been such a piece of theatrical jingoism. Smith's play exceeded all its predecessors in its sheer martial enthusiasm and blatant eulogy for the cause of militant Protestantism in Europe. Yet while the play elevates the Palsgrave to near-mythic status as a paragon of military sagacity, the English King Edward bears some scrutiny. King Edward III is portrayed in a quietly favourable light, though of course heavily overshadowed by the Palsgrave. One of the first scenes in which he appears sees him arbitrate a dispute, while voicing his concern at the events in Europe.[67] An interesting resonance may be detected in this English king keen to be the peacemaker in disputes while taking an active interest in European politics; and Edward, like James, was also the father of a much lamented Prince of Wales. Here the similarities fade, as Edward not only prepares a tournament for the Palsgrave's entertainment, but takes part in it himself, and is the only person not to be unseated by the young visitor.[68] Entering from the tournament King Edward offers his guest a wreath of laurel, 'a *Caesars* wreath' as he

has been the victor of the day. The Palsgrave declines, however, noting: 'Victorious *Edward* keepe it as your right, And let it mingle with your Royall Crowne, That haue deseru'd it in a field of warre'.[69] Edward then presents his guest with that most potent symbol of English knighthood, the Garter, and reminds the audience that it was he who created the Order.[70] The fact that the similarities between Edward and James are not sustained indicates that, through this depiction of an English ruler who knows when to think and when to take up arms and act, James's own inaction is sternly criticised.

The outcome of the play is a victory for the united forces of the Palsgrave and England. The Palsgrave kills Saxon[y] in single combat and the remaining collection of vanquished foes agree on the might of their enemy:

> BASTARD: The Palsgraue is invincible I thinke.
> FRENCH KING: Not to be ouercome.
> MENTZ: Nor to be tam'de by any.
> FRENCH KING: Matchlesse, and farre beyond the praise of words,
> Are all thy actions, let me honour thee.[71]

Savoy is made emperor, the Palsgrave happy to let the more qualified man take the role, while the underlying message of the play is clear. *The Hector of Germany* strongly suggests that Henry Stuart lived on in the hopes surrounding the Elector Palatine, following his marriage to Princess Elizabeth, hopes which indeed were given new impetus by his election in 1618 – but in 1614 the German connection meant that Protestantism was no longer an isolated force in European diplomacy. 'Long liue and happily the *Germaine Cesar*' says the Palsgrave to Savoy, a German imperial ruler brought to power through a just war won by German and English heroism.

The triumph at the close of the play is depicted as the beginning of an important friendship, with the invitation being made to 'the Maiestie of *England,* and all our Friends' to see Savoy crowned in Germany. Despite James's continued unwillingness to overplay his hand in Europe in 1614 it was a friendship which some nonetheless hoped would be further developed.

HENGIST, KING OF KENT

In Middleton's play *Hengist, King of Kent* the Saxon Horsus confides in the audience – after hearing that the British King Vortiger has announced that he will marry the Saxon Roxena – 'For as at a small Breach in towne or Castle When one has entrance, a whole Army followes' (IV.ii.274–5).[72] Set in ancient Britain, the play comments on the analogous fears of the perceived rising Spanish incursion into the Court via the depiction of invading pagans, and it makes this analogy while trying to disclaim any taint of contemporary comment. At the opening of the play the Chorus figure Raynulph warns:

Fashions that are now Calld new
Haue bene worne by more then yoᵘ,
Elder times haue vsd yᵉ same
Though these new ones get yᵉ name,
So in story whats now told
That takes not part with days of old?

(11–16)

The opening of *The Hector of Germany* had of course made a similar disclaimer, and this kind of *non mea culpa* should be treated with the same scepticism.

The play was first performed between 1615 and 1620 and it quickly introduces us to another ancient British King, Constantius, who processes onto the stage with a group of monks. The British lords urge him to withdraw from his monastic life to govern the kingdom, yet he is more interested in religion and study than in the daily business of government. All he wants is a quiet life – and an upstart noble, Vortiger, hatches a plan to seize control of the kingdom by giving him just that. He facilitates the entry into the Court of a group of petitioners, who press their claims upon the unwilling king, and later arranges for murderers to kill him.

The problems really arise when Vortiger has to put down the ensuing rebellion of the people. He is happy to welcome the help of the Saxon general Hengist and his captain Horsus, but by allowing the Saxons land as a reward he in effect betrays his country to the invaders. The Saxons use a trick whereby they ask for all the land that a hide can cover then have the hide cut into strips so that it might encompass enough land to build a castle. From such small incursions the Saxons' power steadily increases and that of their hosts declines. The chief difficulty with the newly arrived Saxons is their religion, as Vortiger tells them: 'For y'are strangers in religion Cheifly, Wᶜʰ is yᵉ greatest alienation Can bee, And breeds most factions in yᵉ bloods of men' (II.iii.34–6). Ultimately it is a defence of religion which forces the British lords to rebel against Vortiger. Legitimising the almost unthinkable, a Gentleman notes: 'But when thou fledst from heauen we fled from thee' (V.ii.72).

The supposed loyalty and friendship of the newcomers is shown to be a worthless prize, Hengist turning against Vortiger and noting that in giving his daughter Roxana to be Vortiger's Queen he did not put himself under any obligation of amity: 'Why y'haue yᵉ harmony of yoʳ pleasure fort Y'haue Crownd yoʳ owne desires; whats that to me' (IV.iii.95–6). Act IV, scene iii is critical for appreciation of Middleton's concerns in the play, as the British lords meet with their Saxon counterparts at Stonehenge to sign a peace treaty. We have already seen how little oaths mean to the Saxons when Roxena swears (falsely) that she is a virgin while the Saxons carry concealed axes, planning to slaughter the unarmed British. Cruelty and betrayal are depicted as being typical vices of these invaders and naiveté on behalf of the British

under Vortiger allows them to secure their every desire. Hengist easily manages to extract from Vortiger the title of King of Kent and the lands of Norfolk and Suffolk, through the threat of violence. An influence introduced through a marriage alliance has grown to be an invasion, all through the foolishness of a king too blind to see what it is that his foreign allies seek.

Middleton's choice of names for his characters is at times highly revealing. In *Hengist* those of the two monks Germanus and Lupus are a case in point. It is Germanus who urges Constantius to take responsibility for his subjects and leave his life of mediation so that he might look to saving their souls as well as his own. The historical Germanus, St Germain, and his companion Lupus arrived in Britain in the fifth century to confront the Pelagian heresy and the argument in the play for a practical Christianity rather than an insular ceremonial version compares Pelagianism with Arminianism. It was a connection made by Calvinist preachers at this time, Henry Airey preaching at Oxford a sermon printed in 1618 in which he asked 'in our Church what Cockatrice egges be now a hatching? what out-worne errors of Pelagianisme be now a broaching?'[73] The fact that this British king prefers to withdraw into a life of meditation rather than lead his people is therefore highly significant, especially as his isolation from his people is portrayed as leading to his murder. The play is very much a tragedy of ambition, Vortiger in the end betraying not only king and people but his country and her religion too. Vortiger is not King James – Constantius would be a better representation of him – and the Saxon's German origins make literal parallels difficult, but there are several strong resonances of Jacobean Britain and her foreign policy concerns. For anyone in the audience who knew of the character of King James and feared the power of Buckingham and his pro-Spanish sympathies at this time, this could hardly pass as a simple innocent story.

Both Middleton and Geoffrey of Monmouth agreed that the Saxons' religion was the main reason against their being granted land to settle in Britain, while the play also represents the danger of a British king marrying a foreigner as well as taking one of these foreigners into his confidence. The Saxons are referred to twice – in the scene in which they have quelled the rebellion – as Romans, an appellation which in discussing *The Virgin Martyr* below will be shown to be no longer associated with civility, but with its religious connotation.[74] It is ultimately on a religious note that the play closes. Uther and Aurelius, rightful heirs to the British throne, are victorious over the Saxons and Vortiger, and Aurelius announces

> As I begine my rule with the destruction
> Of this ambitious Pagan, so shall all
> Wth his adulterate faith distaind, and soild,
> Either turne Christians, dye, or liue exild.

> (V.ii.286–9)

The choice for those potential Catholic fifth columnists living within Jacobean Britain is clear. They must convert or face execution, or leave the country. Any other option will render the country vulnerable to the same kind of incursions from a foreign foe as depicted in this play. Heinemann has suggested that *Hengist, King of Kent* would have been 'safer than something contemporary like *Barnavelt*' yet it is in *Hengist* that we find a far more potent source of popular intermeddling with the mysteries of state so opposed by King James.[75] As a piece of theatre it cuts to the heart of the concerns with the machinations of an external foe impinging on a host nation, bringing a hated religion into the land.

THE VIRGIN MARTYR

Dekker and Massinger's *The Virgin Martyr* also comments on the dangers of courting Spain with a stern warning about the treatment Protestants in Britain could expect at the hands of Catholic Spain.[76] It is at times comically over-indulgent in the images it seeks to portray, driving home the ideas of conquest by a heathen power. As a piece of literature it rates poorly, motivated solely by the authors' Protestant agenda, but it is this very single-minded determination to outrage its audience to justify its agenda that makes it of importance here. The title-page of the 1622 edition claims that the play was 'divers times publickely Acted with great Applause By the seruants of his Maiesties Revels' and while commonplace for an edition to boast of a good reception, on the basis of this play's content it seems likely that it would have gone down very well indeed in a London theatre. The arguments for and against it being a 'Catholic' play – in its treatment of martyrdom – have been adequately settled by Julia Gasper, who has shown that it should be seen as a work of Protestant martyrology. She believes the play comments on the situation in Germany, its references to the torture of Christians in thinly veiled analogy to Ferdinand's desire to enforce Catholicism on his Protestant subjects as Holy Roman Emperor. However, the analogy does not stretch that far. The evidence backing her claims is just too slim for the play to be so explicitly about Germany as she would like, but it is certainly topical. However, its focus lies not on Germany but on Spain.

The play has its two clown characters deride their lifestyle as well as mocking the seemingly grandiose hopes and pretensions of the Jacobean monarchy. Consider the words of the drunkard Spungius: 'Who wud thinke that we comming forth of the arse, as it were, or fag end of the world, should yet see the golden age, when so little silver is stirring' (II.iii.205–7). He is complaining that he has spent all his money, but the satire on the idea of the return of the Golden Age associated with the early years of James's reign and re-stated in Jonson's *The Golden Age Restor'd* is a grim reminder that such days were past indeed.[77]

The piece is set in a period of ancient British history close to that of Rowley's *A Shoe-Maker, A Gentleman*, in which Dioclesian and Maximinus are emperors of Rome. In Rowley's play the disguised British Prince Crispinus meets and father a child on Leodice, the Emperor Maximinus's daughter. In *The Virgin Martyr* we are presented with an incident surrounding Dioclesian's daughter Artemia, ostensibly far from British shores. While Rowley's play sees the death of three of its characters in martyrdom, leading ultimately to Rome's recognition that British Christianity is tolerable if the country continues to pay tribute, *The Virgin Martyr* betrays no such optimism. Throughout the play there is a strong current of violence. The events occur in Cæsarea and the political climate is one with no toleration whatsoever for those tainted with Christianity. They are hunted down, tortured and killed with a sadistic enthusiasm. The wealthy Dorothea is pursued by Antoninus, himself the object of the Emperor's daughter Artemia's desires. Artemia's anger at Dorothea is surpassed only by the violence with which Antoninus' father Sapritius and Theophilus, a zealous persecutor of the Christians, go about trying to destroy her and those like her.

Throughout the play we are presented with verbal and literary reminders of this persecution. Theophilus and Harpax, a devil in his service, reveal that Theophilus' two daughters were recently converted back from Christianity by violence. He refers to how 'the flinty hangmans whips Were worne with stripes spent on their tender limbs' (I.i.185–6) while the captured King of Macedon has no illusions about the manner in which Rome treats her captives:

> We are familiar with what cruelty
> *Roome* since her infant greatnesse, euer vsde
> Such as she triumphd ouer, age nor sexe
> Exempted from her tyranny.
>
> (I.i.228–31)

In the early Jacobean theatre Rome is used to refer to civilisation, dignity and an ideal to which Britain ultimately ascribes. We find such thinking in, for example, Shakespeare's *Cymbeline*, in Rowley's *A Shoe-Maker, A Gentleman* and in Fisher's *The True Trojans*. By the time of *The Virgin Martyr* and of *Hengist, King of Kent*, reference to Rome has become synonymous with the Roman church. The reign of persecution and tyranny carried out by her officers is beyond anything previously depicted on the stage. Indeed, the playwrights are at pains to show the self-reflection of the malefactors.

Theophilus, the Torquemada of the play, quantifies his malice to the devil Harpax:

> Haue I inuented tortures to teare Christians,
> To see but which, could all that feeles Hels torments

> Haue leaue to stand aloofe heere on earths stage,
> They would be mad till they againe descended,
> Holding the paines most horrid, of such soules,
> May-games to those of mine, has this my hand
> Set downe a Christians execution
> In such dire postures, that the very hangman
> Fell at my foote dead hearing but their figures.
>
> (II.ii.66–74)

Minutes later Artemia lets loose her venom:

> Ile not insult on a base humbled prey,
> By lingring out thy terrors, but with one frowne
> Kill thee: hence with 'hem to execution.
> Seize him, but let euen death it selfe be weary
> In torturing her: Ile change those smiles to shreekes,
> Giue the foole what she is proud of (martyrdome)
> In peeces racke that Bawd to.
>
> (II.iii.138–44)

Threatened with a prolonged death, Dorothea notes that she does not fear 'the sight of whips, rackes, gibbets, axes, fires' (II.iii.167), yet the most hideous act of violence carried out is that by Theophilus who kills his daughters after Dorothea converts them back to Christianity. He is totally unrepentant at his actions:

> My anger ends not here, hels dreadfull porter
> Receiue into thy euer open gates
> Their damned soules, and let the furies whips
> On them alone be wasted: and when death
> Closes these eyes, twill be *Elizium* to me,
> To heare their shreekes and howlings, make me *Pluto*
> Thy instrument to furnish thee with soules
> Of this accursed sect, nor let me fall
> Till my vengeance hath consum'd them all.
>
> (III.ii.116–24)

He then exits, as the stage direction notes '*with* Harpax *hugging him, laughing*'. The stage directions in the play continue to provide important clues as to its tone. In Act IV, scene i Sapritius enters '*dragging in* Dorothea *by the Haire*'. Dekker's earlier representation of malevolence, as in *The Whore of Babylon*, betrayed no such consummate evil. That piece may have been 'the definitive militant Protestant play' but it is almost fanciful in its represenions of the threat posed by Spain when compared with the tenor of this later work, written when the stakes were so much higher.[78]

Lest we forget the importance of this play for its British audience we are introduced to a British slave at this distant court:

```
SAPR[ITIUS]:                              from what country
              Wert thou tane Prisoner, heere to be our slaue.
     SLAUE:    From Brittaine.
     SAPR:                    In the west Ocean.
     SLAUE:                                Yes.
     SAPR:     An Iland.
     SLAUE:           Yes.
     SAPR:                I am fitted, of all Nations
              Our Romane swords euer conquer'd, none comes neere
              The Brittaine for true whooring ...
```

<div align="right">(IV.i.130–33)</div>

The insult established, he goes on:

```
                               sirrah fellow,
              What wouldst thou do to gaine thy liberty?
     SLAUE:    Doe! liberty! fight naked with Lyon,
              Venture to plucke a standard from the heart
              Of an arm'd Legion: liberty! Ide thus
              Bestride a Rampire, and defiance spit
              I'th face of death; then, when the battring Ram
              Were fetching his careere backward to pash
              Me with his hornes in peeces, to shake my chaines off:
              And that I could not doo't but by thy death,
              Stoodst thou on this dry shore, I on a rock
              Ten Piramids high, downe would I leape to kill thee,
              Or dye my selfe: what is for man to doe
              Ile venture on, to be no more a slaue.
```

<div align="right">(IV.i.133–46)</div>

A proud defence of the importance of freedom from tyranny: but when told that all he must do for his freedom is ravish Dorothea, the British slave indignantly and honourably refuses and is taken out to be tortured. Even the instruction for the punishment is quite specific: 'with a Bastinado giue him Vpon his naked belly two hundred blowes' (IV.i.158–9).

For all his evil, Theophilus is finally converted to Christianity and dies for it, but not before we are shown him in his study reading and contemplating his past and future deeds. It is an important speech because this resident of Cæsarea reads a book listing the tortures inflicted not upon Christians in his own country but those in Britain:

```
                    Great Britaine, what.
              A thousand wiues with brats sucking their brests,
              Had hot Irons pinch 'em off, and throwne to swine;
              And then their fleshy backparts hewed with hatchets,
              Were minc'd and bak'd in Pies to feed staru'd Christians.
              Ha, ha.
```

> Agen, agen, — *East Anglas* — , oh, East-Angles,
> Bandogs (kept three dayes hungry) worried
> A thousand Brittish Rascals, styed vp, fat
> Of purpose, strip'd naked, and disarm'd.
> I could outstare a yeere of Sunnes and Moones,
> To sit at these sweete Bul-baitings, so I could
> Thereby but one Christian win to fall
> In adoration to my *Jupiter.* Twelue hundred
> Eyes boar'd with Augurs out: oh! eleuen thousand
> Torne by wild beasts: two hundred ram'd i'th earth
> To'th armepits, and full Platters round 'em,
> But farre enough for reaching, eate dogs, ha, ha, ha,
> Tush, all these tortures are but phillipings,
> Flea-bitings.
>
> (V.i.19–38)

Readers of Foxe's *Acts and Monuments* would be accustomed to such tales of persecution of Britons for their faith, and it is here that we are given final proof that this play is not about Pagans and Christians, but Catholics and Protestants. If Gasper believes that Theophilus' gleeful thoughts as to how he will torture the Christians of Britain reflects British fears of their treatment at the hands of Ferdinand's armies, there is an alternative focus for this concern. German Protestants living in the path of those armies were indeed already facing this persecution but the play was licensed on 6 October 1620, a month before Frederick's White Mountain defeat and hence before the situation became truly desperate for the Protestant cause. Given popular concerns in London as to the likelihood of a Spanish marriage for Prince Charles, the play does not therefore necessarily direct its fears at events in Germany. King James was one of few Britons who actively differentiated between the Habsburgs in Spain and Germany. In the popular mind the Spanish remained very much the arch-devils behind Catholic machinations against Britain.

When finally realising the error of his ways Theophilus requests that he might be made to suffer in his death for all those he killed, noting that 'In mine owne house there are a thousand engines Of studied crueltie' (V.ii.182–3). For him there is salvation, but for those in Jacobean London equivocating over support for Protestantism overseas as well as failing to act against Spanish incursions the message is clear. The wages of sinful neglect will be death.

Such a conclusion is enforced by the similarities portrayed between the Pagan religion and Catholicism. Theophilus's reconverted daughters Caliste and Christeta (an interesting choice of name) enter in Act I, scene i following a Priest who carries the image of Jupiter. Image worship is continually referred to in the play, as we see Dorothea scorn the daughters' attempt to turn her from Christianity:

CALISTE: Doe not tempt
Our powerfull gods.
DOR: Which of your powerfull gods,
Your gold, your siluer, brasse, or woodden ones?
That can, nor do me hurt, nor protect you.
Most pittied women, will you sacrifice
To such, or call them gods or goddesses.

(III.i.115–20)

She goes on to tell the two sisters about the Pharaoh who made an idol for Osiris to secure victory over his enemies. She describes how it failed to achieve this end, how he melted down the idol to make a basin that might be used to wash his concubines' feet and how it subsequently became re-elevated to being an idol. A stage direction in Act III, scene ii – '*Enter Priest with the Image of Iupiter, Incense and Censors, followed by* Caliste, *and* Christeta, *leading* Dorothea' – again introduces the processional reverence for the idols. Theophilus hurries Dorothea to worship:

Heere set our god, prepare
The Incense quickly, come faire *Dorothea*,
I will my selfe support you, now kneele downe
And pay your vowes to *Iupiter*.

(III.ii.46–9)

The ceremony is an intrinsic part of the pagan ritual and its significance could hardly have been ignored.

Unlike the pagans, Dorothea's religion is not based on images or miracles. When Sapritius is struck down, having called for ten other slaves to rape her, Dorothea is quick to deny that she has any miraculous powers, stating categorically 'I can no myracles worke' (IV.i.178). As Gasper notes, this is derived from Foxe.[79] Dorothea may be aided by the 'good spirit' Angelo, the 'grand Master Who schooles her in the Christian discipline' (III.iii.220–21) but she is a plain-speaking heroine who dies renouncing idols, incense and superstition.

Were the play to be simply affirming the Christian triumph over paganism and nothing more, the last lines of the play might come as a surprise as they are given to the Emperor Dioclesian. Theophilus dies and the devil Harpax, overcome by the triumph of good, sinks into the ground accompanied by flashes of lightning. Dioclesian is not impressed:

I thinke the centre of the earth be crackt,
Yet I still stand vnmou'd, and will go on,
The persecution that is here begun,
Through all the world with violence shall run.

(V.ii.239–42)

It is a stark warning that if martyrdom has its rewards in heaven then the enemies of the true faith are still ever-present on the earth. Diocletian's persecution of British adherents to the true religion was known to ecclesiastical scholarship, James Ussher later evoking the persecution of British Christians at that time in vivid detail in his *Britannicarum Ecclesiarum Antiquitates* (1639).[80] For all its faults, however, the play draws clear attention to matters of foreign policy but if we are looking for a play which does make quite explicit reference to the problems facing Frederick and Elizabeth, then we need to look to one which was performed a year later, when their fortunes truly were in dire straits.

THE MAID OF HONOUR

While the literary scholar might look upon this play as a lesser piece of writing, and rightly so, the historian can see within Massinger's *The Maid of Honour* (1621) an astoundingly near parallel of events in Jacobean Britain confronted with problems in the Palatinate.[81] Cleora, the heroine of Massinger's later work *The Bondman*, takes the same role as Bertoldo in this play in arousing public feeling in favour of war. Both plays are set in Sicily, an island, and both stress the evils of a peaceful reign that allows the navy to rot in harbour and the warriors to dissipate their strength in idle pleasures and debaucheries. Both plays plead for the invigorating good of war to establish pride in the nation itself, and awe in neighbouring friends and enemies. The tone is impatient, the point continually been driven home that time is being wasted when action should be taken.

Personifications of real-life figures are less disguised in this play, the character of Fulgentio a likely depiction of Buckingham. The character is shamelessly venal, holding 'the King's eare' which 'yeelds him Every houre a fruitfull harvest' (I.i.26–7). Among his other sources of income he is accused of making 'more Bishops In Sicilie, then the Pope himselfe' (I.i.35–6), ecclesiastical manipulation being something not unknown to Buckingham either. It was rumoured that his client Lewes Bayly paid him £600 for the see of Bangor in 1616 while another of his clients, Robert Snoden, gained the bishopric of Carlisle, in spite of neither of the two men having much administrative experience and in the face of objections from Archbishop Abbot and Prince Charles.[82]

Considerable time is given over in the first scene of the play to establishing the nature of the troubles in which the Duke of Urbin has found himself. The Duke's ambassador sent to request help reveals the source of his master's distress to the King of Sicily:

> Your Majesty
> Hath beene long since familiar, I doubt not,

> With the desperate fortunes of my Lord, and pitty
> Of the much that your confederate hath suffer'd
> (You being his last refuge) may perswade you
> Not alone to compassionate, but to lend
> Your royall aydes to stay him in his fall
> To certaine ruine. Hee too late is conscious,
> That his ambition to incroach upon
> His neighbours territories, with the danger of
> His liberty, nay his life, hath brought in question
> His owne inheritance: but youth and heat
> Of blood, in your interpretation, may
> Both plead, and mediate for him. I must grant it
> An error in him, being deni'd the favours
> Of the faire Princesse of *Siena* (though
> He sought her in a noble way) t'endeavour
> To force affection, by surprisall of
> Her principall seat *Siena*.

(I.i.108–26)

The parallels and shared motives with Frederick are clear throughout this speech – the fact that James was Frederick's only real hope, that his 'encroaching' on another territory had been the source of his downfall and that it was a youthful lack of foresight that was to blame for his actions.

Roberto's immediate reply is the voice of James, ever concerned as to the wrongfulness of seizing another's crown: 'Which now proves The seat of his captivity, not triumph. Heaven is still just' (I.i.126–8). Roberto is not moved by this plea to involve himself in another man's problems, especially since his advice had not been heeded, prior to the action:

> But since without our counsell, or allowance,
> He hath tooke armes, with his good leave, he must
> Excuse us, if wee steere not on a rocke
> We see, and may avoyd. Let other Monarchs
> Contend to be made glorious by proud warre,
> And with the blood of their poore subjects purchase
> Increase of Empire, and augment their cares
> In keeping that which was by wrongs extorted;
> Guilding unjust invasions with the trimne
> Of glorious conquests; wee that would be knowne
> The father of our people in our study,
> And vigilance for their safety, must not change
> Their plough-shares into swords, or force them from
> The secure shade of their owne vines to be
> Scorch'd with the flames of warre, or for our sport
> Expose their liues to ruine.
>
> EMBAS: Will you then

In his extremity forsake your friend?
ROBERTO: No, but preserue our selfe.

<div align="right">(I.i.155–72)</div>

This kind of defensive talk depicts classic James Stuart thinking. Not for him the idea of expanding his country's overseas empire through war but instead the desire to be perceived as a paternalistic figure, protecting his people and living at all times up to his motto of *Beati Pacifici*.

But there is always the voice of justice, of reason and of military intervention. The king's brother, Bertoldo, urges immediate action, using language which would doubtless have been current outside the London theatres:

BERTOL: I must tell you Sir,
Vertue, if not in action, is a vice,
And when wee move not forward, we goe backeward;
Nor is this peace (the nurse of drones, and cowards)
Our health, but a disease
 [...]
 But consider
VVhere your command lies? 'Tis not, Sir, in *France*,
Spaine, Germany, Portugall, but in *Sicilie*,
An Island, Sir. Here are no mines of gold,
Or silver to enrich you, no worme spinnes
Silke in her wombe to make distinction
Betweene you, and a Peasant, in your habits.
No fish liues neere our shores, who's blood can dy
Scarlet, or purple; all that wee possesse
VVith beasts, wee have in common: Nature did
Designe us to be warriours, and to breake through
Our ring the sea, by which we are inviron'd;
And we by force must fetch in what is wanting,
Or precious to us. Adde to this, wee are
A populous nation, and increase so fast,
That if we by our providence, are not sent
Abroad in colonies, or fall by the sword,
Not *Sicilie* (though now, it were more fruitfull,
Then when 'twas stil'd the granary of great *Rome*)
Can yeeld our numerous frie bread, we must starve,
Or eat vp one another.

<div align="right">(I.i.185–9, 197–215)</div>

This is Britain. Excess population was used as one of the key reasons behind the necessity of colonisation in North American from the early days of the Virginia Company, mines of gold in their South American possessions were thought to be financing Spain's military in Europe and the cultivation of silk had been one trade James himself had encouraged the Virginia Company to

undertake.[83] A letter was sent on 11 July 1622 'to the Treasurer, Deputy, and others of the Virginia Company, recommending them to breed silkworms for establishing the manufacturing of silk, in preference to the cultivation of tobacco'.[84] Colonial expansion is reckoned the best course of action despite a king whose enthusiasm for overseas ventures was perceived to be lukewarm. In the absence of these projects the only trade in which the inhabitants of Sicily can excel is that of arms. Citing these arguments has an effect on the king who is moved somewhat by what Bertoldo has said.

Bertoldo then makes the comparison between Sicily and England transparent in a direct address:

> May you live long, Sir,
> The King of peace, so you deny not us
> The glory of the warre; let not our nerves
> Shrincke up with sloth, nor for want of imployment
> Make younger brothers theves; 'tis their swordes, Sir,
> Must sow and reape their harvest; if examples
> May move you more then arguments, looke on *England*,
> The Empresse of the European Isles,
> And unto whom alone ours yeelds precedence,
> When did she flourish so, as when she was
> The Mistresse of the Icean. Her navies
> Putting a girdle round about the world,
> When the *Iberian* quak'd, her worthies nam'd;
> And the faire flowre Deluce grew pale, set by
> The red Rose and the white: let not our armour
> Hung up, or our unrig'd *Armada* make us
> Ridiculous to the late poore snakes our neighbours
> VVarm's in our bosomes, and to whom againe
> VVe may be terrible: while wee spend our houres
> Without variety, confinde to drinke,
> Dice, Cards, or whores. Rowze us, Sir, from the sleepe
> Of idlenesse, and redeeme our morgag'd honours.

(I.i.215–35)

The response to this statement, made by one of the young lords around the king, is unequivocal: 'I can forbeare no longer: Warre, warre, my Soveraigne' (I.i.242–3). Three years after Massinger's play John Reynolds was using very similar language, urging Parliament in the preface to his *Vox Coeli* for 'Wars, Wars ... let vs prepare ourselves for Warres'.[85]

Occurring in but the first Act, this has been a quite astonishingly powerful assertion for a change in royal policy. There is no sense of duplicity, of concealed meanings, of hidden subtexts, just a singular agenda advocating the return to war for a country whose interests are depicted in lying in an ever-present martial stance. The mention of England, and the rhetorical question

as to when England was at its strongest, illustrates how by 1621 any desire to conceal meanings is redundant. The memory of 'her worthies' must be respected, the lessons of the past remembered and Bertoldo even throws in mention of an armada for good measure.

Roberto's reply to this clarion call is as measured as had been James's to the problems facing his son-in-law and daughter:

> I will not ingage
> My person in this quarrell; neyther presse
> My Subjects to maintaine it: yet to shew
> My rule is gentle, and that I have feeling
> Of your Masters sufferings, since these Gallants weary
> Of the happinesse of peace, desire to taste
> The bitter sweets of warre, wee doe consent
> That as Adventure[r]s, and Voluntiers
> (No way compell'd by us) they may make tryall
> Of their boasted valours.
> BERTOL: Wee desire no more.
> ROBERTO: 'Tis well, and but my grant in this, expect not
> Assistance from mee.
>
> (I.i.248–59)

When we hear this concern by the king not to press his subjects to maintain a war, we are reminded that James concluded his position on war as early as 1603 in his address to Parliament: 'I shall never give the first occasion of the breach thereof neither shall I ever be moved for any particular or private passion of mind to interrupt your publique Peace'.[86] The desire to sanction independent involvement in the war in the Palatinate without committing himself to personal responsibility was also exactly what James agreed to in allowing limited English and Scottish forces to be raised. Sir Andrew Gray was permitted to levy 1000 English and 1000 Scots in March 1620, the poet John Taylor bidding 'a friendly Farewell to all the noble Souldiers that goe from great *Britain* to that honourable Expedition':

> For God, for Natures, and for Nation's Lawes,
> This martiall Army, vndertakes this cause;
> And true borne Britaines, worthy Countrymen,
> Resume your ancient honors once agen.[87]

While the play ultimately shows how the idealistic Anthonio and Gasparo are disappointed in their idealistic vision of the glories of warfare (III.i), the play then moves in a startlingly contentious direction as it pours scorn on the notion of regal loyalty. King Roberto's duplicity is emphasised in his actions following Bertoldo's capture. As Astutio reveals, Roberto is not at all keen to have his brother released: Astutio tells Gonzaga, who has captured Bertoldo,

'The King will rather thanke you to detaine him, Then give one crowne to free him' (III.i.23–4) and informs the prisoner himself that his brother 'in his displeasure Hath seas'd on all you had' (III.i.159–60). When she hears of the sum demanded for the release of Bertoldo, Camiola remarks that it is not a great sum: 'To the King 'tis nothing. He that can spare more To his minion for a masque, cannot but ransome Such a brother at a million' (III.iii.119–21). As a king, Roberto can be profligate when it comes to pandering to his familiar yet, as Camiola finds out, that same generosity evidently does not stretch to his own brother's safety. With Buckingham indulging himself in a rising number of masques in the 1620s, the real-life parallel would never have been far from the minds of an attentive audience.

But the king goes further than not paying the ransom himself, as Anthonio reveals: 'He does not alone In himselfe refuse to pay it, but forbids All other men' (III.iii.123–5). Added to the betrayal of his brother we later discover he has abandoned the soldiers completely. He writes to Aurelia:

> But for these aides from Sicily sent against us
> To blast our spring of conquest in the bud:
> I cannot find, my Lord Embassadour,
> How we should entertaine't but as a wrong,
> With purpose to detaine us from our owne.
> How e'r the King endeavours in his letters
> To mitigate the affront.

<div align="right">(IV.ii.9–15)</div>

The king seems determined to distance himself from those who are only doing what is just. King James too had attracted considerable anger in the Commons in 1621 after giving Gondomar permission to export one hundred pieces of cannon to Spain, prompting Tom Tell-Troath:

> I am sorry your Majestie is now to learne from so curste a School-master as [the King of Spain]. Who will make no new Scruple to whipp you as your Children, with your owne Rods of Iron, though he fainedly promised to use them only against the *Turke*; and then it will be too late to wish you have beleved *Cassandra*, the Voyce of your loving Parliament.[88]

Yet despite these shameful episodes the play does not continue to condemn King Roberto. The damage has been done and the point made that a king whose loyalties do not lie in the defence of his nation's interests is a less than desirable one. Roberto is ultimately reprieved when he forces Fulgentio to admit to his having slandered the reputation of Camiola. A grateful Camiola proclaims 'Happy are subjects when the prince is still Guided by justice, not his passionate will' (IV.v.93–4). We are forced to ask ourselves whether this is a piece of mock flag-waving, the playwright's attempts to salvage on Roberto's behalf some regal dignity or whether Camiola is voicing the hope that after all

James Stuart might have a genuine change of heart, leading to a redirection of foreign policy from the one on which he seemed to proactive Protestants so hell-bent.

With the publication of his *The History of the Reign of King Henry the Seventh* in 1622, Francis Bacon celebrated the Tudor origins of the Stuart dynasty just as the British origins of the Welsh were lauded in *The Valiant Welshman* and *The Birth of Merlin* (see Chapter 3).[89] The last of the Jacobean plays concerned with Britain, Dekker's *The Welsh Embassador* (1623) also pays homage to that glorious and noble Welsh ancestry. A significant difference between these Welsh plays lies in the manner in which not just a token Welshman but a *bona fide* Welsh character is depicted here. Not since *Henry V* had there been such a lengthy stage portrayal of two of England's neighbours, the Irish and Welsh.[90]

In the play the English king's two brothers, Eldred and Edmond, disguise themselves as Reese ap meridith, ap shon, ap lewellin, ap morris (!) and Teage mac Breean. They then experience life in Wales and Ireland and their hosts, unaware, reveal the extent of the peripheral kingdoms' loyalties to England. We are told of Irish princes loyal to the King of England (III.ii.131–55) and that the King believes Leinster to be a 'noble soldier'. These are emphatically *not* Irish savages. The island of Ireland has, by 1623, become a place far more similar to England, while retaining the difference of its language, tradition and alcohol. The plantation is thus depicted as having begun to take hold, differences are no longer threats to cultural superiority as the culture of the Irish, like that of the Welsh, has been subsumed within an English mantle.

In the play the concern with British matters at times overwhelms the discussion of component nationalities. Dekker lauds the Welsh ancestry of the Britons and is historically accurate when he has the noble soldier Captain Voltimar refer to the 'Welsh' Eldred as 'your bould brittaine' (III.ii.27) while Penda, disguised as the Welsh Ambassador in whose retinue Eldred serves, tells the King, 'You are landlord of *Wales*, my master a prince of royall prittish [British] pludd [blood] your tenants' (III.ii.49–50). Penda later refers to how the real Princes Edmond and Eldred, in fighting against the Welsh, 'did kanaw [gnaw] our prittish sperritts, they fought in *Wales* very finely vppon vs' (III.ii.100–101) while Winchester refers to Penda's 'lofty brittish tongue' (IV.iii.17).

Matters of national origins also dominate the attention of the play's Clown when he decides to become a chronicler:

CLOWNE: Welsh men, whie you are discended from the warlike
 Troians and the mad greekes.
ELDRED: Tis awle true as steele.

CLOWNE: So that twoe famous nations iumbled togeither to make vpp a welshman, but alas Irish men make one another.

ELDRED: Now you tawge of greekes and troshans, it was a troshan pare awaie the laty *Hellenes* and praue greekes fought almost a towzen yeares for her. So a welse man that has true prittish plud in her, ere hee loose his ense will sweare and fide, and runne vpp to his nose aboue his chin in embruings and bee awle dyed in sanguins.

CLOWNE: Nay you awle carry mettale enough about you, thats certaine.

(V.ii.25–34)

Winchester later asks the Clown where his newly written chronicle begins:

WINCHESTER: Your cronicle begins with *Brute* the sonne of *Silvius* the sonne of Astyanax the sonne of *Æneas* as other cronicles of *England* doe, dost not?

CLOWNE: *Brute?* noe my lord; thincke you I will make bruite beasts of cuntry men I weare a sweete Brute then. *Brutus* was noe more heere then I was heere. Where was *Cassius* when *Brutus* was heere?

(V.iii.40–46)

The clown's reference to the wrong Brutus coincides with the contemporary rejection of the Brute origin for Britain, though as the context of this refutation makes clear it does not mean any diminishing of the power of the British history. *The Welsh Embassador* celebrates the amity of Wales and Ireland within a British framework.

As public opinion viewed King James's foreign policy course as drifting ever further towards Madrid, several writers commented upon *arcana imperii* towards the end of his reign. More specifically they expressed the hope that he was acting with secret knowledge and would reveal the true nature of his policy, settling their fears. The writer of *Tom Tell Troath* accepts the need for subjects to leave policy to their king, 'whereas your Majesties courses are not onely inscrutable, but diametrically opposite to poore mans understanding', hoping that the ignorance of the poor man might lead to a blissful realisation that the king was doing the right thing by his subjects in the end.[91] It is a hope expressed in Dekker's *The Noble Spanish Soldier* in which a king claims 'The secret drifts of Kings are depthlesse Seas' (I.i.47) as well as in *The Welsh Embassador* in which the English king Athelstan makes precisely the same claim to secret knowledge. In the latter play he does indeed reveal to all that he has known all along what has been happening:

Oh you weake sighted lords,
Kings thoughts fly from the reach of common eyes.
Tis true our first intentions weare poysond arrowes
Shott att the hart of *Penda*, I then not card
(T'inioye his wife) so half man kind had fell,
Butt better spirritts mee guided *Voltimar*.

This was my diall, whose goinge true sett all
My mad howers right
[...]
I all this while
Sufferd this comedy of welsh disguises
Still to goe on, but now my lord embassador
Y'are welcome out of *Wales.*

(V.iii.184–91, 198–201)

While the Spanish King in *The Noble Spanish Soldier* cannot see the chaos he has created, the English Athelstan has only been distracted during some 'mad howers' from the pursuit of justice.

With the benefit of hindsight the play ultimately appears naive to think that James Stuart was secretly pursuing an emphatically Protestant agenda. Without benefit of hindsight, both *The Hector of Germany* and *The Maid of Honour* also concluded with an expression of confidence in the king's ability to rule well and we need to be suitably wary of assuming that James was seen to be a 'lost cause' for international Protestant hopes in 1623. It certainly *was* possible to make a caustic appraisal of a monarch and pass the censor's eye but traditional literary appraisals of politics and the late Jacobean theatre overemphasise the period 1623–4. Prior to that point there were still fears regarding relations with Spain but, critically, there were also hopes and those hopes were strengthened by the depiction of British unity.

CONCLUSION

James's reaction to the Palatinate crisis as it had unfolded in 1619 surprised even his supposedly close advisers. Naunton wrote to Doncaster in August that year: 'For those reportes of the Transilvanian in Hungarie, or of the new election in Bohemia I finde his Majestie is slowe of beleefe as if he tasted them to be too good to be true'.[92] However, Naunton laboured under a fundamental misconception as to James's thinking.

If we are to believe that the decade immediately preceding the outbreak of war was one of nervous silence on the London stage then we are in danger of making the same kind of mistake. Equally, we need to be wary of thinking that a continued concern with empire was somehow peripheral to the political concerns of foreign policy. By the late 1620s Sir Robert Cotton was discoursing on 'the Kingdomes of the World & the Meanes of inlarging them'.[93] Indeed, Sharpe has shown that the nostalgia many felt for Elizabeth's reign was connected with the perception that in comparison with the state of affairs under James, Elizabeth had done much to recreate Britannia in a Roman imperial vein, 'an empire ordered at home, glorious abroad, led by those of true virtue and valour'.[94]

The theatrical representation of Gondomar, and vilification of him for his treacherously having poisoned the mind of King James, did not bring to the London stage anything surprisingly new in 1624. Public resentment of Spain went deeper than that and the political events of 1624, like the theatrical ones, had been a long time in the making. The climate in which *A Game at Chesse* could be performed had long existed, but so had the political desire to stop it. The public theatre could only take occasional and often indirect lines of attack at this state of affairs. As James became increasingly frustrated in his designs, and those of Charles and Buckingham turned to favouring war with Spain, so too would plays like Dekker's *Match me in London* (1621) and Drue's *The Duchess of Suffolk* (1624) parallel the trend. Even John Fletcher, not known for being as aggressively Protestant in his sympathies as Dekker, was less than happy with the manner in which a Court full of masqueing Neros fiddled while Protestantism on the continent burned. He wrote to the Countess of Huntingdon in 1620, noting that he would not discuss:

> whether ytt bee true
> we shall have warrs with Spaine: (I wold wee might:)
> nor whoe shall daunce I'th maske; nor whoe shall write
> those brave things done: nor summe up the Expence;
> nor whether ytt bee paid for ten yeere hence.[95]

Cogswell's assertion regarding *A Game at Chesse* that 'rarely, if ever, had the London stage presented such a thinly veiled political satire' does not sit comfortably with *The Maid of Honour*.[96] Indeed if 3000 people a day *did* see *A Game at Chesse* – the nine-day run therefore suggesting an audience of potentially up to 27,000 people, almost a tenth of London's population – then it was but the culmination of a series of plays which had dealt in increasing degrees with the same themes.[97] Londoners were interested in war with Spain in the summer of 1624 but it was not an idea they were converted to while watching *A Game at Chesse*.

NOTES

1 Ferdinand's successes against the German states put the continued safety of the United Provinces in question, leading Sir Benjamin Rudyerd to assure Parliament in March 1624 that 'the day of the loss of the Low Country will be no eve of a holiday to us'. Thomas Cogswell, *The Blessed Revolution: English Politics and the coming of war, 1621–1624* (Cambridge University Press, 1989), p. 68.

2 John Taylor, *A Memorial of all the English Monarchs from Brute to King James* (London, 1622), sigs. B–Bᵛ.

3 Daniel Price, *Lamentations for the death of Prince Henry* (London, 1613). Daniel Price, *Prince Henry, the first anniversary* (London, 1613). James Maxwell, *The Laudable Life and Deplorable Death of ... Prince Henry* (London, 1612), sig. C2. James Maxwell, *A*

Monument of remembrance, erected in Albion, in honor of the magnificent departvre from Britannie, and honorable receiuing in Germany, namely at Heidelberge, of the two most noble princes (London, 1613), sig. Bv.

4 On Charles's withdrawal see, for example, Kevin Sharpe, 'The king's writ: royal authors and royal authority in early modern England' in Sharpe and Lake (eds), *Culture and Politics in Early Stuart England*, pp. 131–5.

5 John Webster, *The Duchess of Malfi*, ed. Elizabeth M. Brennan (London: New Mermaids, 1993). Katherine Watson and Charles Avery, 'Medici and Stuart: a Grand Ducal gift of "Giovanni Bologna" bronzes for Henry Prince of Wales (1612)', *Burlington Magazine* cxv (1973), 493–507. See also Roy Strong, *Henry Prince of Wales and England's Lost Renaissance* (London, 1986), plates 45, 110 and 111.

6 Henry Peacham, *Prince Henry revived* (London, 1615). William Fennor, *Fennor's descriptions* (London, 1616), sig. D3r. Prince Henry Frederick was to have little impact on the future for hopeful Protestants in Britain and the Palatinate: he died in 1629, his body being recovered from Dutch coastal waters after the accidental sinking of the ferry that he had been aboard.

7 Translated from Stephen Orgel and Roy Strong (eds), *Inigo Jones and the Theatre of the Stuart Court* vol. I (Berkeley and London: University of California Press, 1973), p. 102.

8 William Slatyer, *The history of Great Britanie to this present raigne* (London, 1621). The figure of Samothes and his pre-Albion British kingdom of Samothea was, however, comparatively little used in the advancement of the British myth at this time. See Katherine Duncan-Jones, 'Sidney in Samothea: a forgotten national myth', *Review of English Studies* xxv (1974), 174–7.

9 John Taylor, *An English-mans love to Bohemia: with a friendly farewell to all the noble souldiers that goe from great Britaine to that honorable expedition* (Dort, 1620), sig. A2r.

10 Cogswell, *The Blessed Revolution*, p. 143. The printed account of Carlton's speech to the lords of the Estates-General of the United Provinces also proclaimed him as representing the greater nation of Britain: *The Speech of Sir Dudley Carlton lord ambassadovr for the King of Great Britaine* (London, 1618).

11 Thomas Scott, *Aphorismes of State* (Utrecht, 1624), title page; In *Symmachia* he referred to Britain as a 'nation'; Thomas Scott, *Symmachia, or a Trve-loves Knot tied Betvvixt Great Britaine and the Vnited Prouinces, by the wisedome of King Iames* (Utrecht?, 1624?), sig. Diijv. Thomas Scott, *The Belgicke Pismire* (London, 1622), sig. A2.

12 John Reynolds, *Vox Coeli or Newes from Heaven*, sig. Bv; quoted in Cogswell, *The Blessed Revolution*, p. 140.

13 Anthony Munday, 'Sidero-Thriambos. The Triumphs Steele and Iron' (London, 1618), reprinted in David M. Bergeron (ed.), *Pageants and entertainments of Anthony Munday* (New York: Garland, 1985).

14 *Ibid.*, lines 28, 50–51, 66, 85–6, 87–8 (p. 126, p. 127).

15 *Ibid.*, lines 129–32 (p. 128).

16 *Ibid.*, lines 216–25 (p. 130).

17 Thomas Middleton, *The Triumphs of Integrity* (London, 1623) in A. H. Bullen (ed.), *The Works of Thomas Middleton*, vol. VII (London, 1886). John Webster, *Monuments of Honour* (London, 1624).

18 *Ibid.*, sig. B.

19 *Ibid.*, sig. Cv.

20 *Ibid.*, sig. C2.

21 *Tom Tell Troath or a Free discourse touching the manners Of the Tyme* (Holland?, 1630?), sig. Av.

22 *Ibid.*.

23 *Ibid.*, sig. A2.

24 *Ibid.*, sig. A4.

25 *Ibid.*, sig. D2v.

26 Margot Heinemann, *Puritanism and Theatre: Thomas Middleton and Opposition Drama under the Early Stuarts* (Cambridge University Press, 1980) and Jerzy Limon, *Dangerous Matter: English Drama and Politics in 1623/24* (Cambridge University Press, 1986).

27 Naunton was sworn in as Secretary of State on 8 January 1618. Roy E. Schreiber, *The Political Career of Sir Robert Naunton 1589–1635* (London: Royal Historical Society, 1981), p. 3. Henry Wright, *The first part: of the disqvisition of trvth concerning political affaires* (London, 1616), pp. 26–7.

28 G. P. V. Akrigg, *Jacobean Pageant or The Court of King James I* (London: Hamish Hamilton, 1962), p. 324.

29 This marked the renewal of interest in chivalry that would continue into Caroline England. See Afterword below and J. S. A. Adamson, 'Chivalry and political culture in Caroline England' in Kevin Sharpe and Peter Lake (eds), *Culture and Politics in Early Stuart England* (London: Macmillan, 1994), pp. 161–97.

30 See Graham Parry, *The Golden Age Restor'd: The culture of the Stuart Court, 1603–42* (Manchester University Press, 1981), pp. 166–7. On Browne and the Spenserians see David Norbrook, *Poetry and Politics in the English Renaissance* (London: Routledge and Kegan Paul, 1984), chs. 8 and 9.

31 Margot Heinemann, 'Drama and opinion in the 1620s: Middleton and Massinger' in J. R. Mulryne and M. Shewring (eds), *Theatre and Government under the Early Stuarts* (Cambridge University Press, 1993), p. 240.

32 See David Norbrook, 'The reformation of the masque' in David Lindley (ed.), *The court masque* (Manchester University Press, 1984), pp. 102–3. The text of the masque is in R. Brotanek, *Die Englischen Maskenspiele* (Vienna, 1902), pp. 328–37.

33 See Tristan Marshall, 'English public opinion and the 1604 peace treaty with Spain' (forthcoming).

34 *CSP Venetian XV* (1617–1619), n. 218, p. 134 (7 February 1618).

35 *Ibid.*, n. 679, p. 421 (late 1618).

36 John Rushworth, *Historical Collections* (London, 1659), p. 20.

37 James VI and I, *A Proclamation against excesse of Lauish and Licentious Speech of matters of State* (London, 24 December 1620).

38 The first East India Company ship arrived at Hirado in 1613. See Derek Massarella, *A World Elsewhere: Europe's Encounter with Japan in the Sixteenth and Seventeenth Centuries* (New Haven: Yale University Press, 1990).

39 Christopher Grayson, 'James I and the religious crisis in the United Provinces 1613–1619' in Derek Baker (ed.), *Reform and Reformation: England and the Continent c.1500–c.1750* (Oxford: Ecclesiastical History Society, 1979), p. 205. Interest in, and colourful imagery referring to, mercantile and exploratory expansionism in the east finds its way into Middleton's *The Witch* (c.1609–1616) where Francisca worries that 'My brother sure would kill me if he knew't, And powder-up my friend and all his kindred For an East Indian voyage'. Thomas Middleton, *The Witch* in Peter Corbin and Douglas Sedge (eds), *Three Jacobean Witchcraft Plays* (Manchester University Press, 1986), at II.i.59–61. On the topical connections between *The Witch* and the Essex divorce see Heinemann, *Puritanism and Theatre*, pp. 107–13.

40 For example, in 1619 recent events were discussed by: Anon., *Trovbles in Bohemia and Diuers Other Kingdomes, Procured by the Diuellish Practises of State-meddling Iesvites*, trans. from French (London, 1619); and John Harrison (trans.), *The Reasons which Compelled the States of Bohemia to Reiect the Archduke Ferdinand &c. & Inforced Them to Elect a New King* (Dort, 1619). For a list of other news-sheets and pamphlets see Julia Gasper, *The Dragon and the Dove: The Plays of Thomas Dekker* (Oxford: Clarendon Press, 1990), pp. 148–9.

41 The timing of performances could, however, be regulated by prudence as much as weather conditions for open-air venues. *A Game at Chesse*, *Sir John Van Olden Barnavelt*, the revival of *The Virgin Martyr*, and the revival of *Match Me in London* were all staged in mid-summer when king and Court were away from London. See Gasper, *The Dragon and the Dove*, pp. 186–7.

42 Cogswell, *The Blessed Revolution*, p. 41, pp. 48–9.

43 James VI and I, *By the King. Whereas We have beene mooued …* (London, 10 September 1618).

44 William Browne, *Britannia's Pastorals* (London, 1616), pp. 22–3, 86–7. Browne was forced to abandon work on this project until c.1624.

45 Cogswell, *The Blessed Revolution*, p. 72.

46 *Commons Journal* I, p. 648.

47 Conrad Russell, 'The foreign policy debate in the House of Commons in 1621', *Historical Journal* xx (1977), 301, 293.

48 Cogswell, *The Blessed Revolution*, p. 75, p. 116.

49 *Ibid.*, p. 97.

50 Limon, *Dangerous Matter*, p. 71.

51 Wentworth Smith, *The Hector of Germany or the* Palsgraue, *Prime Elector* (London, 1615). This chapter was written before the publication of Hans Werner's essay on the play. Our conclusions are similar, though I have attempted to place the play in the context of a much wider milieu of martial anticipation. See Hans Werner, '*The Hector of Germanie, or The Palsgrave, Prime Elector* and Anglo-German relations of early Stuart England: the view from the popular stage' in R. Malcolm Smuts (ed.), *The Stuart court and Europe: essays in politics and political culture* (Cambridge University Press, 1996), pp. 113–32.

52 That Henry II of Spain is called the Bastard in the play is based on historical fact. The Black Prince called him this when writing home to his wife on 5 April 1367. The play also refers to the battle of 'Mazieres', Nájera in real life, which took place on 3 April 1367. See Richard Barber, *Edward, Prince of Wales and Aquitaine* (London: Allen Lane,

1978), p. 203. Pedro was murdered by Enrique in March 1369 (p. 206). On the whole of the Spanish campaign see pp. 192–206. The Hector of the play's title was not an accolade reserved for the Palsgrave alone. Barber cites one opinion of the Black Prince: 'his fortune in war during his lifetime all Christian and heathen peoples feared more than any other, as if he had been another Hector' (p. 235).

53 Choice of Protestant faith in Bohemia was limited to those included in the Confession of 1575. See Geoffrey Parker (ed.), *The Thirty Years' War* (London: Routledge & Kegan Paul, 1984), p. 11.

54 Simon Adams, 'The Union, the League and the politics of Europe' in Parker (ed.), *The Thirty Years' War*, pp. 37–8.

55 Smith, *The Hector of Germany* … , sig. A2ᵛ.

56 *Ibid.*, sig. A3.

57 *Ibid.*, sig. A3ᵛ.

58 See Chapter 3.

59 Smith, *The Hector of Germany*, sig. B.

60 *Ibid.*, sig. A3.

61 *Ibid.*, sig. A4.

62 *Ibid.*, sig. D3ᵛ.

63 *Ibid.*, sigs. A3ᵛ–A4.

64 *Ibid.*, sig. B2.

65 *Ibid.*, sig. D.

66 *Ibid.*, sig. D3; sig. G2.

67 *Ibid.*, sigs. C4–C4ᵛ.

68 *Ibid.*, sig. E2ᵛ; sig. E4.

69 *Ibid.*, sig. E4ᵛ.

70 The date of the creation of the Order of the Garter is disputable. Barber indicates the likelihood of 1348. See Barber, *Edward, Prince of Wales and Aquitaine*, p. 84.

71 Smith, *The Hector of Germany*, sig. Iᵛ.

72 Thomas Middleton, *Hengist, King of Kent; Or the Mayor of Queenborough* (London, 1661), ed. R. C. Bald (New York: Amherst, 1938). The precise date of the play's first performance is believed to lie between 1616–17 or during 1619. See also Heinemann, *Puritanism and Theatre*, pp. 134–150.

73 Henry Airey, *Lectures upon the Whole Epistle of Saint Paul to the Philippians* (London, 1618), p. 302; quoted in A. A. Bromham and Zara Bruzzi, *The Changeling and the Years of Crisis, 1619–1624: A Hieroglyph of Britain* (London: Pinter Publishers, 1990), p. 125.

74 II.iii.1–2 and II.iii.88–9.

75 Heinemann, *Puritanism and Theatre*, p. 137.

76 Thomas Dekker and Philip Massinger, *The Virgin Martyr* (London, 1622) in Fredson Bowers (ed.), *The Dramatic Works of Thomas Dekker*, vol. III (Cambridge University Press, 1958), pp. 365–480.

77 Butler and Lindley believe that Jonson's masque actually celebrated the dawn of a new political agenda at Court in the aftermath of Somerset's fall, and that Essex might have been the lead masquer. Martin Butler and David Lindley, 'Restoring Astraea: Jonson's masque for the fall of Somerset', *English Literary History* LXI (1994), 807–27.

78 Gasper, *The Dragon and the Dove*, p. 62.

79 *Ibid.*, pp. 144–5.

80 James Ussher, *Britannicarum Ecclesiarum Antiquitates* (London, 1639). See Graham Parry, *The Trophies of Time: English Antiquarians of the Seventeenth Century* (Oxford University Press, 1995), p. 139.

81 Philip Massinger, *The Maid of Honour* (London, 1632), ed. Eva A. W. Bryne (London, 1927).

82 That said, Buckingham was in illustrious company in this respect – Miles Smith believed he owed his consecration to Gloucester in 1612 to Archbishop Abbot and John Thornborough his translation to Worcester in 1617 to Pembroke. Kenneth Fincham, *Prelate as Pastor: The episcopate of James I* (Oxford: Clarendon Press, 1990), pp. 23–4, p. 30.

83 'Christian charitie inuiteth you to be cheife worker in the sauing of millions of soules: The necessitie of your Countrie of Great BRITAINE, (ouer populous) doth require it'. Marc Lescarbot, *Nova Francia*, trans. Erondelle (London, 1609), sig. ¶¶ᵛ; William Alexander wrote of the Scots going overseas in the past owing to the problems of overpopulation – *An Encouragement to Colonies* (London, 1624), p. 38; Richard Eburne too cited excess numbers of people as a reason why plantations were necessary, in *A plaine path-way to plantations: that is, a discourse concerning the plantation of our English people in other countries* (London, 1624), p. 9.

84 *CSP Domestic* (1619–1623), p. 422.

85 John Reynolds, *Vox Coeli or Newes from Heaven* (London, 1624), sig. B2.

86 Quoted in Johann P. Sommerville (ed.), *King James VI and I: Political Writings* (Cambridge University Press, 1994), p. 134.

87 Massinger, *The Maid of Honour*, ed. Bryne, p. xxix.

88 *Tom Tell Troath* quoted in Bromham and Bruzzi, *The Changeling and the Years of Crisis*, pp. 54–5.

89 Francis Bacon, *The History of the Reign of King Henry the Seventh* (London, 1622). For a discussion of the Jacobean context of the work see David M. Bergeron, 'Francis Bacon's *Henry VII*: commentary on King James I' *Albion* XXIV:1 (Spring 1992), 17–26. Thomas Dekker, *The Welsh Embassador* in Fredson Bowers (ed.), *The Dramatic Works of Thomas Dekker*, vol. IV (Cambridge University Press, 1961), pp. 301–404.

90 For a discussion of the Irish element in this play and of the stage representation of Ireland in the Jacobean period, see Tristan Marshall, 'James VI and I: three kings or two?', *Renaissance Forum* IV:2 (1999), http://www.hull.ac.uk/renforum/v4n02/marshall. htm

91 *Tom Tell Troath*, sig. B3ᵛ.

92 Schreiber, *The Political Career of Sir Robert Naunton 1589–1635*, pp. 28–9.

93 Kevin Sharpe, *Sir Robert Cotton 1586–1631: History and Politics in Early Modern England* (Oxford University Press, 1979), pp. 243–4.

94 *Ibid.*, p. 245.

95 Cited in Philip J. Finkelpearl, *Court and Country Politics in the Plays of Beaumont and Fletcher* (Princeton University Press, 1990), p. 188.

96 Cogswell, *The Blessed Revolution*, p. 302.

97 *Ibid.*, p. 303.

Afterword

———◆———

'Neuer a trve Britain amongst you?'

In his panegyric to James, *Forth Feasting* (1617), William Drummond refered to his king as 'The Man long promis'd, by whose glorious Raigne, This Isle should yet her ancient Name regaine, And more of *fortunate* deserue the Stile'.[1] By using such language Drummond was contributing to a cultural discourse whose significance is critical for our understanding of Great Britain especially at the time of writing, when it is being so thoroughly deconstructed. While it is too early to speak of there being a British *nation* in the first quarter of the seventeenth century there certainly was an attempt to define a British *identity*. In a recent magazine debate, two commentators made highly pertinent observations regarding the subject of Britain and Britishness. George Kerevan wrote that the British union state was created as a counterweight to continental Europe in its various pre-EU forms, while Andrew Marr argued that 'British' is a political term, not an ethnic one, adding that '"British" surmounts and tames England'.[2] The British union state was indeed a political expedient, but its 1707 creation must not allow us to overlook the imaginative force of that state brought into existence under James VI and I. And the idea that Britain is a political term rather than an ethnic one might hold water now but it certainly did not four hundred years ago, especially in the absence of a British political discourse in the early modern period.[3] That said, Britishness certainly had a cultural impact. It was an idea stimulated by James Stuart's accession to the English throne and taken up by playwrights and antiquarians, not all of whom, to follow the established line of literary criticism, pursued an oppositional agenda.[4]

Lord Mayor's pageants, court masques, stage plays and commemorative coins, a wide variety of cultural forms all celebrated Great Britain, in terms which challenge Professor Morrill's assertions that 'the one group who most resolutely and consistently refused to regard themselves as Britons were the English in England' and that if the English used Britishness at all it was as a

synonym for 'English'.[5] In a similar vein Glenn Burgess has claimed that 'there are ... at best separate Scottish and English discourses of Britain, and part of the problem is that they meet astonishingly infrequently'.[6] In political terms this may be thought surprising, but culturally it was only to be expected. English audiences were not ready to appreciate the ancient history of the Scottish crown or its Parliament. As an example, the dignity of the soldiers in Shakespeare's *Macbeth* is as far as a dramatist was prepared to go in that respect. English politicians who might well have recognised the political maturity of the Scots were less likely to voice that sentiment in the context of the Union debate of the first Jacobean parliament when such concessions could have undermined English parliamentary sovereignty. In political terms there was no pan-British discourse because Union produced at least two armed camps and few people in power on either side of the border were prepared to concede anything. This cultural *realpolitik* shouldn't appear astonishing at all. What is significant is that not *all* English discourse of Britain necessarily followed the line that Scotland should become part of a greater England.

The depiction of Britain on the Caroline stage differed fundamentally in that Charles's vision of both Great Britain and chivalry were linked to his particular notion of love's chivalry, the knightly *mores* of his personal romantic notions of warrior kingship. His father did not have any such pretensions, averse as he was to the mere sight of a drawn blade. James's childhood in Scotland had been during turbulent times, with little scope for any such luxuries as the contemplation of a courtly vision of knightly gentility under the austere supervision of George Buchanan. Charles had enjoyed a safer childhood in this respect and through the benefit of his father's most spurious legacy, peace, the depiction of chivalry was, during his adult life, largely reliant on a pacifist interpretation of the nobility's contribution to warfare.

Where under James it had increasingly become a motif for militancy, the matter of Britain was re-appropriated by Charles to become an integral part of his personal mystique as a British *imperator* guarding the peace, rather than preparing for war. The demise of the accession-day tilts towards the end of James's reign saw the end of the most significant public connection with chivalric spectacle. Furthermore, the creation of mock-chivalric groups involving those born in the early part of the century – and hence distanced from memories of the Armada crisis and the climate of Prince Henry's court – allowed the creation of a pro-Spanish chivalry, with individuals whose loyalty (through Charles's redefinition of the Order of the Garter) was now to the king and not to the defence of international Protestantism.[7]

Inigo Jones and William Davenant's *Britannia Trivmphans* (1637) epitomised the new form of 'Britain triumphant' by mocking the earlier pretensions of martial chivalry as a dwarf, knight, giant, page and damsel are presented,

their doggerel verse ludicrously archaic and highly reminiscent of Cervantes' *Don Quixote*. The appearance of Merlin, who had throughout several of the plays discussed in the chapters above been figured as a spokesman for an emphatically British culture, does nothing to re-align the piece with those plays. Both he and the figure notably representing Imposture are sent from the stage as Charles enters as Britanocles:

> Britanocles and those that in this Isle
> The old with moderne vertues reconcile
> Away! fames universall voyce I heare,
> Tis fit you vanish quite when they appeare.[8]

The rejection of Merlin's Britain is damning, as the only reconciliation made by Britanocles is to bring together the *name* of Britishness with his new definition of what it meant.

The same spirit occurs, with some notable deviations, in *The King and Queenes Entertainement at Richmond* (1636). After the antimasque, the scene shifts to a British camp in which a Captain talks with a Druid. The soldier's language is highly evocative of the British militancy most pronounced in the first half of the Jacobean period:

> O thou God of warre,
> Great father *Mars*, the first Progenitor
> Of BRITOMART, inspire him with a courage
> That may extend his Armes, as farre as is
> Or earth, or sea, that he may think this kingdōe
> As *Alexander* did the worlds, too streight to
> Breath in.[9]

The desire for expansion is then immediately rejected, having become an anachronism in the space of a decade as Charles's appearance and the presence of his French queen renders unnecessary the need for such overseas adventuring. The soldiers are all tamed through the Priests of Apollo, who invoke the power of the Queen present. When five soldiers enter, their wild dance is calmed and they lay their swords at her feet as a Post enters.

Hitherto the direction of the entertainment has been predictable, yet at the appearance of the Post there is a strange change of mood. The newcomer demands to know where the king and queen are but does so in Welsh, '*which they say is the old* British *language*'. Not having received an answer he goes on: 'Here's no body vnderstands me, neuer a trve Britaine amongst you?'[10] The "true Britons", the belligerent patriots of James's reign, have had their day, displaced by the pacifist might of Charles and Henrietta Maria, yet the question seems just as likely to be a taut reminder that this is deliberately not a fair depiction of real-life Britain, for comic effect. Indeed, if it is supposed to be funny it is actually quite lame, there being none of the attempts at Welsh

speaking as there had been in, for example, *The Welsh Embassador*. Of course it is possible that there *were* such attempts but they were not transcribed, but perhaps anti-Spanish patriotism was not yet totally divorced from the pro-British material in which they (and the Welsh) had previously thrived. Having introduced a Spaniard who enters and dances, the Post leaves the stage, saying he would 'bequeath him to your laughter'.[11]

There was continued, if sporadic, anti-Spanish feeling on the stage during the 1630s. *The Tragedy of Alphonsus, Emperor of Germany* was performed on 3 October 1630 at Court and on 5 May 1636 at Blackfriars before the Queen and the Prince Elector. The play is a moody piece of revenge tragedy punctuated by comic scenes in which the mighty German electors are reduced to playing the roles of, for example, chef and jester. Alphonsus, described as the 'Tyrant of Spain', plots to remove the seven electors through various nefarious schemes.[12] He is ultimately thwarted, thanks in large part to the presence of English representatives.

Charles lacked his father's ability to juggle pet projects. For Charles the concept of British imperial thought meant England writ large, an extension of his will in his primary kingdom to the periphery. Other British kingdoms were there to be used. His loyal Catholic subjects in Ireland would provide an army when his turbulent Scots pushed his authority too far but, as Morrill has noted, 'it just did not occur to him that this was inappropriate'.[13] But when war finally did break out there was a British solution on hand to rescue royalist fortunes. By the terms of the Engagement signed in December 1647 the Scots agreed to send forces to join with English and Irish troops to restore Charles, beginning the second civil war.

The significance of the dual concerns with imperium and empire discussed in the chapters above would be made manifest when Oliver Cromwell attempted his 'western design'. For Michael Hawke, who was writing of the enterprise in 1656, 'The assertion of *imperium* was the general privilege of the victor over the vanquished, while the creation of an empire, with rule by a single person, was the necessary particular remedy for "ataxy" and "dissolution" in a commonwealth'.[14] Imperium, in other words, could be better ruled by a monarch advocating the creation and maintenance of the overseas empire. Such a correlation of interests was also commented upon – after the perceived failure of the Design – by Gilbert Burnet, who saw Cromwell's aim as being in fact what Armitage describes as 'the defence of the Seldenian British *imperium*, rather than the expansion of a British empire'. Clearly the two distinctive concepts of empire which we have seen in the Jacobean period were just as powerfully apparent in the middle of the seventeenth century.[15]

John Williams's famous eulogy for James Stuart, that 'Euery man liu'd in peace vnder his *vine*, and his *Figge-Tree* in the daies of *Salomon* ... And so they did in the blessed daies of King *Iames*' conceals a more important message. It

is not without a significant degree of irony for the purposes of this study, which has at times brought to light literary misappropriations, that Williams's message too has been separated from its context. The archbishop was not leaving James to rest so much in peace, as in a state of vigilance. He continues 'And yet towards his End, K. *Salomon* had secret *Enemies, Razan, Hadad* and *Ieroboam*, and prepared for a *Warre* vpon his going to his *Graue...* So had, and so did King *Iames'*.[16]

The king whose reign opened with such concerted efforts to conciliate, to bring together two feuding cousins of such long standing, achieved a significant victory, even if his Britain would drift apart until the early years of the eighteenth century. He reintroduced Great Britain as the name of the island shared by the Scots, Welsh and English; and the greater Britain he created supplied a precedent when a different version was put together in 1707.

In concluding this study, however, we return to an optimistic Purchas, dedicating his *Pilgrimes* to Charles, who, whatever the panegyrists might have hoped, was not the man his brother Henry had been:

> Here ... your Highness may refresh your wearinesse from state-affaires ... in seeing at leisure and pleasure your English Inheritance dispersed thorow the World.... The English Martialist everywhere following armes, whiles his Country is blessed at home with *Beati Pacifici*; the Merchant coasting more Shoares and Ilands for commerce, then his progenitors haue heard off, or himselfe can number; the Mariner making other Seas a Ferry, and the widest Ocean a Strait, to his discouering attempts; wherein we ioy to see your Highnesse to succeed Your Heroike Brother, in making the furthest Indies by a New Passage neerer to Great Britaine. Englands out of England are here presented, yea Royall Scotland, Ireland, and Princely Wales, multiplying new Scepters to His Maiestie and his Heirs in a New World.[17]

English men and women were indeed dispersed around the globe but, as Purchas, admits it was not simply the power of England being extended into new worlds, 'multiplying new Scepters', but also a palpable extension of the British project begun, or rather re-begun in 1603. It had been a movement based on an immediate Elizabethan past yet given new meaning and new drive by James Stuart. And the means of representing it were not the sole prerogative of the panegyrists, as a look at the theatre in this period has shown. Instead it was a transition with popular roots, firmly fixed in a public discourse and one whose effects were to echo throughout the rest of the seventeenth century, haunting us to the present day.

NOTES

1 William Drummond, *Forth Feasting. A Panegyricke to the kings most excellent majestie* (Edinburgh, 1617), sig. B3.

2 *Prospect* XXXIII (August/September, 1998), 18–21. The following discussion is a much abridged version of Tristan Marshall, 'Empire state building: Finding the problem in the British Problem', *Renaissance Forum* III:2 (1998) http://www.hull.ac.uk/renforum/v3no2/marshall.htm.

3 Glenn Burgess, 'Scottish or British? Politics and political thought in Scotland, c.1500–1707', *Historical Journal* XLI (1998), 579–90.

4 Richard Helgerson, *Forms of nationhood. The Elizabethan writing of England* (University of Chicago Press, 1992).

5 John Morrill, 'The British problem, c.1534–1707' in Brendan Bradshaw and John Morrill (eds), *The British Problem, c.1534–1707. State formation in the Atlantic archipelago* (London: Macmillan, 1996), p. 10.

6 Burgess, 'Scottish or British', 587.

7 See J. S. A. Adamson, 'Chivalry and political culture in Caroline England' in Kevin Sharpe and Peter Lake (eds), *Culture and Politics in Early Stuart England* (London: Macmillan, 1994), pp. 161–97.

8 Inigo Jones and William Davenant, *Britannia Trivmphans* (London, 1637), sigs. C–C2v; sig. C3.

9 Anon, *The King and Queenes Entertainement at Richmond* (London, 1636), sig. C3.

10 *Ibid.*, sig. C4.

11 *Ibid.*, sig. D. On the anti-Spanish faction at court in the 1630s see R. Malcolm Smuts, 'The Puritan followers of Henrietta Maria in the 1630s', *English Historical Review* XCIII (1978), 26–45.

12 Anon., [George Peele?, George Chapman?], *The Tragedy of Alphonsus, Emperor of Germany* (London, 1654), sig. I3.

13 John Morrill, 'The Britishness of the English revolution, 1640–1660' in Ronald G. Asch (ed.), *Three Nations – A common history? England, Scotland, Ireland and British history c.1600–1920* (Bochum, 1993), p. 97.

14 David Armitage, 'The Cromwellian Protectorate and the languages of Empire', *The Historical Journal* XXXV (1992), 546.

15 *Ibid.*, 539, 551. Cromwell himself used the Ciceronian idea of empire as referring to authoritarian dominion when he warned that Spain sought an all-powerful empire encompassing the Christian world, an empire which it was up to England to oppose.

16 John Williams, *Great Britains Salomon* (London, 1625), p. 39.

17 Samuel Purchas, *Purchas his Pilgrimes*, vol. 1 (London, 1625), sig. ¶3v.

Select bibliography

PRIMARY WORKS

A., R., [Robert Alleyne?] *The Valiant Welshman, or the True Chronicle History of the life and valiant deedes of Caradoc the Great, King of Cambria, now called Wales* (London, 1615)

Alexander, William, *An Encouragement to Colonies* (London, 1624)

——, *The Monarchick Tragedies* (London, 1604)

——, *A Paraenesis to the Prince* (London, 1604)

Alleyne, Robert, *Funerall Elegies upon the most lamentable and untimely death of the thrice illustrious Prince Henry* (London, 1613)

——, *Teares of Joy shed at the happy departure from Great Britaine, of the two Paragons of the Christian world, Fredericke and Elizabeth, prince and princesse Palatines of Rhine* (London, 1613)

Anon., *Chester's Triumph, in honor of her Prince* (London, 1610)

Anon., *The French Herald. Summoning all True Christian Princes to a generall Croisade, for a holy warr against the great Enemy of Christendome, and all his Slaues* (London, 1611)

Anon., *The King and Queenes Entertainement at Richmond* (London, 1636)

Anon., *Les triomphes, entrées, cartels, tournois, ceremonies, et aultres Magnificences, faites en Angleterre, & au Palatinat, pour le Mariage & Reception, de Monseigneur le Prince Frederic V. Comte Palatin du Rhin ... Et de Madame Elisabeth* (Heidelberg, 1613)

Anon., *Les triomphes, entrées, cartels, tournois, ceremonies, et autres Magnificences, faites en Angleterre, & au Palatinat, pour le Mariage & Reception, de Monseigneur le Prince Friderie V. Comte Palatin du Rhin ... Et de Madame Elizabeth* (Lyon, 1613)

Anon., *No-body and Some-body. With the true Chronicle Historie of Elydure, who was fortunately three severall times crowned King of England* (London, 1606)

Anon., *Tom a Lincoln*, ed. G. R. Proudfoot (Oxford: Malone Society Reprints, 1992)

Anon., [George Peele?, George Chapman?], *The Tragedy of Alphonsus, Emperor of Germany* (London, 1654)

Anon., *The whole Prophecies of Scotland, England, France, and Denmark. Prophecied by marvellous Merling* (?London, 1603)

Bacon, Francis, *The History of the Reign of King Henry the Seventh* (London, 1622)

——, *Instauratio Magna* (London, 1620)

——, *The Letters and the Life of Francis Bacon*, ed. J. Spedding (London, 1868) vol. IV, pp. 116–28

Barnes, Barnabe, *The Devil's Charter*, ed. Jim C. Pogue (New York: Garland Publishing, 1980)

Select bibliography

Bartas, Saluste du, *Posthumus Bartas* (London, 1607)

Birch, Thomas, *The Life of Henry Prince of Wales* (London, 1760)

Brinsley, John, *Ludud Literarius or, The Grammar Schoole* (London, 1612)

Brooke, Christopher, *Two Elegies, consecrated to the never-dying Memorie of the most worthily admyred; most hartily loued; and generally bewayled PRINCE; HENRY Prince of Wales* (London, 1613)

Buc, Sir George, *Daphnis Polystephanos* (London, 1605)

Buckeridge, John, *A sermon preached at Hampton Court before the King's Majestie* (London, 1606)

Calendar of State Papers, Domestic Series vols. VIII, IX and X [1603–10, 1611–18, 1619–23] (London, 1856–1972)

Calendar of State Papers relating to Ireland, of the reign of James I vol. III [1608–10] (London, 1872–80)

Calendar of State Papers relating to English Affairs ... in the Archives and Collections of Venice vols. X, XI, XII and XV [1603–07, 1607–10, 1610–13, 1617–19] (London, 1898–1911)

Camden, William, *Britannia*, trans. Philemon Holland (London, 1610)

——, *Remaines of a greater worke, concerning Britaine, the inhabitants thereof* (London, 1605)

Carlton, Dudley, *The Speech of Sir Dudley Carlton lord ambassadovr for the King of Great Britaine ...* (London, 1618)

Chapman, George, *Euthymiae raptus; or the teares of peace* (London, 1609)

——, *Monsieur D'Olive*, in Allan Holaday (ed.), *The Plays of George Chapman: The Comedies. A Critical Edition* (Urbana: University of Illinois Press, 1970)

Chapman, George (trans.), *The whole works of Homer; Prince of Poetts* (London 1616?)

Cleland, James, *The institvtion of a yovng noble man* (Oxford, 1607)

Cornwallis, Sir Charles, *A Discourse of the most Illustrious Prince, HENRY* (London, 1641)

Cotton, Sir Robert, *An Answer to such motives As were offer'd by certain Military-Men to Prince Henry, Inciting Him to Affect Arms more than Peace* (London, 1665)

Crashaw, William, *A sermon preached in London before the right honorable the Lord Lawarre, Lord Governour and Captaine Generall of Virginea ...* (London, 1610)

Davies, John, *Bien Venu. Greate Britaines Welcome to Hir Greate Friendes, and Deere Brethren the Danes* (London, 1606)

——, *A discoverie of the trve causes why Ireland was neuer entirely subdued ...* (London, 1612)

——, *Microcosmos. The Discovery of the Little World, with the Government thereof* (Oxford, 1603)

Dee, John, *General and Rare Memorials pertayning to the Perfect Arte of NAVIGATION* (London, 1577)

Dekker, Thomas, *The Magnificent Entertainment* (London, 1604)

——, *Troia Nova triumphans. London triumphing* (London, 1612)

——, *The Whore of Babylon* ed. Marianne Gateson Riely (New York: Garland, 1980)

Dekker, Thomas and Massinger, Philip, *The Virgin Martyr* (London, 1622), in Fredson

Bowers (ed.), *The Dramatic Works of Thomas Dekker*, vol. III (Cambridge University Press, 1958)

Donne, John, *Epithalamion or Marriage Song on the Lady Elizabeth and County Palatine being married on St Valentine's day*, in C. A. Patrides (ed.), *The Complete English Poems of John Donne* (London: Everyman, 1985)

Drayton, Michael, *Poly-Olbion* (London, 1612)

Drummond, William, *Forth Feasting. A Panegyricke to the kings most excellent majestie* (Edinburgh, 1617)

Eburne, Richard, *A plaine path-way to plantations: that is, a discourse concerning the plantation of our English people in other countries* (London, 1624)

Fisher, Jasper, *Fuimus Troes Æneid 2. The True Trojanes, being a story of the Britaines valour at the Romanes first invasion* ... (London, 1633)

Fletcher, Giles, *Christ's victorie and Triumphs In Heaven, and Earth, over and after Death* (London, 1610)

Fletcher, John, *Bonduca* (London, 1647), ed. Cyrus Hoy in Fredson Bowers (ed.), *The Dramatic Works in the Beaumont and Fletcher Canon*, vol. IV (Cambridge University Press, 1979)

Gordon, John, *England and Scotlands Happinesse* (London, 1604)

——, *Envtikon, or a Sermon of the Union of Greate Britannie* ... (London, 1604)

Gordon, Sir Robert, *Encouragements for such as shall have intention to bee Vnder-takers in the new plantation of Cape Briton, now New Galloway in America* (Edinburgh, 1625)

Harbert, William, *A Prophesie of Cadwallader* (London, 1604)

Heywood, Thomas, *Apology for Actors* (London, 1612)

Heywood, Thomas and Rowley, William, *Fortune by Land and Sea* (London, 1655)

James VI and I, *His Maiesties speech to both the Houses of Parliament* (London, 1607)

James VI and I, *A Proclamation against excesse of Lauish and Licentious Speech of matters of State* (London, 24 December 1620)

James VI and I, *The workes of ... James ... King of Great Britaine*, ed. James Montagu (London, 1616)

Johnson, Robert, *The New Life of Virginia* (London, 1612)

——, *Nova Britannia. Offring ... fruits by planting in Virginia* (London, 1609)

Jones, Inigo and Davenant, William, *Britannia Trivmphans* (London, 1637)

Lescarbot, Marc, *Nova Francia*, trans. Pierre Erondelle (London, 1609)

Lyte, Henry, *The Light of Britayne. A Recorde of the honorable Originall and Antiquitie of Britain* (London, 1588; reprinted 1814)

Marcelline, George, *The Triumphs of King James the First of great Brittaine, France and Ireland, King; Defender of the Faith* (London, 1610)

Maxwell, James, *The Laudable Life and Deplorable Death of ... Prince Henry* (London, 1612)

——, *A Monument of remembrance, erected in Albion, in honor of the magnificent departvre from Britannie, and honorable receiuing in Germany, namely at Heidelberge, of the two most noble princes* (London, 1613)

Middleton, Thomas, *Hengist, King of Kent; Or The Mayor of Queenborough* (London, 1661), ed. R. C. Bald (New York: Amherst, 1938)

——, *The Triumphs of Love and Antiquity* (London, 1619)

More, George, *Principles for yong Princes* (London, 1611)

Munday, Anthony, *London's love to the royal prince Henrie* (London, 1610)

——, *The Triumphs of Re-united Britania* (London, 1605)

Peacham, Henry, *Minerva Britanna* (London, 1612)

——, *The Period of Mourning* (London, 1613)

——, *Prince Henry revived* (London, 1615)

Petowe, Henry, *England's Caesar. His majesties most royall coronation* (London, 1603)

Price, Daniel, *The Creation of the Prince* (London, 1610)

——, *Lamentations for the death of Prince Henry* (London, 1613)

——, *Prince Henry, the first anniversary* (London, 1613)

Purchas, Samuel, *Hakluytus Posthumus. Purchas his Pilgrimes ... The Fourth Part* (London, 1625)

——, *Purchas his Pilgrimage* (London, 1613)

Rowley, William, [*A Critical, Old-Spelling Edition of*] *The Birth of Merlin (Q 1662)*, ed. Joanna Udall (London: The Modern Humanities Research Association, 1991)

——, *A Shoo-maker, A Gentleman* (London, 1637), in Charles Wharton Stork (ed.), *William Rowley his All's Lost by Lust, and A Shoe-Maker, A Gentleman* (Philadelphia: University of Pennsylvania Press, 1910)

Scott, Thomas, *The Belgicke Pismire* (London, 1622)

—— *Symmachia, or a Trve-loves Knot tied Betvvixt Great* Britaine *and the* Vnited *Prouinces, by* the wisedome *of* King Iames (Utrecht?, 1624?)

Shakespeare, William, *Mr W*[.] *S*[.] *comedies, histories and tragedies...* [The First Folio], (London, 1623)

——, *Cymbeline*, ed. J. M. Nosworthy (London: Arden Shakespeare, 1986)

——, [*The First Quarto of King Lear*], ed. Jay L. Halio (Cambridge University Press, 1994)

——, *Macbeth*, ed. Nicholas Brooke (Oxford Shakespeare, 1990)

——, *The Tempest*, ed. Frank Kermode (London: Arden Shakespeare, 1954)

——, *The Tempest*, ed. Stephen Orgel (Oxford Shakespeare, 1987)

——, *The Tragedy of King Lear*, ed. Jay L. Halio (Cambridge University Press, 1992)

Sharpham, Edward, *The Fleire* (London, 1607), ed. Hunold Nibbe (Louvain, 1912)

Slatyer, William, *The history of Great Britanie to this present raigne* (London, 1621)

Smith, Wentworth, *The Hector of Germany or the* Palsgraue, *Prime Elector* (London, 1615)

Speed, John, *Theatre of the Empire of Great Britain* (London, 1611)

Thornborough, John, *The ioiefull and blessed revniting the two mighty & famous kingdomes, England & Scotland into their ancient name of great Brittaine* (Oxford, 1605)

Virginia Company, *For the Plantation in Virginia or Nova Britannia* (London, 1609)

Webster, John, *A Monvmental Colvmne, Erected to the liuing Memory of the euer glorious HENRY, late Prince of Wales* (London, 1613)

——, *The White Devil* (London, 1612), ed. John Russell Brown (London: Methuen – The Revels Plays, 1967)

Williams, John, *Great Britains Solomon. A sermon preached at the funerals of the late king, James* (London, 1625)

Willymat, William, *A loyal subiects looking-glasse, or A good subiects Direction, necessary and requisite for every good Christian ...* (London, 1604)

Winwood's Memorials of Affairs of State in the Reigns of Q Elizabeth and K James, ed. Edmund Sawyer, vol. II (London, 1725)

Yonge, Walter, *Diary of Walter Yonge*, ed. George Roberts (London: Camden Society, 1848)

SECONDARY WORKS

Adams, Simon, 'Spain or the Netherlands? The dilemmas of early Stuart foreign policy' in Harold Tomlinson (ed.), *Before the English Civil War* (London: Macmillan, 1983), pp. 79–101

Akrigg, G. P. V., *Shakespeare and the Earl of Southampton* (London: Hamish Hamilton, 1968)

Akrigg, G. P. V. (ed.), *Letters of King James VI and I* (University of California Press: 1984)

Andrews, Kenneth R., *Trade, plunder and settlement: Maritime enterprise and the genesis of the British Empire, 1480–1630* (Cambridge University Press, 1984)

Andrews, K. R., Canny, N. P. and Hair, P. E. H. (eds), *The Westward Enterprise: English activities in Ireland, the Atlantic, and America 1480–1650* (Liverpool University Press, 1978)

Armitage, David, 'The Cromwellian Protectorate and the languages of empire', *The Historical Journal* xxxv (1992), 531–55

Axton, Marie, *The Queen's Two Bodies. Drama and the Elizabethan Succession* (London: Royal Historical Society, 1977)

Baker, David J., *Between Nations. Shakespeare, Spenser, Marvell, and the question of Britain* (Stanford University Press, 1997)

Barroll, Leeds, *Politics, Plague, and Shakespeare's Theater* (Cornell University Press, 1991)

Bennett, Josephine Waters, 'Britain among the Fortunate Isles', *Studies in Philology* LIII (1956), 114–40

Bergeron, David M., *English Civic Pageantry 1558–1642* (London: Edward Arnold, 1971)

——, 'Francis Bacon's *Henry VII*: commentary on King James I', *Albion* xxiv:1 (1992), 17–26

Bergeron, David M. (ed.), *Pageants and entertainments of Anthony Munday* (New York: Garland, 1985)

Bevington, David and Holbrook, Peter (eds), *The Politics of the Stuart Court Masque* (Cambridge University Press, 1998)

Bindoff, S. T., 'The Stuarts and their style', *English Historical Review* LX (1945), 192–216

Select bibliography

Bradbrook, Muriel C., 'A new Jacobean play from the Inns of Court', *Shakespearean Research and Opportunities* VII–VIII (1972–4), 1–5

Bradshaw, Brendan, Hadfield, Andrew and Maley, Willy (eds), *Representing Ireland. Literature and the origins of conflict, 1534–1660* (Cambridge University Press, 1993)

Bradshaw, Brendan and Morrill, John (eds), *The British Problem c.1534–1707: State formation in the Atlantic archipelago* (London: Macmillan, 1996)

Bradshaw, Brendan and Roberts, Peter (eds), *British consciousness and identity. The making of Britain, 1533–1707* (Cambridge University Press, 1998)

Braunmuller, A. R. and Hattaway, Michael (eds), *The Cambridge Companion to English Renaissance Drama* (Cambridge University Press, 1990)

Brinkley, Roberta Florence, *Arthurian Legend in the Seventeenth Century* (Baltimore: The Johns Hopkins Press, 1932)

Bromham, A. A. and Bruzzi, Zara, *The Changeling and the Years of Crisis, 1619–1624: A Hieroglyph of Britain* (London: Pinter Publishers, 1990)

Brotanek, R., *Die englischen Maskenspiele* (Vienna: Wiener Beiträge zur englischen Philologie, 1902)

Brown, John Russell and Harris, Bernard (eds), *Later Shakespeare* (London: Edward Arnold, 1966)

Brown, Keith M., *Kingdom or Province? Scotland and the Regal Union, 1603–1715* (London: Macmillan, 1992)

——, 'The Scottish aristocracy, Anglicization and the Court, 1603–38', *The Historical Journal* XXXVI (1993), 543–76

Butler, Martin, *Theatre and Crisis 1632–1642* (Cambridge University Press, 1984)

Butler, Martin and Lindley, David, 'Restoring Astraea: Jonson's masque for the fall of Somerset', *English Literary History* LXI (1994), 807–27

Canny, Nicholas P., 'The Flight of the Earls, 1607', *Irish Historical Studies* XVII (1970–71), 380–99

——, 'The ideology of English colonization: from Ireland to America', *William and Mary Quarterly* XXX (1973), 575–98

Canny, Nicholas (ed.), *The Origins of Empire: British overseas enterprise to the close of the seventeenth century* (Oxford University Press, 1998)

Chambers, E. K.,*The Elizabethan Stage*, vol. III (Oxford: Clarendon Press, 1923)

Clare, Janet, *Art Made Tongue-tied By Authority: Elizabethan and Jacobean Dramatic Censorship* (Manchester University Press, 1990)

Clark, Arthur Melville, *Murder Under Trust, or the Topical Macbeth and other Jacobean Matters* (Edinburgh: Scottish Academic Press, 1981)

Cogswell, Thomas, *The Blessed Revolution: English Politics and the coming of war, 1621–1624* (Cambridge University Press, 1989)

Colley, Linda, *Britons. Forging the Nation 1707–1837* (Yale University Press, 1992)

Collinson, Patrick, *The Birthpangs of Protestant England* (London: Macmillan, 1988)

Cuddy, Neil, 'Anglo-Scottish Union and the Court of James I, 1603–1625', *Transactions of the*

Royal Historical Society XXXIX (1989), 107–24

——, 'The revival of the entourage: the Bedchamber of James I, 1603–1625' in David Starkey (ed.), *The English Court* (London: Longman, 1987), pp. 173–225

Cummings, Robert, 'Drummond's *Forth Feasting*: a panegyric for King James in Scotland', *The Seventeenth Century* II (1987), 1–18

Cust, Richard and Hughes, Ann (eds), *Conflict in Early Stuart England* (London: Longman, 1989)

Dubrow, Heather and Strier, Richard (eds), *The Historical Renaissance* (University of Chicago Press, 1988)

Duncan-Jones, Katherine, 'Sidney in Samothea: a forgotten national myth', *Review of English Studies* XXV (1974), 174–7

Dunlop, Robert, 'Sixteenth-century schemes for the plantation of Ulster', *Scottish Historical Review* XXII (1924–5), 51–60, 115–26, 199–212

Dutton, Richard, '*King Lear, The Triumphs of Reunited Britannia* and "The matter of Britain"' *Literature and History* XII (1986), 139–51

Dwyer, John, Mason, Roger A. and Murdoch, Alexander (eds), *New Perspectives in the Politics and Culture of Early Modern Scotland* (Edinburgh: John Donald, 1982)

Edwards, Philip, *Threshold of a Nation: A Study in English and Irish Drama* (Cambridge University Press, 1979)

Ellis, Steven G. and Barber, Sarah (eds), *Conquest and Union: Fashioning a British State 1485–1725* (New York: Longman, 1995)

Enright, Michael J., 'King James and his island: an archaic kingship belief?', *Scottish Historical Review* LV (1976), 29–40

Epstein, Joel J., 'Francis Bacon and the issue of Union, 1603–1608', *Huntington Library Quarterly* XXXIII (1970), 121–32

Erskine-Hill, Howard, *The Augustan Idea in English Literature* (London: Edward Arnold, 1983)

Ferguson, Arthur B., *The Chivalric Tradition in Renaissance England* (Washington: Folger Books, 1986)

Firth, C. H., 'The British empire', *Scottish Historical Review* XV (1918), 185–9

Galloway, Bruce, *The Union of England and Scotland 1603–1608* (Edinburgh: John Donald, 1986)

Galloway, Bruce and Levack, Brian P. (eds), *The Jacobean Union: Six tracts of 1604* (Edinburgh: Scottish Historical Society, 1985)

Gasper, Julia, *The Dragon and the Dove. The Plays of Thomas Dekker* (Oxford: Clarendon Press, 1990)

Germano, William Paul, *The Literary Icon of James I* (University of Indiana PhD thesis, 1981)

Gillingham, John, 'The origins of English imperialism', *History Today* XXXVII (1987), 16–22

Goldberg, Jonathan, *James I and the Politics of Literature* (Baltimore: Johns Hopkins University Press, 1983)

Greenblatt, Stephen, *Shakespearean Negotiations. The Circulation of Social Energy in Renaissance England* (Oxford: Clarendon Press, 1988)

Grierson, Philip, 'The origins of the English sovereign and the symbolism of the closed crown', *The British Numismatic Journal* xxxiii (1964), 118–34

Gurr, Andrew, *Playgoing in Shakespeare's London* (Cambridge University Press, 1987)

——, *The Shakespearean Stage 1574–1642*, 3rd edn (Cambridge University Press, 1992)

Hadfield, Andrew, 'Briton and Scythian: Tudor representations of Irish origins', *Irish Historical Studies* xxviii (1993), 390–408

Hamilton, Donna, *Shakespeare and the Politics of Protestant England* (New York: Harvester Wheatsheaf, 1992)

Harrison, G. B., *A Second Jacobean Journal. Being a record of those things most talked of during the years 1607 to 1610* (London: Routledge and Kegan Paul, 1958)

Hart, Vaughan, *Art and Magic in the Court of the Stuarts* (London: Routledge, 1994)

Heinemann, Margot, '"Demystifying the mystery of state": *King Lear* and the world upside down', *Shakespeare Survey* xliv (1991, printed 1992), 75–83

——, *Puritanism and Theatre: Thomas Middleton and Opposition Drama under the Early Stuarts* (Cambridge University Press, 1980)

——, 'Rebel lords, popular playwrights and political culture: notes on the Jacobean patronage of the Earl of Southampton', *The Yearbook of English Studies* xxi (1991), 63–86

Helgerson, Richard, *Forms of Nationhood. The Elizabethan Writing of England* (University of Chicago Press, 1992)

Henry, Bruce Ward, 'John Dee, Humphrey Llwyd, and the name "British Empire"', *Huntington Library Quarterly* xxxv (1971–2), 189–90

Hill, J. Michael, 'The origins of the Scottish plantations in Ulster to 1625: a reinterpretation', *Journal of British Studies* xxxii (1993), 24–43

Hoak, Dale, 'The iconography of the crown imperial' in Hoak, Dale (ed.), *Tudor Political Culture* (Cambridge University Press, 1995), pp. 54–103

Hulton, Paul, *America 1585. The Complete Drawings of John White* (University of North Carolina Press, 1984)

Hunter, R. J., 'Ulster plantation towns 1609–41' in Harkness, David and O'Dowd, Mary (eds), *The Town in Ireland* (Historical Studies XIII, Belfast: Appletree Press, 1981), pp. 55–80

James, Mervyn, *Society, Politics and Culture. Studies in Early Modern England* (Cambridge University Press, 1986)

Jones, Emrys, 'Stuart Cymbeline', *Essays in Criticism* xi (1961), 84–99

Kawachi, Yoshiko, *Calendar of English Renaissance Drama 1558–1642* (New York: Garland Press, 1986)

Kay, Dennis C., 'Gonzalo's "lasting pillars": *The Tempest* V.i.208', *Shakespeare Quarterly* xxxv (1984) 322–4

Kendrick, T. D., *British Antiquity* (London: Methuen, 1950)

Koebner, Richard, '"The imperial crown of this realm": Henry VIII, Constantine the Great and Polydore Vergil', *Bulletin of the Institute of Historical Research* xxvi (1953), 29–52

Larkin, James F. and Hughes, Paul L. (eds), *Stuart Royal Proclamations*, vol. I (Oxford: Clarendon Press, 1973)

Lee Jr, Maurice, *Great Britain's Solomon: James VI and I in his three kingdoms* (Urbana and Chicago: University of Illinois Press, 1990)

——, *James I and Henri IV. An Essay in English Foreign Policy 1603–1610* (Urbana: University of Illinois Press, 1970)

Leggatt, Alexander, 'The island of miracles: an approach to *Cymbeline*', *Shakespeare Survey* x (1977), 191–209

Levack, Brian P., *The Formation of the British State: England, Scotland, and the Union 1603–1707* (Oxford: Clarendon Press, 1987)

Limon, Jerzy, *Dangerous Matter: English Drama and Politics in 1623/24* (Cambridge University Press, 1986)

Lindley, David, 'Embarrassing Ben: the masques for Frances Howard', *English Literary Renaissance* xvi (1986), 343–59

——, *The Trials of Frances Howard. Fact and Fiction at the Court of King James* (London, Routledge: 1993)

Lindley, David (ed.), *The Court Masque* (Manchester University Press, 1984)

Logan, George M. and Teskey, Gordon (eds), *Unfolded Tales – Essays on Renaissance Romance* (Cornell University Press, 1989)

McCabe, Richard A., 'Elizabethan satire and the Bishops' Ban of 1599', *Yearbook of English Studies* xi (1981), 188–93

McCavitt, John, 'The Flight of the Earls, 1607', *Irish Historical Studies* xxix (1994), 159–73

——, *Sir Arthur Chichester. Lord Deputy of Ireland 1605–16* (Belfast: Institute of Irish Studies, 1998)

McClure, N. E. (ed.), *The Letters of John Chamberlain* (Philadelphia: University of Pennsylvania Press, 1939)

McIlwain, C. H., *The Political Works of James I* (Harvard University Press, 1918)

Maley, Willy, '"Another Britain"?: Bacon's *Certain Considerations Touching the Plantation in Ireland* (1609)', *Prose Studies* xviii (1995), 1–18

Maltby, William S., *The Black Legend in England: The development of anti-Spanish sentiment, 1558–1660* (Duke University Press, 1971)

Marshall, Tristan, 'Empire state building: finding the problem in the British Problem', *Renaissance Forum* iii:2 (1998) http://www.hull.ac.uk/renforum/v3n02/marshall.htm

——, 'English public opinion and the 1604 Treaty of London' (forthcoming)

——, 'The idea of the British empire in the Jacobean public theatre, 1603–c.1614' (Cambridge PhD thesis, 1995)

——, 'James VI & I: three kings or two?', *Renaissance Forum* iv:2 (1999), http://www.hull.ac.uk/renforum/v4n02/marshall.htm

——, 'Michael Drayton and the writing of Jacobean Britain', *The Seventeenth Century* xv:2 (2000)

——, '*The Tempest* and the British imperium in 1611', *Historical Journal* xli (1998), 375–400

——, '"That's the misery of peace": representations of martialism in the Jacobean public theatre 1608–1614', *The Seventeenth Century* xiii:1 (1998), 1–21

Select bibliography

Mason, Roger A. (ed.), *Scotland and England 1286–1815* (Edinburgh: John Donald, 1987)

——, *Scots and Britons. Scottish political thought and the union of 1603* (Cambridge University Press, 1994)

Massarella, Derek, *A World Elsewhere. Europe's Encounter with Japan in the Sixteenth and Seventeenth Centuries* (New Haven: Yale University Press, 1990)

Mikalachki, Jodi, 'The masculine romance of Roman Britain: *Cymbeline* and early modern English nationalism', *Shakespeare Quarterly* XLVI:3 (1995), 301–22

Moody, T. W., *The Londonderry Plantation, 1609–41: The City of London and the Plantation of Ulster* (Belfast: W. Mullan & Son, 1939)

Morrill, John, Slack, Paul and Woolf, Daniel (eds), *Public Duty and Private Conscience in Seventeenth Century England* (Oxford: Clarendon Press, 1993)

Mulryne, J. R. and Shewring, M. (eds), *Theatre and Government under the Early Stuarts* (Cambridge University Press, 1993)

——, *War, Literature and the Arts in Sixteenth Century Europe* (London: Macmillan, 1989)

Newey, Vincent and Thompson, Ann (eds), *Literature and Nationalism* (Liverpool University Press, 1991)

Nichols, John, *The Progresses, Processions and Magnificent Festivities of King James the First* (4 vols; London, 1828)

Norbrook, David, '"The Masque of Truth": Court entertainments and international Protestant politics in the early Stuart period', *The Seventeenth Century* I (1986), 81–110

——, *Poetry and Politics in the English Renaissance* (London: Routledge and Kegan Paul, 1984)

Notestein, Wallace, *The House of Commons, 1604–1610* (New Haven: Yale University Press, 1971)

O'Callaghan, Michelle, '*The Shepheard's Nation*' (Oxford: Clarendon Press, 2000)

Orgel, Stephen (ed.), *The Renaissance Imagination* (Berkeley: University of California Press, 1975)

Orgel, Stephen and Strong, Roy (eds), *Inigo Jones and the Theatre of the Stuart Court* (2 vols; Berkeley and London: University of California Press, 1973)

Parker, Geoffrey, *The Thirty Years' War* (London: Routledge & Kegan Paul, 1984)

Parker, John, 'Samuel Purchas, spokesman for empire' in van Uchelen, T. C., van der Horst, Koert and Schilder, Günter (eds), *Theatrum Orbis Librorum* (Utrecht: HES Publishers, 1989), pp. 47–56

Parry, Graham, *The Golden Age Restor'd: The culture of the Stuart Court, 1603–42* (Manchester University Press, 1981)

——, *The Trophies of Time: English Antiquarians of the Seventeenth Century* (Oxford University Press, 1995)

Parsons, A. E., 'The Trojan legend in England', *Modern Language Review* XXIV (1929), 253–64, 394–408

Paul, Henry N., *The Royal Play of Macbeth* (New York: Octagon Books, 1971)

Peacock, John, 'Jonson and Jones collaborate on *Prince Henry's Barriers*', *Word and Image* III

(1987), 172–94

Peck, Linda Levy, *Court Patronage and Corruption in Early Stuart England* (London: Routledge, 1993)

Peck, Linda Levy (ed.), *The Mental World of the Jacobean Court* (Cambridge University Press, 1991)

Pennington, Loren E., '*Hakluytus Posthumus*: Samuel Purchas and the promotion of English overseas expansion', *Emporia State Research Studies* xiv (1966)

Perceval-Maxwell, M., *The Scottish Migration to Ulster in the Reign of James I* (London: Routledge, 1990)

Porter, H. C., *The Inconstant Savage. England and the North American Indian 1500–1660* (London: Duckworth, 1979)

Rabb, Theodore K., *Enterprise and Empire* (Harvard University Press, 1967)

——, *Jacobean gentleman: Sir Edwin Sandys, 1561–1629* (Princeton University Press, 1998)

Rosenthal, Earl, 'The invention of the columnar device of Emperor Charles V at the Court of Burgundy in Flanders in 1516', *Journal of the Warburg and Courtauld Institutes* xxxvi (1973), 198–230

——, '*Plus Ultra, Non Plus Ultra*, and the columnar device of Emperor Charles V', *Journal of the Warburg and Courtauld Institutes* xxxiv (1971), 204–28

Rountree, Helen C., *Pocahontas's People. The Powhatan Indians of Virginia Through Four Centuries* (University of Oklahoma Press, 1990)

Russell, Conrad, *The Addled Parliament of 1614: The Limits of Revision* (University of Reading: The Stenton Lecture, 1991)

Schreiber, Roy E., *The Political Career of Sir Robert Naunton 1589–1635* (London: Royal Historical Society, 1981)

Seed, Patricia, 'Taking possession and reading texts: establishing the authority of overseas empires', *William and Mary Quarterly* xlix (1992), 183–209

Sharpe, Kevin, *Criticism and Compliment: The politics of literature in the England of Charles I* (Cambridge University Press, 1987)

——, *Sir Robert Cotton 1586–1631: History and Politics in Early Modern England* (Oxford University Press, 1979)

Sharpe, Kevin (ed.), *Faction and Parliament: Essays on early Stuart history* (London: Methuen, 1985)

Sharpe, Kevin and Lake, Peter (eds), *Culture and Politics in Early Stuart England* (London: Macmillan, 1994)

Sharpe, Kevin and Zwicker, Steven N. (eds), *Politics of Discourse. The Literature and History of Seventeenth-Century England* (University of California Press, 1987)

Sherman, William H., *John Dee: The Politics of Reading and Writing in the English Renaissance* (Amherst: University of Massachusetts Press, 1995)

Simonds, Peggy Munoz, *Myth, Emblem and Music in Shakespeare's Cymbeline. An iconographic reconstruction* (Newark, University of Delaware Press, 1992)

Smith, Alan G. R. (ed.), *The Reign of James VI and I* (London: Macmillan, 1973)

Select bibliography

Smith, David L., Strier, Richard and Bevington, David (eds), *The Theatrical City: Culture, Theatre and Politics in London, 1576–1649* (Cambridge University Press, 1995)

Smuts, R. Malcolm, *Court Culture and the Origins of a Royalist Tradition in Early Stuart England* (University of Pennsylvania Press, 1987)

Smuts, R. Malcolm (ed.), *The Stuart court and Europe: essays in politics and political culture* (Cambridge University Press, 1996)

Somerset, Anne, *Unnatural murder. Poison at the court of James I* (London: Weidenfeld & Nicolson, 1997)

Sommerville, Johann P. (ed.), *King James VI and I: Political Writings* (Cambridge University Press, 1994)

Strong, Roy, *Britannia Triumphans. Inigo Jones, Rubens and Whitehall Palace* (London: Thames and Hudson, 1980)

——, *Henry, Prince of Wales and England's Lost Renaissance* (London: Thames and Hudson, 1986)

Taylor, Gary, 'The war in *King Lear*', *Shakespeare Survey* xxxiii (1980), 27–34

Taylor, Gary and Warren, Michael (eds), *The Division of the Kingdoms* (Oxford: Clarendon Press, 1983)

Tricomi, Albert H., *Anticourt Drama in England 1603–1642* (University Press of Virginia, 1989)

Ullmann, Walter, ' "This realm of England is an empire" ', *Journal of Ecclesiastical History* xxx (1979), 175–203

Vaughan, Alden T. and Vaughan, Virginia Mason, *Shakespeare's Caliban. A Cultural History* (Cambridge University Press, 1991)

Vivanti, Corrado, 'Henry IV, the Gallic Hercules', *Journal of the Warburg and Courtauld Institutes* xxx (1967), 176–97

Warren, Roger, *Staging Shakespeare's Late Plays* (Oxford: Clarendon Press, 1990)

Wickham, Glynne, 'From tragedy to tragi-comedy: "King Lear" as prologue', *Shakespeare Survey* xxvi (1973), 33–48

——, 'Riddle and emblem: a study in the dramatic structure of *Cymbeline*' in John Carey (ed.), *English Renaissance Studies Presented to Dame Helen Gardner* (Oxford: Clarendon Press, 1980), pp. 94–113

Wiener, Carol Z., 'The beleaguered isle. A study of Elizabethan and early Jacobean anti-Catholicism', *Past and Present* li (1971), 27–62

Wilks, Timothy V., 'The Court Culture of Prince Henry and his circle 1603–1613' (Oxford DPhil Thesis, 1987)

Williamson, Arthur H., 'Scots, Indians and empire: the Scottish politics of civilisation 1519–1609', *Past and Present* cl (1996), 46–83

——, *Scottish National Consciousness in the Age of James VI: The Apocalypse, the Union and the Shaping of Scotland's Public Culture* (Edinburgh: John Donald, 1979)

Williamson, J. W., *The Myth of the Conqueror. Prince Henry Stuart: A Study of 17th Century Personation* (New York: AMS Press, 1978)

Willson, D. H., *King James VI and I* (London: Jonathan Cape, 1956)

Wilson, Elkin Calhoun, *Prince Henry and English Literature* (New York: Cornell University

Press, 1946)

Woolf, D., *The Idea of History in Early Stuart England* (University of Toronto Press, 1990)

Woolf, D. R., 'Two Elizabeths? James I and the late queen's famous memory', *Canadian Journal of History* xx:2 (1985), 167–91

Wormald, Jenny, *Court, Kirk and Community. Scotland 1470–1625* (Edinburgh University Press, 1981)

——, 'The creation of Britain: multiple kingdoms or core and colonies?', *Transactions of the Royal Historical Society* ii, 6th ser. (1992), 175–94

——, 'James VI and I: two kings or one?', *History* lxviii (1983), 187–209

Wright, Louis B., 'Propaganda against James I's "appeasement" of Spain', *Huntington Library Quarterly* vi (1942–3), 149–72

——, *Religion and Empire: The Alliance between Piety and Commerce in English Expansion, 1558–1625* (University of North Carolina, 1965)

Yates, Frances, *Astraea: The imperial view in the sixteenth century* (London: Pimlico, 1993)

——, *Shakespeare's Last Plays. A New Approach* (London: Routledge and Kegan Paul, 1975)

Index

Index

Index

3 5282 00497 6521